TREASURES OF THE
NATIONAL MARITIME MUSEUM

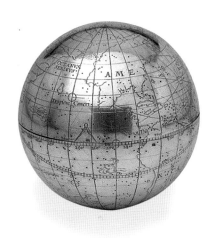

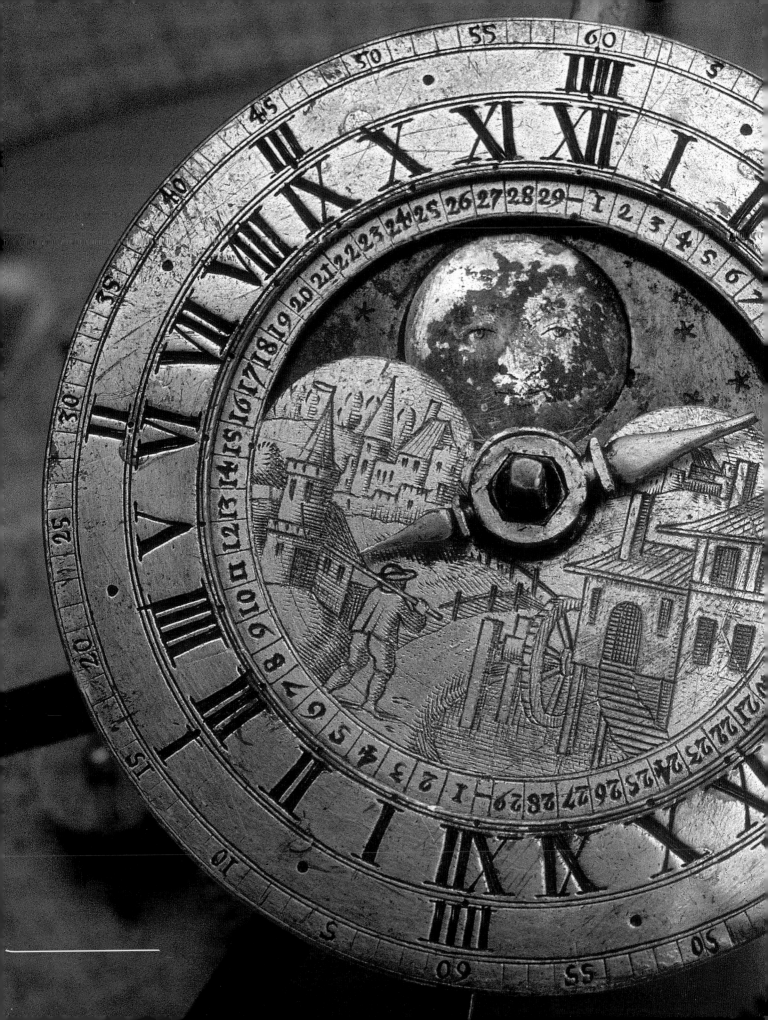

TREASURES OF THE NATIONAL MARITIME MUSEUM

Edited by Gloria Clifton and Nigel Rigby

With a foreword by HRH The Duke of York

First published in 2004 by the National Maritime Museum, Greenwich, London, SE10 9NF.

ISBN 0 948065 4 27

1 2 3 4 5 6 7 8 9

A CIP catalogue record for this book is available from the British Library.

Designed by Bernard Higton
Printed and bound in Slovenia

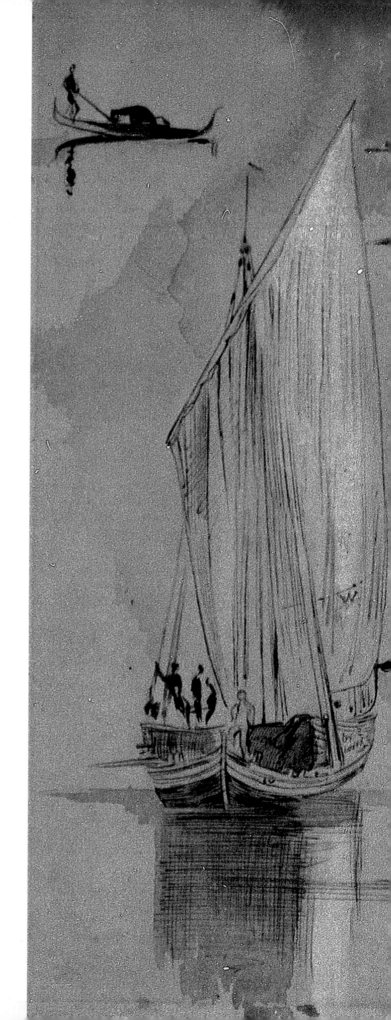

Frontispiece:
Whitwell silver globe, c. 1590, made by Charles Whitwell.

Right:
Studies of Venetian Craft, 29 November 1865, by Edward Lear.

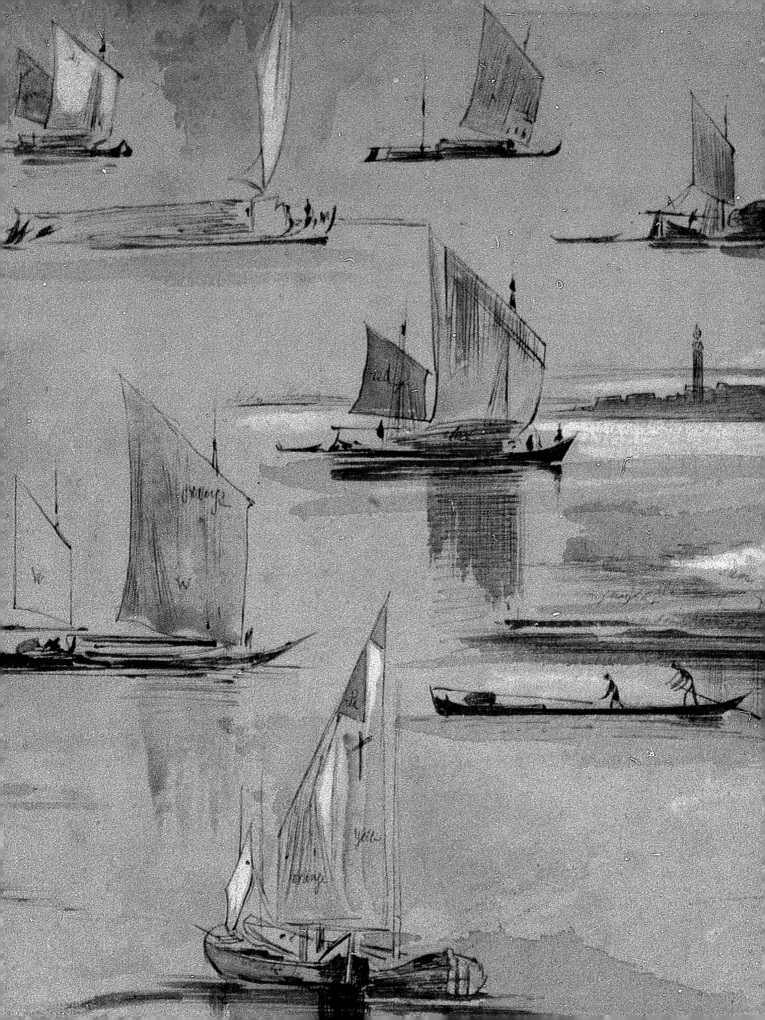

CONTENTS

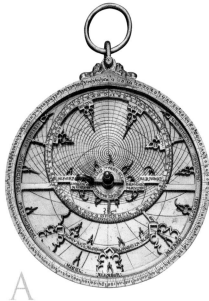

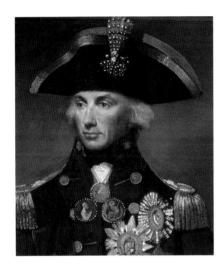

PREFACE

Roy Clare

THE National Maritime Museum at Greenwich has the largest collection of maritime-related objects in the world. *Treasures of the National Maritime Museum* reveals some of the finest examples, all of them chosen by our curators who are expert in and passionate about aspects of the Museum's core subjects – the sea, ships, time and the stars. Some of the items may be in this book because they are too delicate or difficult to display safely in galleries; others could be objects that the curators feel are important but which have been unfairly neglected; some may be here simply because we are particularly fond of them and want to share our favourites with you. Chiefly, though, they have been chosen because they represent the best of a superb national collection.

The *Treasures* shown in these pages again remind us of the Museum's debt to its first and most generous benefactor, Sir James Caird. It was largely through his passion for Britain's maritime heritage and his commitment to the idea of a museum to celebrate it, from the 1920s to his death in 1954, that the Museum's collections were considered to be among the best in the world from the very outset. Many of the objects pictured here were bought for the Museum by him and it is unlikely that we or any other national museum will ever again be in the position of being able to buy quality in such quantity.

Today, our collecting policies are inevitably more selective but thanks to the generosity of the Heritage Lottery Fund, the National Art Collections Fund, the Society for Nautical Research, the Friends of the National Maritime Museum, and many other trusts and corporate and individual supporters we are able continually to improve our collections for the enjoyment of this and future generations.

Meanwhile, Britain's relationship with the sea continues to unfold and is being interpreted in new and exciting ways. This Museum has been among the first maritime museums in the world to strive to reach fresh audiences through a programme of thematic displays and stimulating exhibitions that trace and explore the relationship of the core subjects to the lives of people.

Determined to be relevant to the learning needs of new generations, the NMM has also recognised the opportunities afforded by new information and communication technology. We are continuing to invest in the process of putting our catalogues on-line and creating web-based learning materials, helping to bring our collections alive and making them accessible throughout the world. Our website is now host to a virtual museum and encompasses a vast array of information and research resources.

On your behalf, I would like to thank the curatorial and publishing teams who have produced *Treasures of the National Maritime Museum* to such a high standard. It is our purpose as a team here in Greenwich to illustrate the importance of our subjects and to encourage you to become a regular research user of our facilities and a visitor to our superb museum and its comprehensive website: www.nmm.ac.uk. I hope that we may succeed in this task, that you will enjoy this book and that it will inspire you to celebrate Britain's ongoing relationship with the sea.

Roy Clare
Director, National Maritime Museum, Greenwich
2004

ROYAL FOREWORD

HRH The Duke of York

IT is a pleasure to introduce *Treasures of the National Maritime Museum*, a book whose purpose lives up to its title in giving an overview of the rich collections held by the Museum at Greenwich and the many seafaring subjects to which they relate.

Britain has always been a maritime nation and this remains true in the 21st century. Britain's ports handle over 90 per cent of our international trade and London is still the centre of world shipping organization and finance – not surprising for an island nation whose prosperity depends on import and export by sea. The Royal Navy remains at the forefront of international naval technology and practice, with the largest European fleet and continuing global commitments.

We are also increasingly a nation of boat-owners and users for pleasure, while our competitive sailors continue to excel internationally. The National Maritime Museum is thus, appropriately, the leading museum of its type in the world, celebrating and interpreting for many audiences Britain's engagement with the sea; in the past and the present, in peace and war, in trade and adventure, in sea-related science and the arts, and increasingly in the importance of the oceans to the future of our planet as a whole.

The royal connections of Greenwich are also indivisible from this. Most of what is now the Maritime Greenwich World Heritage Site has been in Crown possession since the fifteenth century. Greenwich Royal Park – the oldest of all – dates from that time, with the famous Royal Observatory at its centre (now part of the Museum) being a creation of Charles II's to improve astronomical science for navigational purposes. More recently, my own family has been closely connected with the Museum since its founding in the 1920s and '30s. That is a tradition which I am delighted to be continuing as a Trustee of the Museum and in commending this book as a guide to what this unique institution offers.

HRH The Duke of York

MARITIME GREENWICH

Pieter van der Merwe

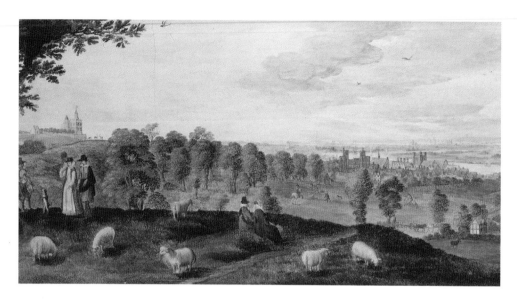

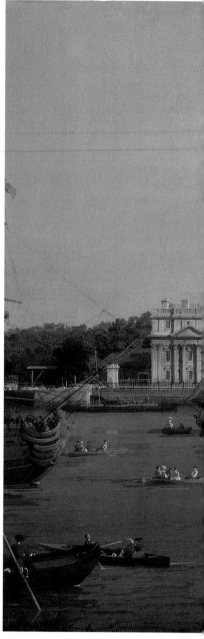

The Greenwich landscape today is almost entirely a creation of the late seventeenth and early eighteenth centuries. The green of the Park sweeps down from the Royal Observatory, perched high in its centre on the river escarpment, to Sir Christopher Wren's monumental Royal Hospital complex on the south bank of the Thames itself. The grand 'visto', over thirty-five metres wide between the Hospital's great paired Courts, countermarches back from the foreshore to Inigo Jones's Queen's House at the foot of the Park, with the nineteenth-century colonnades and flanking wings of the National Maritime Museum spreading out on either side. The picture is one of classical regularity and balance, in Portland stone and pale stucco, quirkily offset by the red brick of the Observatory, the grey of lead and slate roofs, and the gilded weather-vanes of the Hospital's twin domes.

The strength and harmony of the whole composition is such that it now easily conceals its long and tortuous process of imposition on another, older Greenwich, of which the Queen's House and the Park itself are the only visible remnants.

Greenwich from the Park, about 1620. Unidentified artist. Greenwich Castle, left, on the site of the Royal Observatory, overlooks the Palace of Greenwich, right, and the distinctive twin towers flanking Henry VIII's tiltyard.
BHC1820

Greenwich Hospital and The Queen's House, Antonio Canal, called Canaletto. *c.* 1752
This work may commemorate completion of the building of Greenwich Hospital in 1751. It has been suggested that the view was painted for Consul Joseph Smith for his residence on the Grand Canal in Venice, where he entertained many English visitors making the Grand Tour.
BHC1827

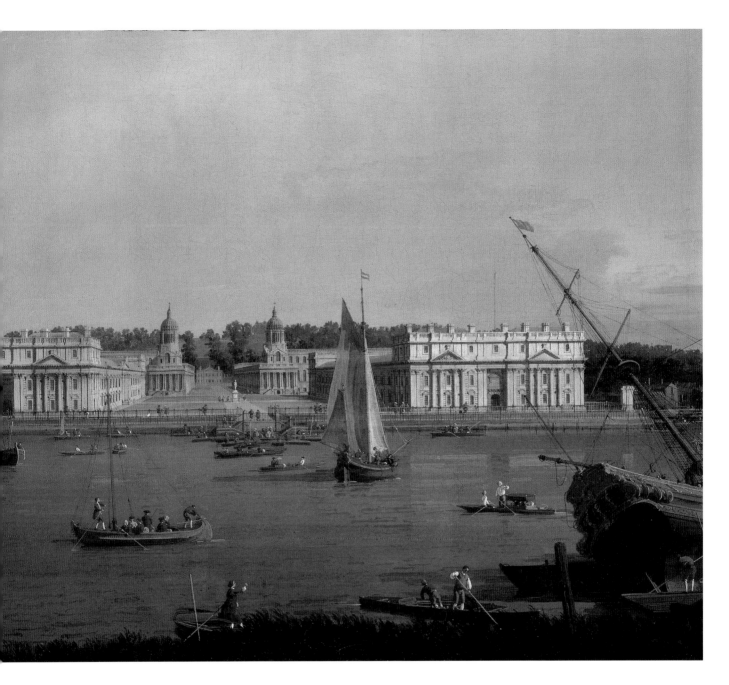

This story began in 1433, when the Park was enclosed by Humphrey, Duke of Gloucester – soldier, scholar and half-brother of Henry V – and a watchtower which he built stood where the Observatory does now. His riverside manor house, called Bellacourt, was later extended and then massively rebuilt by Henry VII from about 1500 as the Palace of Greenwich, where Henry VIII and his daughters Mary I and Elizabeth I were born. The Palace gardens and the tournament ground, added in 1515–16 by Henry VIII, covered the present east lawns of the Museum and ended at the walled Deptford-to-Woolwich road, which separated them from the Park on the present line of the Museum colonnades.

In 1616 Inigo Jones, the first individual British architect of genius, began the Queen's House for Anne of Denmark, queen of James I, as a secret and private garden house which doubled as a bridge between the Palace gardens and Park. He only finished it in 1638 for Queen Henrietta Maria, the wife of their son, Charles I. This white Renaissance

From left to right: Henry VIII, Inigo Jones, Anne of Denmark, Henrietta Maria, Charles II, Mary II
BHC2763, BHC2810, BHC4251, BHC2761, MNT0188 / C9422, BHC2853

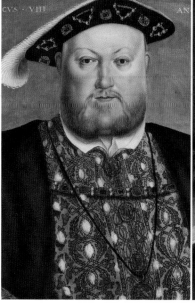

villa – inspired by those Jones had seen in Italy – was the first truly classical building in England. It must have appeared to some as an almost bizarre modern addition, perched on the southern edge of the rambling, red-brick Palace and its knot-gardens and walled plantations. The original form of the House was an H, with a single central bridge-room on the upper floor spanning the road between separate two-storey blocks. It was only in 1662 that it assumed a square plan when Charles II added two further bridge-rooms to east and west, creating formal sets of top-floor apartments for brief occupation by his long-widowed mother, Henrietta Maria. Only from this date do we have any clear idea of how the House was used. In the 1670s this was as a residence for royal servants, including the Willem van de Veldes, father and son, the Dutch marine painters who came at Charles's invitation in 1672–73 and were allocated a studio in the Park-side ground floor.

By that time, both the Palace itself and the much-rebuilt Duke Humphrey's Tower – garrisoned by Parliament in the Civil War and long known as Greenwich Castle – had fallen into decay. The Castle was demolished in 1675, the Royal Observatory being rapidly erected on the same foundations in that year by order of Charles II 'to find out the so much desired longitude of places, for the improvement of navigation and astronomy', under the first Astronomer Royal, John Flamsteed. He moved in and worked there from 1676, laboriously mapping the stars and becoming so associated with the site that the main Observatory building – designed largely by Wren – had already acquired its lasting name of 'Flamsteed House' well before his death in 1719. The extensions to Flamsteed House itself, and the separate additions which make up what is now called the Meridian Building on the south-east side, were added for his successors between the 1720s and 1857. The South Building and

Altazimuth Pavilion to the south were completed in 1899, fifteen years after the Observatory became the official 'home' of world time and the Universal Prime Meridian, Longitude 0°.

The Palace itself had largely been demolished in the 1670s, giving the Queen's House a view to the river, which it originally blocked. On its site, in the 1660s, Charles II had already begun but not finished one wing of a new palace. In the reign of William and Mary, this and the preserved central 'visto' were incorporated at Mary's order into Wren's great design for a Royal Hospital for Seamen – then 'the darling object' of her life. That was short: she died aged 37 in 1694, nearly two years before foundations were laid. The four great Courts – King Charles and King William to the west, Queen Mary and Queen Anne to the east – were only completed after many hold-ups and difficulties in 1751. The first 'Greenwich Pensioners', the wounded and destitute casualties of Britain's long sea wars, entered in 1705 and for some time, as building progressed, the Queen's House served as the residence of the Hospital's Governor. Also Ranger of the Park, he at least no longer had the road running under the House: it was moved to its present position in about 1697–99.

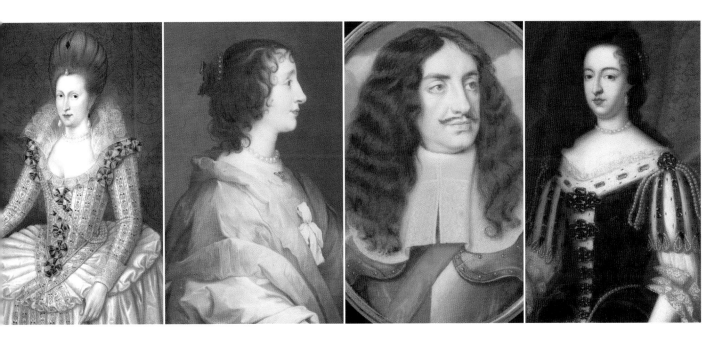

The Queen's House remained a grace-and-favour residence for most of the eighteenth century but was in poor condition by 1806, when George III released it to be a new home for the Royal Naval Asylum, a large residential school for the orphaned children of seamen. From 1841 this was solely for boys, all of whom were destined for the Navy. The House was drastically converted for the purpose although the colonnades and immediately flanking wings, added to the design of Daniel Alexander from 1807 to 1816, complemented Jones's work well. Further extensions to the west wing, including a gymnasium on the site of the present Neptune Court, were added between 1862 and 1876. From 1821 the Asylum amalgamated with the separate Greenwich Hospital School (begun about 1715) under Hospital management, the combined institution being renamed the Royal Hospital School in 1892.

The combined School had then outlived the Greenwich Pensioners. Their numbers diminished during the long *Pax Britannica*, resulting in the Hospital's closure in 1869 and its occupation by the Royal Naval College, the Navy's 'university', four years later.

After 125 years, that too moved away, to Wiltshire. As the Old Royal Naval College the site is now a modern university campus, and open to the public, under the overall care of the Greenwich Foundation.

In 1933 the School also moved out of Greenwich, to Suffolk, and its buildings became the home of the new National Maritime Museum. This was formally established by Act of Parliament in 1934 and opened in 1937, following massive restoration of the Queen's House and the west wing. The east wing was redeveloped and opened in 1951.

The Observatory also became part of the Museum over several years during the 1950s, as its scientific functions moved elsewhere, although its conversion as a museum site was only completed in 1967. The main Museum buildings underwent considerable modification in the 1970s but all of them, including the Observatory and the Queen's House, were entirely restored or redeveloped from 1983, culminating in the £21m Neptune Court project to reconstruct the main gallery wings, completed and opened in 1999.

In 1997, with the end of this work and with the role of 'the home of time' imminent in celebration of the Millennium, the architectural, cultural and scientific importance of 'Maritime Greenwich' was formally recognized by its inscription as a UNESCO World Heritage Site.

ADMIRALS

THE COMMAND FLAG OF RICHARD, EARL HOWE (1726–99)
Before 1801

The Union flag flown at the mainmast of *Queen Charlotte* at the Battle of the Glorious First of June 1794, as the command flag of Richard, Earl Howe, then Admiral of the Fleet. It is without the red diagonal cross of St Patrick, added to the Union flag to represent Ireland after the formation of the United Kingdom of Great Britain and Ireland in 1801. The inaccuracy with which the design has been made up seems characteristic of early British sea flags, of which very few complete examples survive.

AAA0730 / C8499

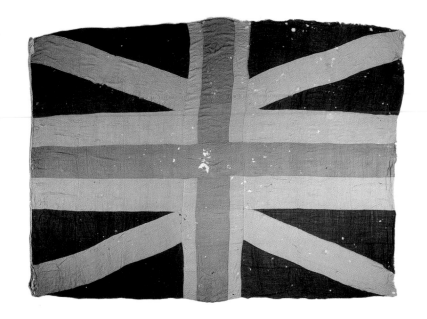

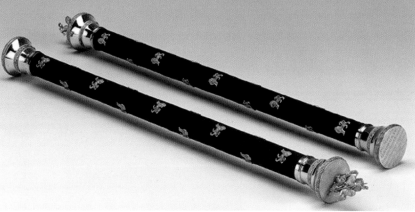

(Above)
ADMIRAL OF THE FLEET BATONS
John Northam, London
1821

Although a plain baton had been a symbol of high naval office since at least the sixteenth century, the first Admiral of the Fleet's baton did not appear until 1821. Originally covered in navy blue velvet, the batons with their gold terminals and figure of St George killing the dragon were identical in all but colour to the more familiar red field-marshal's baton. The two Admiral of the Fleet batons illustrated here, the first ever presented, were owned by William, Duke of Clarence, and John Jervis, Earl of St Vincent.

PLT0174 & PLT0175 / D4624

(Right)
BUST OF ADMIRAL VERNON
Louis-François Roubiliac
1744

Admiral Edward Vernon (1684–1757) was famed both for his capture of Porto Bello from the Spanish in 1739 and for the introduction of 'grog' into the Royal Navy. In 1740 watered rum replaced neat spirits as the seaman's daily ration and the tradition remained a part of naval regulations until the abolition of the rum issue in 1970. The name 'grog' was derived from the nickname 'Old Grog' which Vernon had earned himself by wearing a grogram, or coarse cloth, boatcloak. This marble bust of Vernon is by the great French immigrant sculptor Roubiliac, famed for his remarkable portrait work.

SCU0057 / B3531

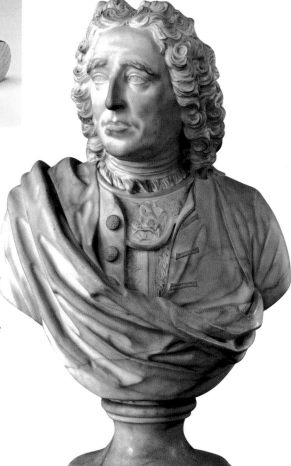

ADMIRAL JOHN JELLICOE, FIRST EARL JELLICOE (1859–1935)
Sir Thomas Monnington
1933

Commissioned by the gunnery school, HMS *Excellent*, in 1932, the portrait was returned to the artist, owing to Lady Jellicoe's objections to the frail appearance of her elderly husband who was then deaf and nearly blind, the results of his involvement in gunnery. Nevertheless it has a haunting and surreal quality, suggesting a sense of nostalgia for Jellicoe's long and distinguished career in the Navy. The painting was exhibited at the Royal Academy in 1934.

BHC2804

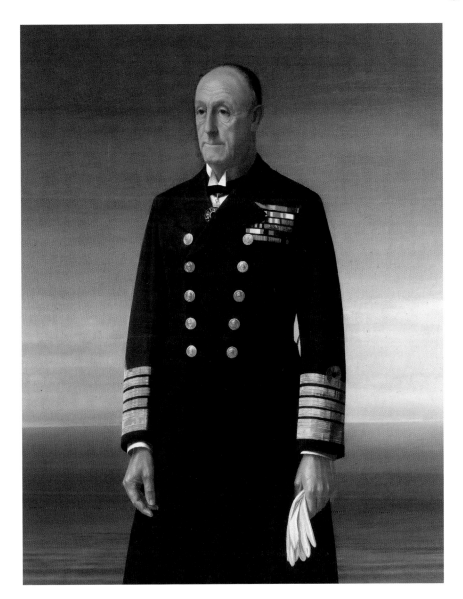

FREEDOM CASKET
Omar Ramsden, London
1919

After World War I, Admiral of the Fleet Sir David Beatty was showered with honours and awards, including a number of civic Freedoms. The Freedom scroll was usually contained in a casket, which was individually commissioned and designed with symbolic and heraldic references to the recipient and the conferring authority. This silver and ebony casket, by the well-known London silversmith Omar Ramsden, was made to contain the Freedom of Oxford. On the lid is Beatty's coat of arms in silver, incorporating the heraldic punning bees and beehive, and on the front are the arms of the City of Oxford.

PLT0010 / D4621-1

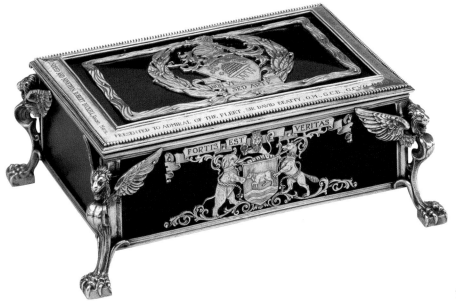

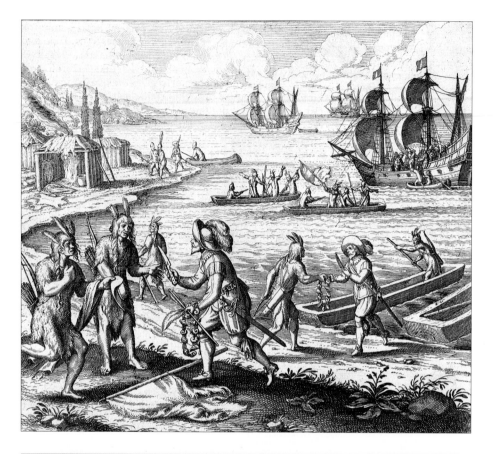

AMERICA

(Left)
CAPTAIN GOSNOLD TRADING WITH THE INDIANS, FROM AMERICA
Theodor de Bry
Bartholomew Gosnold was among the early promoters of the colonization of North America. In 1602 he sailed on the *Concord*, fitted out by Sir Walter Ralegh, landing at Cape Cod, Martha's Vineyard and Elizabeth's Island. He brought back sassafras, cedar and furs – and the idea of an American settlement. In 1606 he set out from the Thames in command of the *Godspeed*, which carried fifty-two of the Virginia Company pioneers. He was thus a founding father of Jamestown. He died in 1607.
D3923

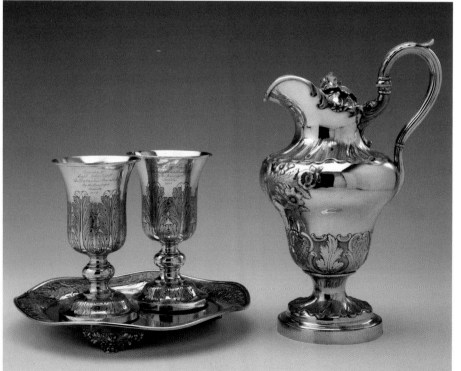

(Left)
BRITANNIA WINE SET
Lows, Ball & Co., Boston, USA
1842
This silver wine set was presented in 1842 to John Hewett, captain of the British and North American Royal Mail steamship *Britannia*. The gift marked the successful completion of a rough transatlantic crossing, which was described in detail by Charles Dickens, one of the passengers, in his *American Notes*. When the grateful passengers arranged a collection to buy the wine set in Boston, Dickens was one of the committee and made the presentation speech in the Tremont Theatre, Boston, on 29 January 1842, declaring that: 'In presenting Captain Hewett with these slight and frail memorials, we are not following out a hollow custom, but are imperfectly expressing the warmest and most earnest feelings, being well assured that, with God's blessing, we owe our safety and preservation, under circumstances of unusual peril, to his ability, courage and skill.'
PLT0200, PLT0201, PLT0202 & PLT0203

Astrolabe

THE CAIRD ASTROLABE
c. 1230

This is the earliest astrolabe in the collection and is among the first European astrolabes known. Astrolabes were used by astronomers to measure the positions of stars and other celestial objects. They could also be used to tell the time and for measuring angles in surveying. The design suggests that this example is Hispano-Moorish in origin, probably made in either Spain or southern France. Astrolabes contain different plates for different latitudes, and this particular one has plates corresponding to the latitudes of Toulouse, Paris, Chartres and Sens, implying that it was produced for the French market. Similarly, although it uses Arabic numbers and constellation names, the Gothic lettering indicates that it was made for a Latin-reading market.

AST0570 / 2112

ASTRONOMERS ROYAL

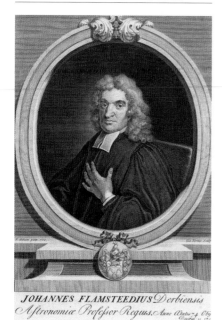

JOHANNES FLAMSTEEDIUS *Derbiensis*
Astronomiæ Professor Regius. Anne Ætatis 44 Obij
Decembr. 31. 1719

REVD JOHN FLAMSTEED (1646–1719)
First Astronomer Royal, 1675–1719

John Flamsteed became the first
Astronomer Royal when the Royal
Observatory, Greenwich (ROG), was
founded in 1675. In all there have been
fifteen Astronomers Royal. All fulfilled
the general role of producing
astronomical data useful to navigators
but each has interpreted the role in a
different way. For Flamsteed, it meant
producing a detailed star map of the
Northern Hemisphere, the first ever
produced with a telescope. Late in life
Flamsteed argued with both Newton and
Halley when, in 1712, Halley published a
private edition of Flamsteed's observations
without his permission. Of the 400 copies
of *Historia Coelestis* published, Flamsteed
recovered 300 and burnt them after
removing the ninety-seven pages he
considered to be his untampered work.
His observations were finally published as
he had intended in 1725, after his death.
Following her husband's wishes,
Flamsteed's wife removed and sold the
entire apparatus of the Observatory, on
the grounds that it was paid for by him
and his patron.
A1905 / PAD2713

(Right)
ANGLE CLOCK
Thomas Tompion
1691

Wishing to express time in a way that
might be of use to astronomers, John
Flamsteed invented this 'angle' clock to
show time as degrees, minutes and
seconds of rotation of the Earth in
relation to the stars. Blocks of ten
degrees are indicated on a rotating
disc visible through a curved aperture
in the dial, the central hand indicates
individual degrees and blocks of ten arc
minutes, and the subsidiary dial shows
individual arc minutes and blocks of ten
arc seconds, advancing ten arc seconds
with every beat of the pendulum. In fact,
the clock never proved particularly
useful as an astronomical instrument
and was adapted to tell mean time. The
clock is now restored to its original
function as an 'angle' clock.
ZAA0559 / D9260

(Opposite, left)
ASTRONOMICAL REGULATOR, NO. 621
George Graham
c. 1725

The Museum's collections include a
number of precision instruments made
for successive Astronomers Royal. In 1720
Edmond Halley succeeded John
Flamsteed as Astronomer Royal.
He was granted £500 to purchase new
equipment for the Observatory and
ordered three new clocks and a new
mural quadrant from the eminent
London maker, George Graham. This clock,
now known as 'Graham 1', cost £12 when
new and stood alongside Halley's
quadrant near the stone pillar that
remains today. Later, Graham improved its
performance by fitting a temperature-
compensated 'gridiron' pendulum, after
the design of John Harrison, the first of
many alterations the clock would
undergo to meet increasingly demanding
requirements. This clock is fitted with a
'dead-beat' escapement, invented in the
1670s but developed by Graham and used
in almost all subsequent astronomical
pendulum clocks.
ZBA2211 / E8946

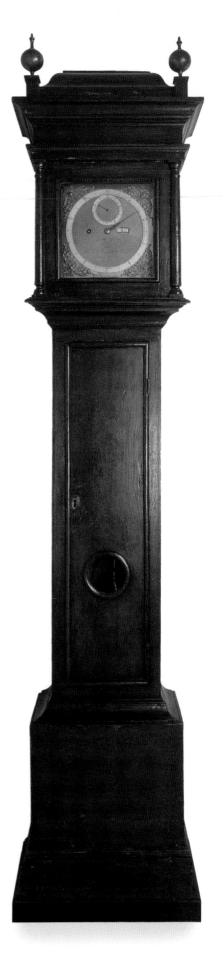

18

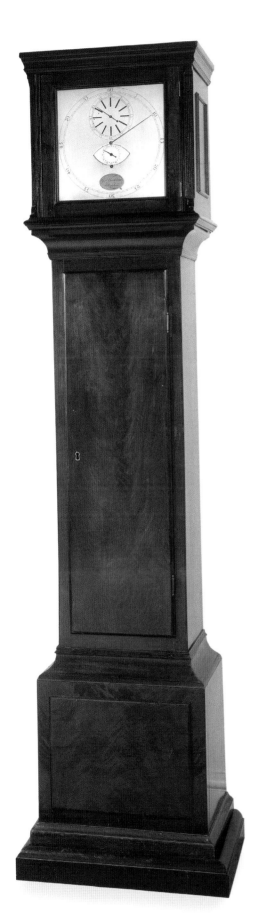

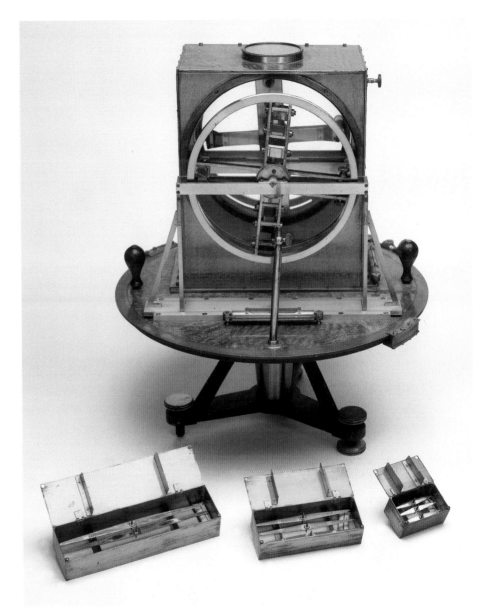

(Above)
AIRY DIP CIRCLE
Troughton and Simms
1860
A dip circle measures the vertical direction (or dip) in the Earth's magnetic field in the same way that a compass measures the horizontal direction. Sir George Biddell Airy (1801–92), Astronomer Royal (1835–81), championed the study of terrestrial magnetism because it improved understanding of the compass and therefore fitted in with the role of the Royal Observatory as a compiler of scientific information to aid navigation. Under Airy, the Magnetic and Meteorological Department was established. This dip circle, designed by Airy, and made in 1860 by Troughton and Simms of London, replaced the Robinson dip circle and was used at the Observatory until 1915 to take daily readings to find the variations in the Earth's magnetic field at Greenwich.
AST0701 (Mag.1) / D9241-2

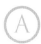

ASTRONOMY

(Below)
COLE COMPENDIUM
Humphrey Cole (Colle)
1569

Humphrey Cole (1520–91) was one of the finest makers of scientific instruments in England in the time of Queen Elizabeth I. A compendium is a small, portable instrument made up of a number of different devices combined. One leaf is an equatorial sundial, others include a nocturnal for telling the time at night from the stars, a calendar, a circumferentor for surveying, a compass and geometric square. Using the various parts of the compendium, it is possible to calculate anything from high and low

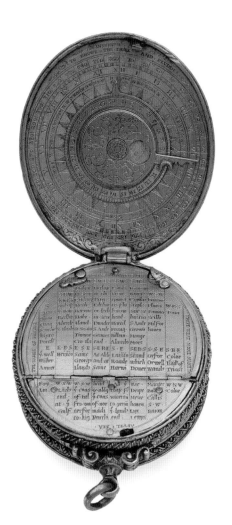

tides and the phases of the Moon, to the height of buildings. Unfortunately, there is no evidence to support an old belief that it once belonged to Sir Francis Drake.
AST0172 (D318) / D8908-1

(Above)
ASTRONOMICAL LONGCASE CLOCK
(DETAIL)
Edward Cockey
c. 1705

This imposing clock is one of only four of its kind known to exist. The 20-inch (51-cm) square dial has indications for time, age and phase of the Moon, degree of the zodiac and annual calendar. The hour hand has a Sun disc attached and sunrise and sunset times are represented on the 24-hour dial by two sliding steel shutters moving up and down during the year. A similar clock, presented to Queen Anne in 1705, was described as 'a very curious piece of clockwork', but it disappeared sometime after 1835. Although very similar, the evidence suggests that the National Maritime Museum's example is not the royal one.
ZAA0598 / B4326

HEMISPHÆRIUM COELI AUSTRALE

(Left)
BRADLEY'S 12FT 6IN. (13.8M) ZENITH SECTOR
George Graham
1727
James Bradley (1693–1762) attempted to use trigonometry to discover the size of the solar system by observing just one star from a fixed position to see how it appeared to move as the Earth moved round the Sun. The atmosphere makes the light from stars bend, so their apparent position differs from their actual position. This bending is greatest at the horizon and non-existent at the zenith, straight overhead. Therefore, to make very accurate observations of a single star, Bradley designed a telescope to observe only in the zenith. It was with this instrument that, in 1729, while trying to detect parallax, Bradley instead discovered the aberration of light (the variation in a star's observed position due to the speed of the Earth's movement through space) and the nutation (or wobble) of the Earth's axis.
AST0992 (OM.Z1) / A3931

(Above)
CELESTIAL CHART, FROM REINER OTTENS'S ATLAS
1730
Ottens used Johannes Honman to engrave a copy of John Flamsteed's celestial chart of the southern hemisphere. Flamsteed's *Atlas Coelestis*, published in 1729, was based on observations at the Royal Observatory, Greenwich, seen here top left. It also incorporated the findings of three other European observatories shown here: Hesse-Cassel, Berlin and Hven.
D4698

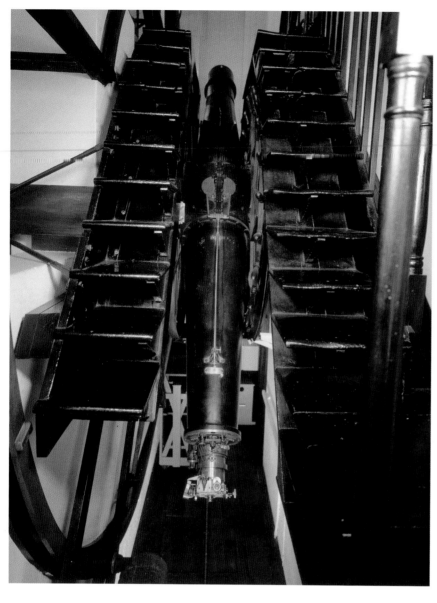

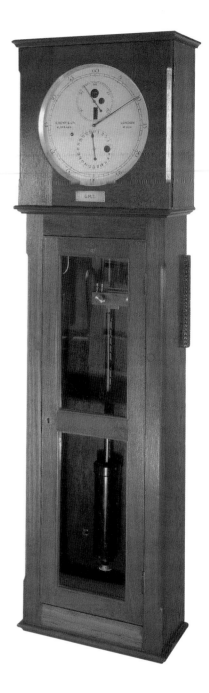

(Above)
AIRY TRANSIT CIRCLE
Troughton and Simms; Ransome and May
1851
The Airy Transit Circle telescope was made to the design of Sir George Biddell Airy (1801–92) and installed at the Royal Observatory, Greenwich, by the beginning of 1851. The first observation was made on 4 January that year. Like all transit instruments, it was set up in alignment with a meridian, one of the lines of longitude between the North and the South Poles. It was used from 1851 to 1954 to carry out observations of the time and height above the horizon at which key stars crossed the meridian.

Since 1884 the meridian passing through the Airy Transit Circle has been internationally recognized as Longitude 0°, the starting point for the world time-zone system.
AST0991 / D7064-1

(Above, right)
ASTRONOMICAL REGULATOR, NO. 2016
E. Dent & Co.
c. 1874
One of a series of almost identical astronomical regulators used during observations of the 1874 and 1882 transits of Venus. By accurately timing this rare astronomical event from various different latitudes and longitudes, astronomers were able to calculate the distance

between the Sun and Earth. For the 1874 transit, this clock was sent to Burnham, in New Zealand, and in 1882 to Barbados. In 1924, when the BBC first established its hourly 'six-pips' radio broadcasts, this clock was chosen as the dedicated time-standard for the service. Electrical impulses produced by contacts fitted to the clock were sent from Greenwich via a land-line to the BBC, where they were converted into the distinctive sounds we recognize today.
ZBA1293 / E0007

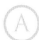

AUSTRALIA

(Right)
TERRESTRIAL GLOBE
Jacob Aertsz Colom
c. 1640
This Dutch printed terrestrial globe is
the earliest in the Museum's collection
to show the exploration of Australia.
Most other discoveries on this globe
were copied from a 1627 map by Hessel
Gerritsz, cartographer of the Amsterdam
Chamber of the VOC (the Dutch East
India Company). This globe and its
companion celestial globe (see *Globes*)
are dedicated to Jacob Golius (1596–1667),
Professor of Arabic at the University of
Leiden, who helped with the Arabic star
names for the celestial globe.
GLB0170 / D3340-1

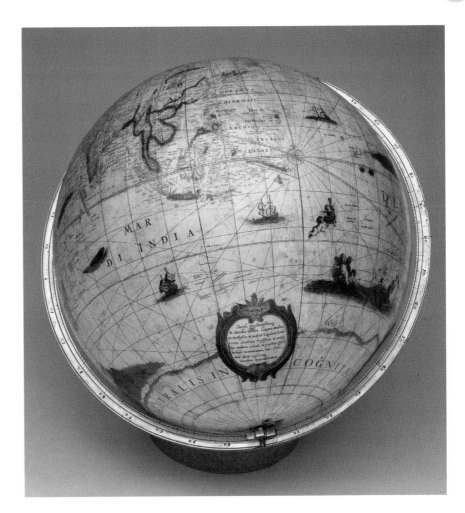

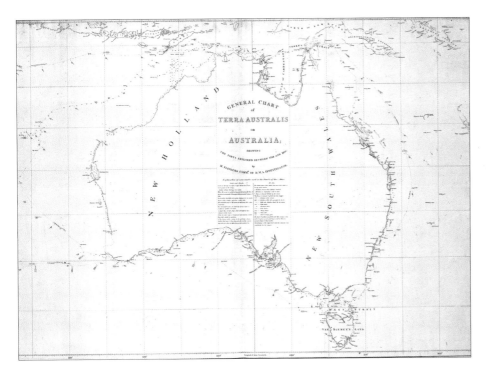

(Left)
AUSTRALIA
Matthew Flinders
1814
From 1801 Flinders spent three years
charting the coast of *Terra Australis*,
or Australia, as he preferred to name
it. On the voyage home he was
shipwrecked but made a successful
boat journey to obtain help in rescuing
his crew and charts. Misfortune also
dogged his second attempt to return
home: on putting into Mauritius for
repairs he was detained by the French
until 1810. In England he prepared his
work for the engraver but died, aged 40,
the day before this chart was published.
His work awakened people to the size
of the continent and its interior, which
was unknown to Europeans.
G262:1 / D4666

BOATS

LONGBOAT FROM THE *MEDWAY*
1742, scale 1:48

A rare example of an eighteenth-century model of a ship's boat complete, with its original mast and rigging. The longboat was generally the largest boat carried on board ship. It could be towed astern or stored on deck on top of the spare topmast spars in the waist area, between the fore and main masts. It could be either rowed or sailed and this model is fitted with a windlass just aft of the mast to assist with working the ship's anchors.
SLR0330 / D4058-D

(Below)
LIFEBOAT
Henry Greathead
1803, scale 1:12

As a result of the horrific wreck of the brig *Adventure* at the mouth of the Tyne in 1789, a local committee was formed and offered a premium for the best design of a lifeboat 'calculated to brave the dangers of open sea, particularly of broken water'. A local boat-builder, Henry Greathead, eventually claimed the prize with his double-ended design, fitted with cork for extra buoyancy. In 1803, Greathead unsuccessfully petitioned Parliament for a financial reward claiming to be 'the inventor of the lifeboat'.
SLR0563 / D7012-3

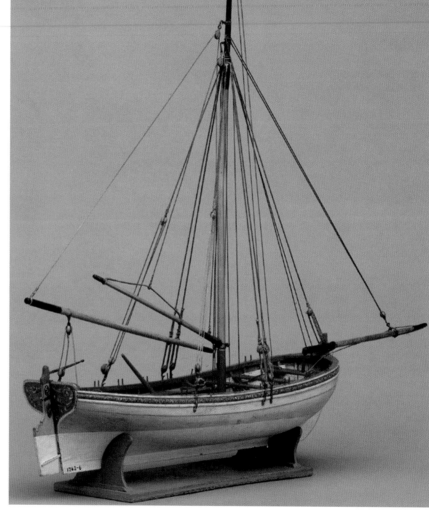

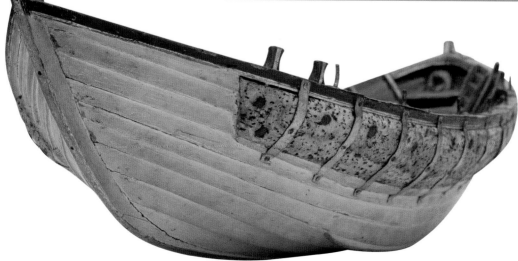

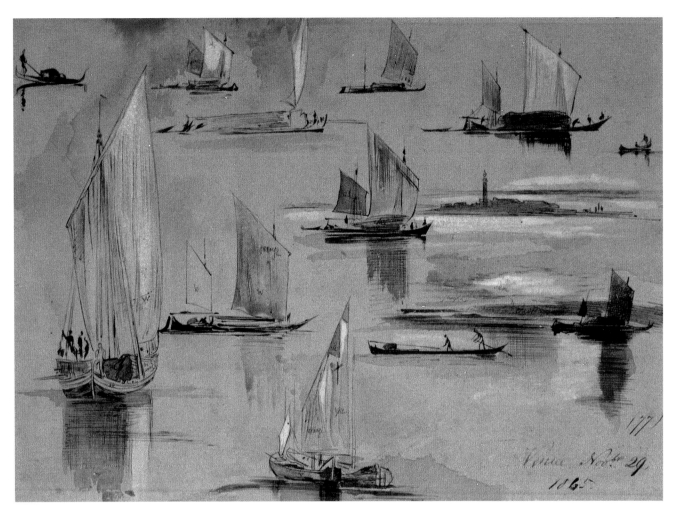

(Above)
**STUDIES OF VENETIAN CRAFT,
29 NOVEMBER 1865**
Edward Lear

The writer, Edward Lear, travelled extensively in Europe and around the Mediterranean, drawing constantly. The Museum holds a collection of his watercolours depicting local craft in Venice, Malta and on the Nile.
PAF6129 / PW6129

(Below, left)
MARINERS FRIEND, LIFEBOAT
H. J. Pope
1877, scale 1:16
This delightful model shows the Hastings lifeboat, *Mariners Friend*, on its horse-drawn launching carriage, together with its crew. Made by the local coastguard and crew member, H. J. Pope, it also includes the standard design lifeboat house adopted by the RNLI during the late nineteenth century. The lifeboat was built of double diagonal mahogany planking and the air cases at bow and stern enabled it to self-right if overturned while on service. The crew are shown wearing their cork lifejackets and oilskins.
SLR1083 / D7013-E

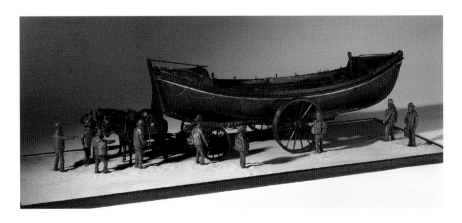

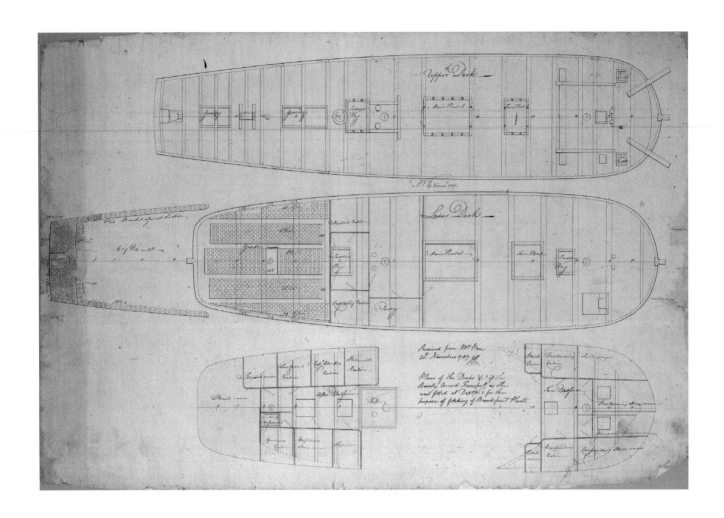

BOUNTY

DECK PLANS OF THE *BOUNTY*
The Navy Board
1790

The *Bounty* was built as the merchant vessel *Bethia* in 1784. She was purchased in 1787 by the Admiralty to transport breadfruit seedlings from Tahiti to the West Indies. In December 1787, the *Bounty* set sail under the command of Lieutenant William Bligh (1754–1817) and arrived at Tahiti in October 1788, after a long and difficult voyage. Breadfruit was planned to be an inexpensive source of food for slaves working on the plantations. *Bounty*'s great cabin was converted to house the pots holding the breadfruit plants. The crew of over forty men included two gardeners. Conditions on the already overcrowded ship worsened due to the introduction of these plants and may have led to the famous mutiny.

ZAZ6668 / D3970-3

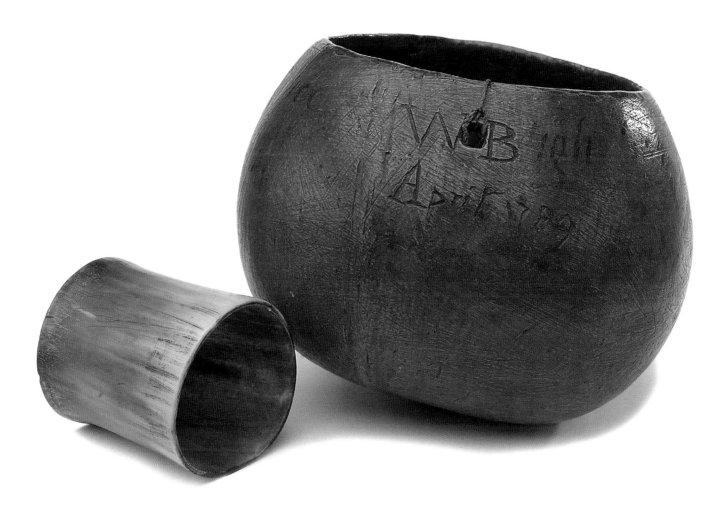

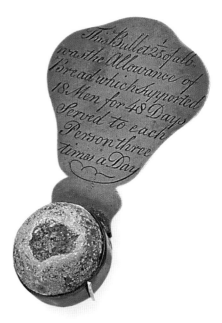

HORN BEAKER, COCONUT BOWL (Above) AND BULLET WEIGHT (Right)
c. 1789

Bligh found it impossible to maintain naval discipline during the five-month shore visit on Tahiti. Freed from shipboard routine, the forty-five-man crew enjoyed the island's many attractions. When, on 4 April 1789, the *Bounty* sailed for the Caribbean, Bligh seemed unaware of the growing tensions on board.

On the morning of 28 April, the master's mate, Fletcher Christian, led a mutiny and seized control of the ship with his supporters. Bligh and eighteen crew members were set adrift in the ship's launch, a 23-ft (7-m) open boat. They made for the nearby island of Tofua, part of the Tonga group. They landed successfully and found some fresh supplies but were driven away by the islanders: one member of the crew was killed. Forced back out to sea, Bligh and his men now embarked on an epic 3600-mile (5800-km) voyage across the largely uncharted Pacific. The limited supplies of bread, pork, water, wine and rum were strictly rationed. Bligh used a bullet to weigh out the meagre bread ration of one twenty-fifth of a pound, and a horn beaker to measure the water that each man received three times a day. Bligh ate from a coconut bowl, which he carved with his initials and the date. He added an inscription: 'The cup I eat my miserable allowance out of'. They spent nearly seven weeks at sea before reaching land on Timor, in the Dutch East Indies, from where they returned to Britain.

ZBA2701, ZBA2702, ZBA2703 / F1346

BRITANNIA'S TRIDENT:
BRITISH SEA POWER SINCE 1800

Robert Blyth

The rise and fall of British sea power since 1800 is closely linked with the growth and decline of Britain as a major industrial, commercial and imperial power. Sea power, therefore, encompasses more than the transformation of the Navy from Nelson's great wooden fleets to the small, high-tech force of today. It should be thought of as a trident with three distinct but interconnected prongs: the Royal Navy; merchant shipping and shipbuilding; and ship-broking, insurance and other maritime services.

Nelson's famous victory over the French and Spanish fleets at Trafalgar in 1805 signalled the beginning of more than a century of British naval supremacy. The defence of Britain, her expanding empire and her vital trade and communication routes all required a large, powerful fleet. The Navy became central to British strategy. The scale of Britain's overseas interests meant that warships were stationed across the globe to protect her settlements and shipping, to 'show the flag' and to suppress the slave trade and piracy. The size, strength and distribution of the fleet were not constant but fluctuated, based on assessments of the threat to Britain's security and on the financial resources available to the Royal Navy. By 1889, faced with new challenges and ever greater commitments, Britain had adopted the two-power standard: the capital ships of the Royal Navy were to be maintained at a strength equal to that of its nearest two rivals. In the 1890s, this was achieved with relative ease. By the early 1900s, however, the introduction of new battleship technology in the form of 'all big-gun' Dreadnoughts, and the resulting naval arms race with Germany, posed a very serious threat to Britain's mastery of the seas.

Despite the importance attached to the Dreadnought race with Germany before 1914, World War I

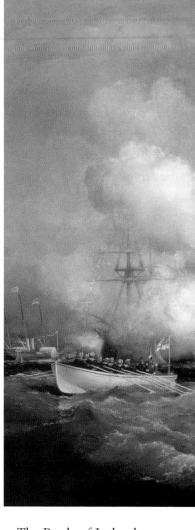

HMS Devastation *at the review of the fleet by the Shah of Persia, 13 January 1873*, Edward William Cooke. BHC3287

involved few major sea battles. The Battle of Jutland in May 1916 was the most important engagement between the British Grand Fleet and the German High Seas Fleet. It proved indecisive: the British lost more ships but the German fleet returned to base for the rest of the war. The greatest challenge to British sea power came from German U-boats operating in the Atlantic.

In 1917, the merchant fleet suffered unsustainable losses as U-boats embarked on unrestricted submarine warfare against Allied shipping. With the loss of so many vital cargoes, Britain's supplies of food and raw

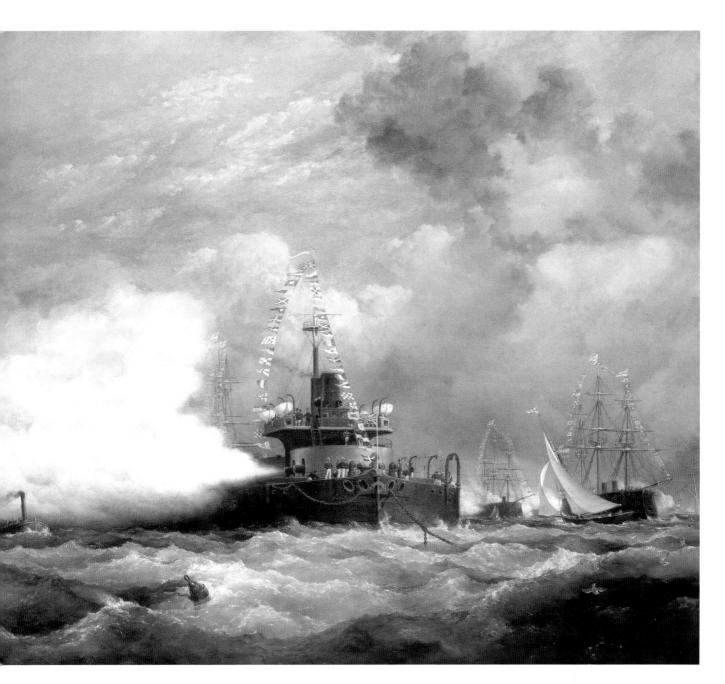

materials began to run dangerously low. The introduction of armed convoys, more sophisticated anti-submarine tactics and America's entry into the conflict eventually allowed Britain to regain the upper hand and secure her supply routes.

Even as Britain emerged victorious from the Great War, Lloyd George, the British Prime Minister, noted that 'the trident was passing peacefully from Britain to the United States'. With the decline in her share of world trade and manufacturing between the wars, Britain was no longer able to afford another costly arms race to maintain her supremacy at sea.

Consequently, following a series of international naval agreements, Britain had to accept a fleet of similar size to that of the United States. Restrictions were placed on the size, firepower and number of vessels that each of the major naval powers could operate.

By 1939, British sea power had been seriously compromised: the Royal Navy simply lacked the strength to tackle the combined threat of Germany, Italy and Japan, without the support of its allies.

During World War II, the Navy concentrated its operations in the North Atlantic and the Mediterranean. It was again required to undertake

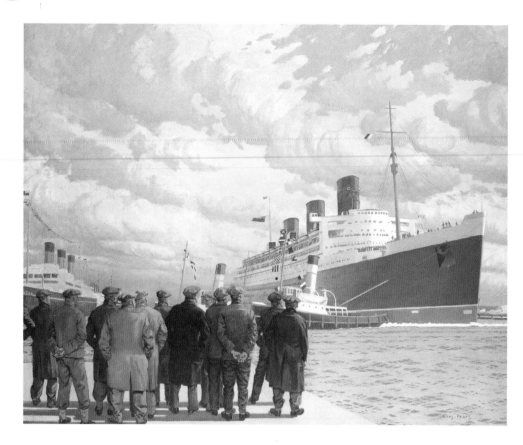

(Left)
The passenger liner
Queen Mary first arriving at
Southampton, 27 March 1936,
after her sea trials,
Charles Pears.
BHC2492

(Opposite)
Clear flight deck: on board
an aircraft carrier,
Stephen Bone.
BHC1550

dangerous convoy duties to counter the even greater U-boat menace and to tackle formidable German warships like the *Bismarck*. The vulnerability of these large ships to air and submarine attack further demonstrated that the age of the battleship had passed. Since 1945, Britain's relative economic weakness, the process of decolonization, the Cold War and rapid changes in naval technology have all had an impact on the size, strategic role and operational effectiveness of the Royal Navy. It is now a small but important component of NATO's naval forces.

By the early years of the nineteenth century, the Industrial Revolution had transformed Britain into the 'workshop of the world'. Britain's important shipping and shipbuilding industries expanded to meet the demands of British commerce and manufacturing. Britain's shipping companies not only carried British goods but also competed for foreign and imperial trade. Indeed, the growth of the British Empire provided great opportunities to large firms such as P&O, which took advantage of government subsidies, mail contracts and the need to move troops, officials

and emigrants to India and Australia. The shipping companies grew in size, taking over their rivals and widening their area of operations. The development of iron- and, later, steel-hulled vessels from the 1850s gave Britain, with its large iron and steel industry, an enormous advantage in shipbuilding. The shipyards of the Clyde, Belfast, the Tyne and the Wear were soon building most of the world's ships. By 1890, the tonnage of the British merchant fleet accounted for more than 60 per cent of the world's total and British yards built nearly 80 per cent of the world's ships.

During World War I, British shipping suffered losses of 9 million tons out of a fleet totalling 19 million tons in 1914. Although these losses were hard to replace during the conflict, there was a brief shipping and shipbuilding boom immediately after the war. Shipowners made large profits as a result of the war but the British fleet was diverted to government supply work and therefore had to abandon its usual routes and markets to foreign rivals. When peace returned, the British found it difficult to reclaim this business. In the inter-war period, sluggish

international trade and over-capacity in the shipping sector meant that many firms struggled to make a profit. The surplus of merchant shipping – worsened by the maintenance of a large, heavily subsidized and under employed American fleet – dealt a massive blow to Britain's shipbuilding industry. When the post-war rebuilding boom ended abruptly in the early 1920s, many yards closed or scaled down their operations and thus lost a highly skilled workforce. This led to a reduction in building capacity, which limited Britain's ability to replace the 11 million tons of British merchant shipping sunk during World War II.

Since the war, British shipping and shipbuilding have steadily declined. Although still a major force in shipping through the 1950s and 1960s, the British merchant fleet accounted for less than two per cent of the world total by the late 1980s, as more companies chose the cheaper option of registering their vessels under flags of convenience, like those of Panama and Liberia. Declining orders, stiff competition from overseas and perhaps the slow adoption of new technologies and working practices led to the collapse of British shipbuilding in the 1970s and 1980s. The once mighty shipping and shipbuilding sector now accounts for only a tiny part of the British economy.

Britain's domination of international maritime services – ship-broking, insurance and banking – was a direct result of her early industrialization, commercial success and imperial expansion. Given the scale and scope of British trade and shipping, large and complex service industries had to develop to meet the diverse and often specialist needs of merchants,

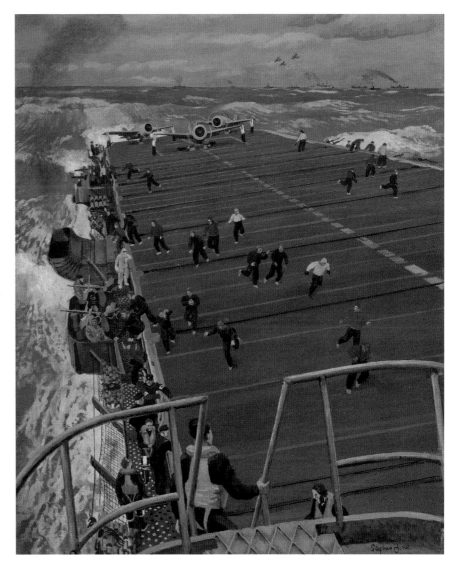

shipowners and shipbuilders. This gave Britain, and the City of London in particular, a huge international advantage. Rather than create their own maritime service sectors, other countries tended to use British institutions, like Lloyd's of London and the Baltic Exchange. London thus became the hub of global shipping and related services and this was reflected by the decision to locate the International Maritime Organisation in the City in 1948, the only United Nations agency based in Britain. Although Britain's visible sea power may have largely disappeared, Britannia can still be said to rule the increasingly 'virtual' waves of maritime services, which continue to contribute millions of pounds of invisible earnings to the British economy each year.

BRUNEL

(Right)
ISAMBARD KINGDOM BRUNEL
(1806–1859)
Mezzotint
John Callcott Horsley (artist);
Henry Cousins (engraver);
Henry Graves (publisher)
1858
The most famous of the Victorian engineers, Brunel masterminded various major transport projects, working with his father, Marc Brunel, on the Rotherhithe - Limehouse Thames tunnel and later on the Clifton suspension bridge and the Great Western Railway from London to Bristol. He extended this passenger route across the Atlantic to New York through the construction of a series of revolutionary steam vessels – the *Great Western* in 1837, *Great Britain* in 1843 and finally the massive *Great Eastern* in 1858. The traumatic launch and difficult maiden voyage of the *Great Eastern* immediately preceded Brunel's death.
PAH5577

(Opposite)
BUILDING THE *GREAT EASTERN*
Valhalla Wargames
1978, scale 1:200
This fine example of a scenic model shows the construction of I. K. Brunel's steamship *Great Eastern* at John Scott Russell's Millwall yard on the banks of the Thames in 1857. Because this event was so well covered by the media of the time, it has been possible to make an accurate re-creation of the scene during preparations for launching the ship in September and October 1857.
SLR2146 / D4794-1

(Right)
LONGITUDINAL PROFILE OF THE
GREAT EASTERN
This longitudinal section of Brunel's *Great Eastern* clearly shows how the machinery spaces took up more than half the length of the ship, with the midships engine powering the massive paddles and the after engine turning the screw propeller. Initially designed for service to India, she was modified to permit use on the North Atlantic but

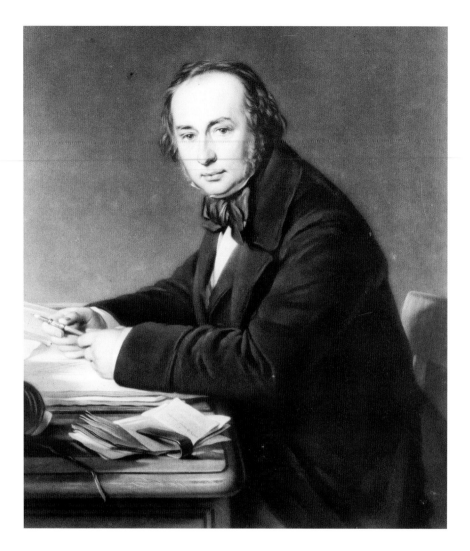

she was not successful as a passenger liner. Her ocean-going service lasted a mere ten years, half of this being on cable-laying duties. An impressively large vessel for her time, it was more than forty years before her length and displacement were exceeded.
H2576

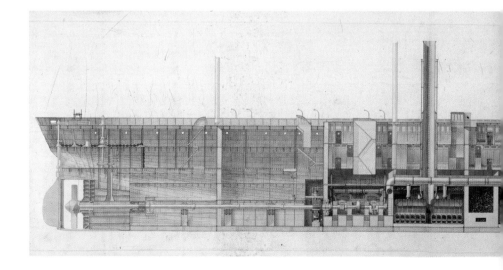

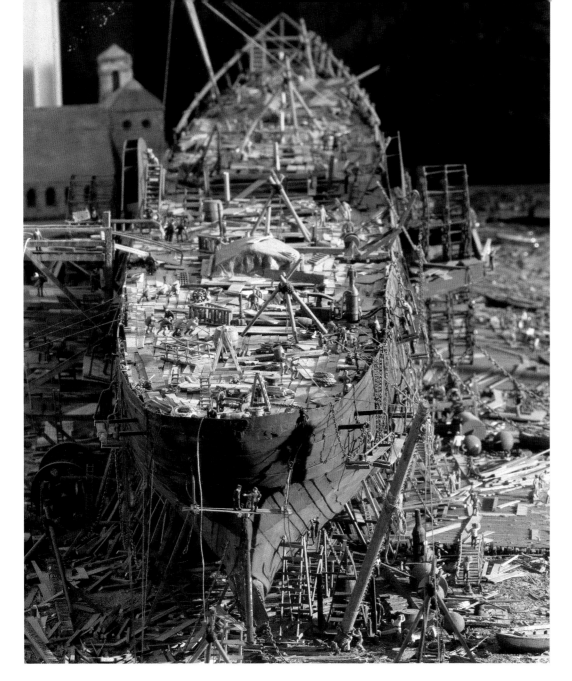

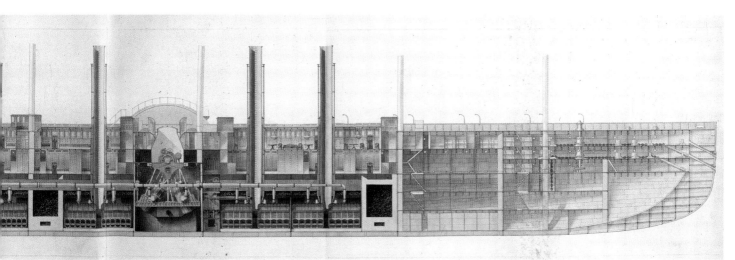

33

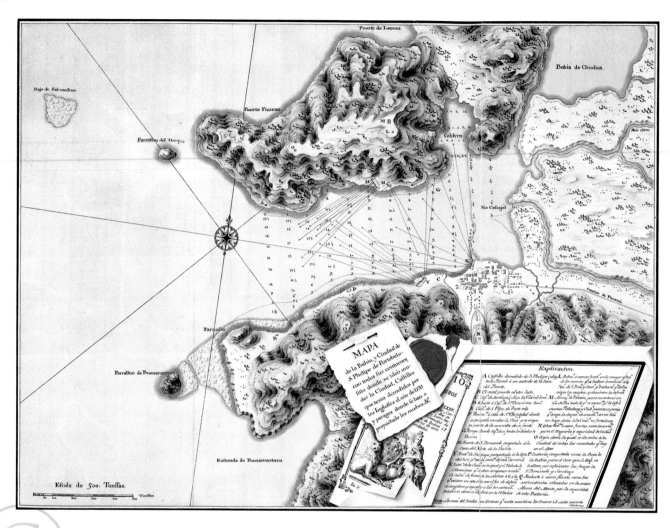

CARIBBEAN

(Above)
S. PHELIPE DE PORTO BELLO
Luis de Surville
1778

This is one of the fourteen exquisite manuscript charts illustrating a report on the defences of Spanish-held ports and anchorages in Central and South America. De Surville was Deputy of the Archives of the Office of the Indies. He added flourishes to his cartography by drawing titles, descriptive lists and decorative features to look as if they are separate documents lying on, or even pinned to, the page. This chart of Porto Bello shows the fortifications destroyed by the English in 1739, the current system of defence and proposals for future works.

P18 / C4627-2

(Right)
PORTO BELLO PLATE
Lambeth
After 1739

The earliest large-scale production of maritime commemoratives celebrated Admiral Edward Vernon's victory at Porto Bello in 1739. To counter Spanish interference in British trade to the West Indies, Vernon was sent to Porto Bello in Panama with six ships and succeeded in capturing the Spanish base. A range of souvenirs was produced, all bearing the likeness of Vernon or a view of the captured town. This rare delftware plate is hand-painted in blue with a view of the harbour and fort at Porto Bello. The border is decorated with four naval guns mounted on wooden carriages bearing the royal cipher 'GR'.

AAA4352 / D0852-13

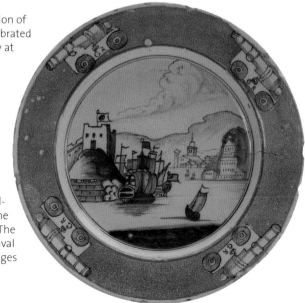

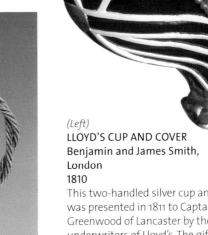

(Right)
FIGUREHEAD FROM HMS *BULLDOG*
1845
The first-class paddle sloop, HMS *Bulldog* (1845), had a colourful career. In October 1865, while bombarding rebels in Haiti, she rammed the enemy steamer *Valorague*. As a result, she ran aground within point-blank range of the rebel battery. Despite this disaster, she sank the *Valorague* and another vessel, blew up the gunpowder magazine on shore, set fire to the town and dispersed rebel troops with grapeshot. By nightfall, with ammunition low, the *Bulldog*'s captain, Charles Wake, scuttled the vessel and the US Navy rescued the crew. The figurehead's collar reads: *Cave Canem* (Beware of the Dog).
FHD0068 / E7342

(Left)
LLOYD'S CUP AND COVER
Benjamin and James Smith,
London
1810
This two-handled silver cup and cover was presented in 1811 to Captain Thomas Greenwood of Lancaster by the underwriters of Lloyd's. The gift was made in recognition of his thirty-two successful voyages to the West Indies in the Lancaster merchant ships *Comet*, *Molly*, *Chatsworth*, *Aurora*, *Mars*, *Harriet Pasey Hall* and *William Ashton*. An inscription on one side describes how during a voyage in *William Ashton*, with only 25 men and sixteen 9-pounder guns, he had succeeded in beating off a French corvette of eighteen 18-pounders and 125 men. The other side of the cup is decorated with naval trophies and a laurel wreath encircling the monogram 'TG'.
PLT0060 / D4602-1

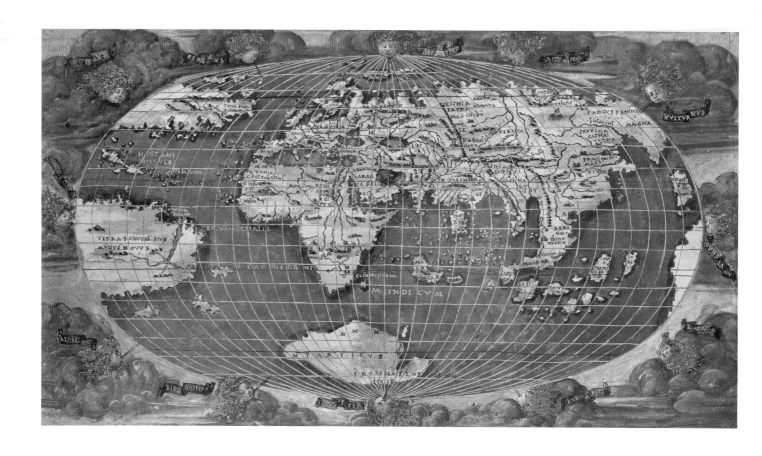

CHARTS AND MAPS

PLANISPHERE
Francesco Rosselli
c. 1508

The planisphere and sea-chart by Rosselli in the Museum's collection were long thought to be manuscripts but have been shown to be fine copper engravings, exquisitely coloured. Their dating depends partly upon the fact that the names given by Columbus during his fourth voyage to features in Central America, including Hispaniola and Cuba, are here shown on the Indo-China coast. This is consistent with Columbus's own belief that he had reached the coasts of Asia. This style of world map, with wind cherubs and clouds surrounding an ovoid planisphere, originated with Ptolemy and continued into the seventeenth century.

P27 / C4568-1

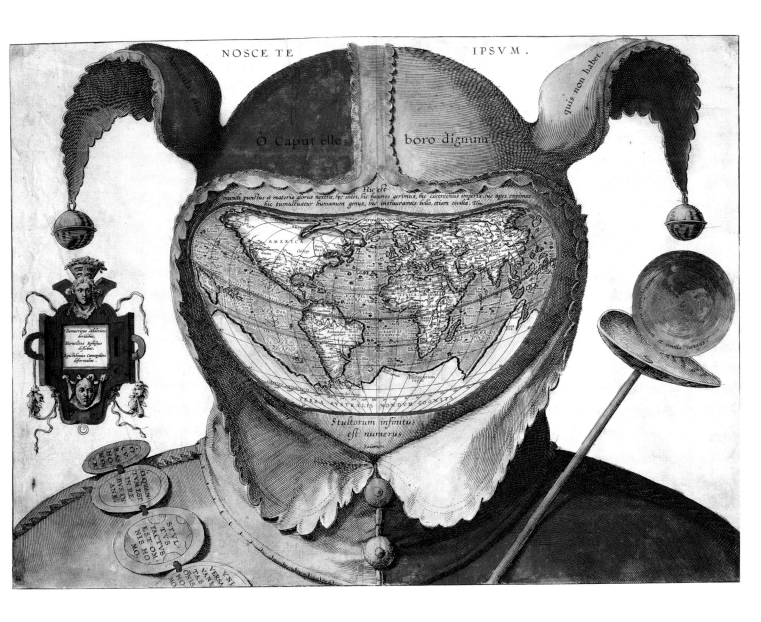

FOOL'S-HEAD MAP
Anonymous
After 1587

The map forming the fool's face is based on the world map published by Abraham Ortelius in 1587. Ortelius had embellished the margins of his map with quotations from classical authors proclaiming the cleverness of man in being able to discover and gain mastery of the whole world. The maker of the fool's-head map satirizes the vanity of this view, declaring instead that 'the stupidity of man is limitless'. Ortelius, and presumably his satirist, lived in Antwerp, which had been crushed by the Spaniards, the very people responsible for much new knowledge of the world, as they extended their empire over the Netherlands.

G.201:1/43 / D2806

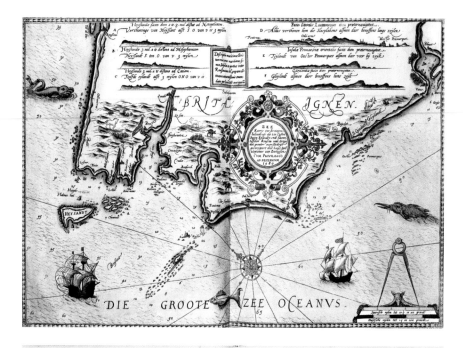

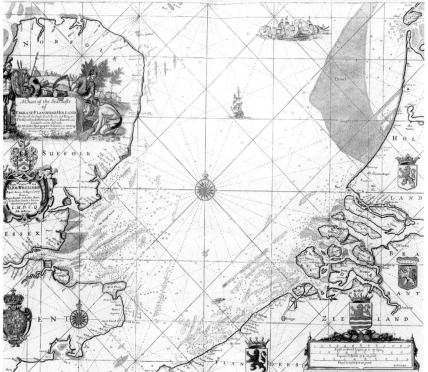

Europe, from Spain to Norway. Lord Howard, Lord Admiral of England, proposed its translation into English in 1585 and Anthony Ashley published the English edition, with added material about Sir Francis Drake's exploits, in 1588. It was so influential in England that all the sea-atlases which came after it were known as 'waggoners'.
D8264 / B5750

(Bottom left)
THE ENGLISH PILOT
John Seller
1751

Using second-hand Dutch copper plates, John Seller tried to publish a full set of charts for the British Isles and much of the rest of the known world. He was unable to raise sufficient capital and could not afford to have all the plates brought up to date. On the frontispiece to one edition he shows old St Paul's Cathedral but nearby he also shows Wren's monument to the Great Fire which destroyed it.
On these pages, showing the coast of Suffolk, quite a large part of Dunwich – once a flourishing community – had eroded into the sea between the time the plates were made and the time they were published.
8290

(Opposite)
NEW YORK HARBOUR
J. F. W. Des Barres
1779

Following full occupation of French Canada in 1763, Britain possessed a vast territory in North America. The coastline was virtually uncharted, so the British government funded a programme of surveying on an unprecedented scale, superintended by J. F. W. Des Barres. Several assistants were employed, including James Cook, but Des Barres undertook all the engraving for publication himself, creating charts that were both accurate and elegant. The American Revolutionary War began while the work was in progress and the complete atlas, *The Atlantic Neptune*, was not published until 1777. The individual charts were then revised frequently until 1782. The Museum holds the definitive reference collection of *Atlantic Neptune* charts.
HNS146 / B5314

(Top)
THE COAST OF BRITTANY
Lucas Jansz Waghenaer
1588

In 1584 Waghenaer, a Dutch chart-maker, published a new type of printed sea atlas. *De Spieghel der Zeevaert* (The Mariner's Mirror) aimed to contain everything a navigator would need, including charts, sailing directions, coastal views and navigational tables. It covered all the coasts of western

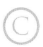

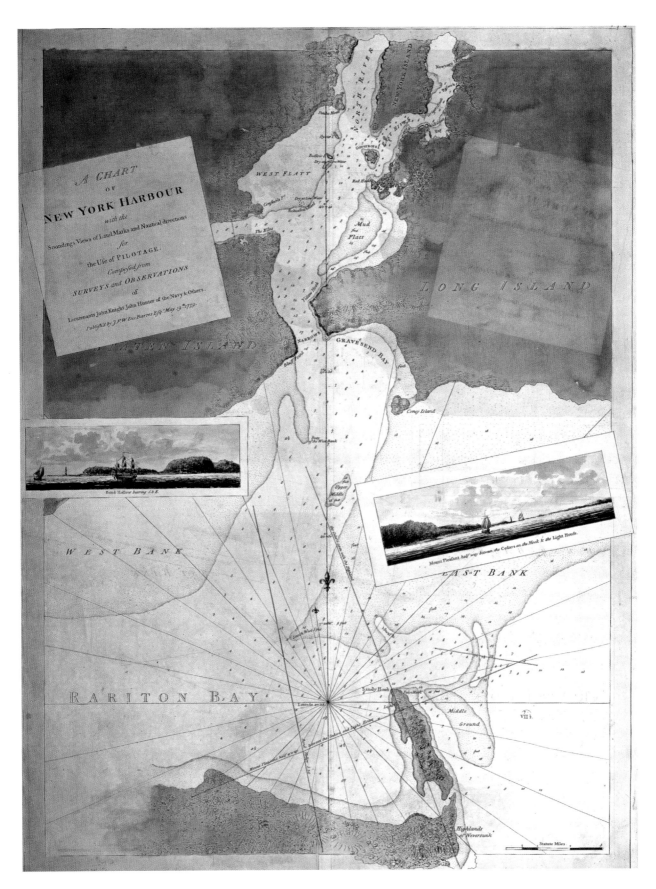

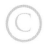

CHINA

CHINESE *KO'SSU*
c. 1793

The early European trade with China was mainly in luxury products such as fine porcelains and silks. By the end of the eighteenth century, by far the most important Chinese export was tea, with over a million pounds in weight of it being bought by Britain each year. While a profitable trade, China would only accept silver for tea and Britain constantly tried to interest the Chinese in other products. *Ko'ssu* means 'cut silk', and this silk tapestry picture shows the arrival of George III's embassy led by Lord Macartney at the Summer Palace of the Emperor of China in Peking. The picture was intended to show the King's gift of large astronomical instruments arriving in Peking in September 1793, but the artist wrongly models the instruments on a celestial globe of Ferdinand Verbiest and a large armillary sundial from the Jesuit Observatory at Peking. He has also shown the Europeans in sixteenth-century dress. The Chinese inscription is a rather dismissive poem composed by the Emperor on the occasion of the embassy's arrival.
TXT0107 / D9668

(Bottom, left)
'BATTLE OF THE SAINTS' PUNCH-BOWL
c. 1783

On 12 April 1782 Admiral Sir George Brydges Rodney won the greatest naval victory of the American Revolutionary War by defeating the French fleet in the West Indies off the islands known as Les Saintes. Commemorative items of all types were produced to celebrate the victory, including a series of Chinese export-porcelain punch-bowls decorated with a grisaille painting of the battle. The scene is after an oil painting by Robert Dodd, which was engraved and published in 1783. The engraving would have been sent to the porcelain painters in China, who supplied the order, producing different inscriptions, coats of arms and caricatures on individual bowls as commissioned.
AAA4357 / D9638

(Below)
SHIPBUILDING PUNCH-BOWL
c. 1785

This large Chinese export-porcelain punch-bowl shows half-built ships set in an imaginary Chinese landscape, and the Chinese artist has probably copied the vessels from engravings in Diderot's *Encyclopédie Méthodique* of 1783. The inscription in the bottom of the bowl reads 'Success to Mr Barnard's Yard', a reference to the Barnard family of shipbuilders with yards at Ipswich, Harwich and Deptford, who built ships for the Navy and the Honourable East India Company.
AAA4440 / D3894-1

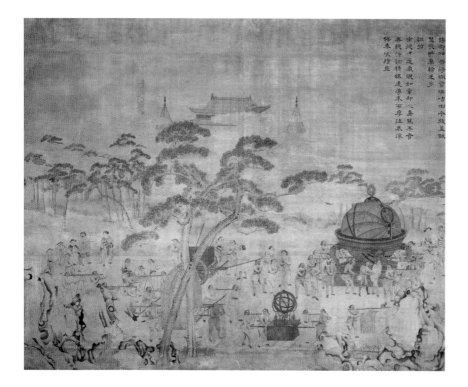

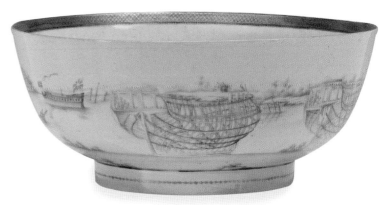

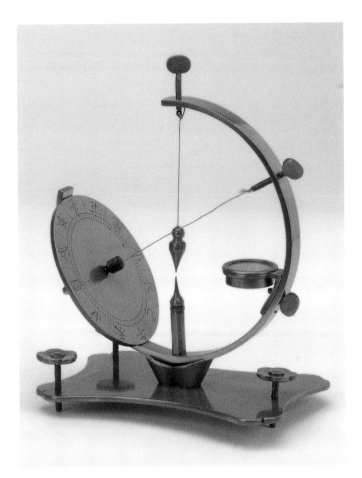

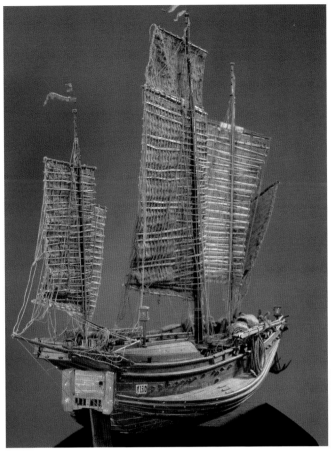

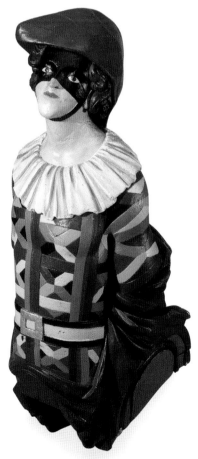

(Above, left)
CHINESE EQUINOCTIAL SUNDIAL
Unknown maker
Eighteenth century
This brass Chinese equinoctial (equal hour) dial uses a string gnomon to cast a shadow on the circular dial. Animal characters indicate the hours. The compass allows the user to align the dial in the correct north-south position. The three screws and plumb-bob are to ensure that it is level. The angle between the gnomon and the dial indicates the latitude for which it was made, in this case, latitude 30°N.
AST0334 / D8644

(Above, right)
PECHILI TRADING JUNK
Nineteenth century
The Pechili trading junks belong to one of the oldest types of Chinese vessel and can be traced back as far as the early fifteenth century. This model was made in 1938 at Wei Hai Wei and is an accurate representation of these large ocean-going vessels. The sails are supported with bamboo battens, which provide extra strength.
AAE0201 / D4741-2

FIGUREHEAD FROM HMS *HARLEQUIN*
1836
The 16-gun brig-sloop, HMS *Harlequin* (1836), was sent to the China Station, taking part in the Anglo-Chinese Opium War, 1839–42. *Harlequin* remained in the East Indies after the conflict and was involved in anti-piracy patrols. In 1844, HMS *Wanderer* and the East India Company steamer *Diana* joined *Harlequin* in an attack on the Sekrang pirate strongholds of Batu and Murdu on the Sumatran coast. The force faced little resistance at Batu but there was fierce fighting at Murdu before the pirates were defeated. *Harlequin* served off West Africa in the 1850s, was converted to a coal hulk in 1860 and was finally broken up in 1899.
FHD0081 / B3836

CIRCUMNAVIGATION

CENTURION, 60 GUNS
Benjamin Slade
1747, scale 1:48

This model of Commodore (later Admiral) George Anson's *Centurion*, the ship in which he made his famous circumnavigation of the world from 1740 to 1744, was made by Benjamin Slade, master shipwright at Plymouth, in 1747. It has been beautifully made, showing such fine detail as the treenails, wooden nails or pegs used to fasten the planks to the frames. During the early part of the eighteenth century the style of models changed. Most had fully planked hulls and were painted below the waterline.

SLR0442 / B1346-1

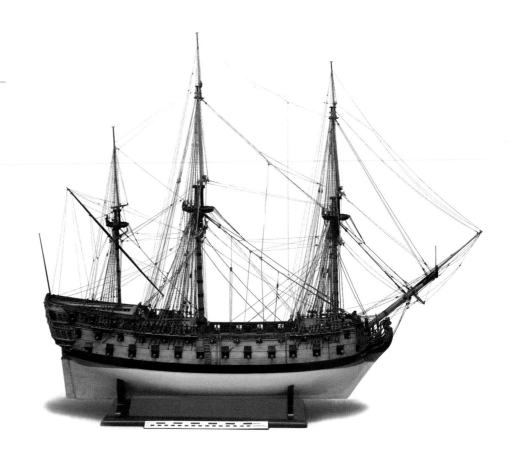

LOG OF THE *GLOUCESTER*
Lieutenant Patrick Baird
1742

During Anson's circumnavigation of the world in the 1740s, approximately 1300 men died of disease, chiefly scurvy. Over a quarter of the crew on the *Gloucester* were so badly affected that she was abandoned and set on fire, the log being transferred in August 1742 to Anson's own ship, the *Centurion*. The log of the *Gloucester* makes grim reading.

Men were dying day-by-day from this mysterious disease, with their skin blotchy, gums swollen and bleeding, and suffering from acute lethargy. Its then entirely unknown cause was a deficiency of vitamin C, the source of which (fresh fruit and vegetables) was always lacking on long sea voyages.

ADM/L/G/53 / D4670

Clocks

TABLE CLOCK
Caspar Buschman
c. 1586
This magnificent example of the Renaissance clockmaker's art is reputed to have once belonged to King Casmir V of Poland who, after abdicating, retired to Paris, where he became Abbot of St Germain. The highly decorated gilt-brass case contains a spring-driven clockwork mechanism of 30-hour duration which, in addition to telling the time and date, has complex gearing to provide over forty different indications. The main astrolabic dial shows relative lunar, solar and stellar positions for any given date. Although signed by Buschman, the clock is believed to have been made by Johann Reinhold of Augsburg.
ZAA0011 / D9245

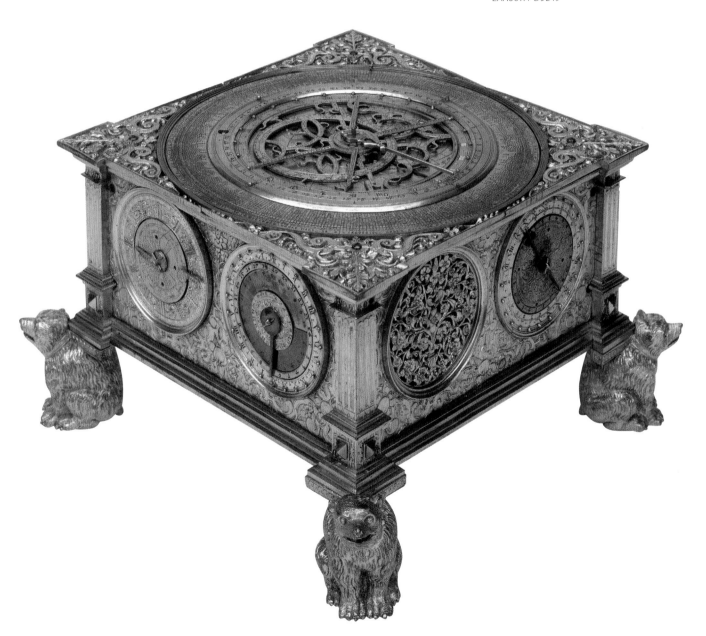

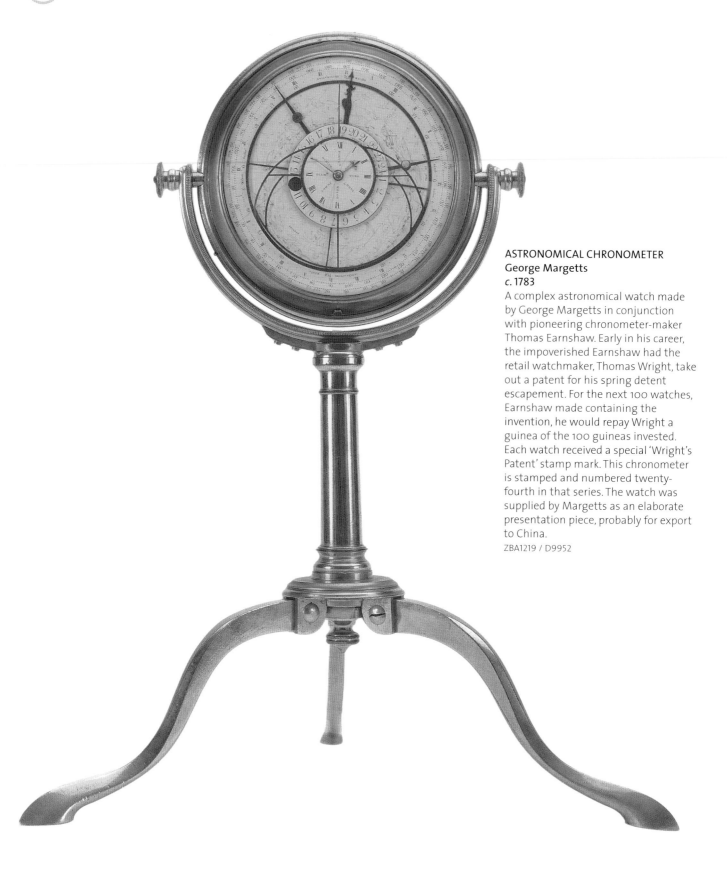

ASTRONOMICAL CHRONOMETER
George Margetts
c. 1783

A complex astronomical watch made by George Margetts in conjunction with pioneering chronometer-maker Thomas Earnshaw. Early in his career, the impoverished Earnshaw had the retail watchmaker, Thomas Wright, take out a patent for his spring detent escapement. For the next 100 watches, Earnshaw made containing the invention, he would repay Wright a guinea of the 100 guineas invested. Each watch received a special 'Wright's Patent' stamp mark. This chronometer is stamped and numbered twenty-fourth in that series. The watch was supplied by Margetts as an elaborate presentation piece, probably for export to China.

ZBA1219 / D9952

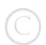

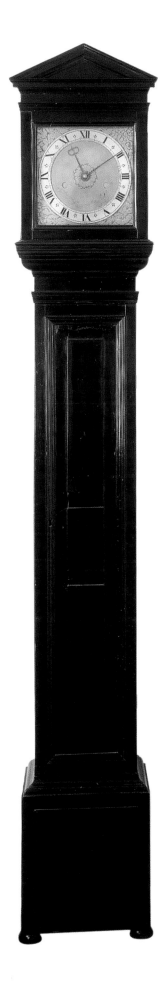

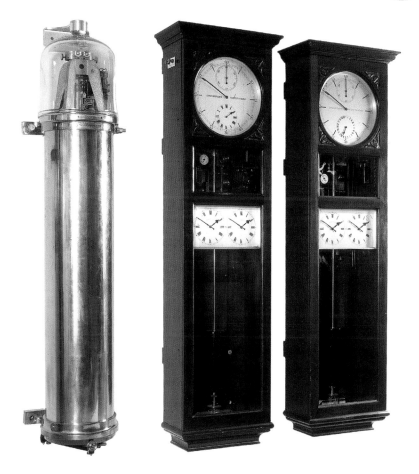

(Left)

EARLY PENDULUM-CONTROLLED CLOCK
John Fromanteel
c. 1670

In 1657 Christiaan Huygens was the first to use a pendulum successfully as a means of controlling the rate of a clock. This invention led to an immediate and dramatic improvement in timekeeping. When news of his invention reached England, clockmaker Ahasuerus Fromanteel sent his son, John, to work in Holland with Huygens's maker, Salomon Coster. In 1658 Fromanteel advertised that 'There is lately a way found out for making clocks that go exact and keep equaller time than any now made'. In addition to an hour hand, clocks such as this early 'longcase' now had the added sophistication of a minute hand, a feature of little value on previous, relatively inaccurate clocks.

 This type of elegant but sombre ebony or ebonized case of architectural design soon gave way to the use of exotic veneers and elaborate marquetry.
ZAA0260 / D9259

(Above)

'FREE-PENDULUM' MASTER AND SLAVE SYSTEM
W. H. Shortt & The Synchronome Co. Ltd
1927

First conceived by R. J. Rudd in the late nineteenth century, the idea of a 'free pendulum' was developed by William Hamilton Shortt in the early 1920s. In all clocks, the natural period of the pendulum is disturbed by the impulse needed to keep it swinging. With this system, the pendulum swings almost entirely without outside influence, sustained by a single impulse given every 30 seconds from a pair of remote 'slave' clocks. By suspending the pendulum in a partial vacuum, the usual effects caused by changes in atmospheric pressure and temperature are greatly reduced. The Shortt system was capable of keeping time to within a few seconds a year.
ZAA0544 / E0251

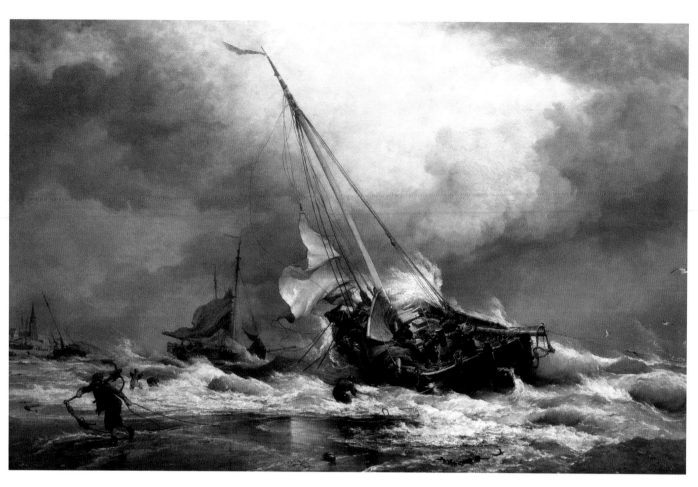

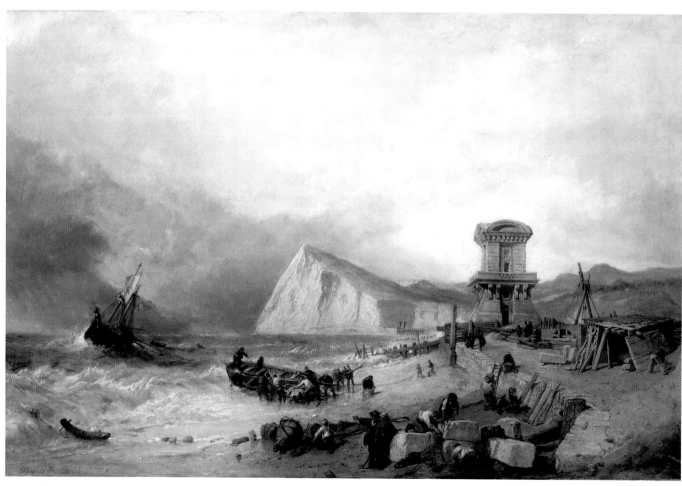

COASTAL VIEWS

(Opposite, top)
A NORTH SEA BREEZE ON THE DUTCH COAST
Edward William Cooke
1855
Inspired by Dutch seventeenth-century marine painters, the artist was interested in scenes of Holland and Dutch shore life. He gave this work the secondary title; *Scheveling Fishermen Hauling the* Pinck *Out of the Surf.* The artist has included the church tower of Scheveningen, on the North Sea coast near The Hague, in reference to the earlier masters who often included it as a landmark. Cooke invests the commonplace scene with the drama of human struggle against the elements. He made his basic studies in the open air, and on his visit to Holland in 1855, the year of this painting, he recorded in his diary for October that the sea was very rough and that he 'pottered about the strand, got some sketches'.
BHC1246

(Opposite, bottom)
SHAKESPEARE CLIFF, DOVER, IN 1849
Clarkson Stanfield
1862
Stanfield and E. W. Cooke were the leading marine painters between the 1830s and the 1870s, and both became successful Royal Academicians. Stanfield's marine subjects can be compared to those of more famous landscape painters of the period such as John Constable or Richard Parkes Bonington, as well as J. M. W. Turner. His origins as a theatre painter are reflected in the dramatic quality of works such as this, in which a brig in distress off Dover is about to be assisted by a group of fishermen.
BHC1212

(Below)
BRIGHTON BEACH
Frith & Co.
c. 1902
Elegant Edwardian society is seen here enjoying the sea air at Brighton in the summer of 1902. The steamer *Brighton Queen* approaching the Palace Pier, the bathing huts wheeled out on to the beach and the shops opened for business, evoke the hustle and bustle of a fashionable seaside town. The development of the railways meant that seaside resorts such as Brighton became popular for days out, away from the smog and dirt of London.
G3030

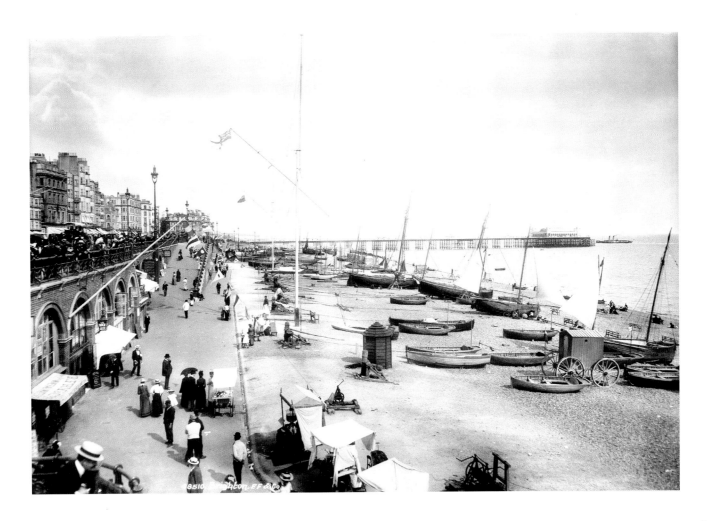

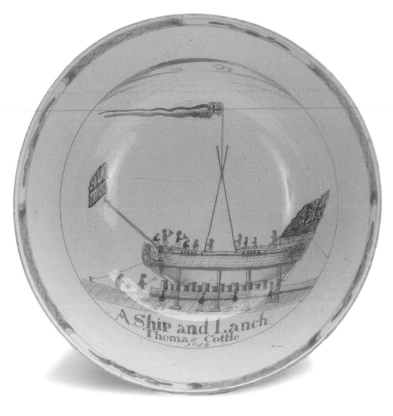

Commemoratives

(Above, left)
SHIP BOWL
1752
This hand-painted delftware punch-bowl commemorates the launch of a small vessel, as yet unrigged, but wearing a large red ensign, jack and pennant in preparation for the traditional ceremony. Workmen can be seen wielding axes, while other men on board raise their hats. Although the jack and pennant were flags normally exclusive to the Royal Navy, the vessel has no guns, and it is likely that she would be rigged as a merchant brig. A painted inscription identifies the scene as 'A Ship and Lanch. Thomas Cottle, 1752', which makes it the earliest dated ship bowl in the Museum's collection. Such a scene is extremely rare on a piece of pottery.
AAA4424 / D0852-46

(Right)
SAILOR TAPERSTICK
William Café, London
1761
This cast-silver taperstick is modelled as a sailor wearing the distinctive seaman's costume typical of a century before ratings were given an official uniform, in 1857. Like the equally rare ceramic sailor figures, such representations are particularly valuable in depicting the back view of garments seldom seen in paintings and engravings. This sailor taperstick was probably originally paired with a silver 'lass'. The Cafés were one of the two families of London silversmiths who virtually monopolized the manufacture of silver candlesticks in the eighteenth century.
PLT0724 / D3468-1

COMPASSES

IVORY COMPASS
Unknown maker
c. 1570

Dating from around 1570 and probably Italian, this is the earliest marine compass in the Museum's collection and one of the oldest in Europe. It has a decorated vellum and paper card, divided into 32 points – as usual for the time. Both the north and east points have additional decoration, to mark their importance: north because it was the point which the compass needle indicated and east to remind the user of the direction of the Holy Land. The soft iron needle is diamond-shaped and fixed to the underside of the card. The compass bowl is set in a brass gimbal in order to reduce the effects of the motion of the ship at sea. The case and lid are carved from ivory, rather than the more common wood, suggesting this fine instrument was intended to be used by a person of wealth.

NAV0276 / D9602

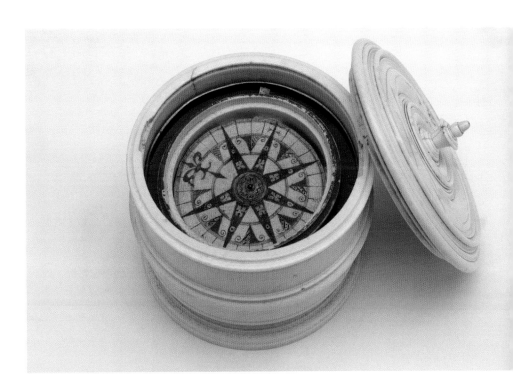

AZIMUTH COMPASS
John Fowler, later card by Henry Gregory
c. 1730 and *c.* 1760

An azimuth compass had sights to allow bearings to be taken from landmarks in coastal navigation or surveying, and from the Sun or stars, for checking the compass itself. The fact that a compass needle does not always point to true north was known in Europe long before the voyages of exploration of the late fifteenth century. The extent of this variation could be measured by using celestial observation to establish true north. The azimuth compass made by John Fowler of London has a diagonal scale to enable more accurate measurements of bearings to be taken than was possible from the main scale.

NAV0288 / A5963

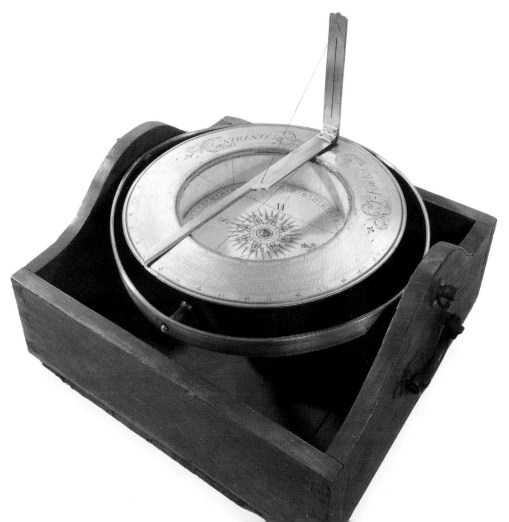

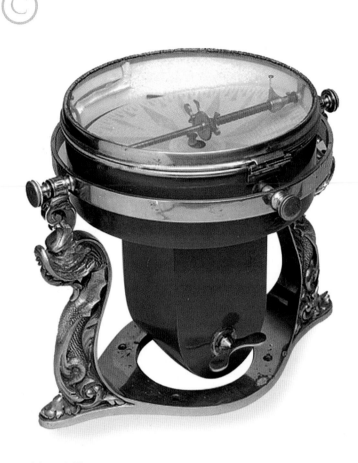

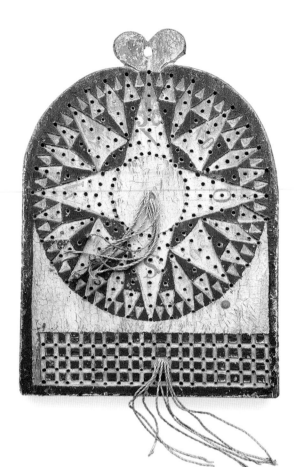

(Above, left)
MARINER'S RECORDING COMPASS
D. Napier & Son
1848

In 1848, David and James Napier took out a patent for a type of compass which kept a permanent record of the direction of the ship's head, as indicated by the compass needle. A circle of squared paper was placed over the compass card and a clockwork mechanism caused a pin to make a hole in the card at three-minute intervals, automatically recording the direction. This enabled an accurate record of the course to be transferred to a chart. The compass bowl is held in a highly decorative brass gimbal with an elaborate sea serpent on each side.

NAV0254 / A5157-1

(Above, right)
TRAVERSE BOARD
c. 1800

The traverse board was a simple but effective method of recording the course of a ship. This example, dating from around 1800, is thought to be of Scandinavian, Dutch or German origin, suggested by the use of 'O' for East. It was found in 1844 on the Scottish isle of Barra and is unusually decorative in design. Traverse boards are thought to have been used only by northern european navigators since no Mediterranean examples have ever been found.

NAV1697 / 3158

(Left)
'DOLPHIN' BINNACLE AND COMPASS
Kelvin and James White Ltd
1899

A binnacle is a casing which supports and protects a ship's compass. This carved binnacle, decorated with dolphins, painted white and gilded, comes from the Royal Yacht *Victoria and Albert* of 1899. It was made by the firm of Kelvin and James White to patent no. 7376, taken out by Sir William Thomson, later Lord Kelvin. The specification included corrector magnets and iron spheres to counteract the effect on the compass of local attraction caused by iron used in the construction of the ship. The compass card has eight parallel needles and is divided both into quarter-points and degrees, arranged as four quadrants of 90° each.

NAV0352 / D8148

COOK, CAPTAIN JAMES

CAPTAIN JAMES COOK
William Hodges
c. 1775

James Cook (1728–79) was born the son of a farm labourer in Yorkshire and worked until the age of 26 in the coal trade. He then joined the Royal Navy as an able seaman and quickly gained a reputation as a navigator and surveyor of extraordinary talent. These skills earned him command of HM Bark *Endeavour* on a voyage of scientific exploration to the Pacific in 1768. The voyage was successful and Cook was promoted and sent out on a second voyage, the main purpose of which was to find the mythical southern continent. Cook's third voyage ended tragically, in 1779, when he was killed on the island of Hawaii. This fine and revealing portrait was painted by William Hodges, the artist on Cook's second voyage.
BHC4227

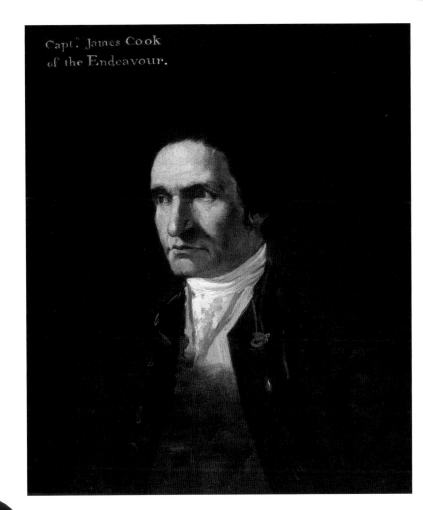

FULL-DRESS COAT OF A ROYAL NAVY CAPTAIN 1774 PATTERN
This is the type of uniform that would have been worn by Captain James Cook (1728–79), although the provenance of this coat is unknown. Captains and commanders had a full-dress uniform with white lapels and gold lace at this date, and a plainer undress uniform. The coat is made of a plain-woven woollen fabric with a nap, and the flat gilt buttons are die-stamped with an anchor and cable.
UNI0011 / E8954

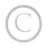

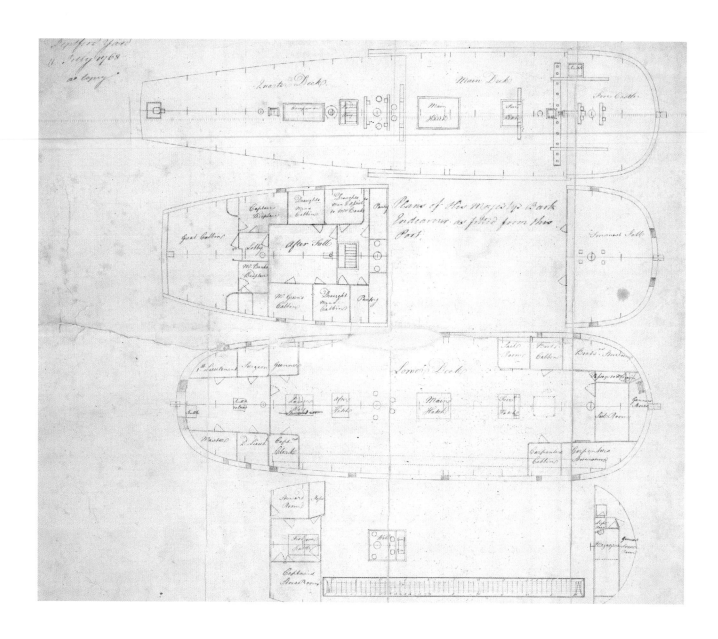

(Above)
ENDEAVOUR, DECK PLANS
The Navy Board
1768
The *Endeavour* was originally built at Whitby as the collier, *Earl of Pembroke*. She was purchased by the Admiralty in March 1768 and assigned to Captain Cook for his first Pacific voyage. Cook and his complement of over 100 set sail from Plymouth on her in August 1768. During her refit at Deptford an internal deck was added to provide the additional living space needed. Dated July 1768, the deck plans detail the final layout and new cabins fitted to accommodate the naturalist Joseph Banks and his party of eight 'scientific gentlemen' and servants, who joined the ship in August 1768.
ZAZ7845 / D7009

(Opposite, top)
ENDEAVOUR
R. A. Lightley
1975–76, scale 1:48
Probably one of the most popular objects with visitors to the Museum, this model of Captain Cook's *Endeavour* was commissioned to illustrate the internal layout of the ship and the cramped conditions endured by those on board. The model is fully planked on the port side and is complete with a full complement of crew and stores. Returning from her voyages with Cook in 1771, *Endeavour* was converted once again into a store ship. She was lost off Newport, Rhode Island, some years later.
SLR0353 / D3358-3

(Below)
A VIEW IN CAPE STEPHENS IN COOK'S STRAITS WITH WATERSPOUT
William Hodges
1776
Hodges was appointed by the Admiralty to record the places visited on Cook's second voyage, 1772–75, undertaken by the *Resolution* and *Adventure*, to locate and chart the southern continent.
The painting depicts an incident in May 1773 when *Resolution* was threatened by waterspouts. Departing from Hodges's topographical images of the voyage, it fuses continuous narrative, landscape, classical references and other diverse elements with personal experience.
BHC1906

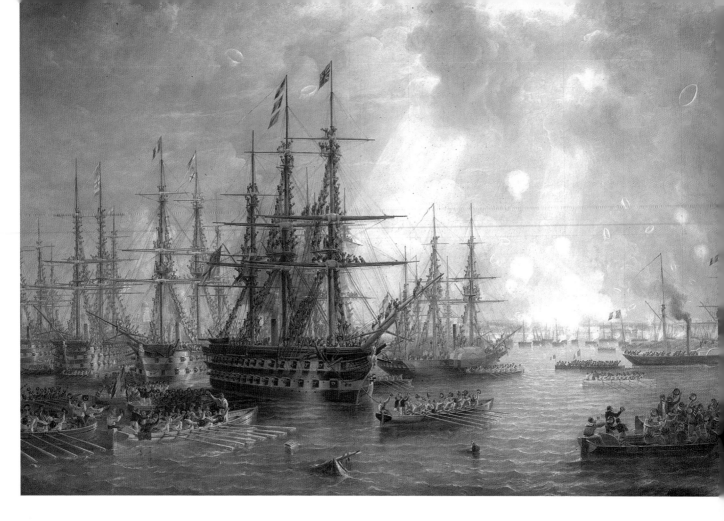

CRIMEAN WAR

(Above)
BOMBARDMENT OF SVEABORG
John Wilson Carmichael
1855

The Crimean War began as a conflict between Russia and Turkey in the Black Sea in 1853. From 1854, British and French involvement broadened its geographical scope. On land, the war in the Crimea produced no truly decisive battles, but at sea Britain and France had a definite advantage. The key naval engagements took place in the Baltic, with the bombardment of Russian positions in Finland. The attack on Sveaborg in August 1855 was a success, but the naval campaign also revealed weaknesses in the Anglo-French fleets. Ships were still built of wood and proved unable to withstand the firepower from shore batteries, which now included explosive shells. Following peace in 1856, navies began to adopt iron hulls to strengthen their vessels, introducing a new breed of warship.

BHC0636

(Below)
RUSSIAN INFERNAL MACHINE
1855

This mine consists of an iron cone filled with gunpowder that was designed to explode when struck by a ship. 'Infernal machines' were used by the Russians during the Crimean War, 1854–56, and were sometimes treated in a somewhat cavalier fashion by British naval officers. The

Illustrated London News in 1855 reported that one was examined by Admiral Seymour on HMS *Exmouth* who 'incautiously tapping a little bit of iron projecting from its side said "This must be the way they are exploded" when bang! the thing went off'. The Admiral was temporarily blinded and several of his officers had their whiskers burnt off.
KTP1307 / D9752

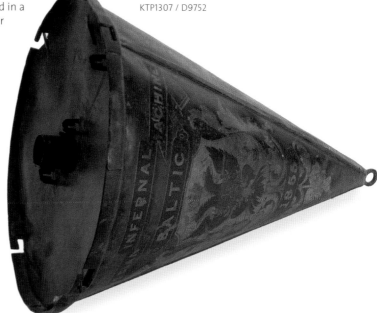

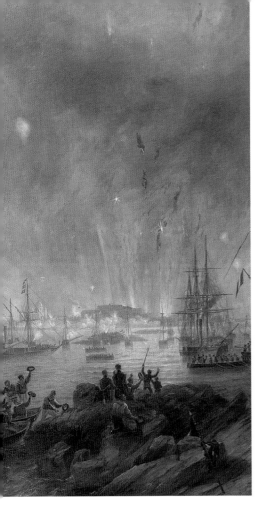

(Right)

FIGUREHEAD FROM
HMS *LONDON*
1840

HMS *London* was a 92-gun warship launched at Chatham in 1840. During the Crimean War she was badly damaged while participating in the bombardment of Sebastopol, the crew suffering many casualties. After the war, the *London* was repaired and converted into a screw vessel. She was the harbour guard-ship at Zanzibar between 1874 and 1881 when she was involved in suppressing the East African slave trade. The ship was broken up in 1884. The figurehead depicts a woman wearing the White Tower of the Tower of London as a crown.

FHD0091 / B3842

(Below, left)

VICTORIA CROSS AWARDED TO CAPTAIN
SIR WILLIAM PEEL, RN (1824–58)
Before 1858

The Victoria Cross was established in 1856 during the Crimean War. It was awarded for individual acts of bravery by officers and men of the Army and Navy in the presence of the enemy. One of the earliest recipients was Captain William Peel, third son of the statesman Sir Robert Peel. By the age of twenty-five he was the youngest post-captain in the Navy. He served as a naval brigade commander at the Siege of Sebastopol. The Victoria Cross was awarded for three acts of gallantry during this campaign. Peel threw a Russian shell bodily over the parapet of a battery, preventing it from exploding among powder cases. During the Battle of Inkerman he managed to warn a group of Grenadier Guards that they were about to be surrounded by the enemy. On 18 June 1855, he led the first party to attempt to scale the Redan wall at Sebastopol, being wounded in the process. He subsequently led a naval brigade during the Indian Mutiny and was wounded again during the second relief of Lucknow. He died a few weeks later, having fallen ill with smallpox.

MED1252 / D9723

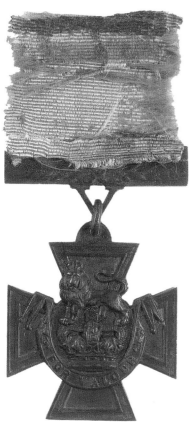

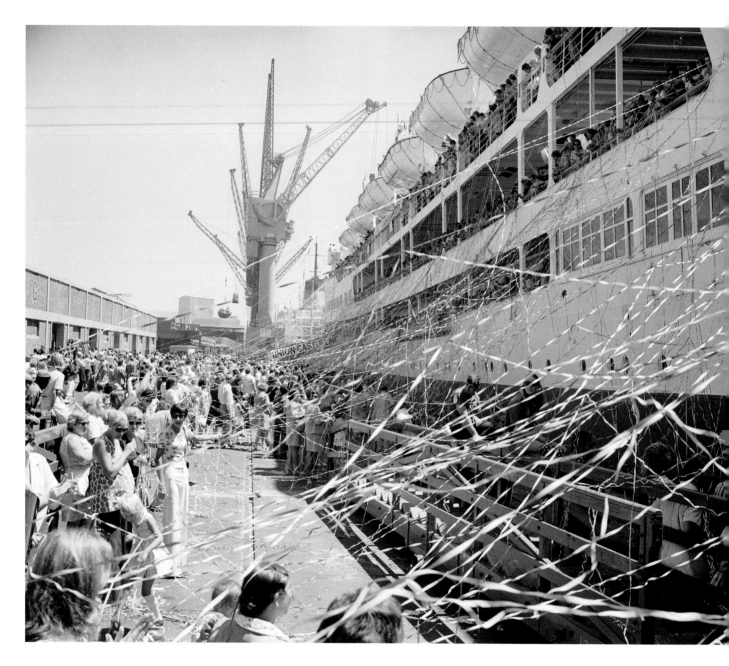

CRUISING

**REINA DEL MAR; A STREAMER FAREWELL,
13 FEBRUARY 1975**
T. J. McNally
Streamers, large crowds, cheering and
band music made the ceremony of
embarking one of the highlights of a
cruise. *Reina del Mar* was built in 1956
for the Pacific Steam Navigation
Company as a cargo and passenger

vessel. In 1964 she was extensively
refitted as a cruise liner and her former
cargo holds were converted to
accommodate extra passengers. *Reina
del Mar* is shown setting off on one of
her last voyages from South Africa in
1975. In July of the same year she was
broken up in Taiwan.
P47556

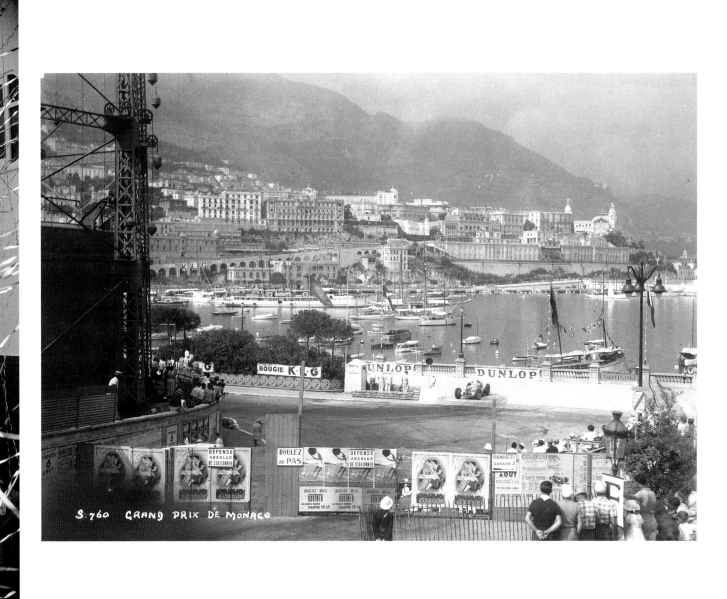

MONACO GRAND PRIX, AUGUST 1937
Waterline Collection
The *IX Grand Prix Automobile de Monaco* was held on 8 August 1937. Car no. 12 was a Mercedes Benz driven by the Swiss driver Christian Kautz, who ended the race in third place. This negative is one of more than 16,500 purchased by the Museum from Waterline International Ltd. They were taken by photographers who worked on board various British cruise ships on behalf of Marine Photo Service, the first company in the world to provide such a service. Photographs were taken throughout the cruise and sold at the end as albums of the voyage.
P93446

DEPTFORD

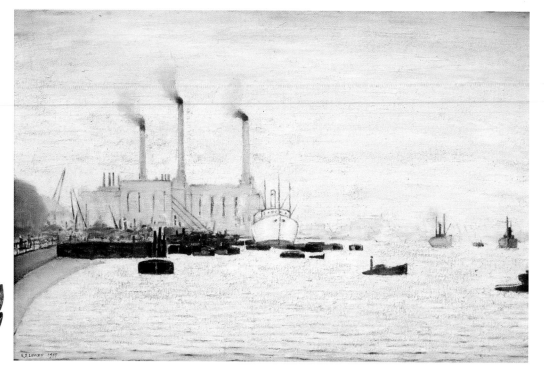

(Left)

FIGUREHEAD FROM HMS *BLENHEIM*
1813

The 74-gun, third-rate warship HMS *Blenheim* was launched in 1813 at Deptford, just upstream of Greenwich. She was converted to steam in 1837 and saw action in the China Wars. HMS *Blenheim* was sent to the Baltic during the Crimean War and took part in the bombardment of Bomarsund. She later became a coastguard vessel before being broken up in 1865. The figurehead is said to depict John Churchill, first Duke of Marlborough, victor of the Battle of Blenheim in 1704 although the style of uniform is contemporary with the ship. The coat of arms on the side of the figurehead was granted to the Spencer-Churchill family in 1733.
FHD0064 / B3829

(Above)

DEPTFORD POWER STATION
FROM GREENWICH
Lawrence Stephen Lowry
1959

A great visual recorder of the industrial landscape, Lowry painted very few pictures of London. He was concerned with immense industrial buildings at the heart of manufacturing towns, and the effect this landscape had on the inhabitants. Here the humans have been pushed to the far left of the picture space, looking over the quay. Cranes rise out of mist on the far right. Lowry's interpretation is a disquieting vision, revealing a sense of alienation and man's inconsequence against the juggernaut of industrialism.
BHC1806

DISASTERS

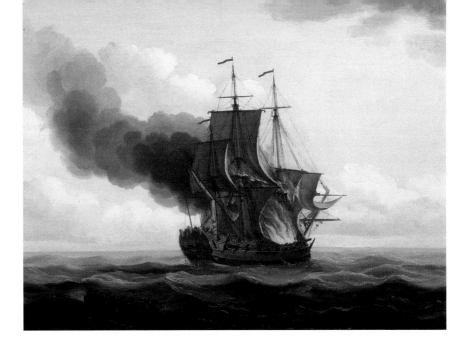

(Above, right)
THE *LUXBOROUGH GALLEY* ON FIRE, 25 JUNE 1727
John Cleveley, the Elder
1760

The *Luxborough Galley* was lost in mid-Atlantic in 1727, returning to England on the third leg of the infamous triangular trade that took goods from England to Africa, slaves to the Caribbean and sugar and rum back to England. The ship caught fire, with the flames spreading quickly and giving the crew no time to put provisions in the lifeboat.
The shipwreck achieved notoriety when it was discovered that the survivors had been forced to eat their dead companions in order to survive.
This painting is one of six that follow the tragic story from the sinking of the ship to the arrival of the survivors in Newfoundland.
BHC2389

(Below)
ROYAL GEORGE BELL
Thomas Bartlett, Portsmouth
1773

'Toll for the brave
The brave! That are no more
All sunk beneath the wave,
Fast by their native shore.'

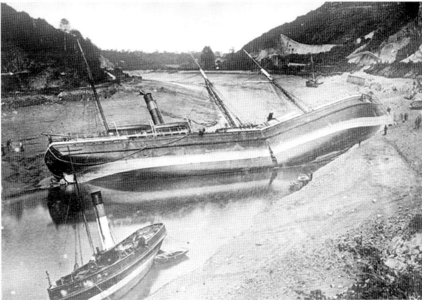

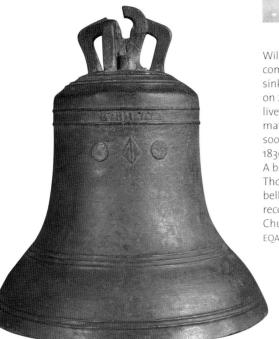

William Cowper's well-known poem commemorates the tragic accidental sinking of HMS *Royal George* at Spithead on 29 August 1782 with the loss of 900 lives. Some of the most valuable materials and the guns were salvaged soon after the loss, and explosions in the 1830s cleared the remains of the wreck. A broad arrow and the initials 'T B' for Thomas Bartlett are cast in relief on the bell, as well as the date. After its recovery, the bell was hung in St Anne's Church in Portsmouth Dockyard.
EQA0480 / D4685

(Above)
GIPSY WRECKED IN THE AVON
Unknown artist
May 1878

The steam schooner *Gipsy* was built at Waterford for the Waterford Shipping Co. Ltd in 1859. On 12 May 1878, *Gipsy* was being towed by the tug *Sea King* down river from Bristol, *en route* to Liverpool and Waterford when she struck rocks and listed over on to the mud. Despite several attempts by tugs to right her, she broke in two and completely blocked the river for nearly a week. No one was injured by the accident and her cargo was easily removed, but eventually the ship's remains had to be dynamited to clear the channel.
P10478

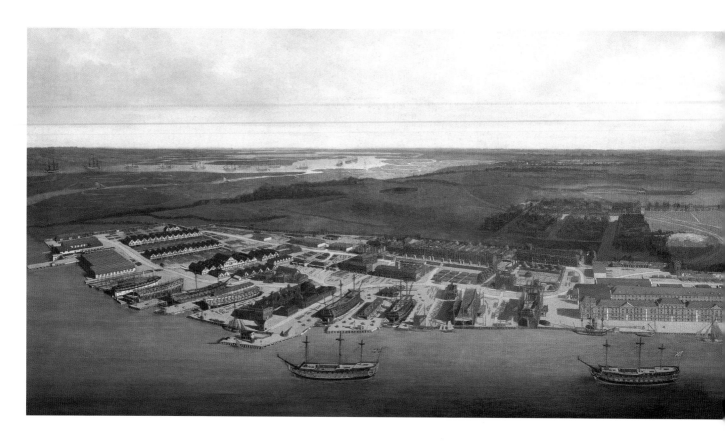

DOCKS & DOCKYARDS

(Above)
CHATHAM DOCKYARD
Joseph Farington
c. 1792
One of a series of four paintings showing the main dockyards at the end of the eighteenth century. To the right is the anchor wharf, with two long storehouses behind and the new ropery behind them. In the centre foreground, two ships are under repair in dry-docks and two more are being built. Between the bows of these two is the Commissioner's House of 1703, with its large garden, with the other officers' houses behind and to the left. To the left of the picture more ships are under construction and repair, with industrial buildings behind, including the mast-house with a high central bay.
BHC1782

(Below)
PATCH BOX
G. Stephany and Dresch
c. 1793–1800
This unusual box, only 4 in. (10 cm) in length, is decorated with a detailed scene carved in ivory, set under glass in a gold mount. The miniature shipping scene with a two-decked warship in dock in the foreground may be

Portsmouth. The box, which has a mirror inside the lid, was probably intended to be a container for the fashionable cosmetic patches worn on the face. The box is likely to be the work of Stephany and Dresch, 'Royal Carvers in Miniature', who worked in Bath and London at the end of the eighteenth century.
OBJ0267 / D5713

SHEERNESS DOCKYARD
1772–74, scale 1:480
Arguably the finest of the six dockyard
models commissioned for George III,
this one shows such detail as water
pumps, piles of shot for the guns, and
two-horse teams with tiny human
figures. Sheerness, founded in the 1670s,
was the smallest of the Royal Dockyards.
The ship to the top left of the model
is the 64-gun *Polyphemus*, the largest
built at Sheerness in the age of sail.
The fortifications against land attack
dominate the centre of the model, and
to the left are the hulks, old ships sunk
to help to reclaim the land and to
provide primitive accommodation
for the workmen.
SLR2148 / D7824

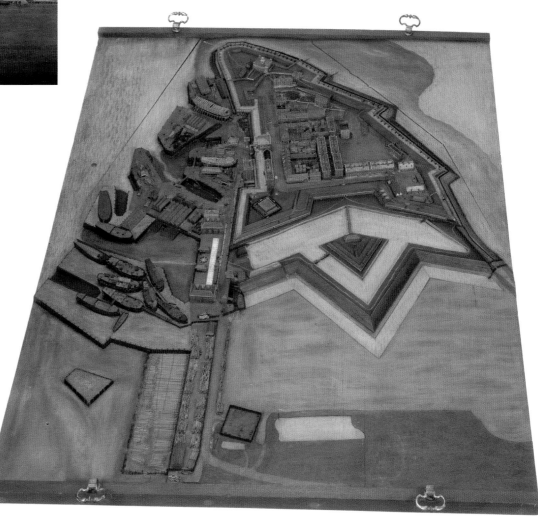

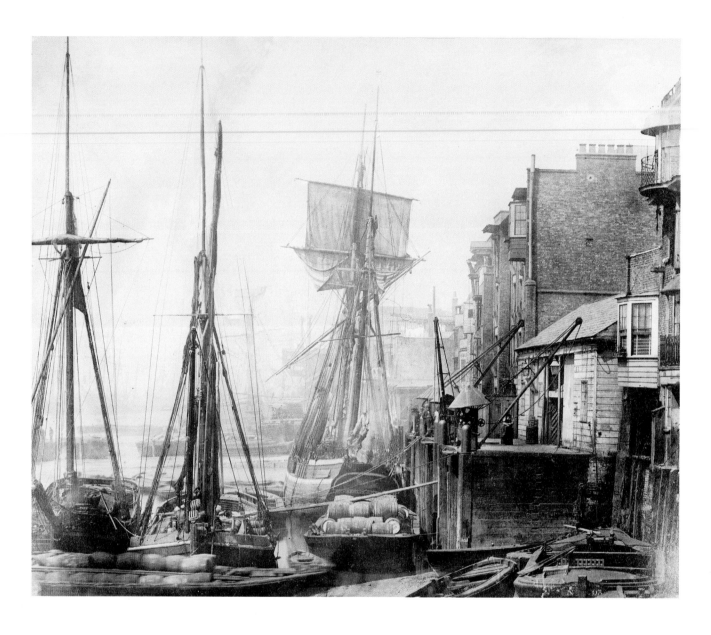

(Above)
BLACK EAGLE WHARF, WAPPING
Unknown artist
1856

Wapping, on the north bank of the River Thames just below Tower Bridge, was one of the busiest waterfronts in London. As Britain's empire expanded, sea trade into London became ever busier and so more wharves and warehouses were built along the river from the Pool of London to the area now known as Docklands. The area began to decline with the arrival of larger steam vessels which could not sail so far up the river and which had to unload their cargoes further downstream. The old warehouses of Wapping have now been transformed into luxury apartments and the river no longer bustles with traffic.
6660

(Opposite)
PENANG **IN BRITANNIA DRY-DOCK, MILLWALL**
E. A. Russell Westwood
1932

The barque *Penang* was built in 1905 as the *Albert Rickmers* at Bremerhaven, Germany, but was bought by the Finnish shipping tycoon Gustav Erikson. When other shipping companies were turning to steam and motor vessels for their fleet, Erikson bought up the remaining sailing vessels and started his own company. Erikson's ships will always be best remembered for their voyages in the 1930s with the writer and photographer Alan Villiers. In this photograph the *Penang* towers over houses and back gardens in Westferry Road, Millwall, London.
P39610

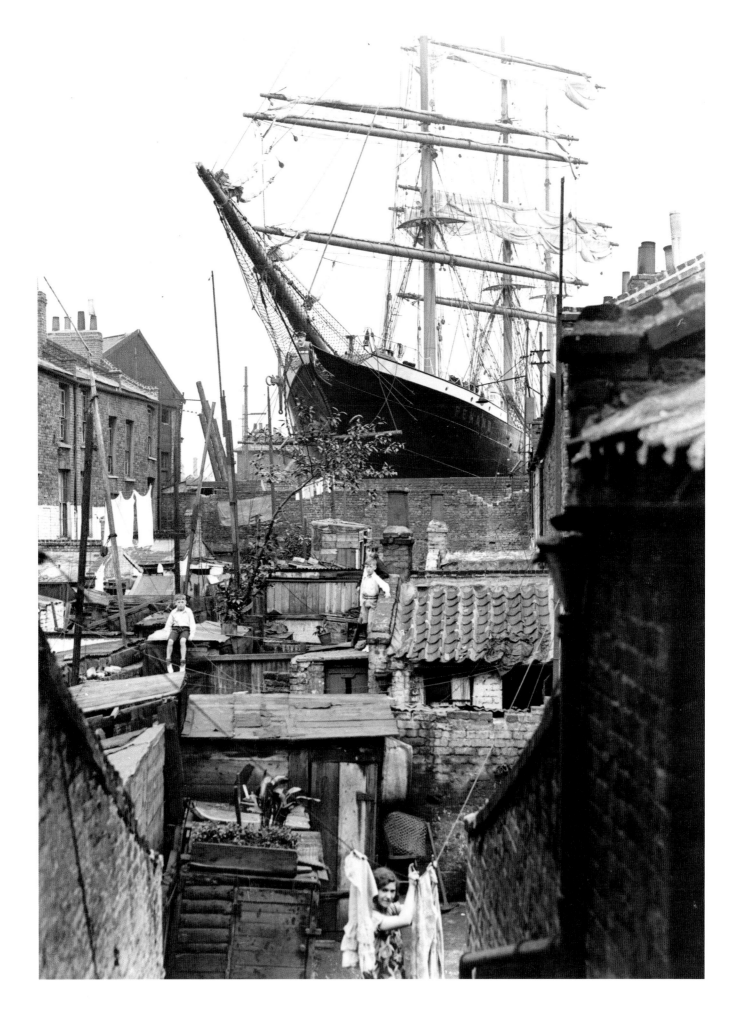

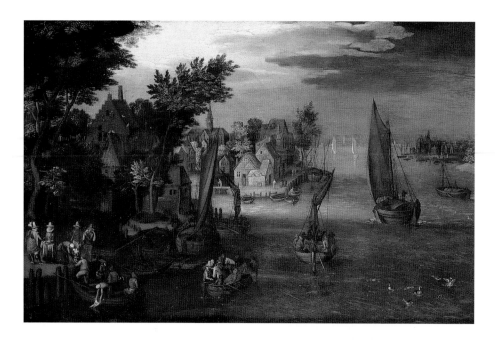

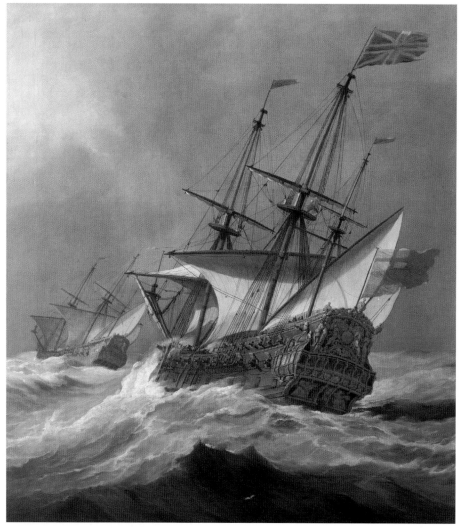

DUTCH ARTISTS

(Above, left)
A BUSY RIVER SCENE WITH DUTCH VESSELS AND A FERRY
Attributed to Jan Brueghel
Early seventeenth century
Jan Brueghel the Elder, known as 'Velvet', was one of the most important painters of early seventeenth-century Antwerp. He produced exquisite cabinet-sized landscapes painted on copper for the great collectors of the age, since domestic architecture made smaller paintings more desirable.
BHC0711

(Below, left)
***RESOLUTION* IN A GALE**
Willem van de Velde the Younger
c. 1678
This was probably painted for Admiral Sir Thomas Allin, whose portrait by Sir Peter Lely is also in the Museum's collection. Allin went to the Mediterranean as Commander-in-Chief in 1669–70 with *Resolution* as his flagship. Van de Velde's painting may reflect Allin's journal entry for 14 December 1669: 'we tried all Morning with our mainsayle the wind at E and by south and the ship laboured very much...'. *Resolution* was one of the first 70-gun two-deckers built at Harwich in 1667.
BHC3582

(Opposite, top)
THE BEACH AT SCHEVENINGEN
Simon de Vlieger
1633
Scheveningen is a village on the coast close to The Hague and was frequently painted by Dutch landscape and marine painters. In the foreground the catch is being unloaded from a fishing boat, and a fish market is taking place. Other boats and groups, including a carriage, can be seen as the beach sweeps away towards the horizon. The picture is a remarkable early example of atmospheric landscape painting in which observation of nature is of supreme importance. The effect of the wind on the waves and the wet sand are keenly observed.
BHC0774

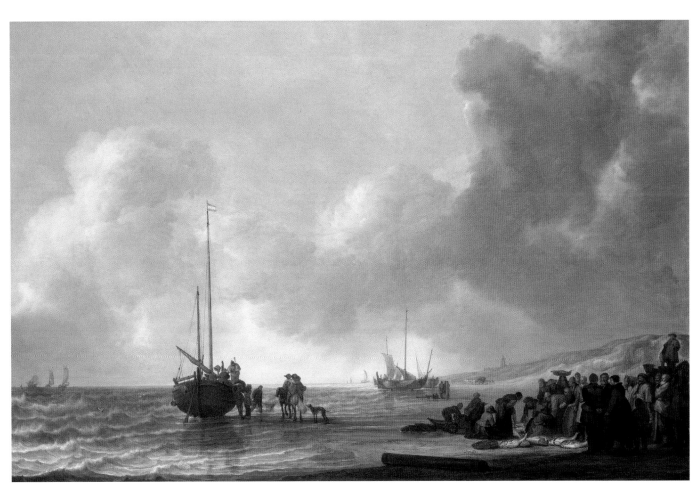

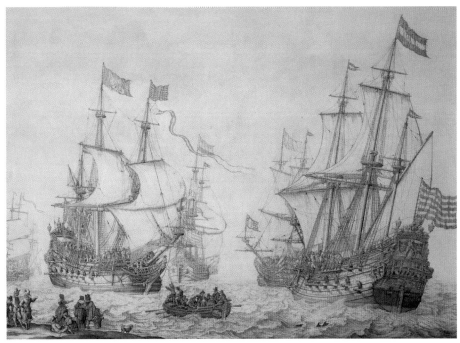

(Right)

**TWO DUTCH MERCHANT SHIPS
UNDER SAIL NEAR THE SHORE IN A
MODERATE BREEZE**
Willem van de Velde the Elder
c. 1650

The Museum has one of the best
collections of Dutch 'pen-paintings' in
the world. The elder van de Velde is
considered the leading exponent of the
process, which involved drawing on a
prepared white surface, usually a wooden
panel. The effect closely resembled that
of an engraving. It was ideally suited
to reproducing detail, such as the
decoration of ships. The stern of the
right-hand ship has a full-length figure
of St Catherine and her wheel and the
inscription ANNO CATARINA 1649, which
indicates the name and date of the ship.
The composition is crowded and there is
a celebratory atmosphere, probably
because van de Velde's client wished to
show off his two ships returning from a
successful voyage to the East.

BHC0860

ELIZABETH I

(Right)
ELIZABETH I (1533–1603)
British school
Sixteenth century
Elizabeth was born at Greenwich Palace on 7 September 1533 to Henry VIII and his second wife, Anne Boleyn. Henry was devastated, as he desperately wanted a male heir to secure the Tudor succession. Elizabeth's early life was tumultuous. Her mother was executed before she was three and she herself came close to execution during the reign of her Catholic half-sister, Mary I (1553–58). Elizabeth reigned for nearly 45 years. It was unprecedented in English history for the ruler to be an unmarried, childless woman. She presided over an era that witnessed a flowering of artistic expression, an increase in overseas expansion and a consolidation of English national identity.
BHC2680

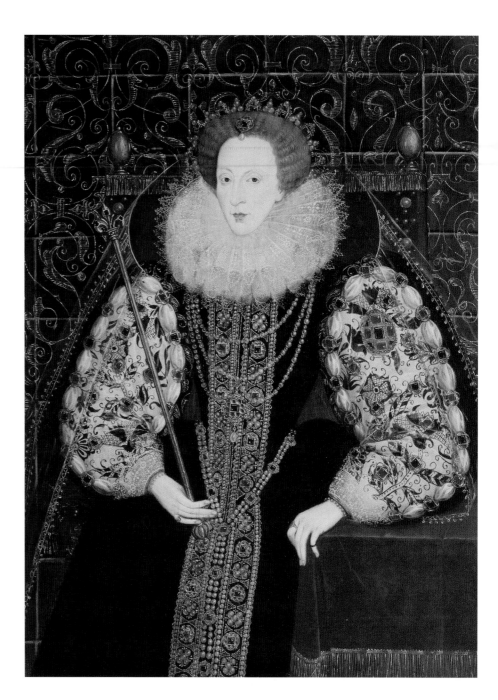

(Opposite, above left)
'A SONGE MADE BY HER MAJESTIE AND SONGE BEFORE HER AT HER COMINGE FROM WHITE HALL TO POWLES [ST PAUL'S] THROUGH FLEETE STREETE IN ANNO DOMINI 1588'
Elizabeth I
1588
A song on the victory over the Spanish Armada, said to have been composed by Elizabeth I. Protestants were eager to proclaim the role of God in the conflict:

'...He made the wynds and waters rise
To scatter all myne enemyes

This Josephes Lord and Israells god
The fyry piller and dayes clowde
That saved his saincts from wicked men
And drenshet the honor of the prowde
And hathe preservud in tender love
The spirit of his Turtle dove.'

SNG/4 / E9077

(Opposite, above right)
GEORGE CLIFFORD, THIRD EARL OF CUMBERLAND (1558–1605)
Nicholas Hilliard
***c.*1590**
The Museum has a collection of over 200 miniatures. This famous full-length miniature portrays Cumberland as Queen's Champion and Knight of Pendragon Castle at the Accession Day Tournament in 1590. Courtier, gambler, privateer, mathematician and navigator, he had commanded the *Elizabeth Bonaventure* against the Armada and brought the news of victory to Tilbury after the action at Gravelines.
MNT0193 / 2673

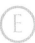

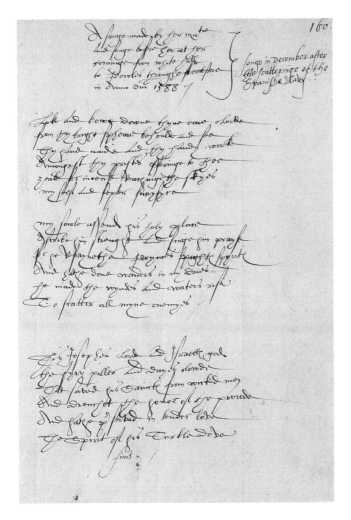

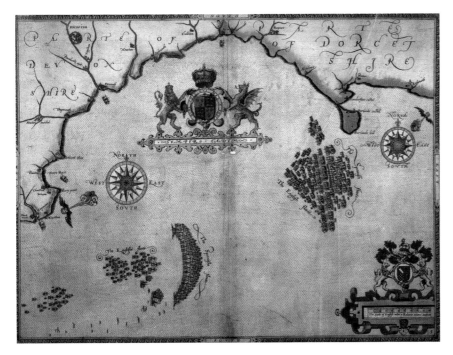

(Left)
ARMADA TRACK CHART: THE FLEETS OFF BERRY HEAD AND THE ENGAGEMENT NEAR PORTLAND BILL,
1–2 AUGUST 1588
Robert Adams
1588–90

This is one of a series of ten engraved charts showing the progress of the Spanish Armada's assault on England in 1588. These charts were made to illustrate a history of the campaign based on Lord Howard's account, and are a visual record of the official story. The events of 1 August are shown to the west on this chart, with the English pursuing the crescent-shaped formation of the Armada, while some English ships capture the *San Salvador*, which had been crippled by an explosion. The action on 2 August took place farther east off Portland Bill, where the Armada was engaged by the English fleet.
223-2/32 / D3295

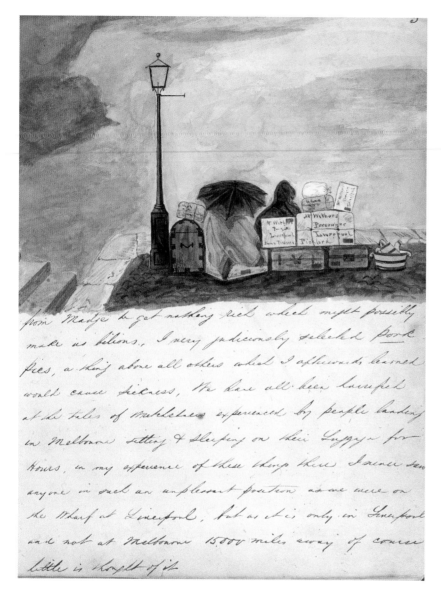

Emigration

(Above, left)
THE *JAMES BAINES* JOURNAL OF ALFRED WITHERS
1857

The *James Baines* was one of the few clippers fitted as an emigrant ship. It sailed on 5 January 1857 from Liverpool and arrived at Melbourne on 23 March. Withers sailed as a passenger on his honeymoon. He describes the confusion and crowding on the wharf with the emigrants anxious to secure their berths and he buys food for the outset of the voyage: 'I very judiciously selected pork pies, a thing above all others which I afterwards learned would cause sickness.'
JOD/171 / D4768

(Above, right)
EMIGRANTS
James (Jacques Joseph) Tissot
Drypoint
1880

A drypoint etching based on a painting of 1879, for which only a small replica now exists. Sited in the London docks this complex image shows a woman carrying her child and their possessions, hesitating to take the hand proffered by the man below. This moment highlights the tension in the image, underscoring the woman's precarious situation. Although she and her child are emigrating to find a better life, they are also travelling into the unknown. Drawing on religious iconography, the composition shows the woman against a dramatic backdrop of masts, ropes and spars. Thus she appears enmeshed and trapped, lacking the independence of movement of the two birds in the rigging on the left. The theme of emigration and the conditions that forced people to seek a life overseas was a fascinating subject and demonstrated the social awareness of artists such as Tissot.
PAG9432 / B9460

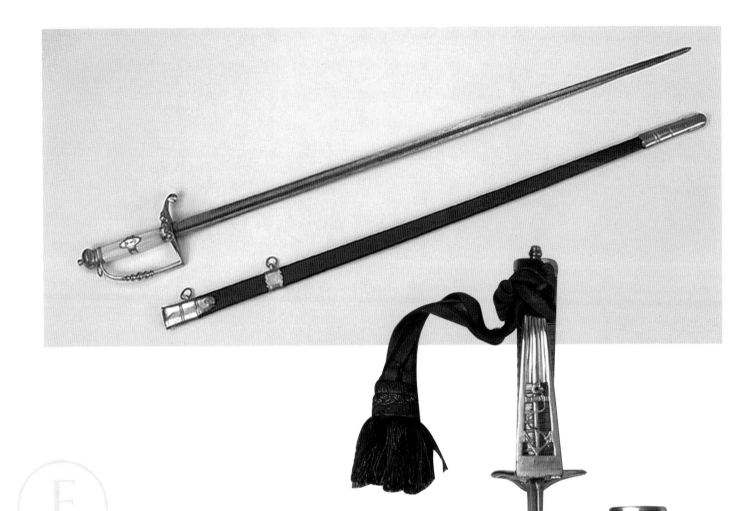

FIGHTING SWORDS

(Above)
FIVE-BALL HILTED SWORD
Cullum, Charing Cross, London
Date unknown
In the eighteenth century the preference of naval officers was for the hunting sword: its short curved blade made it an ideal weapon for close hand-to-hand fighting. By the end of the century the spadroon, with its distinctive five-ball hilt, became popular. So described because of the decoration of five beads on the guard, this example has a fluted grip with a gilt band and shield on its centre on which is engraved a crown and fouled anchor. These swords were fitted with cut-and-thrust blades.
WPN1006 / E1060

(Right)
FIGHTING SWORD
Cullum, Charing Cross, London
c. 1782
This sword has a gilt slotted hilt inset with anchors and was a popular type with naval officers in the 1780s. This example belonged to Vice-Admiral Sir Samuel Hood (1762–1814), who served under Admiral Rodney at the Battle of the Saints in 1782 and with Nelson at the Battle of the Nile in 1798, when he was in command of the 74-gun *Zealous*. Hood went on to serve in the Baltic as second-in-command to Admiral Saumarez and ended his career as Commander-in-Chief, East Indies. He died in Madras in 1814.
WPN1305 / D6109

69

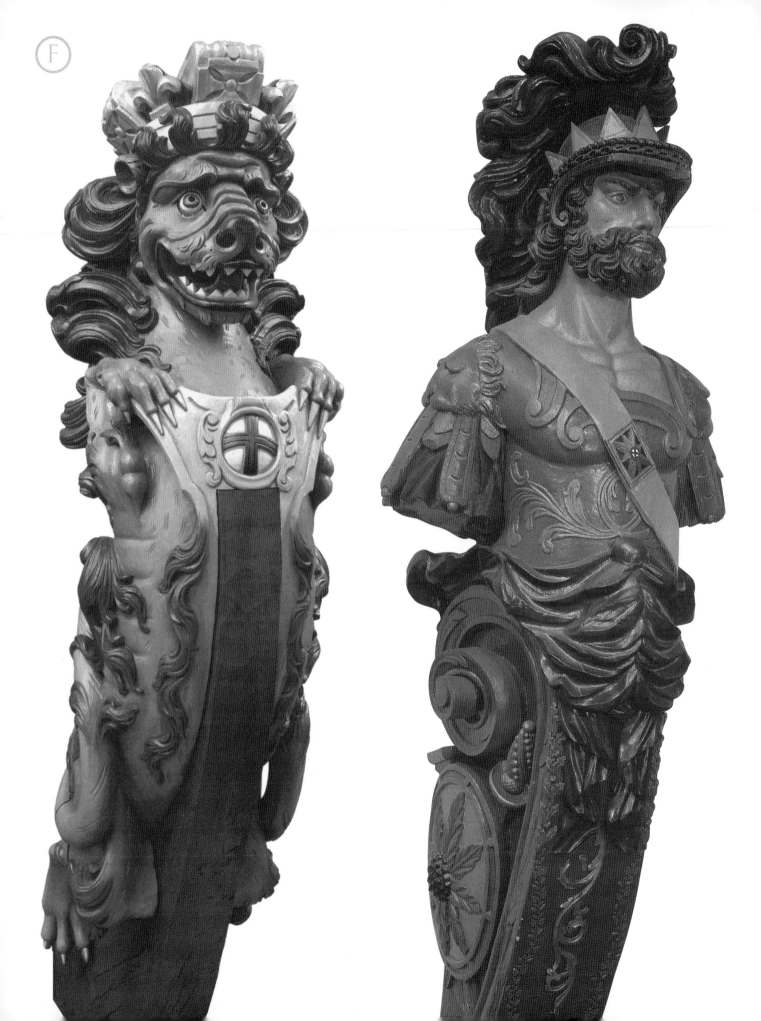

FIGUREHEADS

(Opposite, far left)
LION FIGUREHEAD
c. 1720

The lion was the most common subject for naval and merchant figureheads across much of Europe from the seventeenth until the mid-eighteenth century. The lion had obvious traits that made it especially suitable for Royal Navy warships: it was not only a fierce predator but also a national symbol, and formed part of the monarch's coat of arms. There are a number of lion figureheads in the Museum's collection but, because of their widespread use, it has not always been possible to identify the ships they adorned.
FHD0088 / B7933

(Opposite)
FIGUREHEAD FROM HMS *AJAX*
1809

The figurehead of HMS *Ajax*, depicting the giant Greek warrior wearing the Order of the Garter, is one of the finest warship figureheads in the Museum's collection. By the time *Ajax* was launched at Blackwall in 1809, the Admiralty had imposed restrictions on the scale of decorative carving on ships of the line. These measures were enforced but concessions could be negotiated, which helps to explain the size and quality of *Ajax*'s figurehead. The ship saw action during the blockade of Toulon in 1810 and captured the French vessel *Dromadaire* the following year. She was converted to steam in 1848 and finally broken up in 1865.
FHD0120 / B3822

(Below)
FIGUREHEAD FROM HMS *DARING*
1844

The 12-gun sloop *Daring* was launched at Portsmouth Dockyard in 1844. Her rather uneventful career consisted of two tours of duty in North America and the West Indies and two lengthy spells laid up at Chatham. *Daring* was broken up in 1864. The figurehead depicts the bust of a typical Victorian 'Jack Tar' wearing the style of dress popular before regular uniform was introduced in 1857. *Daring* appears on the cap badge and the front of the seaman's jumper.
FHD0073 / B3835

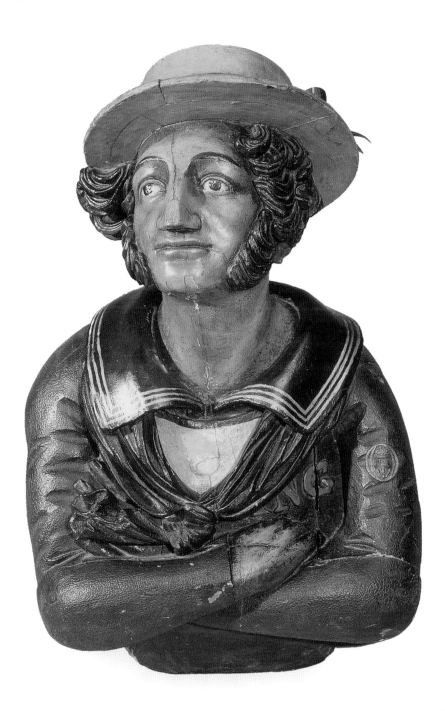

FIREARMS

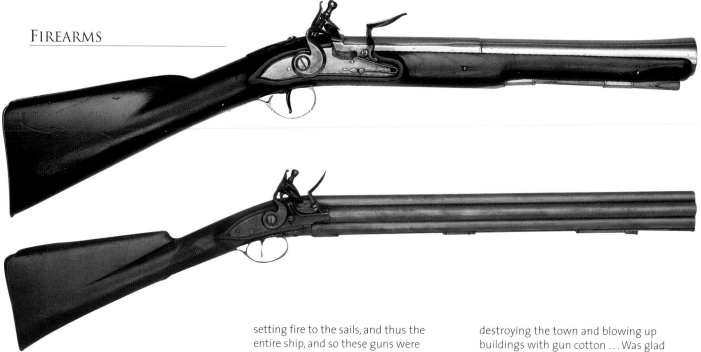

(Above, top)
FLINTLOCK BRASS-BARRELLED BLUNDERBUSS
J. Buttall
c. 1750
Used throughout the eighteenth century for defending ships from boarding parties, the blunderbuss was a popular weapon for self-defence. It was loaded with buckshot or pistol balls, which would scatter over a wide area. Contrary to popular belief, blunderbusses were never loaded with any form of irregular or sharp objects, which would have damaged the barrel. They were almost always flintlock weapons and large quantities were manufactured with brass barrels.
AAA2516 / D6108

(Above, bottom)
VOLLEY GUN
c. 1780
James Wilson invented the seven-barrelled volley gun and presented it to the Board of Ordnance for trials in 1779. The Board decided that the gun would be most useful on board ship, leading the Admiralty to purchase some for use in the fighting tops of naval vessels. They were first used at the siege of Gibraltar in 1782. However, as all seven barrels fired at once, there was considerable risk of

setting fire to the sails, and thus the entire ship, and so these guns were seldom used afloat.
AAA2519 / D6105

(Opposite, top)
SNIDER ENFIELD RIFLE, CALIBRE 0.577 IN.
1867
Jacob Snider, an American, invented a breech-loading mechanism which was used by the British to convert percussion muzzle-loaders into percussion breech-loaders. The percussion lock was replaced with a hinged block containing a spring-loaded firing pin, which could be opened to allow a cartridge to be loaded. The Snider was the first breech-loading rifle to be introduced for general issue and was used by the Navy in both the Abyssinian Campaign of 1868 and the Ashanti Campaign of 1874.
AAA2520 / D5931

(Opposite, centre)
DOUBLE-BARRELLED 16-BORE SHOTGUN
W. Foerster, Berlin
Nineteenth century
This shotgun was presented by the German Emperor to Fumo Bokari, Sultan of the German East African protectorate of Witu. In the 1890s, when Witu was under British rule, the gun was appropriated by Admiral Edmund Fremantle, commander of a punitive expedition against the Sultan. Fremantle wrote in his autobiography: 'Stayed at Witu burning and

destroying the town and blowing up buildings with gun cotton ... Was glad to get a wash in the marsh; and we had quite a nice dinner, with a bottle of champagne to celebrate our victory, which I should have enjoyed more but for a splitting headache, due to sun, anxiety, and the smoke of the burning town ... my loot was the Emperor's gun, a nice fowling piece inlaid with gold wire which I received his permission to keep'.
AAA2541 / D5933

(Opposite, bottom)
LANCHESTER MARK I
9-MM SUB-MACHINE-GUN
Sterling Engineering Co.
c. 1941
As firearms became more complex and expensive with the introduction of the breech-loading system, there was an increasing tendency to standardize the patterns of small arms carried by the armed services. During World War I, the Royal Navy did use models peculiar to itself but these were generally modernizations of older arms or substitute arms considered unsuitable for land service. From 1918, the Royal Navy used land-service arms with the exception of the Lanchester sub-machine-gun. The Lanchester was produced exclusively for the Navy from 1941. It was fully automatic, firing 600 rounds per minute.
AAA3152 / E8741

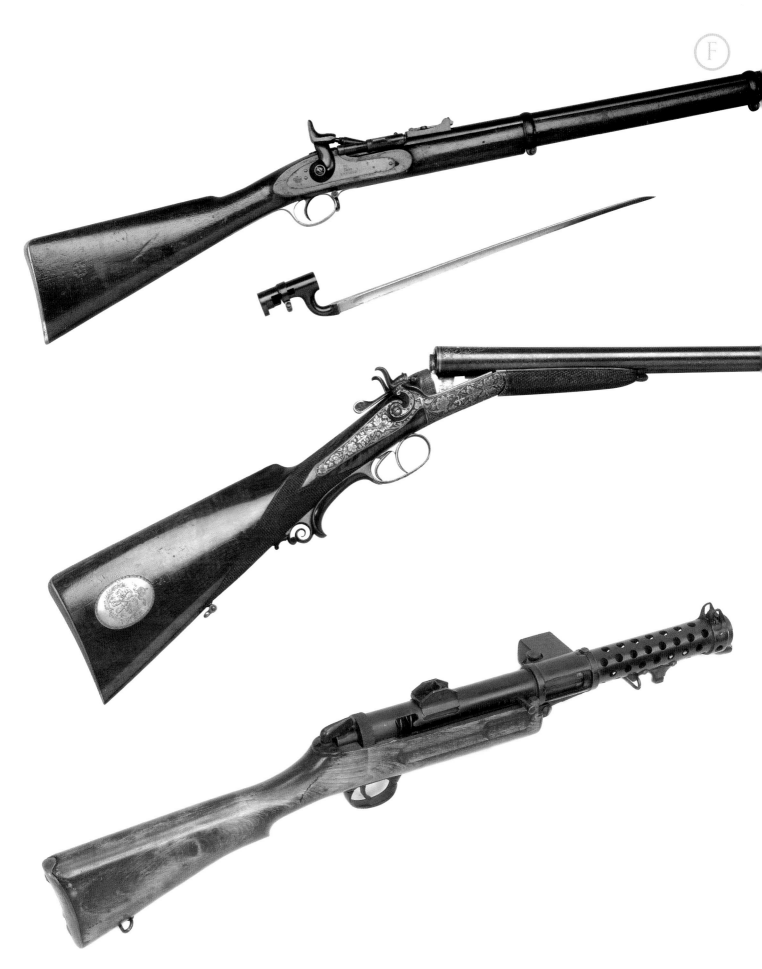

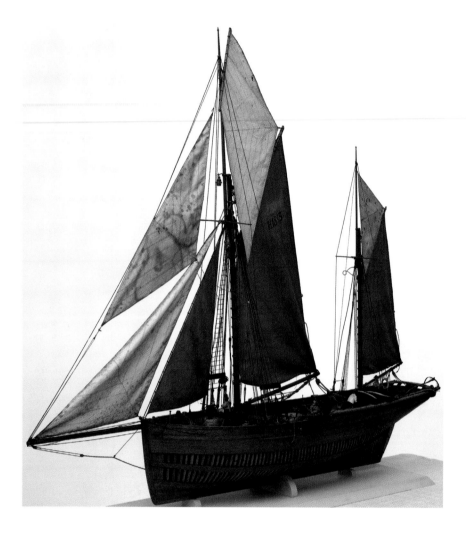

FISHING

AUTHENTIC, FISHING SMACK
J. Hodgson
1880, scale 1:24
The model of *Authentic* was constructed by Mr J. Hodgson, who was a young shipwright and able to make detailed measurements of the actual vessel while it was in dry-dock at Hull.

The quality of the workmanship of the model was recognized when it was awarded a gold medal at the International Fisheries Exhibition held in London in 1883. *Authentic* was built at Burton Slather in 1880 and owned by Charles Farr of Hull. It was designed to be fast and seaworthy and was fitted with all the latest equipment, including a steam capstan.
SLR1129 / C6553-6

FORTIFICATIONS

THE TOWER OF ST AUBIN
Thomas Phillips
1680
Thomas Phillips was an engineer to the Board of Ordnance. These drawings are part of the Channel Islands survey carried out under the direction of George Legge, later Baron Dartmouth, containing descriptions of the harbours and forts, illustrated by Phillips's plans, views and charts. Phillips was a highly talented draughtsman who created bird's-eye views and other perspective drawings. He was killed in an explosion on Admiral Benbow's ship during the bombardment of St Malo in 1693.
P48 / C4576-17

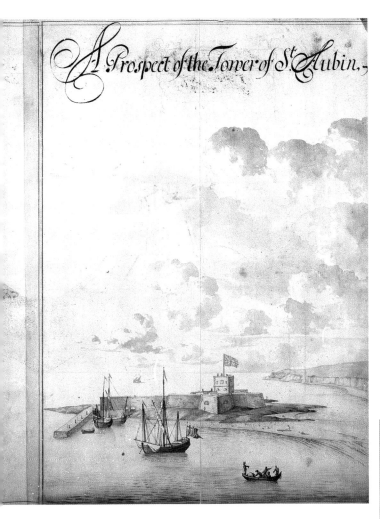

A Prospect of the Tower of St Aubin.

FRENCH REVOLUTIONARY WARS

THE BANNER OF THE BOARDING DIVISION OF THE 74-GUN FRENCH WARSHIP, *L'AMERIQUE*
1794
The banner is embroidered with the slogan *MARINS LA REPUBLIQUE OU LA MORT* (Sailors, the Republic or death). It was captured during the first major naval battle of the French Revolutionary War on 1 June 1794. The aristocratic ranks of the French officers had been thinned by dismissals, arrests and executions, and the inferior firepower of the French fleet was further weakened by the disbanding of the old-established divisions of trained seamen-gunners. To counter these disadvantages, the French navy fell back on the tactics of capturing the enemy by boarding.
AAA0564 / D5481

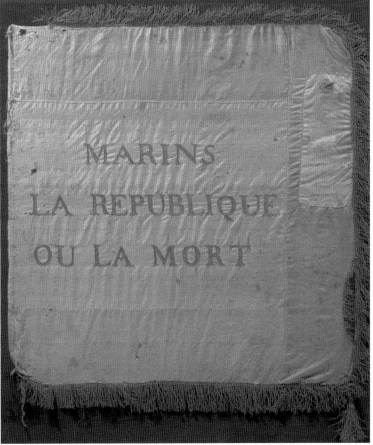

BRASS-BARRELLED PISTOL
INSCRIBED H. NOCK
1796

This pistol was designed in 1796 for Philippe d'Auvergne, Prince of Bouillon and an Admiral in the Royal Navy. Born in Jersey in 1754, d'Auvergne had an eventful career during which he was shipwrecked, captured by the French and later stranded on a desert island. During the Napoleonic Wars he was stationed in the Channel Islands where he ran a secret-service network passing information from the French Royalists to the British government. He also formed a military corps from French Royalist refugees who had fled to Jersey. It was for this corps that 200 of these pistols were made at 48 shillings a pair.

AAA2439 / D5921

(Right)

MASTHEAD OF *L'ORIENT*
Before 1798

There were relatively few trophies and documents of Nelson's victory at the Battle of the Nile in 1798, partly through the exhaustion and isolation of the victors after the battle, and partly because *Leander*, carrying Nelson's despatches home, was captured by the French. This piece of the French flagship, complete with lightning conductor, was salvaged by Captain Hallowell and presented to Nelson. The wreck of *L'Orient* is currently being investigated by archaeologists.

REL0295 / D4721

(Far right)

NAVAL GENERAL SERVICE MEDAL
AWARDED TO ADMIRAL OF THE FLEET,
SIR GEORGE COCKBURN (1772–1853)
W. Wyon
1848

The Naval General Service Medal was awarded retrospectively in 1848 to those present at specified naval actions from 1793 to 1840. Cockburn's has six bars (the maximum number was seven). The bars are for the defeat of the French fleet off Genoa by Admiral Hotham, 14 March 1795, the action between *Minerve* and the Spanish frigate *Sabina*, 19 December 1796, for the battles of St Vincent, the Nile and at Martinique and for boat service in the Chesapeake Bay area on 29 April and 3 May 1813. Cockburn is chiefly remembered as the man who burnt the White House in 1814, having masterminded the capture of Washington in the War of 1812–15.

MED0750 / D4675-1

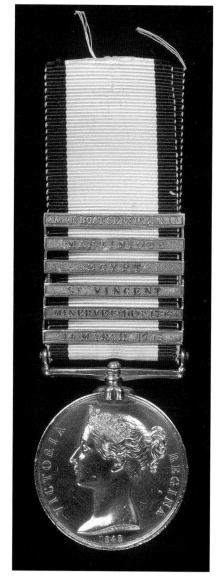

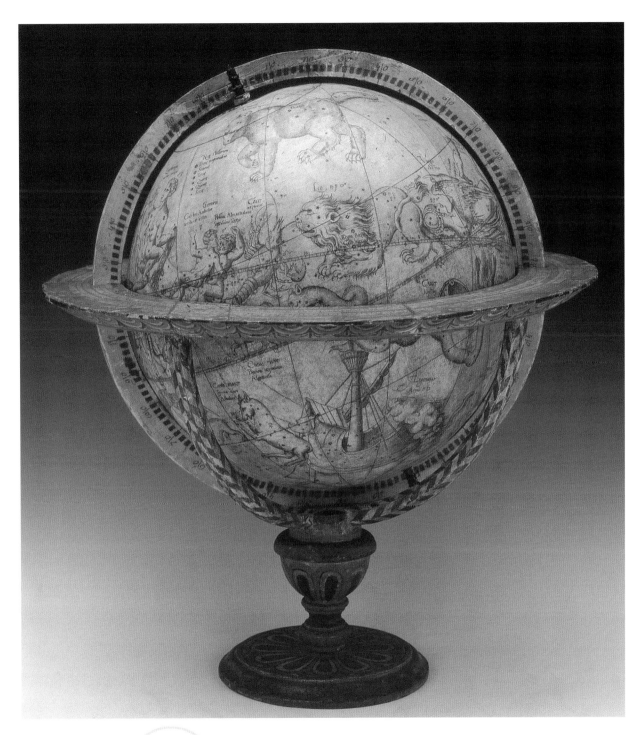

GLOBES

CELESTIAL GLOBE
Gemma Frisius
1537

This is the oldest globe in the Museum's collection. Its most probable intended use was for calculating, using the positions of the stars and astrological principles to determine the right moment for acting or decision-making. It is a printed celestial globe made in the Louvain workshop of Gaspard van der Heyden (c. 1496–after 1546) by Gemma Frisius and Gerard Mercator. It may have been made as a companion to a 'cosmographic' globe – a terrestrial globe combined with the most important stars – which is known to have been in production. The constellations on the globe are mainly copied from the definitive maps made by Albrecht Dürer (1471–1528) early in the same century, though there are some variations.

GLB0135 / D7958-2

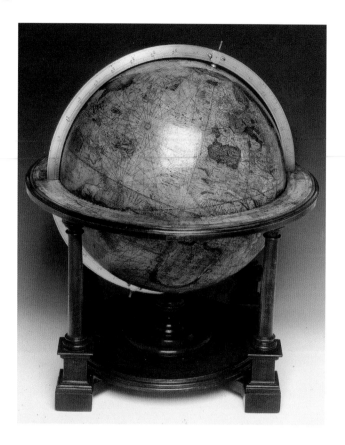

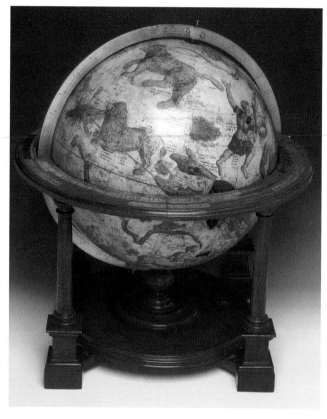

(Above, left)
TERRESTRIAL GLOBE
Gerard Mercator
1541
This globe and its accompanying celestial globe have been described as the most important pair of globes made in the sixteenth century. Having trained as an instrument maker with Gemma Frisius and Gaspard van der Heyden, Mercator made the first terrestrial globe of his own design in 1541, followed in 1551 by a celestial globe. Mercator went on to apply his navigational knowledge to produce a world map in the projection that to this day bears his name. There are a number of stars plotted on the globe, Asia and America are separated by an ocean, the Americas are together labelled 'America' with North America also labelled as *Hispania maior capta anno 1530*. There is a hypothetical southern continent drawn
GLB0096 / D7694-A

(Above, right)
CELESTIAL GLOBE
Gerard Mercator
1551
This celestial globe was made after the Mercator terrestrial globe of 1541 but in the same style so they may have been intended to form a pair. The globe shows the 48 constellations described by Ptolemy, all the constellations then known, and uses Latin, Greek and often

transliterations of the Arabic for star names. The style of drawing of the constellations is also different to previous celestial globes.
GLB0097 / D7693-A

(Left)
WHITWELL SILVER GLOBE
Charles Whitwell
c. 1590
Small silver and gilt globes of the sixteenth century were generally made as luxury items for the rich. This silver globe is the earliest example made in England and really consists of two globes in one. It is made up of two silver hemispheres, with a map of the world engraved on the outside, and holes pierced in them marking the different positions of the stars. When the globe is separated into its two halves and held up to the light, the light coming through the holes gives a view of the night sky as it would be seen from Earth. This makes it the earliest concave celestial globe. The cartography for both aspects of this globe appears to have been copied from the Mercator 1541 and 1551 globes, which were very popular in

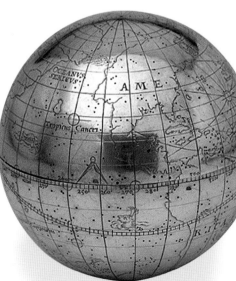

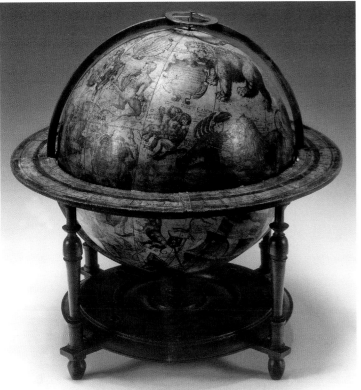

England at the time. The style of the
engraving suggests that the globe was
made by the mathematical instrument
maker, Charles Whitwell.
GLB0025 / D7949-1

(Above)
CELESTIAL GLOBE
Jacob Aertsz Colom
c. 1640

Making a pair with the Colom terrestrial
globe (see *Australia*), this is the earliest
known globe to show the Arabic names
for the southern hemisphere
constellations, newly invented by Petrus
Plancius (1552–1622) in the late 1590s.
Most of the cartography of this globe is
copied from a 13-in. (33 cm) diameter
globe by another Dutch globe maker of
the seventeenth century, Willem Jansz
Blaeu (1571–1638). New to this globe are
the Arabic star names provided by
Golius (1596–1667), Professor of Arabic
at Leiden University from 1625, who took
the names from the star map of the
famous Arabic astronomer, al-Sufi
(903–986), published in his book on the
constellations of the fixed stars.
GLB0171 / D7399-A

(Below)
TERRESTRIAL GLOBE
Vincenzo Coronelli
1688/1707/1752

This is the largest globe in the Museum's
collection. Coronelli made his name as a
globe maker in 1681 when he constructed
the famous Marly globes, a pair 13 ft (4 m)
in diameter, for King Louis XIV of France.
Though he never made any quite so big
again, he used space well, providing all
kinds of information about various
places so that the globes became a
three-dimensional encyclopaedia of the
world. Demand was high, and transport
extremely difficult, so Coronelli invented
a new sales ploy, whereby the gores
could be sold by subscription and then
mounted by a local maker. The gores
bearing the map for this globe, 3 ft 6 in.
(108 cm) in diameter, were designed in
1688, printed in 1707 and mounted in 1752.
GLB0123 / D7690-N

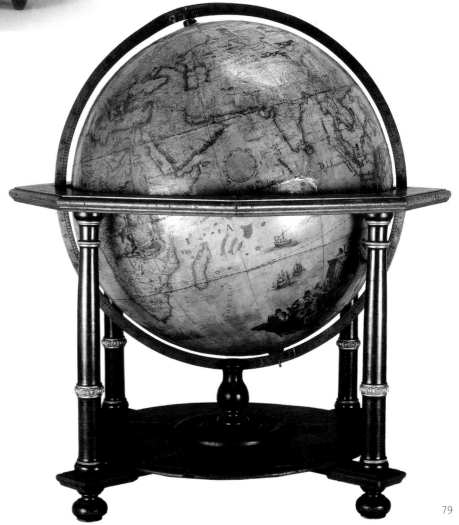

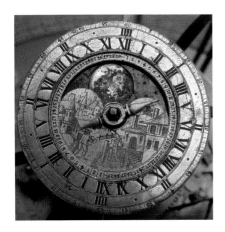

(Opposite and above)
CLOCKWORK CELESTIAL GLOBE
Isaac Habrecht
1646

Isaac Habrecht came from a long line of clockmakers. This clockwork celestial globe is traditional in design, for the time it was made. Mounted on the meridian ring, over the North Pole, is a dial showing mean solar time in hours and minutes. There is also a lunar calendar on the dial. In the centre of the dial is an engraved scene of a village, with a blue-steel lunar disc, which revolves, showing the phases of the Moon. The whole globe is supported by a figure of Atlas. If set up correctly, this globe will show what is visible in the sky, including the phase of the Moon, for any given time and date.
GLB0174 / D8013-6 & D8013-1

(Right)
THE 'SELENOGRAPHIA'
John Russell
1797

This mechanical lunar globe is unique in that it is constructed in such a way as to reproduce the motion of the Moon, including its libration, or apparent 'wobbling' when seen from the Earth. The maker, John Russell, was better known for his paintings, but spent thirty years perfecting his map of the Moon. Only one side is illustrated, the other is blank, since we only ever see one side of the Moon from Earth. Mapping the Moon became a serious focus of interest only after the invention of the telescope in the seventeenth century. An extra impetus, around the time this globe was made, was the so-called 'extraterrestrial life debate', in which there was much serious consideration that there might be life on the Moon.
GLB0140 / D7960-1

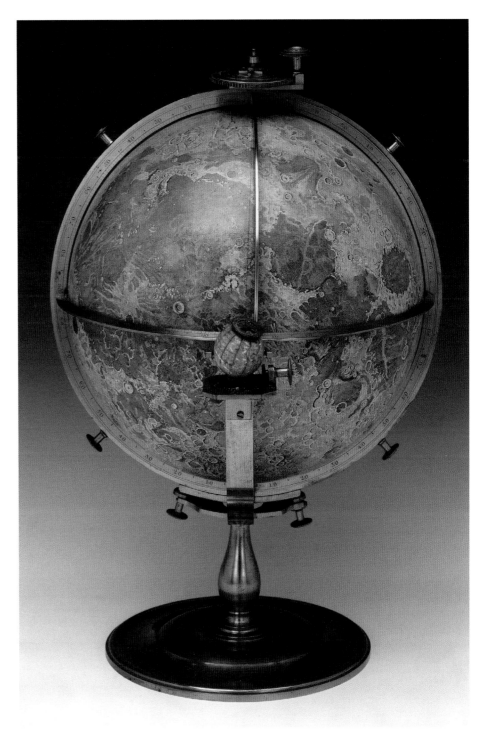

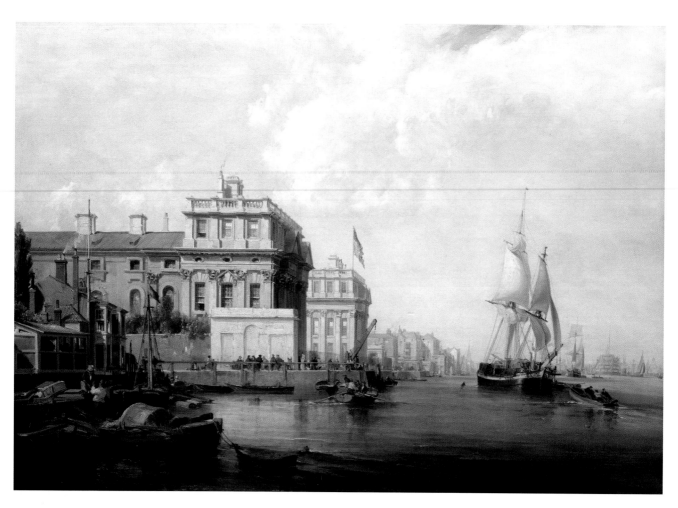

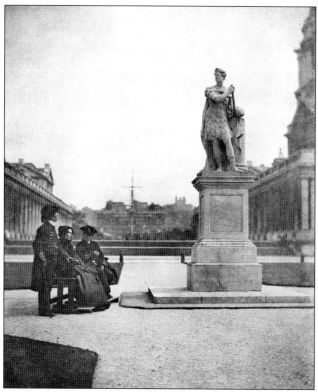

GREENWICH

(Opposite, top)
GREENWICH HOSPITAL FROM THE EAST
George Chambers
1835
A view across the Greenwich waterfront, with Hospital pensioners and others crowding the Five-Foot Walk. On the left, by the old landing place is the George Tavern, replaced by the Trafalgar in 1837. Beyond the Governor's residence, flying his flag, are the houses round Fisher Lane and the Ship Tavern. A collier brig is coming down river on the right.
BHC1823

(Opposite, bottom left)
GREENWICH PENSIONERS
W. H. Fox Talbot
c. 1845
The Royal Hospital for Seamen at Greenwich was founded by King William III and Queen Mary II in 1694 as an equivalent to that for army veterans at Chelsea. Greenwich pensioners were men of all ages who were no longer fit to serve at sea as a result of age, wounds or disabilities. The Hospital's maximum occupancy was 2710 in 1814, during the Napoleonic Wars. It was eventually closed in 1869. Here, two pensioners and

a woman, probably one of the Hospital nurses, are seen beside Rysbrack's statue of George II (1735).
C3607

(Opposite, bottom right)
TRAFALGAR TAVERN, GREENWICH
c. 1915
The Trafalgar Tavern was built in 1837 and was soon celebrated for its whitebait suppers, attended by Members of Parliament, who arrived by decorated ordnance barge from Westminster. These suppers continued until 1883, with only the Liberals patronizing the Trafalgar Tavern, the Conservatives dining at The Ship, on the site where the clipper ship *Cutty Sark* now stands. The Trafalgar was a hotel from before the turn of the twentieth century until 1914–15, when the building was taken over on a temporary basis by the Royal Alfred Aged Merchant Seamen's Institution. After later use as flats it was restored as a pub and restaurant in 1964.
P39246

(Left)
TRAVELLER'S POCKET WATCH
Benjamin Lewis Vulliamy
1847
The adoption of Greenwich Mean Time throughout Britain in the mid-nineteenth century was neither immediate nor

universal. Railways and telegraph companies were keen to embrace the new system but certain provincial towns were reluctant to abandon local 'sundial' time. This traveller's pocket watch, made during this transitional period, has two separate minute hands, allowing both time standards to be shown at once. The gold watch-case is engraved with the names of various British and European towns and cities with their respective time differences from Greenwich. A few provincial towns had public clocks made in the same manner.
ZAA0744 / D7165-1

(Above)
ROYAL OPENING OF THE NATIONAL MARITIME MUSEUM BY KING GEORGE VI
1937
The photograph shows Sir Geoffrey Callender (far left), Sir James Caird and the first trustees of the Museum, with the Royal party consisting of King George VI, his mother Queen Mary, his wife Queen Elizabeth and their daughter Princess Elizabeth, the present Queen. Sir James Caird (behind Queen Mary) was the Museum's first and most generous benefactor, and Callender, formerly Professor of History at the Royal Naval College, was the Museum's first Director.
C9138-2

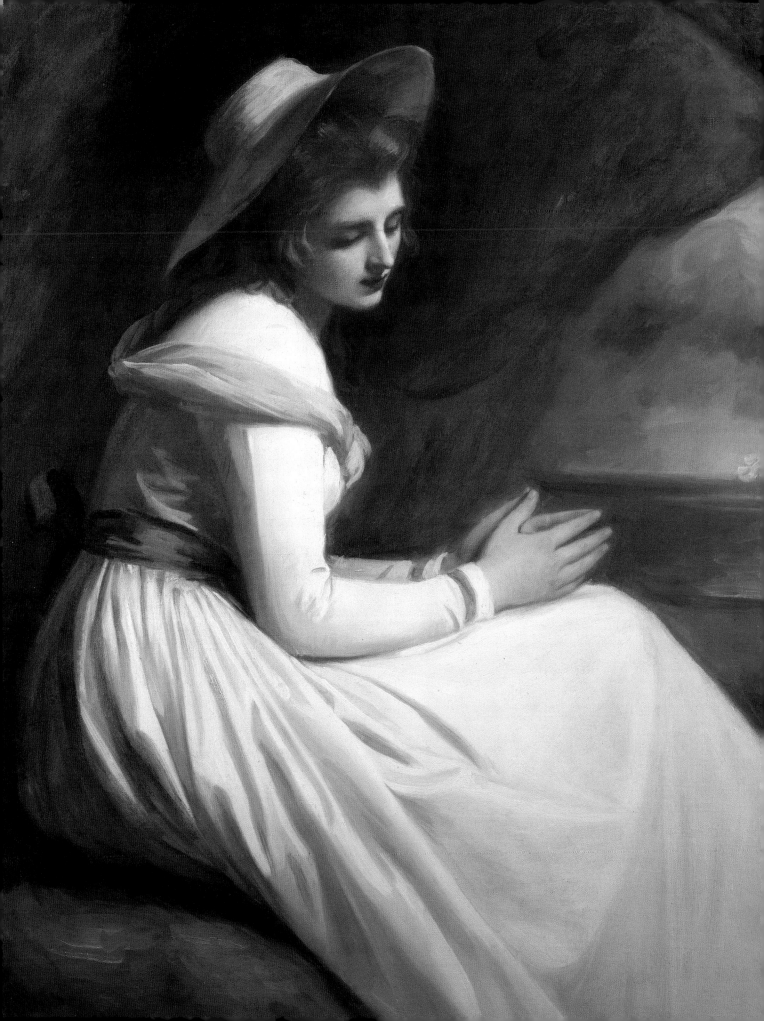

HAMILTON, EMMA

(Opposite)
EMMA HART, LATER LADY HAMILTON
(c. 1765–1815)
George Romney
1785
Lady Hamilton was born Amy Lyon,
daughter of a Cheshire blacksmith.
As Emma Hart she entered domestic
service but became the mistress of
Sir Henry Fetherstonhaugh, who
discarded her when she became
pregnant. She then became mistress
of the Hon. Charles Greville who, in
effect, sold her to his uncle, Sir William
Hamilton: he took care of Greville's
debts in exchange. Emma and Sir
William married in 1791. Emma met
Nelson in 1793 but their famous love
affair only began after the Battle of the
Nile in 1798 and lasted to his death at
Trafalgar seven years later.
BHC2736

(Below)
**RING SET WITH AN INTAGLIO PORTRAIT
OF EMMA, LADY HAMILTON, AS A
BACCHANTE**
Teresa Talani
The ring is set with a green sard, cut
with a profile portrait of Emma as a
Bacchante or follower of Bacchus, a
somewhat unfortunate anticipation
of her later decline into alcoholism.
The depiction of contemporary sitters

in classical roles reflected the interest
in the art of antiquity prevalent at the
time. This interest was shared by
Emma's husband, Sir William Hamilton,
whose position as British ambassador
in Naples gave him ample opportunity
to accumulate a famous collection of
Greek and Roman ceramics. This ring is
said to have formerly been the property
of Lord Nelson.
JEW0161 / E9036

(Above)
NELSON'S PIGTAIL
While Lord Nelson lay dying at the Battle
of Trafalgar, he said to Captain Thomas
Hardy, 'I am a dead man, Hardy. I am
going fast: it will be all over with me
soon. Come nearer to me. Pray let my
dear Lady Hamilton have my hair, and
all other things belonging to me.' After
his death the pigtail was cut off and
duly delivered to Emma as Nelson had
requested. In 1881 the children of
Horatia, Nelson and Emma's daughter,
presented the pigtail to Greenwich
Hospital, where it was displayed for
many years in the Painted Hall, before
being transferred on loan to the
National Maritime Museum in 1936.
REL0116 / D3210

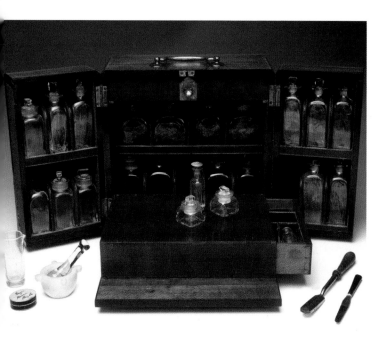

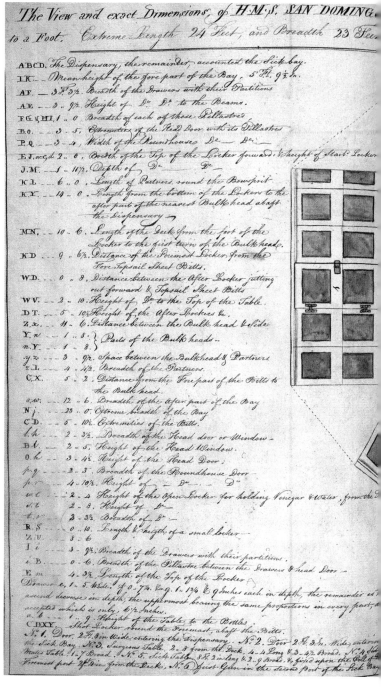

The View and exact Dimensions of H.M.S. SAN DOMINGO
to a Foot. Extreme Length 24 Feet, and Breadth 23 Fee...

HEALTH AT SEA

(Above, left)
MEDICINE CHEST
c. 1801
Surgeons, like other professionals of the day, were expected to provide their own tools and equipment, including herbs, drugs and surgical instruments. This set was used by Benjamin Outram at the Battle of Copenhagen.

Surgeons were the main medical officers on board ship in the age of sail. They had lower status than physicians but were highly skilled at amputation. At other times they had to minister to the general medical needs of the crew. A warship would carry one surgeon or surgeon's mate for about every 200 men.
TOA0130 / D7562

(Centre)
THE SICKBAY AND DISPENSARY ABOARD HMS *SAN DOMINGO*
From a watch and quarter bill belonging to Captain S. J. Pechell
c. 1812–14
Properly equipped and ventilated sickbays in large British warships were established largely through the efforts of Lord St Vincent (1753–1823), who was responsible for many reforms which improved the health of the Navy.

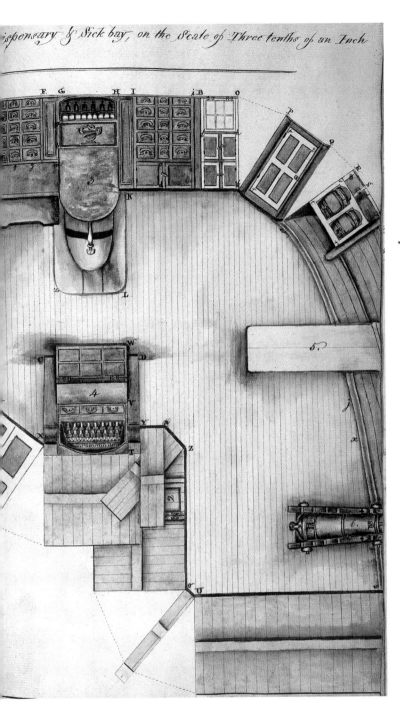

The sick-berth was originally situated near the galley fire, as it was assumed that smoke killed germs. As the lessons of cleanliness and fresh air were slowly learnt, sickbays were situated on the upper deck under the forecastle, with windows and skylights. From 1800 onwards all ships began to be fitted with sickbays to a design by Captain Markham of HMS *Centaur*.
WQB/49 / C8423

(Above, right)
THE CHATHAM CHEST
1625
The Chatham Chest was established in 1590 by Sir John Hawkins and others to provide pensions for wounded seamen. The fund was supported by compulsory deductions of 6d a month from seamen's wages. The ironbound chest illustrated here was the safe ordered in 1625 to contain these funds securely.

The chest had five locks: a disguised keyhole in the top, which operated an elaborate lock covering the entire interior of the lid, and four hasps for padlocks. The keyhole in the front of the chest is false. Although five separate officers held the keys, it still proved possible to embezzle the fund.
AAA3310 / D2953-2

Hydrography and Surveying

(Above)
THEODOLITES
J. Sisson (left) and G. Dollond (right)
c. 1737 and *c.* 1840
The theodolite was invented in the sixteenth century for use in land surveying. It enabled the user to measure both the horizontal angle between two points and their angle of elevation. These examples were made in brass by two of the leading mathematical instrument makers of their day. Sisson appears to have been the first maker to provide a telescope rather than open sights for the theodolites he made. Dollond's instrument has the further refinement of microscopes to assist in reading the scales. Both theodolites have levelling screws so that they could be adjusted correctly before use.
NAV1461 & NAV1451 / D9399

(Right)
DRAWING INSTRUMENT SET
Peter Dollond
c. 1780
This elegant drawing instrument set was made by the eighteenth-century optician and mathematical instrument maker Peter Dollond, of St. Paul's Churchyard. It includes a rule and sector of ivory, a brass parallel rule, dividers and pens. The set fits into an elegant case of silver-mounted green shagreen, or ray skin. Drawing instruments became increasingly important from the fifteenth century on as the need for accuracy developed in surveying, cartography and engineering. At less than 7 in. (18 cm) long, a set such as this was easily portable, allowing work to be done in the field.
NAV0652 / A5318

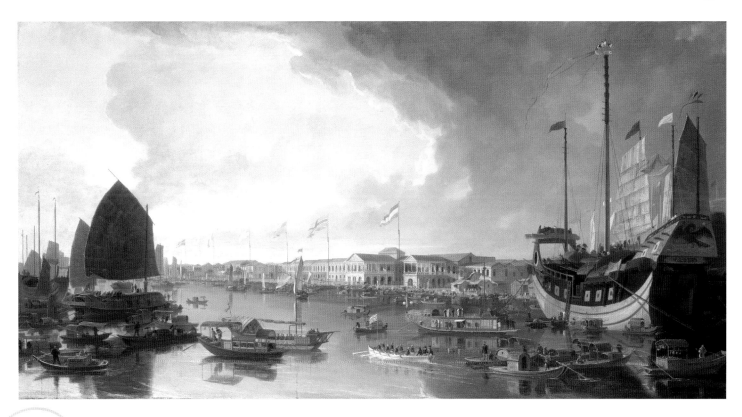

IMPERIAL TRADE

(Above)
A VIEW OF THE EUROPEAN FACTORIES AT CANTON
William Daniell
c. 1806

William Daniell – an artist and engraver – travelled to China in 1786, sketching there for some months before leaving for Calcutta. He visited China again in 1793. Daniell used his drawings to produce oil paintings and a very popular series of topographical prints, which he included in his book *A picturesque voyage to India by the way of China* (1810). This panoramic scene – probably exhibited at the Royal Academy in 1806 – depicts the European factories, or trading houses, at Canton, the major Chinese port of the late eighteenth century. The Chinese authorities

limited access to China's vast market, permitting European merchants to trade only within the factories. These restrictions encouraged illegal private trade. It was only during the nineteenth century, when the Chinese Empire began to crumble, that China was forced to open up to the European merchants.
ZBA1291 / E0074

(Below)
GOLD AND ENAMEL TELESCOPE
Fraser & Son
c. 1792

In 1792, the British diplomat, Lord Macartney, embarked on a major mission to China. He aimed to negotiate more equitable terms of trade between Britain and the Chinese Empire, which would allow British manufactures rather than bullion to be exchanged for tea. Macartney brought many gifts for the Chinese Emperor, including this gold and enamel telescope. Although impressed by the mission, the Emperor refused to accept Britain's offer and the Macartney embassy came home in defeat. The telescope remained in the Chinese imperial collection until 1900, when it was seized by European troops involved in suppressing the Boxer Rebellion and returned to Britain.
NAV1597 / D9590

FLAG OF NANA OLOMU, CHIEF OF THE ITSEKRI PEOPLE
1894

Chief Nana Olomu (1852–1916), the most influential chief on the north bank of the Benin River, controlled much of the trade in palm oil between the Kingdom of Benin in the interior and the West African coast. Local British interests thought he had become too powerful and in the resulting dispute his town of Brohimi was captured by a naval expedition sent in 1894. He was exiled to the Gold Coast until 1906. Cloth flags were adopted by West Africans as long ago as the seventeenth century. During the colonial period they frequently incorporated the Union Flag (sometimes, as in this case, upside down).
AAA0555 / E0569

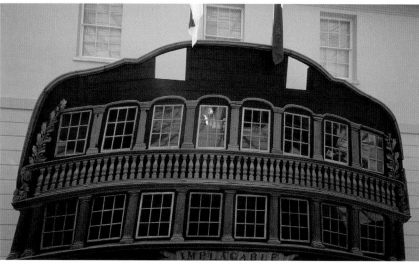

IMPLACABLE

(Above and right)
STERN CARVINGS AND FIGUREHEAD FROM HMS *IMPLACABLE*, EX-FRENCH *DUGUAY-TROUIN*
c. 1800

The French warship *Duguay-Trouin*, 74 guns, was launched at Rochefort in France in 1800. She fought at Trafalgar but managed to evade the British fleet until 3 November 1805, when she was captured, taken into the Royal Navy and renamed *Implacable*. She saw action in the Baltic in 1808–09 and off the Syrian coast in 1840 before becoming a training vessel for boy seamen at Devonport and later at Portsmouth. The Admiralty requisitioned the vessel during World War II but in 1947 it was decided to dispose of her. This caused a public outcry but, despite an appeal to save her, she was scuttled in 1949. The figurehead and stern carvings were preserved and presented to the Museum in 1950. The figurehead dates from her refit in Britain in 1805 and is a representation of the gorgon Medusa.
FHD0085 / D9801-1 & E0382

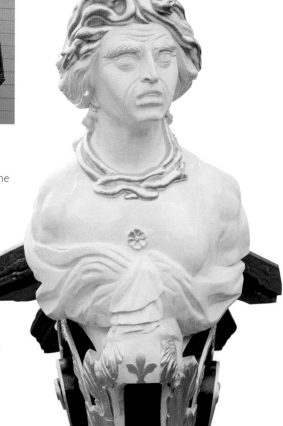

INDIAN OCEAN

GROUP OF GUNNERS
Edward Hovell Thurlow
1865

In this watercolour sketch, soldiers of the Royal Horse Artillery are relaxing on the deck of the British troopship *Hydaspes*. They are leaning against crates, smoking, reading, writing or chatting. Their loose clothing, bare feet and casual stance indicate the effects of the heat in the Indian Ocean. In the foreground, the soldier sitting on an overturned barrel reading a book can be identified as a sergeant by the stripes on the sleeve of his tunic. The sketch is from an album of watercolour drawings illustrating a voyage on the *Hydaspes* in 1865. The anecdotal and closely observed images by Captain Thurlow, Royal Horse Artillery, provide a rare insight into life on board. He travelled from Gravesend, England, to Calcutta, India, to help to establish a new British regiment there in response to the crisis in India after 1857.

ZBA2880 / E9693

BOMBAY AND SALLSET
John Thornton
c. 1685

In 1661 Bombay was ceded to Britain by Portugal as part of Catherine of Braganza's dowry on her marriage to Charles II. It was transferred to the East India Company in 1668, becoming the chief of the Company's possessions in India. John Thornton styled himself 'Hydrographer to ye honrble East India Company' and this chart is based on a careful survey, giving numerous soundings in hazardous areas and showing the positions of fish traps and anchorages.

G254:6/8 / F0242

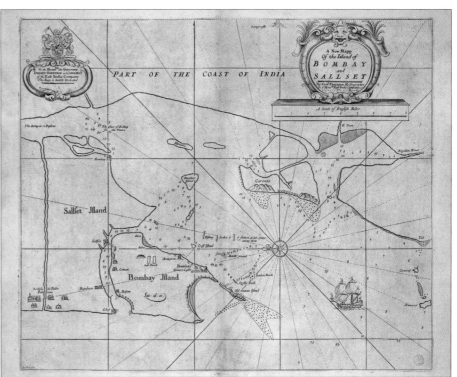

ISLAMIC INSTRUMENTS

PERSIAN ASTROLABE
Muhammad Khalil; decorated by Muhammad Baqir IsFahani
1707–08

This astrolabe is probably the product of a school of astrolabists headed by Abd al-A'imma, located in Isfahan (Iran), of which both maker and decorator were members. There is an Arabic inscription on the instrument, which reads 'Made by the humble and poor who looketh to the Glorious God, Muhammad Khalil son of Hasan Ali'. In Persian there is a verse from the 'Gulistan' of Shaykh Sadi of Shiraz, which reads 'The object of this is, that something of us should remain, for I cannot see that existence continues for ever.' Around the edge is engraved a prayer in Arabic, 'O God, favour Muhammad, the Apostle, and Ali, and his descendants' mentioning the names of the other eleven imams, or religious leaders, of the Shiah sect.

AST0535 (A4) / D7075-1

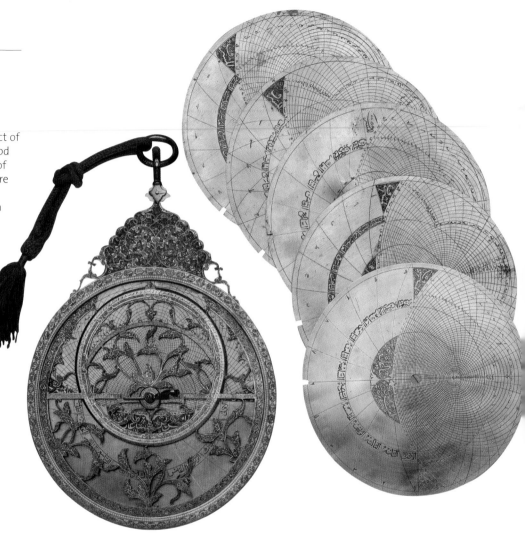

ISLAMIC QUADRANT
Unknown maker
1813

A quadrant is a measuring instrument in the shape of a quarter of a circle, from which it takes its name. There is a degree scale along the curved edge which, with the plumb line, can be used to measure the angular height of landmarks or celestial bodies. They were made in Europe from the Middle Ages onwards. This Islamic version is of lacquered wood, in a style typical of those made in the Turkish Ottoman Empire. On one side are scales for telling the time: on the reverse are scales for solving problems in trigonometry.

NAV1056 / D9009

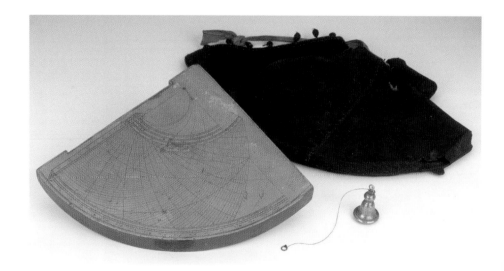

JERVIS, ADMIRAL SIR JOHN

CITY OF LONDON FREEDOM BOX
James Morisset, London
1794

Admiral Sir John Jervis received the Freedom of the City of London in 1794, together with this gold box, then valued at 100 guineas, in recognition of his recent services in the West Indies. Each City of London freedom box was designed individually for its recipient. In this case, the enamel plaque on the lid is painted with Jervis's personal coat of arms, including his motto 'Thus', fitting reference to the steering order given to a helmsman when the ship was to be kept sailing on the present course. The remainder of the lid is chased with naval trophies. Smaller plaques on the sides of the box are decorated with the City of London coat of arms and Jervis's initials.

PLT0075 / D4588-1

GOLD AND ENAMEL-HILTED SMALL-SWORD
J. Morisset and R. Makepeace
1797

This magnificent small-sword was presented to Admiral Sir John Jervis, Earl St Vincent, by the City of London. Described by Nelson as 'the very ablest Sea-Officer his Majesty has', Jervis is best remembered for his victory over the Spanish fleet in 1797 off Cape St Vincent, for which battle this sword was presented. The hilt is gold with the arms of the City of London painted on one side of the pommel and the arms of Jervis on the other. The grip is of blue enamel and in the centre is painted a man-of-war, below which is the name of Jervis's flagship, *Victory*.

WPN1439 / D4861-5A

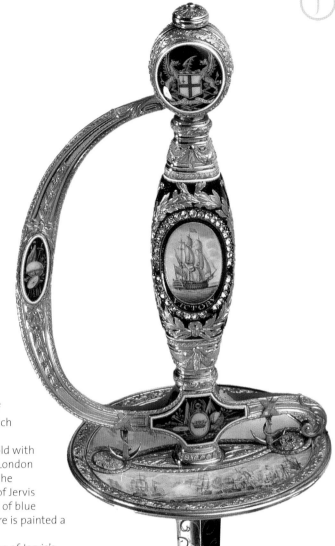

KEPPEL, CAPTAIN AUGUSTUS

(Opposite)
CAPTAIN, THE HON AUGUSTUS KEPPEL (1725–86)
Joshua Reynolds
1752–5
Keppel, the second son of the Earl of Albemarle, served under Commodore Anson on his voyage around the world in the *Centurion*, 1740–44. In 1749, he himself commanded *Centurion* to the Mediterranean, to negotiate against the depredations of the Barbary corsairs, and helped the young Reynolds by taking him as a passenger, so he could go on to study in Rome. Painted by Reynolds on his return from Italy, as a tribute to Keppel, this is the picture which made his reputation. It remained for many years in his studio where his patrons could see it. Observers noted that Reynolds took great pains with the composition, scraping off paint to make changes, which can now be seen through the use of X-rays. The portrait is revolutionary in its portrayal of character through dramatic effect. The pose, derived from classical sculpture, is one that was current in England at the time.
BHC2823

KEPPEL TEAPOT
William Greatbatch, Leeds
c. 1780
In 1778 the Hon. Augustus Keppel was appointed Admiral of the Blue and Commander-in-Chief of the Channel Fleet. This Leeds creamware teapot is transfer-printed in black with a half-length engraved portrait of Keppel by William Greatbatch, showing the Admiral in uniform and holding a telescope. The portrait, with the uniform coat incorrectly hand-painted in red, is set against a background of naval trophies, while small figures of Fame and Justice hover above. On the other side of the teapot is an engraving of a warship under sail.
AAA4407 / D5526

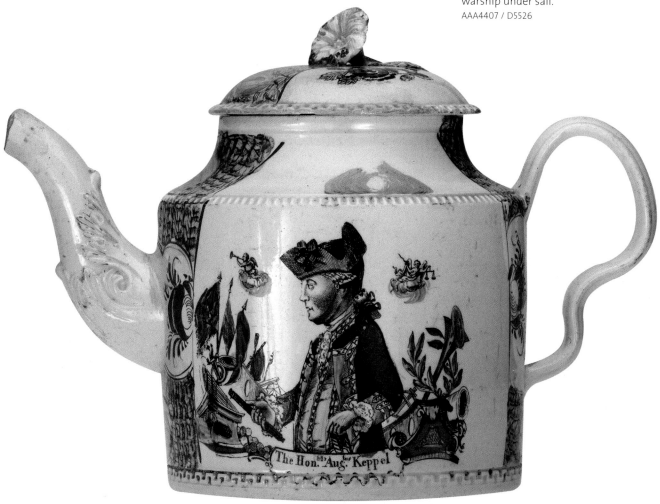

The Hon.^{ble} Augst Keppel

94

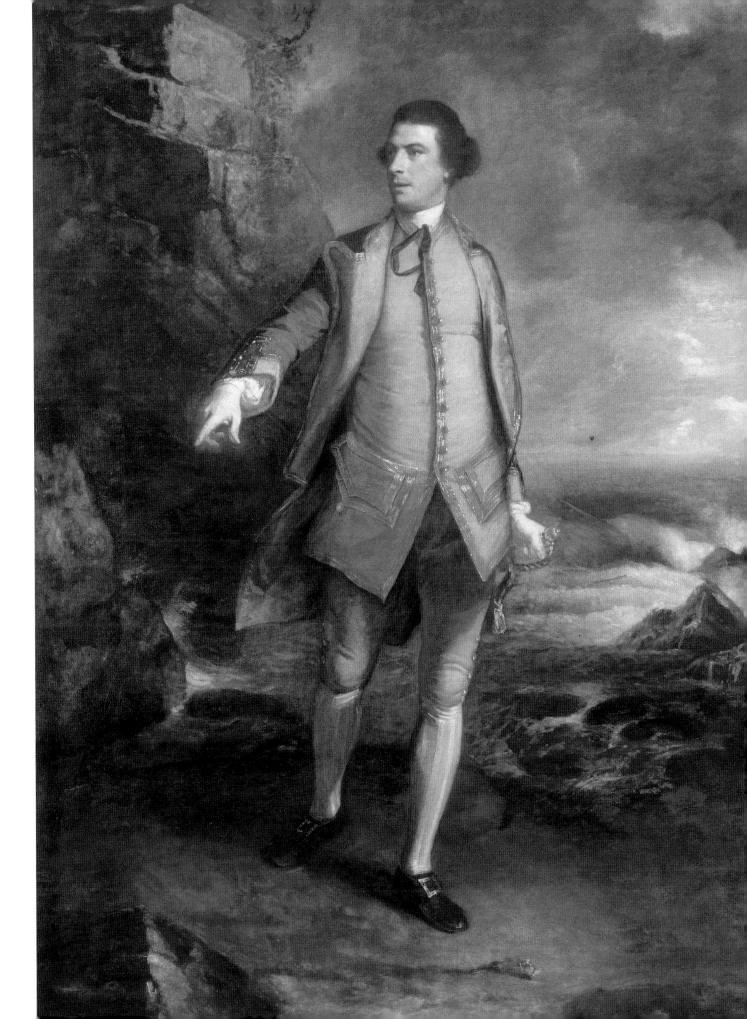

LATITUDE AND LONGITUDE

Gloria Clifton

The Greeks, in the third century BC, were the first to devise a system of pinpointing a position on the globe by means of a grid of imaginary lines. Lines of latitude were drawn parallel with the Equator and lines of longitude, or meridians, crossed them, linking the North and South Poles. Hipparchus of Nicaea refined the system in the second century BC. He divided the circumference of the Earth into 360 degrees, creating the basis of the system still in use today. Astronomers applied a similar network of lines to the heavens, for fixing the positions of stars.

Early navigators did not use these formal systems to find their way, although they understood that the apparent positions of heavenly bodies were affected by the distance of the observer from the Equator. Those, such as the Arabs, Polynesians and Vikings, who voyaged across oceans, well out of sight of land, developed methods of what was later called latitude sailing. They knew the height above the horizon of the midday Sun, or a particular star, such as the Pole Star, at the ports they used regularly. They sailed north or south, using simple devices to measure the altitude of the chosen object until it was in the position corresponding to that at their destination, then sailed east or west, keeping the star or noonday Sun at the same height above the horizon, until they reached port.

Apart from the Vikings, European voyages in classical and medieval times were mainly within the land-locked Mediterranean or around the coasts of western and northern Europe. Mariners relied chiefly on knowledge of the winds, tides and currents, recognition of landmarks and on taking soundings of the depth of the water. By the late twelfth century a new device was available to the European navigator, the magnetic compass. It had been known much earlier in China but so far no conclusive evidence has been found to show whether the Europeans learnt of it from the Chinese or invented it independently. It was a great advance, as it provided a mariner with an indication of the direction in which he was sailing, even when the sky was covered by cloud and he could get no help from the Sun or stars. The methods of navigation then in use were reflected in the books of sailing directions, or *portolani*, which appeared during the Middle Ages.

From them developed the first European mariners' charts, or portulans (see *Portulans*). In 1569, Gerard Mercator published a map of the world based on a new projection, devised so that parallels of latitude and meridians of longitude appeared as straight lines and crossed at right angles. Although intended to assist the mariner, it was not until the mid-seventeenth century that Mercator's projection began to be used on sea charts.

During the fifteenth and sixteenth centuries Western European sailors began to search for sea routes to Asia, after the traditional overland trade in silk and spices was disrupted by the collapse of the Moghul Empire. The Portuguese, led by Diaz, explored routes around the coast of Africa and across

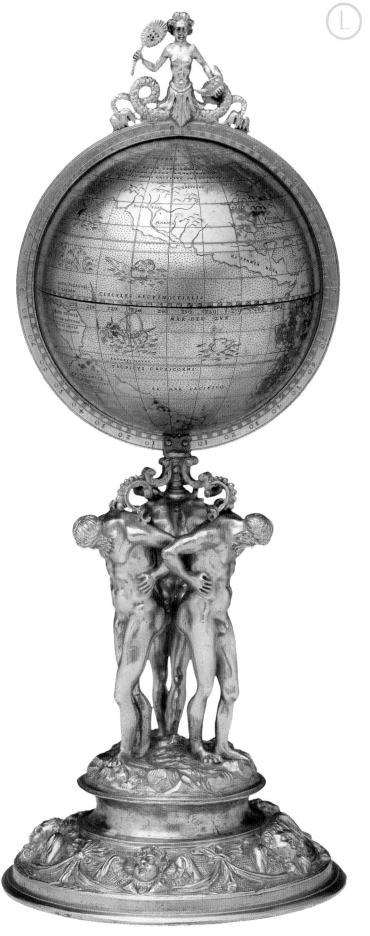

the Indian Ocean. In order to do this they refined the methods of finding latitude at sea. No longer able to rely on the Pole Star as they approached the Equator, they devised tables of the position of the Sun throughout the year, adapting the astrolabe, quadrant and cross-staff, used in astronomy, to measure its altitude. Meanwhile, the Spanish, led by Columbus, Magellan and others, sailed westwards across the Atlantic to the West Indies, the Americas and eventually the Pacific. British-based explorers, such as Cabot and Frobisher, tried to find a route to the East Indies by sailing north-westwards but were defeated by polar ice. Those crossing the Atlantic regularly used latitude sailing and kept a record of their estimated position by 'dead reckoning'; that is, by recording the direction the ship had sailed and the distance covered. On a long voyage, winds, tides and currents could carry a ship miles off the calculated course, resulting in loss of life and cargo. With the expansion of trade and the acquisition of colonies, which followed in the wake of European exploration, both wealth and power came to depend on sailors' ability to find their way at sea. A method was needed to enable the navigator to check his position and for this he had to be able to work out his longitude as well as latitude.

Governments soon realized the importance of a reliable means of finding longitude at sea and offered prizes to stimulate the search for a solution to the problem. First was Philip II of Spain in 1567, shortly followed by the Dutch Republic. The largest prize, of £20,000, was offered in 1714 by the British government, which set up a Board of Longitude to adjudicate. The theory of finding longitude was relatively simple: given that the Earth spins on its axis through 360 degrees in 24 hours, an hour's difference in local time is equivalent to 15 degrees of longitude.

A mariner needed to be able to find his local time accurately and compare it with time at some other fixed reference point, in order to determine his longitude. Local time could be obtained easily from the Sun, the problem was knowing the time elsewhere. The simplest method would be to carry on board ship an accurate clock set to the time of the home port, but no timepiece then available would work reliably on a moving ship. The heavens could also act as a kind of celestial clock, with the Moon as a pointer and the stars as numerals. But this 'lunar distance' method required accurate tables of the motion of the Moon and stars, and instruments precise and handy enough to enable the distance between them to be measured correctly from the deck of a ship. Neither the tables nor the instruments existed in 1714.

By the 1760s the solutions had been found. The British carpenter and clockmaker, John Harrison, laboured for more than thirty years to develop an accurate marine timekeeper, eventually succeeding with his longitude watch, usually referred to as 'H4', which was tested on two voyages to the West Indies in 1761–62 and 1764. This proved to be the prototype for the marine chronometer, which became the standard instrument for finding longitude at sea from the late eighteenth until the mid-twentieth centuries. Meanwhile, in 1731, John Hadley devised an octant for determining the positions of heavenly bodies at sea, which was much more accurate than earlier instruments. However, it could be used to measure only up to 90 degrees and the lunar distance method sometimes required wider angles, so Captain John Campbell and the London instrument maker, John Bird, adapted it with a scale reading to 120 degrees, to create the sextant. In 1756, the German astronomer, Tobias Mayer, published accurate tables of the motion of the Moon, which the Astronomer Royal, Nevil Maskelyne, combined with other astronomical information to create the first *Nautical Almanac* (1766).

Although the sextant and the almanac made it possible to find longitude by astronomical means, the amount of calculation involved meant that the chronometer method came to be preferred.

Further advances in methods of finding latitude and longitude did not come until the twentieth century. The development of radio transmissions by Marconi paved the way for various systems of radio direction-finding in the 1920s and 1930s. These in turn were eclipsed by the development by the Americans and Russians in the 1970s of global positioning systems (GPS), based on a series of satellites orbiting the Earth. Initially intended for military use, they were later made available to civilian shipping. With modern GPS equipment, a ship's position can be determined to within a few metres, an accuracy previously unimaginable.

Page from the *Nautical Almanac* for 1767, published in 1766. The tables in the almanac made it possible to find longitude from observations of the Moon, Sun and stars. 7147

 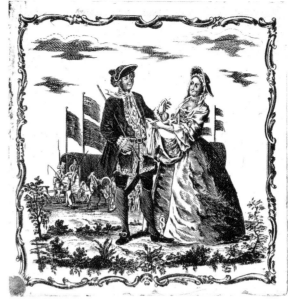

LIFE AT SEA

(Above)
SAILOR'S FAREWELL AND RETURN
John Sadler, Liverpool
c. 1760
This pair of Liverpool delftware tiles is one of the earliest scenes on pottery of a sailor's farewell and return. The first tile shows the sad parting in sight of the sailor's ship, while his shipmates wait. The second scene is the reunion after the voyage, with the sailor elegantly dressed and showering his love with riches. In fact, the scene is even earlier than the date of the tiles: it is taken from engravings published in 1744, after Boitard's paintings of sailors returning from Commodore George Anson's circumnavigation in the *Centurion*, completed that year. The return print includes the wagons filled with treasure captured from the Manila galleon, *Nuestra Señora de Covadonga*, on their way to the Royal Mint in the Tower of London.
AAA4500 & AAA4501 / D5836

(Right)
BRODIE STOVE
George Cawthorn
c. 1780
Until the middle of the eighteenth century, ships had large copper kettles for boiling the crews' food, set into brick hearths. After that, all-metal stoves

were used. Brodie stoves were an improvement on the original model. The lids of the kettles on this model are almost out of sight in this view, behind the chimney. On the side can be seen the door to the oven, and in front is a grill and turnspit, operated by a chain, driven by the rising air in the chimney. The more sophisticated cooking facilities were reserved for the officers.
MDL0025 / D3996-1

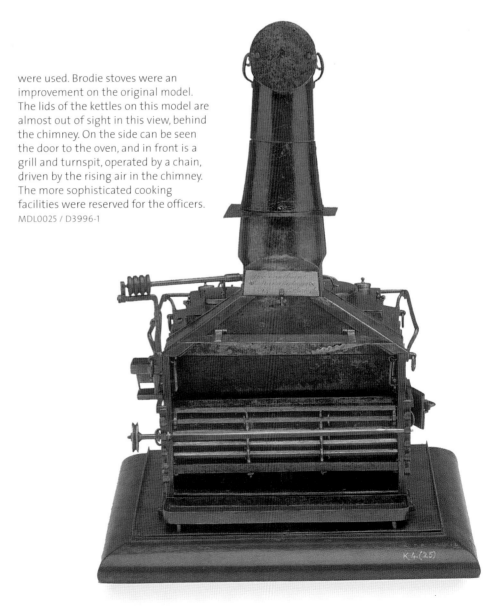

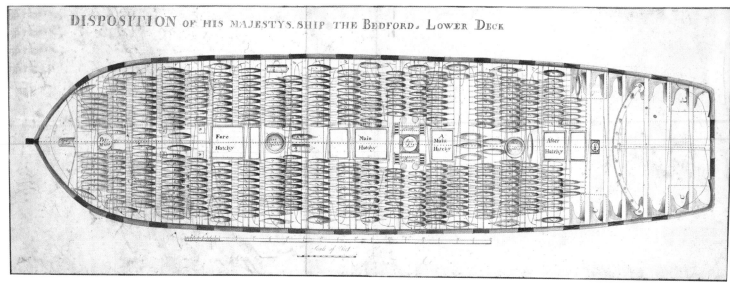

DISPOSITION OF HIS MAJESTYS. SHIP THE BEDFORD. LOWER DECK

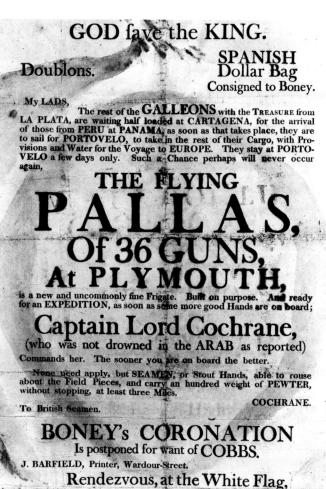

(Top)

HAMMOCK PLAN OF THE LOWER DECK
OF HMS *BEDFORD*
c. 1800

The *Bedford* was a third-rate 74-gun ship, built at Woolwich and launched in 1775. Hammocks were in use in the English navy by 1597, replacing the then common practice of sleeping on the bare deck. Living arrangements were rarely fully detailed in plans for Royal Navy vessels. Five hundred men were given a space of 666 sq yd (557 m²) to berth in, giving each seaman only

14 in. (35.6 cm) in which to sling his hammock. The marines were berthed aft of the seamen and this is shown on the plan by the use of different colours.
ZAZ6793 / D4647

(Opposite, bottom left)
FLYING PALLAS RECRUITMENT POSTER
1804
Though many captains issued posters to recruit men for their ships, most of them relied heavily on press-gangs to provide the bulk of the experienced seamen, who made up the core of the crews. Lord Cochrane, captain of the *Flying Pallas*, was rather different. One of the most successful captains in terms of prize-money, he could usually pick and choose his men. This poster offered the chance to become very rich through the capture of Spanish treasure ships in 1804.
CDA0036A / A0765

(Opposite, bottom right)
SHIP'S COOK
Thomas Rowlandson
1799
Rowlandson's prints give a picture of the life and status of the crew of a typical warship at the end of the eighteenth century. This shows a ship's cook – disabled, as many of them were.
PAF4969 / PW4969

(Below, left)
SHIP'S BISCUIT
1784
The ship's biscuit, made of flour and water slowly baked, was a standard part of the seaman's diet, in place of bread. According to the standard Victualling Board contract, they were to be 'made from biscuit stuff, arising from wholemeal, ground good sound wheat and dressed through a cloth not coarser than a patent cloth no 4'. Each man was entitled to a pound every day. This biscuit was presented to Miss Blackett of Berwick in 1784.
AAB0003 / D4001-1

(Right)
SCRIMSHAW STAY BUSK
Unknown maker
Mid-nineteenth century
Scrimshaw was produced by men on whaleships from the by-products of their trade. Whalebone, baleen and sperm whale teeth were all decorated with inscribed pictures of the whale hunt, ships or nostalgic motifs. Creating scrimshaw helped to pass the time during quiet moments at sea, and then served as souvenirs to take home to loved ones. The most intimate of such gifts was a scrimshawed stay busk carved on a narrow strip of whalebone or baleen for a sweetheart to wear as a stiffener in a corset. The example illustrated is decorated on both sides with colours rubbed into the incised lines.
AAA0031 / D6119

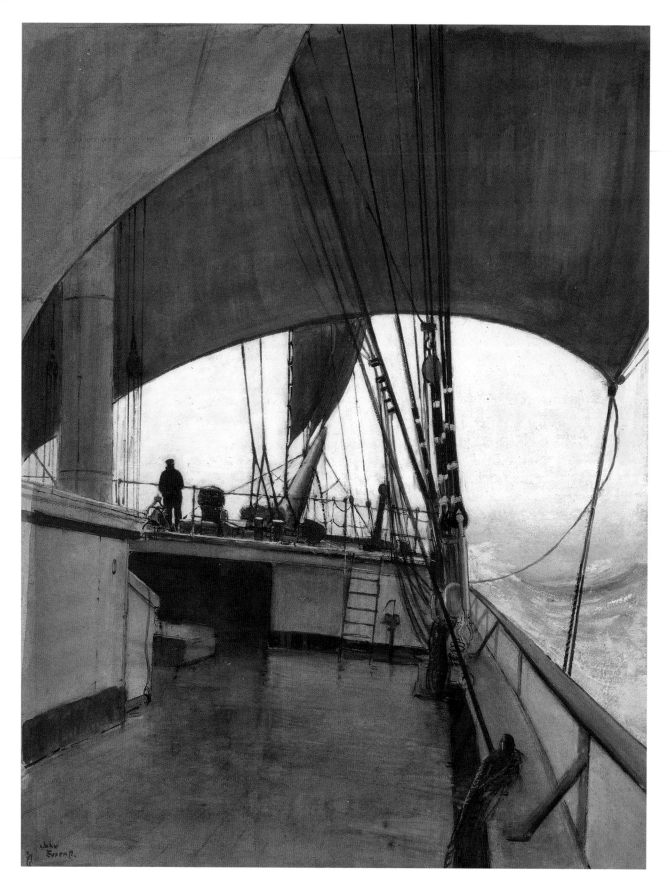

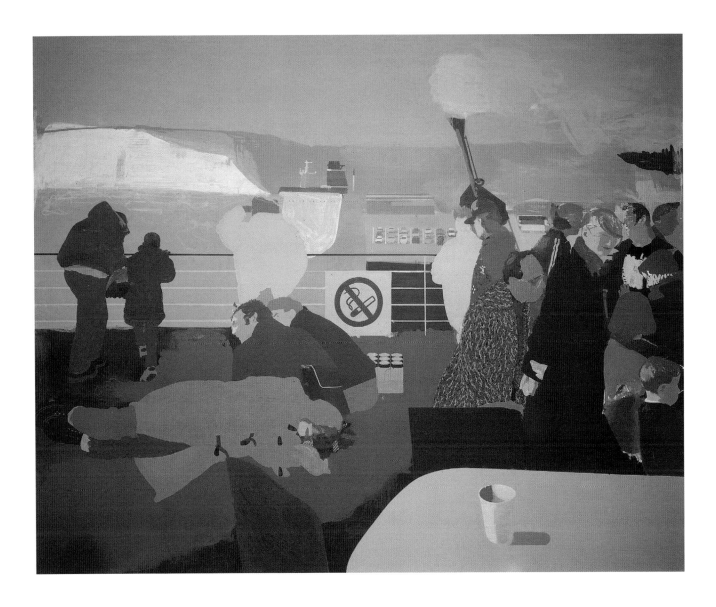

DECK SCENE ON THE *KYLEMORE*, BARQUE
(Herbert Barnard) John Everett
*c.*1930
John Everett trained at the Slade School
of Art, 1896–98. His friends there were
Augustus John and William Orpen and he
shared lodgings with them at his
mother's house, 21 Fitzroy Square, London.
In 1898 he made his first voyage as an
ordinary seaman in the *Iquique*. In
1929–30 he made two voyages to the
West Indies in the *Kylemore*. He made
many drawings on board these sailing-
ships, which he used to develop his

unique stylized paintings. Everett used
this watercolour to make an aquatint.
PAH6703 / D2571

(Above)
THE FIRST OF ENGLAND
Humphrey Ocean
1998
This picture was commissioned as part
of the Museum's initiative to collect
contemporary art. Humphrey Ocean has
written: 'I was commissioned to paint a
picture about modern maritime Britain
and "The First of England" is my response.
I imagine a fair proportion of Britons have

at one time or another been on a ferry,
which is now the extension of the car,
as well as being a floating high street.
Oddly, while I was doing the painting, I
thought quite often of the First World
War. The "moustached archaic faces"
from the poem "MCMXIV" by Philip Larkin,
describing a nation of innocents, were
brought to mind by my 50-pence-each-
way crowd returning to the White Cliffs
from a day-trip, neither shattered nor
shell-shocked nor dead, fortunately, but
bearing a trolley of duty-free lager and
three Toblerones for the price of one.'
ZBA0739 / D9948

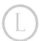

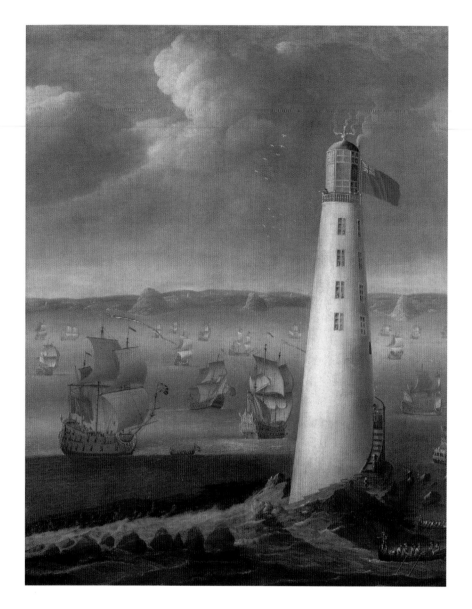

LOGBOOKS

(Opposite, top)
A PERSONAL LOGBOOK
Nicholas Pocock
1770
A logbook is a formal summary of the day's activities at sea, recording the course and speed, the weather and any important events. This one records a voyage from Bristol to the Mediterranean aboard the *Betsey* in 1770. It was kept by her captain, Nicholas Pocock (1740–1821), who later became an eminent marine painter.
LOG/M/21 / D1784-1

(Opposite, bottom)
LOGBOOK OF THE *SANDOWN*
Samuel Gamble
1793
The beautiful illustrations in the logbook of the *Sandown* belie the grim trade in which the ship was engaged. The *Sandown* was commanded by Samuel Gamble and carried slaves from Sierra Leone on the west African coast to the Caribbean, in 1793. On this page, Gamble illustrates and describes the arrival of slaves, who had been brought many hundreds of miles to the coast by Fulani traders to be sold to the European ships.
LOG/M/21 / E0064

LIGHTHOUSES

(Above)
THE SECOND EDDYSTONE LIGHTHOUSE, WITH THE *ROEBUCK*, *CHARLES GALLEY*, *ALDBROUGH* AND *SWALLOW*
Isaac Sailmaker
c. 1708
Rudyerd's wooden lighthouse of 1708 replaced Winstanley's two attempts of the of late 1690s. The lighthouse, built on a rock south-west of Plymouth was the first successful offshore-rock lighthouse in the world, and survived until burnt in the 1750s, when it was replaced by Smeaton's structure. The picture also shows the four men-of-war that attended on the work, *Roebuck*, *Charles Galley*, *Aldbrough* and *Swallow*. The marine painter, Sailmaker, like the van de Veldes, came to England from Holland. According to George Vertue, writing in the early eighteenth century, 'he ... came very young into England ... [and was] imployed to paint for Oliver Cromwell a prospect of the Fleet before Mardyke when it was taken in 1657 ... This little man imploy'd himself always in painting views small and great of many Sea Ports and Shipps, he was a constant labourer in that way ... His contemporaries, the van der Veldes, were too mighty for him to cope with. But he outlived them & painted to his last.' The picture has an unbroken provenance of nearly 300 years. It is one of the four versions commissioned by John Lovett in 1708: one for the Lord High Admiral, Prince George of Denmark (not traced), one for Trinity House (destroyed), and a different family version at Claydon House (National Trust). This painting was acquired with the assistance of the Society for Nautical Research and the National Art Collections Fund.
BHC1796

From Leghorn towards London in the Ship Betsey 1770

H	K	½K	Courses	Winds	Monday July 23ᵈ 1770

Latt. Observ'd 42.30 North

H	K	½K	Courses	Winds	Tuesday July 24ᵗʰ 1770

Latt. Observ'd 42.11 North

H	K	½K	Courses	Winds	Wednesday 25ᵗʰ July 25ᵗʰ 1770

Latt. Observ'd 41.41 South

H	K	½K	Courses	Winds	Thursday 26ᵗʰ July 1770

Latt. Observ'd 39.44 No.

H	K	½K	Courses	Winds	Friday 27ᵗʰ July 1770

Latt. Observ'd 38.52 North

H	K	½K	Courses	Winds	Saturday July 28ᵗʰ 1770

Latt. Observ'd 38.14 North

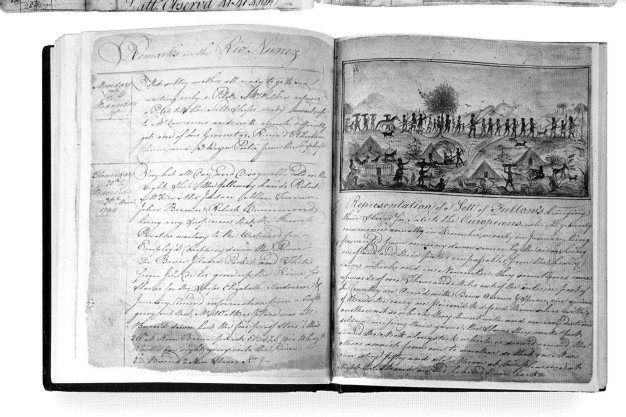

Remarks in the Rio Nunez

Representation of a Coffle of Fellatas bringing their Slaves for Sale to the Europeans

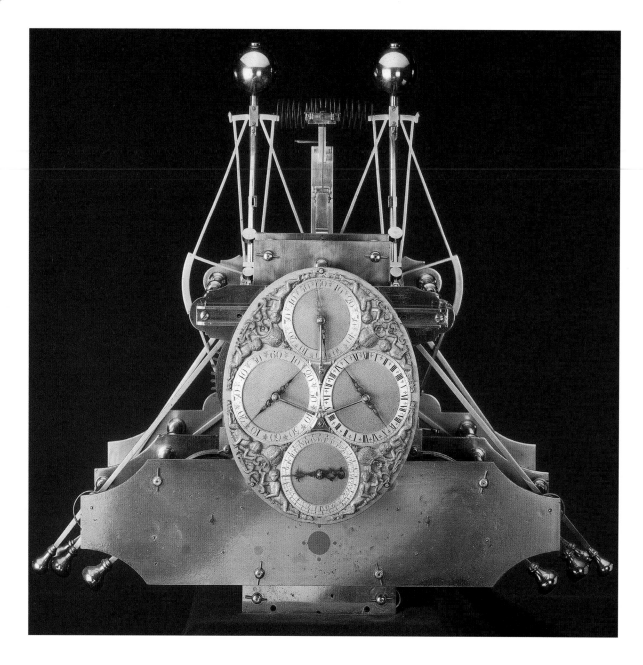

LONGITUDE TIMEKEEPERS

(Above)
MARINE TIMEKEEPER, 'H1'
John Harrison
1730–35

By 1713, at the age of 20, John Harrison had made his first clock, and went on to construct a series of precision pendulum clocks, which out-performed even those of the great London makers. It was with knowledge gained in the development of these early precision clocks and the incentive of the £20,000 Longitude Prize that, in 1730, Harrison started work on his first experimental marine timekeeper. Despite his relatively humble education, Harrison knew that a successful sea clock must be spring-not weight-driven, and that it must have an alternative kind of oscillator to the pendulum that controlled land-based clocks. By fitting the machine with a pair of perfectly matched, linked balances, controlled by his 'artificial gravity' springs, Harrison made an oscillator he thought would be unaffected by the motions of a ship. 'H1' was tested at sea in 1736 on a return voyage to Portugal. Although 'H1' did not perform well enough to win him the prize, it did prove to him, and to his backers, that the possibility of using a clock to solve the longitude problem was worthy of further investigation. Harrison immediately started work on an improved version, 'H2'.

ZAA0034 / D6783-1

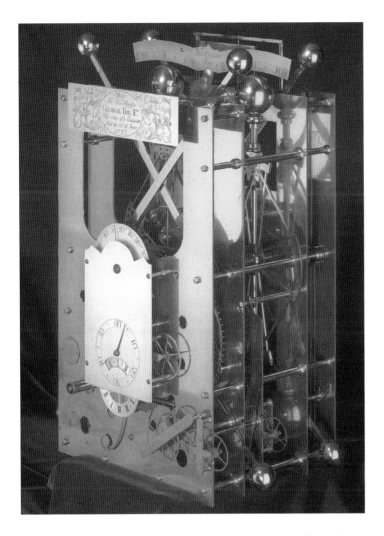

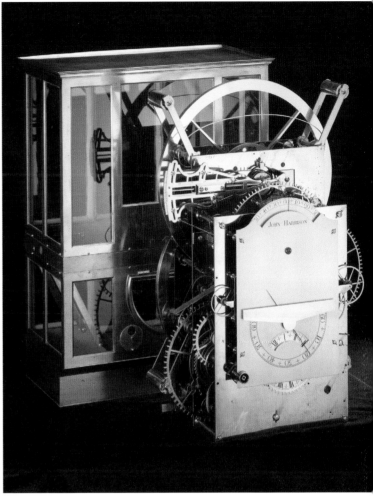

(Above, left)
MARINE TIMEKEEPER, 'H2'
John Harrison
1737–39
Granted money from the Board of
Longitude to make a second, improved
marine timekeeper, Harrison moved to
London where he began work on 'H2'.
Knowing that the delivery of power
from the mainsprings of 'H1' to its
balances had been inconsistent, Harrison
decided to fit 'H2' with a device called a
remontoire. Rather than the balances
being driven from a mainspring through
a train of several gear wheels, a clock
with a remontoire is kept running by a
relatively weak spring, or a weight, acting
directly on the escapement, and thus
the train of gear wheels then simply
keeps the remontoire wound up. This
way any inconsistencies in the gear
wheels or changes in torque from the
mainspring are negated. Although
Harrison completed 'H2' in 1739 it never

went for trial at sea. He realized there was
a fundamental problem with the design
of his bar balances and immediately
started work on his third machine.
ZAA0035 / D6784-2

(Above, right)
MARINE TIMEKEEPER, 'H3'
John Harrison
1740–59
Unlike his first two marine timekeepers,
Harrison designed 'H3' to have circular
rather than bar balances, thinking that
this would overcome inherent faults
found in 'H1' and 'H2'. He also further
simplified the system for temperature
compensation. Rather than having
separate 'gridiron' rods of brass and steel
as in his earlier machines, Harrison
created the world's first bi-metal, by
riveting together a strip of steel and a
strip of brass. He used this new device
to alter the effective length of the spring
controlling the speed at which the two

balances oscillate. Like its predecessors,
'H3' ran entirely without lubrication.
What Harrison called his 'rolls of great
radii' (large anti-friction segments)
evolved, in this machine, into much
smaller units, each consisting of four
separate rollers surrounding a single
pivot. By running these rollers within a
metal cage, Harrison produced the
forerunner of all caged roller bearings,
used in their millions today. Harrison
dedicated almost twenty years' work to
this one timekeeper but still couldn't
improve its performance sufficiently to
win the great Longitude Prize. In 1753 he
commissioned John Jefferys, a respected
London watchmaker, to make a pocket
watch incorporating some of his own
ideas. It was the outstanding performance
of this watch that led Harrison to believe
that a more sophisticated version, made
on the same principles, could win him the
Longitude Prize.
ZAA0036 / D6785-5

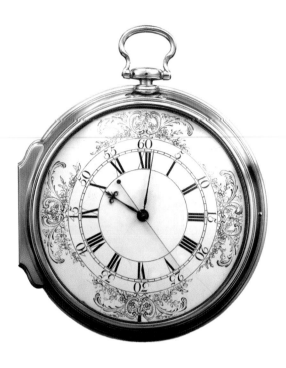

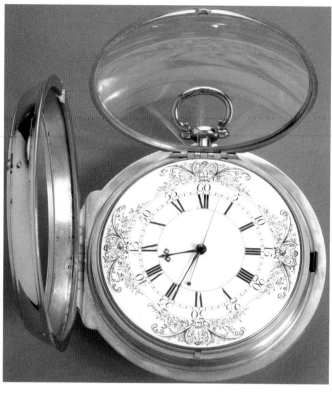

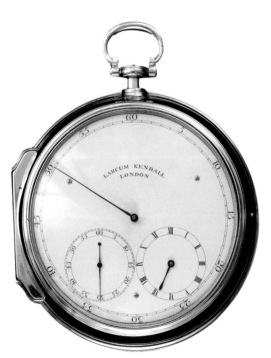

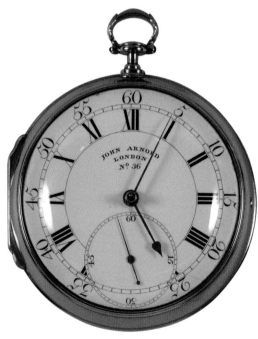

(Top left)
MARINE TIMEKEEPER, 'H4'
John Harrison
c. 1755–59

The culmination of a lifetime's work, on its trials to the West Indies, 'H4' proved beyond doubt that a mechanical timekeeper could be used as a 'practicable and useful [method of finding longitude] at sea'. Never before had a timekeeper of such compact size and portability kept time as closely as this watch. Harrison's previous machines had pendulums or balances that beat once per second, but by making the balance in his new watch beat five times per second and at a much larger amplitude than a standard watch, he found the timekeeping or 'rate' to be inherently stable. By Harrison's reckoning, on its first six-week trial on a voyage to the West Indies, the watch accumulated an error of just over five seconds. By disclosing how 'H4' was

made and by surrendering it to the Board of Longitude, Harrison was awarded half the £20,000 Longitude Prize, with a later payment of £8750 made directly from Parliament in 1773. During the nineteenth and twentieth centuries, thousands of chronometers were made as a direct result of the pioneering work of John Harrison. These clocks helped countless mariners to navigate safely, who might otherwise have lost their lives through shipwreck or starvation.
ZAA0037 / D0789-1

(Opposite, top right)
MARINE TIMEKEEPER, 'K1'
Larcum Kendall
c. 1769
The Longitude Act of 1714 stipulated that prizes would only be awarded if the proposed solution was 'practicable and useful'. In order to fulfil these criteria the Board of Longitude needed to know if other makers could duplicate John Harrison's timekeeper 'H4'. In 1767 Kendall was commissioned to make an exact copy, for which he was paid £450 plus a £50 bonus. This watch was sent with Captain James Cook on his second (1772–75) and third (1776–80) voyages of exploration, and Cook was soon relying on 'My trusty friend ... and never failing guide'. When Captain Arthur Phillip established Britain's convict settlement at Botany Bay in 1788, 'K1' also accompanied him.
ZAA0038 / C9303-1

(Opposite, bottom left)
'K2', THE *BOUNTY* TIMEKEEPER
Larcum Kendall
c. 1771
After producing 'K1', the close copy of John Harrison's watch, 'H4', Larcum Kendall was commissioned to create a simplified, less expensive version. The watch was lent to Captain Constantine John Phipps for use on his polar expedition of 1773. In late December 1787, 'K2' was allocated to Lieutenant William Bligh for *Bounty*'s voyage to Tahiti. On 28 April 1789 the ship and its timekeeper were seized by mutineers, who eventually settled on Pitcairn Island, where they remained undiscovered for nineteen years. The watch was eventually returned to

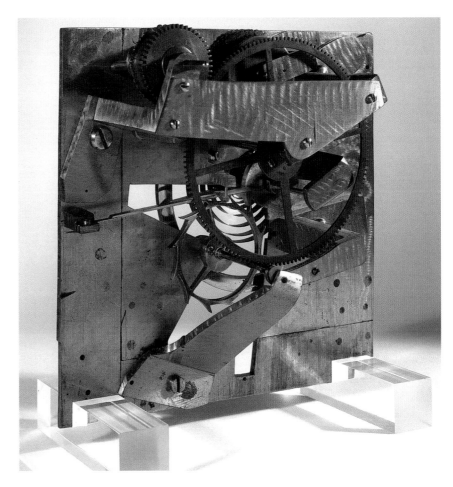

England by Captain Thomas Herbert, who presented it to the Royal United Services Institution.
ZAA0078 / A5510

(Opposite, bottom right)
POCKET CHRONOMETER, NO. 1/36
John Arnold
1778
The names of John Arnold and Thomas Earnshaw are pre-eminently associated with the rapid development of the marine timekeeper in the late eighteenth century. By introducing his helical 'Ballance Spring' and 'A Compensation for the Effects of Heat and Cold In the Ballance' Arnold greatly simplified and improved the performance of marine timekeepers. For thirteen months this watch, number 1/36, was put on non-stop trial at the Royal Observatory, Greenwich. During that entire period its daily rate never varied more than a few seconds, proving beyond doubt that it was, at the time, the world's most accurate portable timekeeper. Arnold referred to this very

watch as his 'Chronometer', the first use of this name in its modern sense.
ZBA1227 / D7073

(Above)
ESCAPEMENT MODEL
Thomas Earnshaw
c. 1804
In order to satisfy themselves as to the actual function of the spring detent escapement for marine timekeepers, in March 1804 the Board of Longitude ordered rivals Thomas Earnshaw and John Roger Arnold each to make a scale model of their inventions. The cost of producing these models was to be met by the Board. Considering it is only roughly made, mostly from pieces of scrap metal, Earnshaw charged a high price of £52 10s. for his work, more than five times that charged by Arnold. Ultimately both parties were awarded £3000 for their work in advancing the technology of timekeepers for use at sea. The debate as to who did, in fact, invent the disputed escapement still continues today.
ZAA0123 / E8944

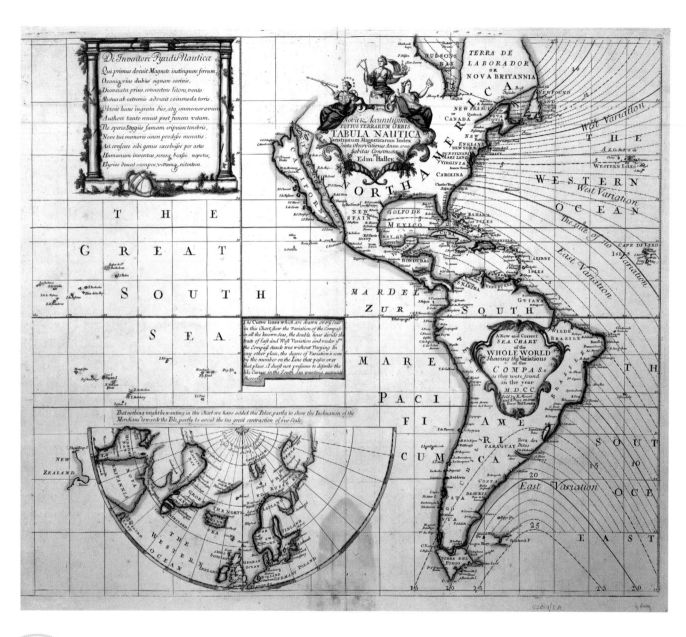

Magnetism

WORLD MAGNETIC VARIATION
Edmond Halley
1701

Edmond Halley was a distinguished scientist who was given command of a naval vessel, the *Paramore*, to obtain data on magnetic variation in the Atlantic. The Earth's magnetic field is not uniform and, as a result, the mariner's compass points to a variable degree to either side of north depending on the ship's position. This was an acknowledged problem and Halley set out to make an extensive series of comparisons between compass readings and determinations of north by astronomical observation. The results enabled navigators to set courses with far more confidence but also proved that magnetic variation was too inconsistent to be used for finding longitude at sea, as had been hoped. Halley later became Astronomer Royal at Greenwich.

G.210:1/1 A&B / C0507

(Right)
THOMSON PATTERN BINNACLE
James White
c. 1876

Sir William Thomson (1824–1907), later Lord Kelvin, was Professor of Mathematics at Glasgow University. After buying his own yacht, he turned his mind to the effects of local magnetic attraction, caused by iron used in the construction of ships, on the reliability of the compass. He took out a series of patents for improved compass binnacles, or housings, and for compass cards. The specifications of 1876, with some further improvements in 1879, provided the pattern which was the basis for both standard commercial and naval binnacles for about a century. The binnacles had iron spheres and corrector magnets, which could be adjusted to counteract the magnetic effects of iron in the ship.

ACO0036 (ACO.46) / C9296

(Left)
LODESTONE
Unknown maker
c. 1600

Lodestone, or magnetite, is a naturally occurring magnetic rock. It was used by mariners in medieval and early modern times to remagnetize their soft iron compass needles on long voyages. In the mid-eighteenth century, Dr Gowin Knight invented a much more powerful artificial steel magnet, which he used to make steel compass needles that did not need remagnetizing during a voyage. Scholars also used lodestones to study the properties of magnetism. Those in elaborate cases were more likely to have been owned by scholars or aristocratic naval officers, rather than ordinary mariners.

NAV0713 (M.14) / D0872

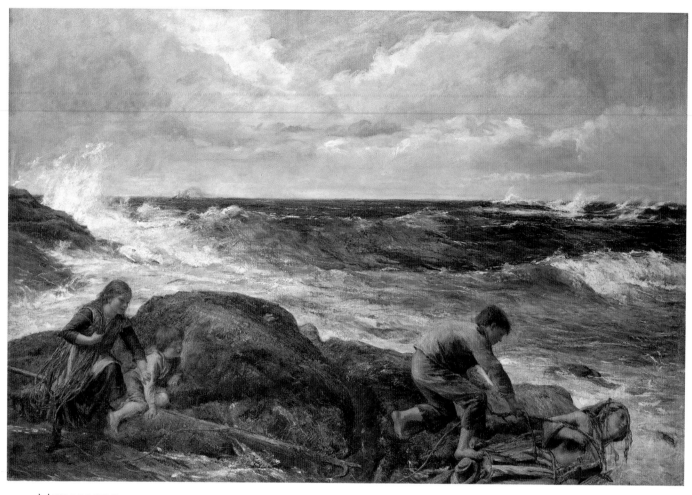

MERMAIDS

CATCHING A MERMAID
James Clarke Hook
1883
Hook was one of the most famous Victorian sea painters. His marine works often idealized fisher-folk, and were a familiar part of the Victorian art scene. He spent his summers in Devon and Cornwall and painted numerous scenes of fishermen and their wives at work, and of their children at play. Seascapes like this were considered imaginative works of art and bought by wealthy connoisseurs. When exhibited at the Royal Academy in 1883, the critic of the *Athenaeum* wrote that 'the glory of the picture is the sea whose waves dash themselves against the points of rocks'. Although designed to appeal to the emotions, the narrative may be seen as an intimation of man's fate, and the menace of the deep is implied in the precarious position of the children on the ledge of rock.
BHC4162

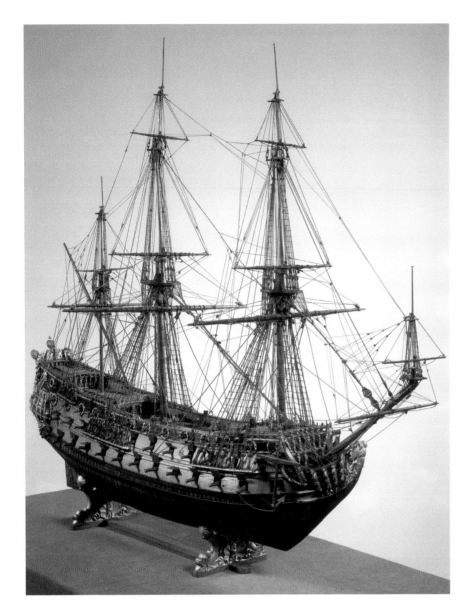

(Below)
SHIP MODEL IN 'NAVY BOARD' STYLE, 58 GUNS
c. 1655, scale 1:48
Although this model cannot be identified as any particular ship, it is the oldest 'true-scale' example in the collection, and probably in Europe as well. Built in the 'Navy Board' style whereby the hull frames have been assembled in a stylized fashion, rather than as actually built, the planking has been omitted to show the construction and internal layout of the hull. The proportions of the model agree closely with the third-rate frigates built during the Commonwealth period. However, the Stuart coat of arms prominently displayed on the stern would suggest the model was made, or the arms added, after the Restoration in 1660.
SLR0217 / D4060-4

MODELS

(Above)
ST MICHAEL, 98 GUNS
1669, scale 1:48
This model of the *St Michael* is the oldest that can be positively identified. Not only does it agree perfectly with the ship's dimensions at the scale of 1:48, there are also several drawings by the Dutch artist, Willem van de Velde, of the stern and figurehead decoration. The model was largely re-rigged in 1930, although it was most unusual to rig models during the late seventeenth century as the practice of rigging altered very little during this period. The *St Michael* took part in the battles of Solebay in 1672 and Barfleur in 1692 before being rebuilt in 1706 and renamed *Marlborough*.
SLR0002 / C4672-2

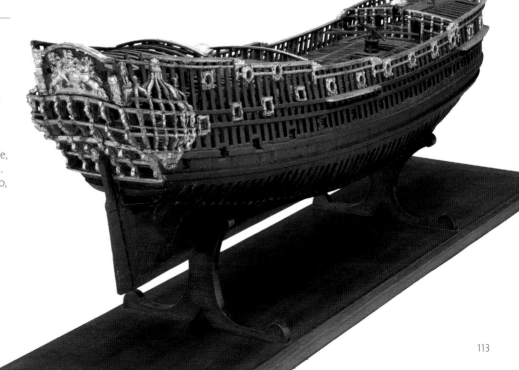

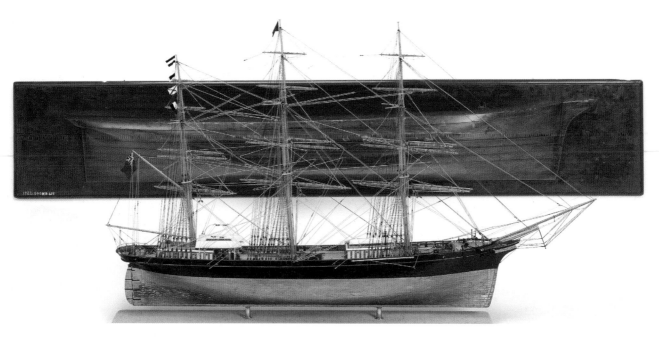

(Above)
TITANIA
Clifford Oldham
1866, scale 1:48
The construction of this model was to
become a labour of love, taking the
maker over fifty years to complete. His
painstaking research, attention to detail
and fine craftsmanship have produced a
model of superb quality. Behind is the
original builder's half-model from which
Clifford Oldham took the lines to produce
his model. The *Titania* was a composite-
built clipper and was highly competitive
and profitable in the tea trade to the Far
East. Bought by the Hudson's Bay
Company in the 1880s, *Titania* ended her
days working in the Mediterranean and
was finally broken up in 1910.
SLR3043 / D7792

(Left)
ROYAL GEORGE, 100 GUNS
1777, scale 1:48
The Earl of Sandwich was determined
to get King George III more interested
in the Navy, and in 1772 the Admiralty
gave orders for 'a model to be forthwith
made of a section of the *Royal George*
lengthways'. The result was probably the
finest example of eighteenth-century
modelmaking. The model is fully
planked on the starboard side, while the
port side is left in frame so as to show
the internal layout and the numerous
fittings such as galley stoves, capstans
and cabin furnishings. The friezes along

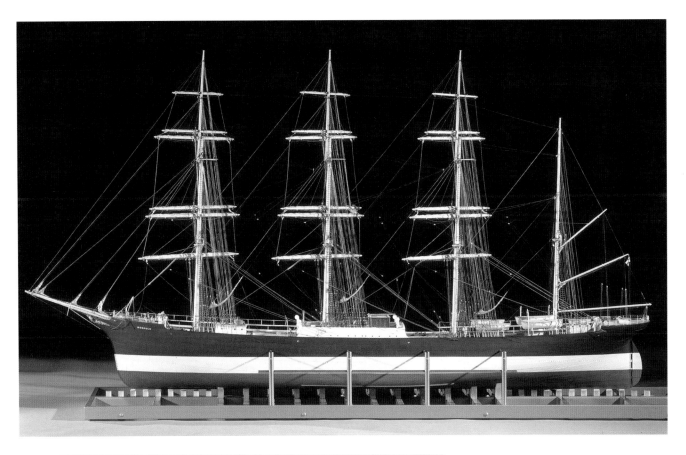

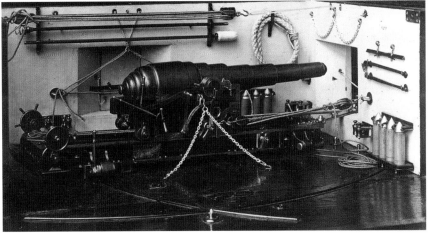

one shows a transitional stage between the smooth-bore muzzle loader of Nelson's day and the far more accurate and powerful rifled shell-gun of World War I. The gun is made in several parts, but is mounted on a variant of the traditional carriage. It fires streamlined projectiles rather than round shot but it is still muzzle-loading.
3815

(Above)
MOSHULU, FOUR-MASTED BARQUE, 1907
Kenneth and Donald Bradley
1988, scale 1:48
Commissioned by the Museum to illustrate the ultimate development of the sailing-ship, the *Moshulu* model was the result of seven years' work by the Bradley brothers. The hull plating alone has over a quarter of a million simulated rivet heads, while the wire rigging is complete with working bottle screws. Built by Alexander Hamilton & Co. in 1904, *Moshulu* had a varied career, carrying nitrate, grain and coal. She is currently lying afloat on display in Philadelphia, USA.
SLR0357 / D3817-8

the bulwarks were painted by the artist Joseph Marshall and the carved decoration was by Thomas Borroughs, master carver to Deptford Dockyard. Not surprisingly, the model took five years to build and was delivered to the King in July 1777. The *Royal George* was launched in 1756 and was Admiral Hawke's flagship at the Battle of Quiberon Bay in 1759. She sank accidentally at Spithead in 1782 with

the loss of 900 lives, including that of Rear-Admiral Kempenfelt.
SLR0336 / D4082-7

(Centre)
FRAZER-WOOLWICH GUN
1874
Developments in gun design and construction were rapid in the second half of the nineteenth century, and were often represented by models. This

THE MUSEUM'S ART COLLECTION

Roger Quarm

The Museum's art collection, largely assembled since 1930, is remarkable for both its artistic quality and the variety of its subject matter. It comprises approximately 4500 oil paintings, more than 60,000 prints and drawings and more than 200 miniatures.

The main elements of the paintings collection are early Dutch and Flemish marine paintings, British marine paintings, 1700–1900, topography, portraits, history and genre paintings and ship portraits. The 60,000 or so prints and drawings consist of works on paper in a wide range of media and processes, both original and reproductive. These illustrate many aspects of maritime history in the period 1600–2000, and there are numerous unusual works of high artistic importance, as well as amateur works by talented naval officers and others. Both collections offer the potential for a wide range of uses, including research, reproduction and display, and for new kinds of

interpretation, both historical and art-historical. The collection of miniatures includes good examples from the sixteenth to nineteenth centuries.

The tradition of maritime pictures at Greenwich goes back well over two hundred years to when a number of pictures were presented to the newly completed Royal Hospital – notably, Gainsborough's portrait of the fourth Earl of Sandwich in 1783. William Locker's idea of a gallery of pictures to commemorate British naval achievements was finally realized in the 1820s by Edward Hawke Locker. The Greenwich Hospital Collection was placed on permanent loan to the Museum in 1936 and has been used ever since as the core of the gallery displays devoted to British naval history. The collection contains paintings originally donated to the Hospital by George IV, amongst them the 'Flagmen' portrait series by Sir Peter Lely, portraits by Kneller and Dahl, J. M. W. Turner's monumental

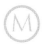

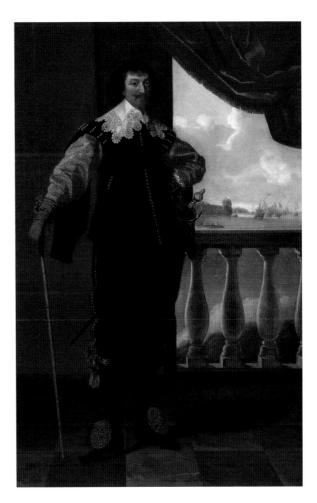

Opposite: A Dutch squadron attacking a Spanish fortress, Adam Willaerts. BHC0801

Right: Robert Rich, second Earl of Warwick, by Daniel Mytens. BHC3080

and controversial *The Battle of Trafalgar* and its companion piece, Philippe-Jacques de Loutherbourg's *The Battle of the Glorious First of June, 1794.* Naval families and other individuals gave other paintings during the nineteenth century.

Between 1930 and 1950 Sir James Caird collected naval portraits and marine paintings for the Museum along the same lines as the Greenwich Hospital Collection, including Reynolds's famous full-length portrait of Keppel. But he also collected more broadly – acquiring merchant service pictures and Dutch marine paintings, notably paintings by the van de Veldes. He helped to form the magnificent assemblage of *penschilderij* (pen paintings), now a world-class collection. In the late 1920s he helped to buy A. G. H. Macpherson's collection of prints and merchant ship paintings, an act which gave impetus to plans to found the Museum.

In the early 1960s the Museum acquired two major collections of early Dutch and Flemish marine paintings from Captain Eric Palmer and Sir Bruce Ingram. Valuable for the study of seventeenth-century ships and naval events, they are study collections for the development of marine painting in the Netherlands, 1600–1700, and its influence on the emerging English marine painting in the early eighteenth century. Many artists are represented, including the minor ones, making it the foremost collection of its kind in the world. Artists who are particularly well represented include Simon de Vlieger, Andries van Eertvelt, Adam Willaerts, Ludolf Backhuysen, Abraham Storck and, most notably, the elder and younger Willem van de Veldes. Seventeenth-century Dutch prints and drawings complement the Dutch paintings collection.

The collection of van de Veldes now amounts to more than fifty works: it includes pictures painted for

the Dutch market in the 1650s and 1660s and for the English market from 1673, when the artists migrated to England. The Elder's pen paintings drawn for the Dutch market in the 1640s and 1650s, the Holland of Rembrandt and Vermeer, contain exceptionally detailed portraits of ships and human activity. These pictures are complemented by a collection of 1400 drawings by father and son, mainly of Dutch and English ships, as well as actions in the Anglo-Dutch Wars, which the artists sometimes witnessed themselves. The Younger's large painting of the Battle of the Texel, painted when he briefly returned to Holland in 1687, was acquired with the help of the National Art Collections Fund in 1952, and is considered his masterpiece.

After the younger van de Velde's death in 1707 English marine painters gradually grasped the

Storm and Sunshine: a battle with the elements, 1855,
William Lionel Wyllie. BHC1348

opportunities presented by the wars in the middle of
the eighteenth century. Artists such as Peter Monamy
(who had worked in van de Velde's studio), Samuel
Scott and Dominic Serres were commissioned by
naval patrons to depict their ships and also battles.
Accuracy was all-important. Brooking, on the other
hand, maturing in the 1750s, worked for a rather
different market, for while his pictures were accurate,
he was also interested in landscape and atmosphere,
learnt from the Dutch artists. The collection of
Brooking's paintings is equalled only by that of his
follower, the Frenchman Dominic Serres who, as a
founder member of the Royal Academy and marine
painter to George III, elevated the status of marine
painting in England. The next generation of artists
who satisfied the demand for pictures of the French
wars of 1793–1815 – notably Nicolas Pocock,
Robert Dodd, Thomas Whitcombe and Thomas Luny
– are extremely well represented.

Perhaps the most extraordinary and revolutionary
paintings in the collection are those by William
Hodges, who was the official artist on Captain Cook's
second voyage of discovery, 1772–75. Trained as a
landscape painter in the classical tradition under
Richard Wilson, his paintings of the South Pacific and
New Zealand are highly original, sometimes disturbing
evocations, technically far ahead of their time.
Hodges's recently discovered portrait of Captain Cook
is a less formal and perhaps more human painting of
the 'great navigator' than Nathaniel Dance's, which is
also in the Museum's collection.

After 1815 there was a decline in the need for the
kind of marine painters who had painted ships and
battles in the eighteenth century. The nineteenth
century saw enormous growth in the number of artists
who painted portraits of merchant ships for their
owners, and this is reflected in the high proportion of
such works in the painting and print collections.
Marine painting in the mid-nineteenth century
became much more closely allied to landscape

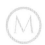

painting, as may be seen in the works of Clarkson Stanfield, E. W. Cooke and John Wilson Carmichael. Some of the Museum's best Victorian paintings are by artists who were not marine painters, such as James Clarke Hook and Henry La Thangue. William Wyllie is something of an exception. Living well into the twentieth century, his work grew out of landscape but he increasingly turned to painting naval subjects, an interest that is well documented by the large Wyllie collection of maritime drawings.

The Museum's collection of portraits covers the period 1550 to the present day. As well as oil paintings it includes drawings, miniatures, engravings, sculpture and photographs, and although naval officers predominate, there are merchant captains, shipbuilders, scientists, royalty, artists and writers. The paintings collection is particularly rich in seventeenth- and eighteenth-century portraits and includes works by Lely, Hogarth, Gainsborough and Reynolds and, since 1995, Lawrence. But its strength also lies in the portraits by less well-known artists, such as Claude Arnulphy, who painted naval officers during the blockade of Toulon in 1744. Among the portraits of Tudor and Jacobean royalty is the exquisite portrait by Robert Peake of Elizabeth of Bohemia aged seven, and Largillière's portrait of her nephew James II. The collection of miniatures also contains portraits of James as well as Charles II, both by Samuel Cooper. Questions of attribution and interpretation remain, as with other parts of the collection: the miniature of Thomas Seymour, long attributed to the school of Holbein, may well be by Holbein himself. Lieutenant Gabriel Bray's drawings of his shipmates, made during a

voyage on the *Pallas* in the 1770s, are forerunners of the portraits of sailors during World War II. Wonnacott's portrait of Lord Lewin (1998), in contrast, reflects the formal portraiture of the past.

The Museum's most significant twentieth-century pictures are those commissioned by the War Artists Advisory Committee, which from 1939 employed artists to paint aspects of World War II. Many innovative works resulted – for instance, the paintings of Richard Eurich and the submarine drawings and lithographs by Eric Ravilious. Ordinary people, including sailors and their activities, provided the focus for artists such as Henry Lamb, Henry Marvell Carr, Stephen Bone, William Dring and Eric Kennington, and marked a significant departure from the paintings of admirals and senior officers that dominated earlier periods. Later acquisitions, paintings by L. S. Lowry, Alfred Wallis and Edward Wadsworth, strengthened the modern British element of the collection. In the 1990s a number works by John Wonnacott and Humphrey Ocean were commissioned by the Museum as part of an initiative to encourage artists to explore Britain's contemporary relationship with the sea. The twenty-first century offers exciting opportunities to expand this theme.

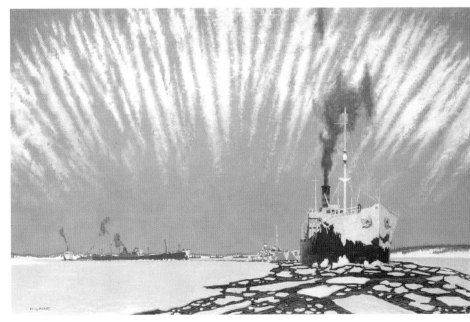

Convoy to Russia, c. 1944–45, Charles Pears. BHC1576

N

NAVIGATION BY THE STARS

(Right)
MARINER'S ASTROLABE
Unknown maker
c. 1588

The astrolabe was a two-dimensional representation of the universe and was used for a variety of tasks, including astronomy, timekeeping and surveying. The mariner's astrolabe is a simplified version used to determine latitude by measuring the height of the Sun or Pole Star above the horizon. It was characteristically made of much thicker metal than those used in astronomy and heavily weighted at the base to minimize its movement on board ship. This Spanish or Portuguese example was found in 1845 on Valentia Island near the area off southern Ireland, where three vessels from the Spanish Armada sank.

NAV0022 / 8450

(Bottom left)
OCTANT PRESENTED TO JOHN AND WILLIAM HARRISON
Unknown maker
1761

This brass and mahogany octant was presented to John and William Harrison to mark the successful trial of John Harrison's fourth marine timekeeper (H4) during a voyage to the West Indies and back on HMS *Deptford*. An octant was needed along with a chronometer, as the marine timekeeper came to be called, for finding longitude at sea. The octant was used for determining local time, from the Sun or stars, which was then compared with the time shown by the chronometer to work out the longitude of the ship. The octant had been invented by the scholar John Hadley, who described it to the Royal Society in London in 1731.

NAV1251 (S.4) / 2097

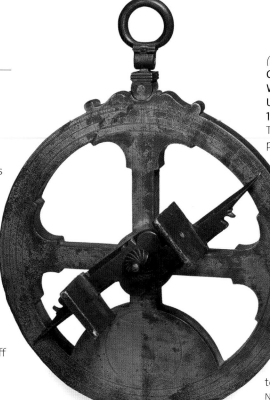

(Opposite, bottom right)
SEXTANT
Jesse Ramsden
c. 1770
The marine sextant was developed in
the late 1750s by Captain John Campbell
and the instrument maker John Bird.
This example, made by the great
instrument maker Jesse Ramsden, dates
from around 1770. The angle is read off
the curved scale at the bottom of the
instrument and the vernier scale on the
arm. It is made of brass with a wooden
handle and its open design minimizes
the effect of high wind. It has a 15 in.
(38 cm) radius and a scale capable of
measuring 120 degrees. It is thought
to have been supplied by the Board of
Longitude for Captain James Cook's
third voyage to the Pacific between
1776 and 1780.
NAV1236 / C8745

(Right)
**PRESENTATION SET OF IVORY
NAVIGATIONAL INSTRUMENTS**
Thomas Tuttell
c. 1700
The set includes:

Cross-staff *(Centre)*
The cross-staff enabled the navigator
to work out his latitude by measuring
the height above the horizon of the Sun
or the Pole Star. The main staff was held
to the eye and pointed at the object
to be measured; one of
the crosses was chosen
and moved up the staff
until the top appeared
to touch the object and
the lower end the horizon. The altitude
of the celestial object could then be read
off the scale on the main staff. The
cross-staff was
originally used by
astronomers but
was adapted for
nautical use by
the Portuguese in the fifteenth century.
Cross-staves for ordinary use were
normally made of wood.

Back-staff *(Top)*
The back-staff, or 'Davis quadrant',
was invented by the English navigator,
John Davis, in about 1594. During his
voyage to the Arctic, he found it difficult
to use a cross-staff to find his latitude
because of the glare so he devised the
back-staff to enable the navigator to
make an observation without having
to look directly into the Sun. The
observer held the instrument with
the short arc uppermost and stood
with the Sun behind him. He then
observed the horizon through both
a small hole in the sight on the large arc
and through the slit in the horizon vane,
then aligned the shadow from the vane
on the small arc with the horizon.

Gunter scale *(Bottom)*
A Gunter scale was a straight rule on
which were engraved mathematical
scales used for logarithms and
trigonometry. It was devised by the
mathematician, Edmund Gunter, in
about 1607. This example is 24 in. (61 cm)
long. Gunter scales were used with
dividers by navigators for making the
calculations necessary to determine
their position and plot it
on a chart.
NAV0505, NAV0040
& NAV0107 / D0423

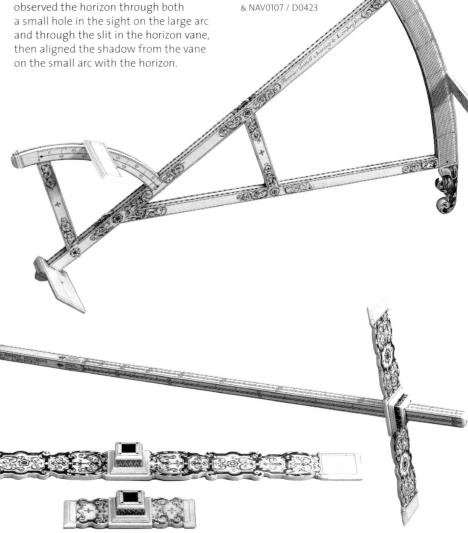

THE NAVY IN THE AGE OF SAIL

Brian Lavery

The English Royal Navy was a mainly defensive force until the middle of the seventeenth century, its power rising and falling according to the inclinations and needs of the reigning monarch. It trebled in size to 150 ships under Oliver Cromwell and after that it continued to grow. During three wars with the Dutch, 1652–74, it developed the tactic of the line of battle in which all the major ships formed a single line. At the same time, Samuel Pepys did much to set the naval administration on a permanent footing.

For a century and a quarter after James II was deposed by William of Orange in 1688, France was the main enemy. The United Kingdom (as formed by the union with Scotland in 1707) was at war with France for more than half of the eighteenth century, and there were also conflicts with the Spanish, Dutch, Danes, Russians, Turks and other naval powers.

In the first phase, up to 1714, the wars were about the rising power of Louis XIV of France; in the middle phase (1739–83) they were about the control of colonies in the Americas, India and the West Indies. In the final phase (1793–1815) the British aim was to prevent the spread of the French Revolution and the power of the Emperor Napoleon. By the end of the French wars in 1815, the Royal Navy had more than a thousand ships.

Ranking top of the naval order were the great ships of the line, so called because they were strong enough to stand in the line of battle against the largest opponents. For most of the century the biggest were three-deckers of 100 guns, exemplified by Nelson's *Victory*, launched in 1765. The minimum size of a ship of the line tended to increase over the years, from 50 guns in 1700 to 74 in 1815. The 74-gun ship was influenced by French design in the middle of the eighteenth century but not directly copied from it. By the 1770s it formed the majority of the line of battle.

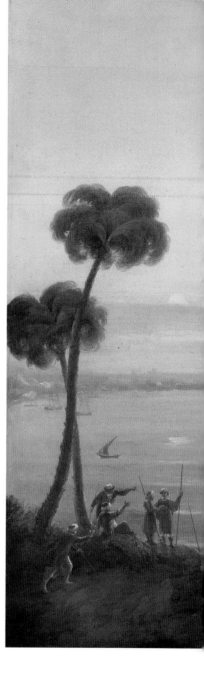

The Battle of the Nile, 1798,
Nicholas Pocock.
BHC0513

Next in the scale were the frigates, which also evolved in the middle years of the eighteenth century. They carried a single deck of guns and sailed well, and were powerful enough to take on enemy frigates. They carried out many other duties, including fleet reconnaissance and convoy escort. Sloops were smaller versions, and brigs had two masts instead of three. Below them were smaller ships of specialized rig, such as schooners or cutters, or of specialized function such as fireships and bomb vessels.

The naval officer corps began to evolve under Pepys, with fixed ranks and examinations for

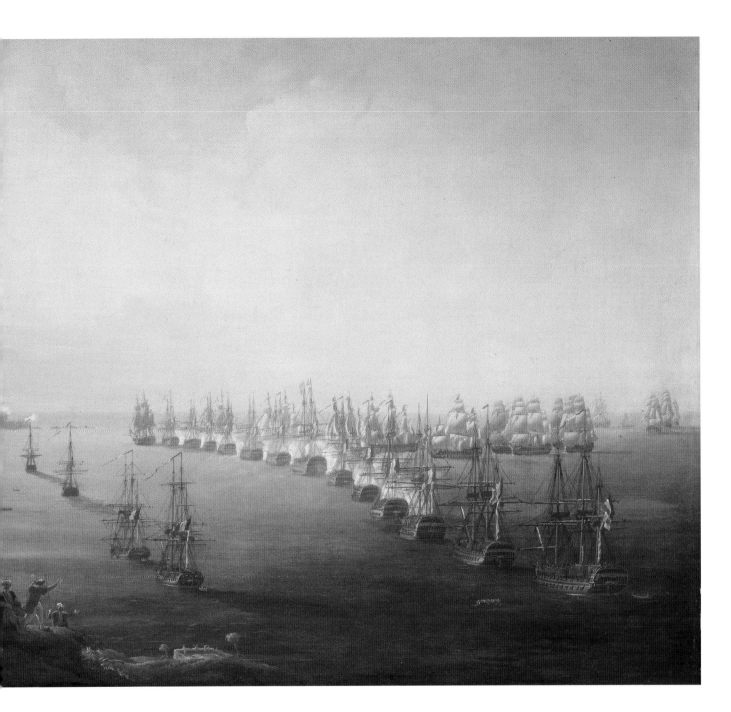

promotion. It offered a good career for a young gentleman, with a unique opportunity to combine service to the king with the chance to become rich through prize-money after the capture of enemy ships. Declining aristocratic families were able to restore their fortunes, while others rose from the merchant class to the gentry.

The Navy was far less successful in attracting ordinary sailors to the fleet, and relied on press-gangs to recruit the experienced merchant seamen who would form the core of a warship's crew. Seamen were proud of their skills and fought well in battle but they were constantly liable to desert. Their discontent led to many mutinies, culminating in those at Spithead and the Nore in 1797, which formed a very real threat to the survival of the British state.

The great naval battle was the high point of naval power, as perceived by the public and the Navy. In the first half of the eighteenth century over-rigid tactics tended to make battles indecisive. This began to change in the second half, with decisive British victories at Quiberon Bay (1759) and the Saints (1782). The French Revolutionary War, which began in 1793, saw three great victories, including Admiral

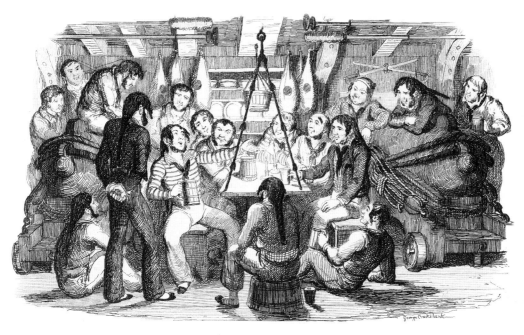

SATURDAY NIGHT AT SEA.

Duncan's destruction of the Dutch fleet at Camperdown in 1797, before Nelson won the first of his great battles at the Nile in 1798, almost annihilating the enemy. He defeated the Danes at Copenhagen in 1801, though the fight was far less decisive and the success depended partly on negotiation and a change in the political circumstances. At Trafalgar in 1805 there was no doubt about the scale of the victory against the French and Spanish, though Nelson lost his life, to the great grief of his countrymen.

The Navy had many other tasks to carry out. It blockaded the main enemy fleets in ports and this tactic was a cornerstone of naval strategy by the 1740s. In convoys of up to a thousand, it escorted merchant ships to protect them against enemy privateers. It landed troops in many parts of the world, with campaigns in the West Indian islands and a notable landing in Egypt in 1801. Most important of all, it formed the country's main defence against invasion; for example, in 1803–05 when the French built up a great flotilla of invasion craft at Boulogne.

The Navy was supported by the six Royal Dockyards, the largest industrial units in the world

Above: Saturday Night at Sea,
George Cruikshank, c. 1820.
PAI9813 / 3646

Right: The Battle of the Texel,
11–21 August 1673,
Willem van de Velde,
the Younger.
BHC0314

at the time. They launched many ships, though others were built by privately owned shipyards on the Thames and around Portsmouth and Plymouth. The main work of the dockyards was the maintenance and repair of ships, including dry-docking. They made and stored all kinds of naval goods, including anchors and rope.

The naval campaigns of the age also produced a great wealth of art and crafts, which is well

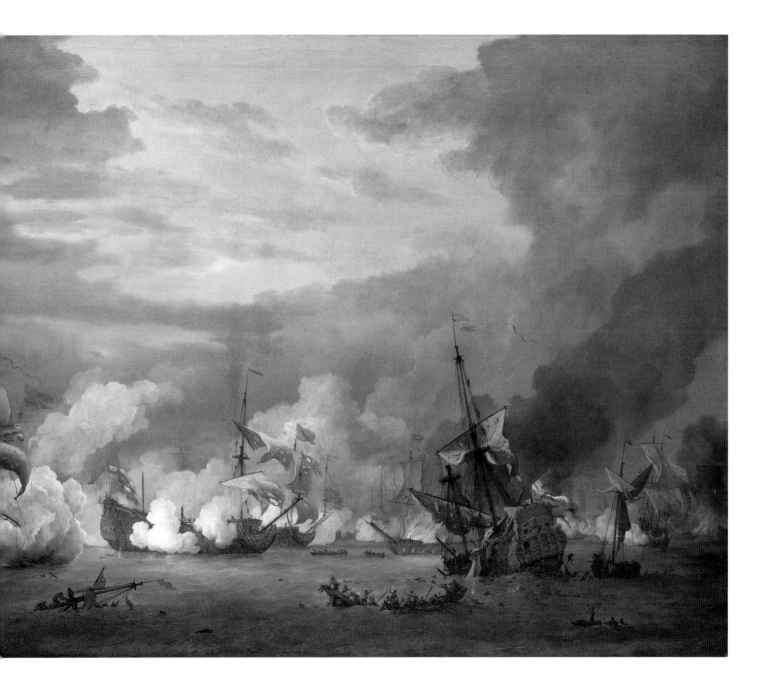

represented in the Museum. The type of ship model of the late seventeenth century, known as the 'Navy Board model', reached a peak around 1730. England became the leading centre of marine painting after the van de Veldes arrived here from the Netherlands in the 1670s. A native style was developed by artists such as Brooking, Serres and Pocock, and the sea had a profound influence on the genius of Turner. Thousands of artefacts were produced to

commemorate naval victories and other events, ranging from cheap plates and mugs to the gold boxes and medals presented to victorious commanders.

The wars of 1688–1815 are at the centre of naval history and tradition. They created a confidence in British sea power which has never really faded, despite a much-reduced fleet. They provided the iconic figure of Nelson, the best of many successful admirals, and thousands of brave and skilled seamen.

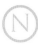

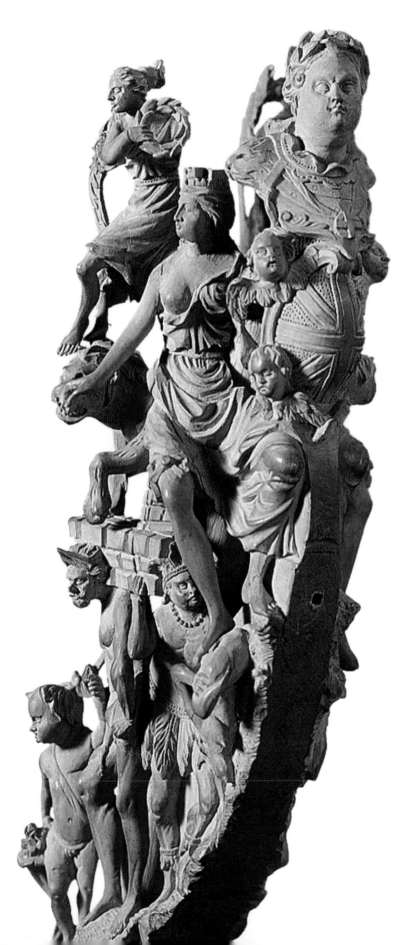

NELSON, VISCOUNT HORATIO

(Opposite)
VICE-ADMIRAL HORATIO NELSON
(1758–1805)
Lemuel Abbott
1798–99

Horatio Nelson, Britain's greatest sea commander, was born in Norfolk in 1758. He entered the Navy as a boy under the protection of his uncle and rose rapidly to become a captain at the age of twenty. In 1798, as a rear-admiral, he defeated the French at the Battle of the Nile, and three years later he fought the Danes off Copenhagen. Though married to Frances Nisbet, he conducted a passionate affair with Emma, Lady Hamilton. In 1805, after two years in command of the Mediterranean fleet, he was killed at the moment of victory in the Battle of Trafalgar. One of the best-known portraits of Nelson, this shows him as a rear-admiral, soon after the Battle of the Nile. The artist worked from earlier sketches and was unaware that, due to a battle wound, Nelson had to wear his hat tipped back. The hat bears the *chelengk*, an amazing clockwork decoration, presented by the Sultan of Turkey, also painted by guesswork.
BHC2889

(Left)
MODEL OF THE ORIGINAL FIGUREHEAD
OF HMS *VICTORY*
William Savage

Victory, Nelson's famous flagship, was launched in 1765, and this carver's model from 1763 shows the detail of the original, pre-Trafalgar-rebuild design. The figurehead symbolizes Britain's victory over France and Spain in the Seven Years War (1756–63), noting the global nature of the conflict and Britain's expectation of peace and prosperity. A bust of George III and a shield bearing the Union flag are supported by the four winds. On the starboard side, Britannia is crowned by Peace. She steps on the defeated figures of Envy, Discord and Faction. The figures of Europe, America and Plenty are also depicted. On the port side, Victory and Fame trample on Rebellion, with representations of Africa, Asia and Navigation in support.
FHD0109 / D5909

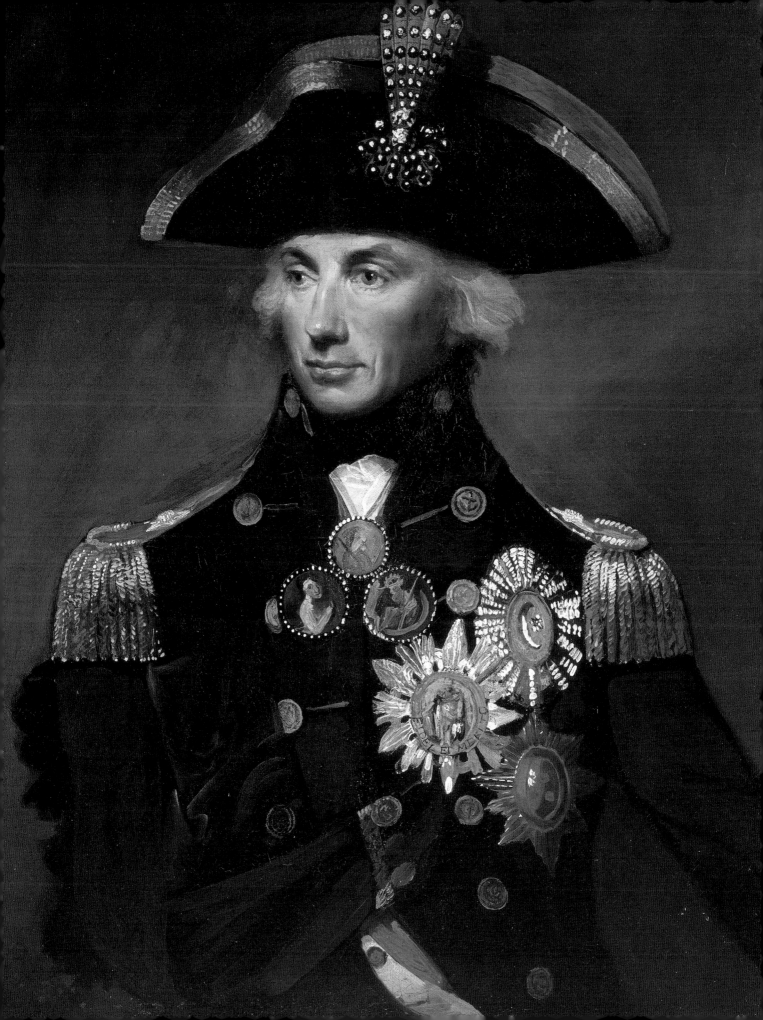

Theseus July 27th 1797

My Dear Sir

I am become a burthen to my friends and useless to my Country Got by my letter wrote the 24: you will perceive my anxiety for the promotion of My son in law Josiah Nisbet, when I leave your Command, I become dead to the World I go hence and am no more seen, If from poor Bowen's loss, You think it proper to oblige me I rest confident you will do it, the Boy is under obligations to Me but he repaid me by bringing Me from the Mole of Santa Cruz. I hope you

will be able to give me a frigate to convey the remains of my carcase to England, God Bless You My Dear Sir & Believe Me your

Most Obliged & faithful
Horatio Nelson

You will excuse My Scrawl considering it is my first Attempt

Sir John Jervis K.B.th

This Letter was bequeathed to Admiral Sir William Parker Bart G.C.B by his Uncle by marriage and kinsman, Admiral Sir John Jervis K.B, afterwards Earl of St Vincent, to whom it was addressed.

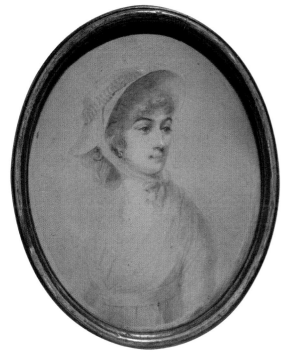

(Top left)
FRANCES NELSON
Daniel Orme
1798
As senior captain in the Leeward Islands, 1785–87, Horatio Nelson became isolated because he insisted on enforcing the Navigation Acts and trying to stop trade with the United States. He met Frances Nisbet, a widow of the same age, on the island of Nevis, where her uncle was governor. They were married there in 1787 and spent the next five years at Burnham Thorpe while Nelson was unemployed. The marriage deteriorated rapidly after Nelson became involved with Lady Hamilton in 1799, though Lady Nelson was always faithful. She died in 1831.
MNT0047 / A0094

(Bottom left)
GOLD RING BELONGING TO NELSON
A ring with the bezel moulded in the form of two clasped hands of the type known as a 'fede ring'. It is one of a pair exchanged by Nelson and Emma Lady Hamilton (Emma's ring is in the collection of the Royal Naval Museum, Portsmouth). Nelson's ring was passed down through the family of his daughter Horatia Nelson-Ward. The entry for the ring in the catalogue of the Royal Naval Exhibition in 1891 says that it was 'taken from Lord Nelson's hand after death'.
JEW0168 / D5575

(Above, right)
WATCH NO. 1104 (NOW MOUNTED AS A CARRIAGE CLOCK)
Josiah Emery
c. 1783 (case *c.* 1850)
Worn by Nelson at the Battle of Trafalgar, this watch was fitted into its current carriage-clock style case in about 1850 (the cost of this conversion may have been met by selling the original gold watch-case). The front panel of the clock-case is engraved 'The Chronometer of Horatio Viscount Nelson worn by him at the Battle of Trafalgar, placed in this case by his niece, Charlotte Mary, Lady Bridport, to be preserved for any one of her descendants who may enter the Navy'.
JEW0248 / E2053

(Opposite)
NELSON'S FIRST LETTER WITH HIS LEFT HAND
Horatio Nelson
1797
When Nelson had his right arm amputated off Tenerife in 1797, it was far more traumatic than the loss of the sight of his right eye in 1794, the seriousness of which only gradually became apparent. Nelson was exhausted and depressed after the amputation and his physical pain can almost be felt in the writing. Despite his anxieties, he was nursed back to health by Lady Nelson and was back with the fleet in the following spring.
B8623-A & B8623-B

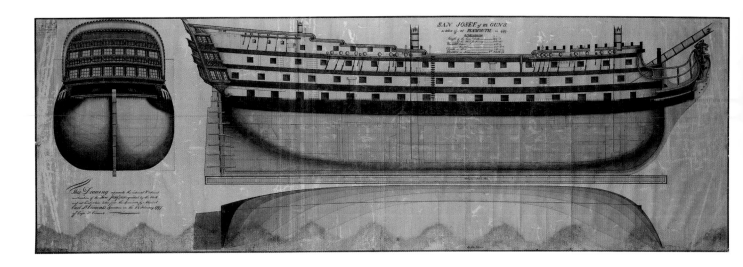

(Above)
SAN JOSEF
The Navy Board
1797
San Josef was captured by Nelson at the Battle of Cape St Vincent in February 1797. This occasion became known as 'Nelson's Patent Bridge for Boarding First-rates' as he captured *San Josef* from the deck of another captured Spanish vessel, *San Nicolas*. *San Josef* was refitted in 1801 at Plymouth as the only prize first-rate to serve in the Royal Navy. Due to her glorious capture and size – 114 guns – the ship merited a full-colour plan, unusual for this era of Admiralty draughts.
ZAZ0100 / D9697

(Below)
SILVER-GILT-HILTED SMALL-SWORD
R. Clarke
1797
This sword is inscribed: 'Presented by Commodore Nelson to Capn George Cockburn of His Majesty's Ship Le Minerve in Commemoration of two gallant Actions fought on the 19 and 20 Decr 1796'. In 1796, Nelson and Cockburn sailed from Gibraltar for Elba, capturing two Spanish frigates *en route*. Cockburn was promoted to Admiral of the Fleet in 1851 and had his portrait painted, wearing this sword, by William Beechey.
WPN1167 / E1280

(Right)
CITY OF LONDON FREEDOM BOX
James Morisset, London
1798
Captain Edward Berry commanded Nelson's flagship *Vanguard* at the Battle of the Nile on 1 August 1798. Following this popular victory Nelson and his captains received valuable rewards and Captain Berry was granted the Freedom of the City of London, together with this 100-guinea gold and enamel box by the celebrated goldsmith James Morisset. The finely painted enamel lid depicts the moment in the battle when the French flagship *L'Orient* exploded with such deafening effect that the action was silenced for several minutes. The base of the box is engraved with a broadside view of *Vanguard*.
PLT0023 / D4590-1

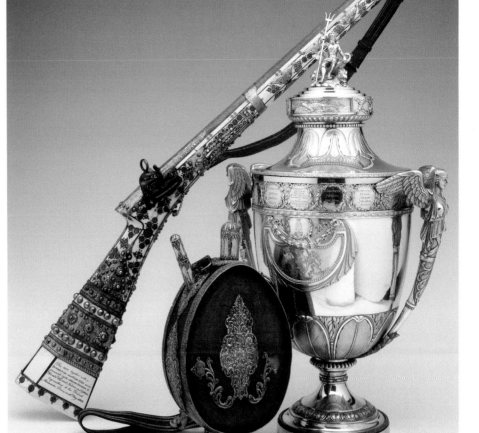

(Right)
TURKISH FLINTLOCK RIFLE, CANTEEN AND NILE TURKEY CUP
c. 1798–1799

This rifle and canteen were presented to Admiral Nelson by the Sultan of Turkey after Nelson's defeat of the French at the Battle of the Nile in 1798. Ivory-stocked, the rifle is decorated with silver and gilt studs and with bands of gilt brass and mother-of-pearl. Engraved on the butt is: 'This gun together with a scymeter and canteen were presented by the Grand Signior to Horatio Viscount Nelson and by Will bequeathed to his Friend Alexander Davison 10th May 1803'.

As another memento of the Battle of the Nile, Nelson received a valuable silver presentation from the Governor and Company of Merchants trading into the Levant, which he referred to as his 'Turkey Cup'. The design of the cup, made by Paul Storr of London, one of the leading craftsmen of the time, includes several references to the Nile, from the winged Egyptian female figures which form the handles, to the crocodile on the cover and the list of prizes taken in the battle, which appear in laurel wreaths around the top. Nelson's coat of arms on the side displays his newly acquired augmentations, motto and crest, all granted to mark the victory. The finial of the cover is in the form of a seated Neptune, which, according to a complaining letter written by Nelson to his wife in 1801, arrived on board his ship with the trident 'bent double from ill package'.

AAA2565 / D4424

(Right)
BATTLE OF THE NILE MUGS
Derby
1798

After the Battle of the Nile on 1 August 1798, Lord Nelson's friend and prize-agent, Alexander Davison, commissioned some fine porcelain items from the Derby factory as presentation pieces. Only five of these pieces are known to exist today. The roundels painted in full colour on these pieces are the obverse and reverse designs of the Nile medals, also paid for by Davison, presented to every officer and man who had served at the Nile. The design on the large mug is a figure of Peace supporting a medallion portrait of Nelson, while the chocolate cup has a view of the rival fleets in Aboukir Bay.

AAA4737 & AAA4738 / D5528

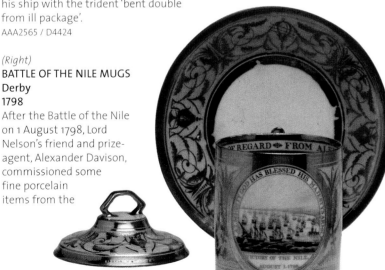

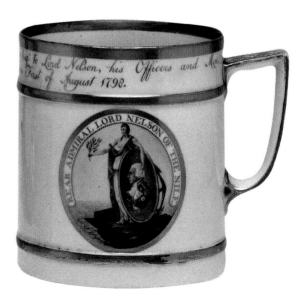

(Right)
MALTA
R. Bougard and John Thomas Serres
1801

When this chart was published, Malta was at a crucial point in its history. In 1798, Napoleon expelled the Knights of the Order of St John from Malta and took control. In 1800 the Maltese revolted against the French and sought British assistance. Returning from his victory at the Battle of the Nile, Nelson ordered a blockade of the French garrison in Valletta and starved them into submission. Malta came under British protection. The chart was originally drawn by a French cartographer, le Sieur Bougard, in the late seventeenth century and has additions and corrections by J. T. Serres, 'marine painter to his majesty … and marine draughtsman to the Admiralty' and son of the artist Dominic Serres.
BOU02 / D8274

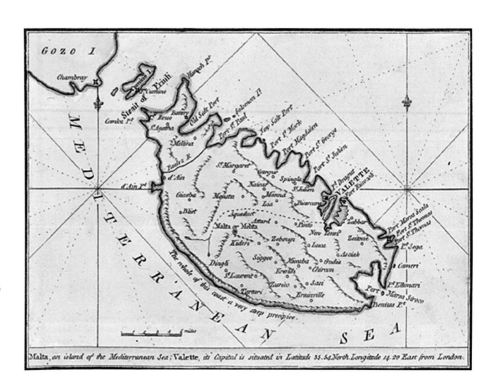

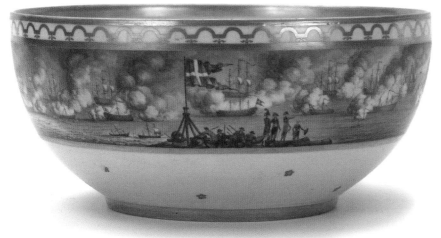

(Above)
COPENHAGEN PUNCH-BOWL
Royal Danish Porcelain Manufactory, Copenhagen
1807

Nelson's third great battle, off Copenhagen on 2 April 1801, was the least popular of his victories, since the Danes were not a traditional enemy of Britain. The battle produced few souvenirs from the British side, compared with the Nile and Trafalgar, but this fine porcelain punch-bowl was one of a series commissioned by a Dane. The panoramic scene of the battle is after a watercolour by C. A. Lorentzen. The bowl is dedicated to Olfert Fischer (the Danish commander) and all brave Danes. Governor Roepstorff ordered twenty-one of the coloured bowls for presentation to Danish naval officers for their defence of Copenhagen and a further twenty-three in monochrome for the less high-ranking officers.
AAA4773 / D0852-17

(Below)
NELSON'S SEAL
1800

An ivory-handled silver desk seal representing Nelson's coat of arms as a baron with his crests of the *chelengk* and the stern of his Spanish prize, the *San Josef*. It was used at the Battle of Copenhagen in 1801 to seal the truce document in which Nelson threatened to set fire to the floating batteries captured from the Danes unless they agreed to a ceasefire.
JEW0078 / D5828

(Below)
NELSON'S BREAKFAST SERVICE
Chamberlain's, Worcester
c. 1802
In August 1802, Lord Nelson visited the Royal Porcelain Factory at Worcester with Sir William and Lady Hamilton and put in a large order for porcelain to be decorated with his arms. By the time of his death in 1805 only the breakfast service had been completed. The Museum has a number of pieces of the service, including these egg cups and muffin dish with a double bottom to hold hot water. The design chosen by Nelson was a standard Worcester Japan pattern but his personal crests and coronets were inserted and his full coat of arms appeared on the two teapots in the service.
AAA4541 / D5950

(Above)
A LETTER FROM NELSON TO ADMIRAL KINGSMILL
Horatio Nelson
1804
Here Nelson lists his injuries ' . . . eye in Corsica, Belly off Cape St Vincent, Arm at Tenerife, Head in Egypt. I ought to be thankful that I am what I am'. He lost the sight of his right eye during the siege of Calvi, in north-west Corsica, in 1794, from sand thrown up by enemy shot at a land battery.
MSS/87/051 / D3755

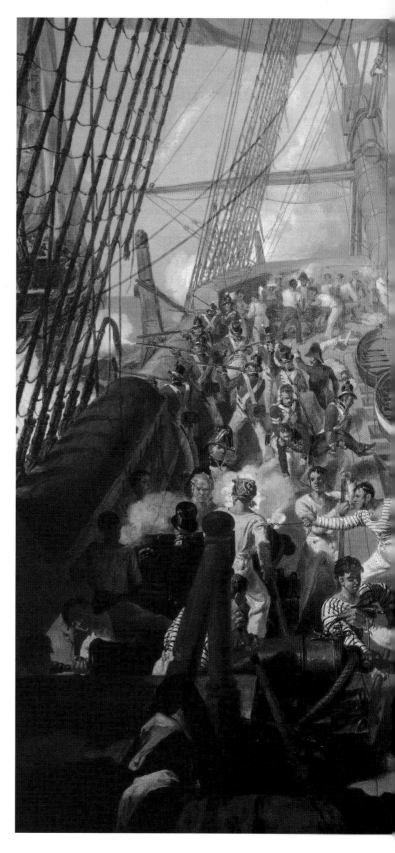

LIFE MASK OF NELSON
c. 1800

This striking image of Lord Nelson was believed to be a death mask taken at the request of his sister by the surgeon, Dr Beatty. There is no contemporary report of a death mask having been taken and recent research has suggested that it is actually a life mask made several years before Nelson's death. A commemorative engraving by P. W. Tomkins showing the marble bust by Thaller and Ranson, for which Nelson sat in Vienna in 1800, has an inscription stating that Nelson permitted a cast to be taken from his face by Franz Thaller as an aid to perfecting the bust. This is confirmed by the portrait painter Sir William Beechey, who in describing the Thaller and Ranson bust wrote

'…the Bust, tho it was done from a cast from his face is very deficient; he pursed up his chin and screwed up his features when the Plaister was poured on it'.
SCU0106 / D6591-1

134

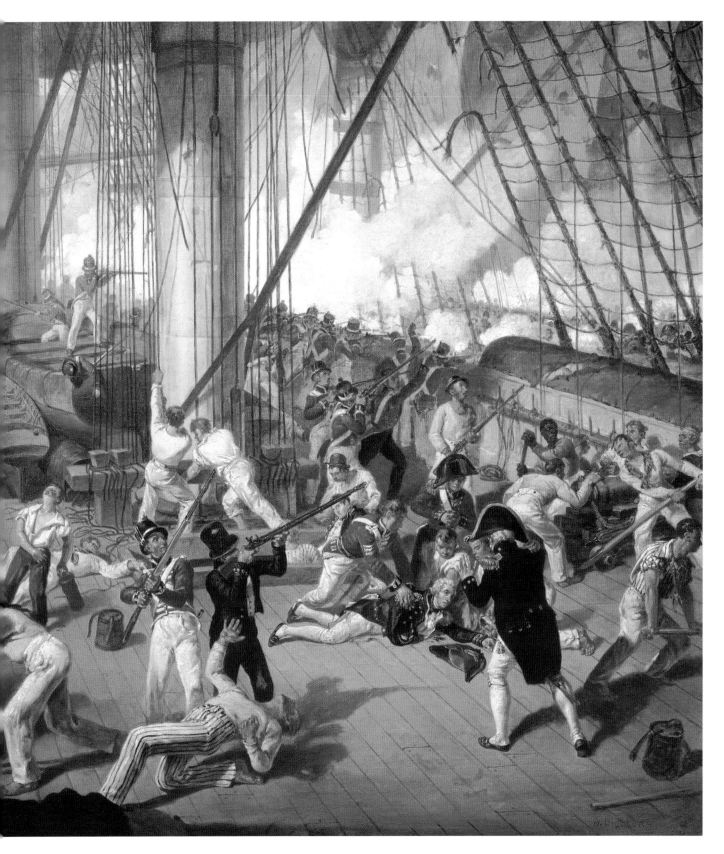

DEATH OF NELSON
Dennis Dighton
*c.*1825
Nelson, mortally wounded by a musket shot from one of the tops of the French ship *Redoutable*, falls to the deck to the right of centre. Captain Hardy rushes to his aid, as do a marine sergeant and several seamen. The picture provides much detail on the conduct of a naval battle at close quarters and the work of gun crews, as well as showing the circumstances of Nelson's death.
BHC0552

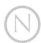

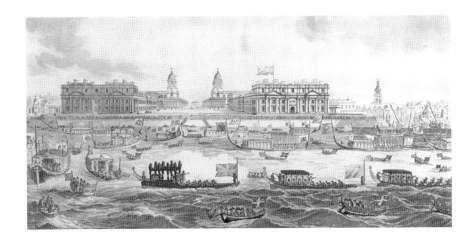

(Opposite)
UNDRESS UNIFORM WORN BY NELSON AT TRAFALGAR, 1805

As the fleet sailed into the Battle of Trafalgar, Nelson put on his 'undress' uniform, used for everyday wear and informal occasions. His officers intended to persuade him to cover up his decorations, which made him a clear target for enemy snipers, but they never had the chance. Nelson was shot through the shoulder by a marksman in the mizzen top of the French *Redoutable* and the bullet passed through his spine. He was carried below and his breeches were cut from him by the surgeon. He died a few hours later. The coat and waistcoat were returned to Lady Hamilton, by whom they were surrendered to Alderman Joshua Jonathan Smith, in discharge of debts. They were purchased by the Prince Consort in 1845, who presented them to Greenwich Hospital. The breeches and stockings also came into Greenwich Hospital's collections via the daughter of HMS *Victory*'s Lieutenant of Marines, Lewis Rotely.
UNI0024, UNI0065, UNI0067 & UNI0021 / B9701, 4468-1 & 4468-2

(Above)
NELSON'S FUNERAL
A. C. Pugin
1806

After his death at the Battle of Trafalgar the body of Admiral Lord Nelson was returned to Portsmouth. Later, it lay in state in the Painted Hall at Greenwich Hospital for four days. His coffin was then rowed up a very choppy River Thames in a

procession made up mainly of City Livery Company barges. It was landed and taken to the Admiralty in Whitehall for the night before his funeral.
PAH7324 / PY7324

(Right)
FIGUREHEAD FROM NELSON'S FUNERAL CARRIAGE
1806

On 9 January 1806, Nelson's coffin was transported through the crowded streets from Whitehall to St Paul's Cathedral, in a cortège that stretched all the way

between the two places, and was buried during a four-hour service. The carriage was a replica of HMS *Victory* and had a miniature figurehead, depicting Victory or Fame holding aloft a laurel wreath.
FHD0093 / D5510

(Left)
ODDFELLOWS BADGE COMMEMORATING NELSON

This charming ivory badge in a silver mount shows a seaman and Britannia mourning over an imaginary monument to Nelson. An inscription around the edge reads LOYAL.TRAFALGAR.LODGE.OF.ODD. FELLOWS. LD. NELSON.DAWLEY.GREEN. SHROPSHIRE. The Oddfellows were a friendly society with customs similar to the Freemasons. Many items commemorating Nelson are decorated with Masonic symbols.
JEW0356 / F3155

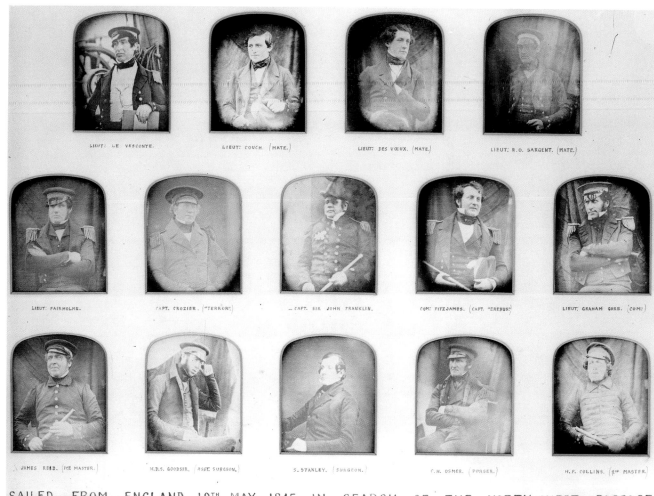

LIEUT: LE VESCONTE. LIEUT: COUCH. (MATE.) LIEUT: DES VŒUX. (MATE.) LIEUT: R.O. SARGENT. (MATE.)

LIEUT: FAIRHOLME. CAPT. CROZIER. ("TERROR".) — CAPT. SIR JOHN FRANKLIN. COM: FITZJAMES. (CAPT. "EREBUS".) LIEUT: GRAHAM GORE. (COM:)

JAMES REID. (ICE MASTER.) H.D.S. GOODSIR. (ASST. SURGEON.) S. STANLEY. (SURGEON.) C.H. OSMER. (PURSER.) H.F. COLLINS. (2ND MASTER.)

SAILED FROM ENGLAND 19TH MAY 1845 IN SEARCH OF THE NORTH-WEST PASSAGE

NORTH-WEST PASSAGE

(Above)

SIR JOHN FRANKLIN AND THE OFFICERS OF HMS *EREBUS*, MAY 1845
Unknown photographer
1845

The original mounting for these photographs read, 'Officers of Sir John Franklin's Expedition, The White North has their Bones'. In 1845 Sir John Franklin was chosen to command two ships, HMS *Erebus* and *Terror*, to find the North-West Passage between the Atlantic and Pacific Oceans via the Arctic Circle. These posed studio portraits, taken at a time when photography was a very modern invention, suggest the importance of this exploration to the prestige of Britain. The ships were last seen in Baffin Bay on 26 July 1845 and few remains have ever been found. A message discovered in 1859, dated 25 April 1848, showed that Franklin died on 11 June 1847 after his ships had become trapped in ice.
8859

(Opposite)

FRANKLIN EXPEDITION'S LAST MESSAGE
1847

This stained and emotive document is the all-important last message from the 1845 Arctic expedition led by Sir John Franklin in search of the North-West Passage. A search expedition led by Captain Francis Leopold McClintock recovered the note in 1859 in a cairn near Point Victory, King William Island. Two messages written a year apart on a standard printed form told the sad story. The annotations briefly summarized the first two years of the expedition and revealed that Franklin had died in June 1847, that another nine officers and fifteen men had also died and that the remaining members of the expedition had left the ships in April 1848 in a forlorn attempt to reach safety via Back's Fish River. Those who wrote these entries also died, as did the entire expedition – 128 men in all.
MSR/C/9 / D2184

(handwritten, top margin, various notations)

H. M. S. *ships Erebus and Terror*
{ Wintered in the Ice in

28 of *May* 1847 { Lat. 70° 5' N Long. 98° 23' W

Having wintered in 1846—7 at Beechey Island
in Lat 74° 43' 28" N. Long 91° 39' 15" W after having
ascended Wellington Channel to Lat 77°— and returned
by the West side of Cornwallis Island .

Commander.

Sir John Franklin commanding the Expedition

All well

WHOEVER finds this paper is requested to forward it to the Secretary of
the Admiralty, London, *with a note of the time and place at which it was
found*: or, if more convenient, to deliver it for that purpose to the British
Consul at the nearest Port.

QUINCONQUE trouvera ce papier est prié d'y marquer le tems et lieu ou
il l'aura trouvé, et de le faire parvenir au plutot au Secretaire de l'Amirauté
Britannique à Londres.

CUALQUIERA que hallare este Papel, se le suplica de enviarlo al Secretario
del Almirantazgo, en Londrés, con una nota del tiempo y del lugar en
donde se halló.

EEN ieder die dit Papier mogt vinden, wordt hiermede verzogt, om het
zelve, ten spoedigste, te willen zenden aan den Heer Minister van de
Marine der Nederlanden in 's Gravenhage, of wel aan den Secretaris der
Britsche Admiraliteit, te London, en daar by te voegen eene Nota,
inhoudende de tyd en de plaats alwaar dit Papier is gevonden geworden

FINDEREN af dette Papiir ombedes, naar Leilighed gives, at sende
samme til Admiralitets Secretairen i London, eller nærmeste Embedsmand
i Danmark, Norge, eller Sverrig. Tiden og Stædit hvor dette er fundet
önskes venskabeligt paategnet.

WER diesen Zettel findet, wird hier-durch ersucht denselben an den
Secretair des Admiralitets in London einzusenden, mit gefälliger angabe
an welchen ort und zu welcher zeit er gefundet worden ist.

(handwritten around margins) party consisting of . . . Officers and 6 Men
left the Ships on Monday 24th May 1847 —

(signatures)

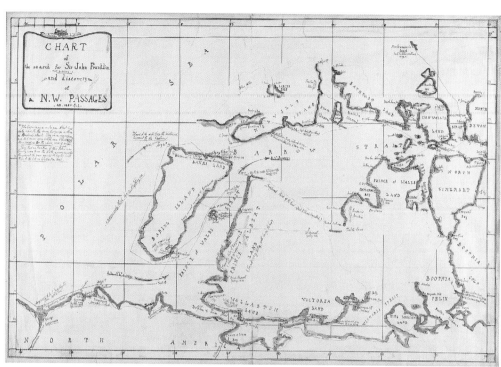

a week of Inglefield's return, the Admiralty engraved and published a version of this chart.
G285:4/36 / E2234

Hanoverian Guelphic Order on 25 January 1836. The badge of the order has the white horse of Hanover in the centre surrounded by the motto *NEC ASPERA TERRENT* (Nor do difficulties daunt).
AAA2079 / D5780

(Top left)
THE NORTH-WEST PASSAGE
E. A. Inglefield
1853
In 1853, Commander Inglefield was sent to the Arctic to make contact with the ships searching for the Franklin expedition. He learnt that the search parties had at last found the North-West Passage but no traces of Franklin. As Inglefield sailed home, he plotted out on this sketch chart the information he had received, including the coastline newly discovered and the tracks and remarks of the explorers. He recorded comments about the natural features and the 'Esquimaux'. Such was the demand for news in England that within

(Top right)
BADGE OF A KNIGHT COMMANDER, ROYAL HANOVERIAN GUELPHIC ORDER, AWARDED TO SIR JOHN FRANKLIN (1786–1847)
1836
The first search expedition to hear news of Franklin's fate was led by Dr John Rae of the Hudson's Bay Company. During the spring and summer of 1854, he purchased many small items belonging to members of the expedition from Inuit at Pelly Bay and Repulse Bay. They told him that Franklin's crews had abandoned ship near King William Island. This item, which Rae bought from the Inuit, belonged to Franklin himself. He was made a Knight Commander of the Royal

(Above)
A DOUBLE-BARRELLED 10-BORE PERCUSSION SHOTGUN TAKEN ON THE FRANKLIN EXPEDITION
1845
Captain McClintock's expedition in 1859 to search for Franklin and his crew discovered the boat from the *Erebus*, mounted on a sledge at the western extremity of King William Island. Two loaded shotguns were found propped up against the boat, which contained two skeletons and the remains of equipment and personal possessions from the ill-fated expedition.
AAA2531 / D6106

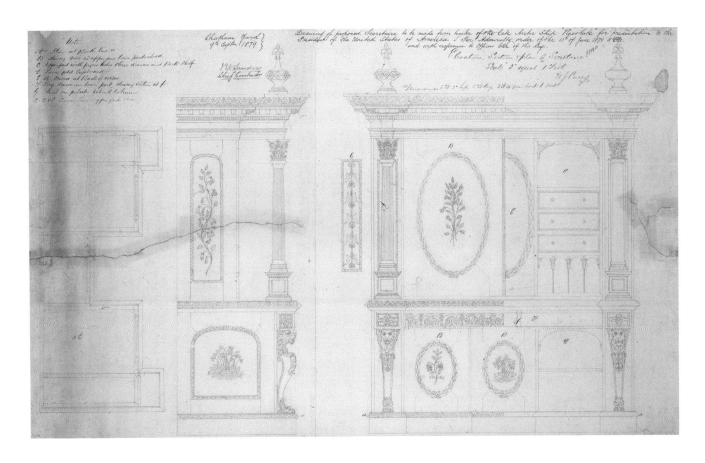

(Left)
POCKET CHRONOMETER NO. 980
Parkinson and Frodsham
c. 1810
One of five watches discovered on King William Island in 1859 by Captain McClintock of the steamship *Fox*.
AAA2203 / D9246

(Above)
PLAN OF A DESK FOR THE PRESIDENT OF THE USA MADE FROM TIMBERS OF HMS *RESOLUTE*
The Navy Board
1879
HMS *Resolute* was one of the ships commissioned by the Admiralty in 1852 to search for Sir John Franklin. There had been no word from Franklin since he had left England in 1845. The *Resolute* itself was caught fast in ice floes and was abandoned, the crew being rescued by the *North Star*. An American whaling ship, the *George Henry*, discovered the *Resolute* in 1855, more than a thousand miles from her original position. The *Resolute* was sailed back to New London, Connecticut, where the US government restored and refitted the vessel and returned it to Britain. Queen Victoria later ordered that timbers from the *Resolute* be made into a desk for the US President as a token of goodwill to the American people.
E8876-1

OCEAN LINERS

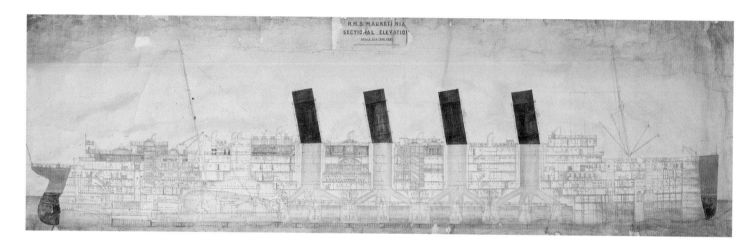

(Above)
MAURETANIA
Unknown draughtsman
1908

The *Mauretania* was built by Swan
Hunter & Wigham Richardson at
Wallsend-on-Tyne and launched in 1906.
Prior to completion, the owners of the
Mauretania, the Cunard Line, agreed
with the Admiralty that the ship was
to be available to the country in times
of war as an armed merchant cruiser.
This inboard profile plan was made
for the Admiralty, partly to show
where the guns would be positioned.
Mauretania was commissioned as a
troopship and hospital ship during
World War I and was withdrawn
from passenger service in 1934.
NPB6674 / D5782-2

(Opposite)
AQUITANIA; THE LOUIS XVI
DINING SALON
H. Bedford Lemère
1914

The early years of the twentieth
century saw intense competition
in the transatlantic passenger trade.
Each new ship built was publicized as
the largest and fastest in the world.
Although the *Aquitania* was not built
to win speed ribands, her lavish décor
and sumptuous facilities attracted the
attentions of the world's richest people.
The restaurant on D Deck, for the 600
first-class passengers, was decorated
in Louis XVI style with rich blue carpets
and satinwood furniture with
blue silk covers.
G10892

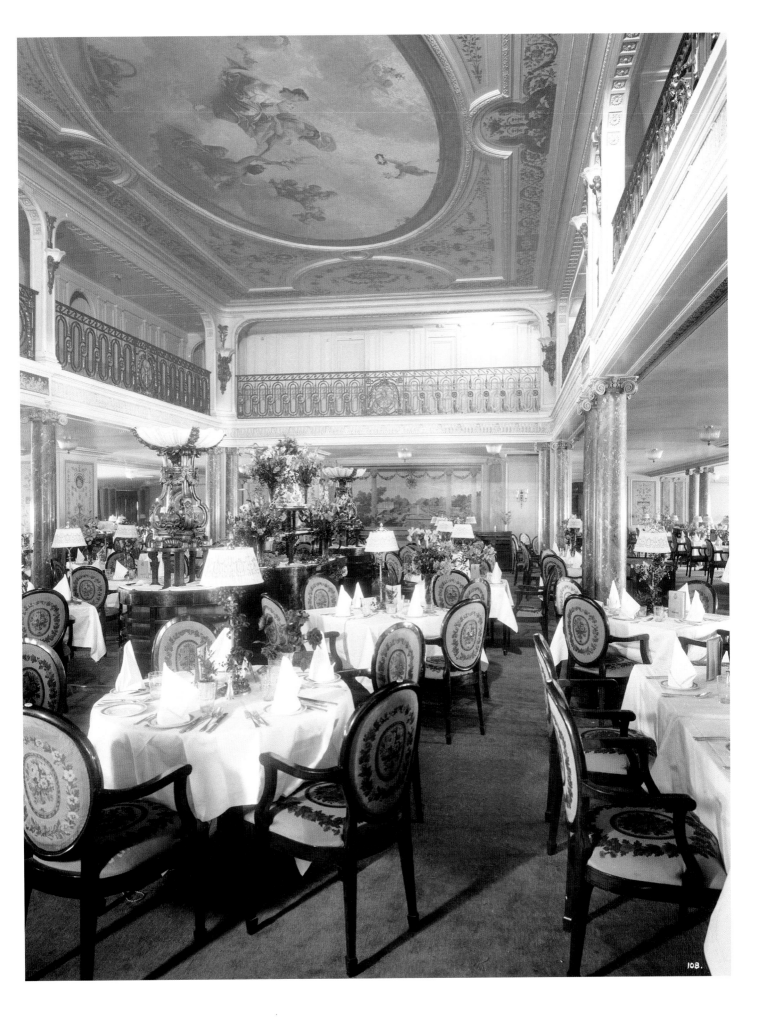

OCEANIC EXPLORATION

Nigel Rigby and Jonathan Potts

In his introduction to *The Principal Navigations, Voyages, Traffiques and Discoveries of the English Nation* (1589), Richard Hakluyt describes how his fascination for voyages of exploration and discovery was first started by his cousin, who showed him 'certain books of cosmography, with an universal map', pointing to and describing 'all the known seas, gulfs, bays, straits, capes, rivers, empires, kingdoms, dukedoms and territories of each part'. Hakluyt's *Voyages* chronicles the first great age of European oceanic exploration, an era which had effectively begun about a hundred years earlier when Portuguese vessels began pushing south along the coast of Africa,

looking for a sea route to India. *Voyages* is, however, unashamedly patriotic. There is no place in the book for Vasco da Gama's voyage to Calicut in India in 1498; neither is there mention, except in passing, of Christopher Columbus's 'discovery' of the Americas in 1492, nor of Magellan's circumnavigation of the world in 1520. For Hakluyt, it was the English, or adopted English, like Cabot, who had always been 'stirrers abroad, and searchers of the remote parts of the world', and who had 'excelled all the nations and people of the earth' in 'searching the most opposite corners and quarters of the world'.

Hakluyt was a wonderful salesman but the long

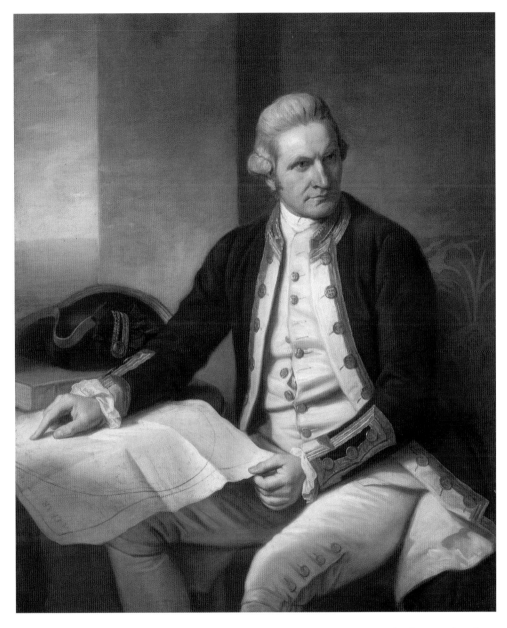

Opposite: Thomas Cavendish
(1560–92), Sir Francis Drake
(*c.* 1540–96) and Sir John
Hawkins (1532–95),
seventeenth-century
English school.
BHC2603

Right: Captain James Cook
(1728–79), Nathaniel Dance.
Painted in 1776, just before
his last voyage, for Sir
Joseph Banks.
BHC2628

English tradition of maritime exploration that he
describes is not backed up by historical fact. His
Voyages captures the excitement of the age created by
the new 'discoveries' but the English were, in truth,
relatively late arrivals as oceanic explorers. In terms
of the wider world, even the earlier Spanish and
Portuguese maritime expansion was comparatively
delayed: the Indian Ocean had been criss-crossed by
Asian and Arab seamen for centuries before the
arrival of the Portuguese; Polynesian settlement of the
Pacific islands, in a series of drift voyages from south-
east Asia, was probably complete by 1200; and the

Vikings are now known to have reached Greenland,
and even North America, in their longships.

 The sixteenth-and early seventeenth-century English
voyages of exploration by seamen such as Ralegh,
Hawkins or Cavendish, were, in the final analysis,
commercially driven attempts to break into existing
trades, to find alternative routes to the East, or to
plunder Spanish and Portuguese vessels. The
hardships and dangers faced on these voyages were
many: scurvy and other diseases took the lives of
countless Elizabethan and Stuart sailors; the routes
sought were often impassable; and some expeditions,

like Frobisher's search for a north-west passage to the Indies, simply disappeared. Navigation relied largely on what was known as the three Ls – the lead for measuring the depth of water; the latitude on which the ship was sailing, which could be measured relatively easily; and lookout, arguably the most important of the three – and the ships were small, vulnerable to extreme weather conditions and relatively unmanoeuvrable. However, the rewards were potentially huge and some voyages were almost indecently successful. Queen Elizabeth's share of the plunder brought back from Sir Francis Drake's circumnavigation of the world in 1577–80, for example, paid off England's entire foreign debt.

From about the middle of the seventeenth century, the drive to look for new markets waned as English ships stuck mainly to tried, tested and profitable oceanic trade routes. Maritime exploration was revitalized once more by George Anson's voyage around the world in the 1740s. His circumnavigation was, in one sense, an old-fashioned Elizabethan buccaneering voyage, with Anson famously capturing a Spanish treasure ship in the Philippines in 1743 but losing some two-thirds of his men to scurvy. In another sense, however, Anson's careful observations and mapping reflected the emerging scientific ideals of the Enlightenment, which would gain their fullest expression in the three great Pacific voyages of Captain James Cook between 1768 and 1780. The main aim of Cook's first Pacific voyage was scientific: an astronomical observation of the transit of Venus across the Sun from the island of Tahiti. On his second and third voyages Cook would answer the two big remaining geographical questions of the age. Was there really a great southern continent which ancient philosophers and geographers believed had to exist in order to balance the land masses of the Northern Hemisphere? And was it also possible to find a navigable sea route to the East over the top of Canada?

The answer to both of these questions was 'no' but in finding out, Cook pushed his ships and his men to their limits and, as he wrote in his journal of the second voyage, sailed as far south 'as I think it possible for man to go'. Although thought of as a great discoverer, Cook actually 'discovered' very little. The main achievements of his voyages were to fix the positions of land masses already known to European navigators, and to chart their coastlines accurately. Cook's map of New Zealand was still in use until the middle of the nineteenth century, some eighty years after he had first traced its outline. The voyages and the accuracy of the charting were made possible by the dramatic advances in navigational and cartographic techniques, and in the design of ships, which by the eighteenth century were more manoeuvrable and reliable than the small, unhandy vessels of the Elizabethan explorers.

An early biographer of Cook described the voyages as having 'the enlarged and benevolent design of promoting the happiness of the human species'. This interest in the world and its peoples was typical of the Enlightenment and made the voyages very different in intent from the violent colonization, trade and plunder that had marked the first period of European maritime exploration. However, scientific enquiry was not the only reason for the voyages, which also had strong, if less obvious, commercial and imperial motivations. Nor were the effects of the voyages always entirely happy: Maori, Australian Aborigines and Pacific islanders, whose lands were colonized and populations were decimated by the diseases that followed in the wake of Cook's explorations, may have viewed the arrival of Europeans somewhat differently. Violence often lurked beneath the surface of these early encounters: Cook himself was killed in a brief but bloody fight on a beach in Hawaii in 1779, the causes of which continue to intrigue historians to this day.

The lasting legacy of Cook, in terms of oceanic exploration, was that he set extremely accurate standards for observation and hydrography. For example, he was followed in the Pacific by Matthew Flinders, who continued the work of charting Australia that Cook had begun thirty years earlier; by Vancouver, who completed Cook's survey of the north-

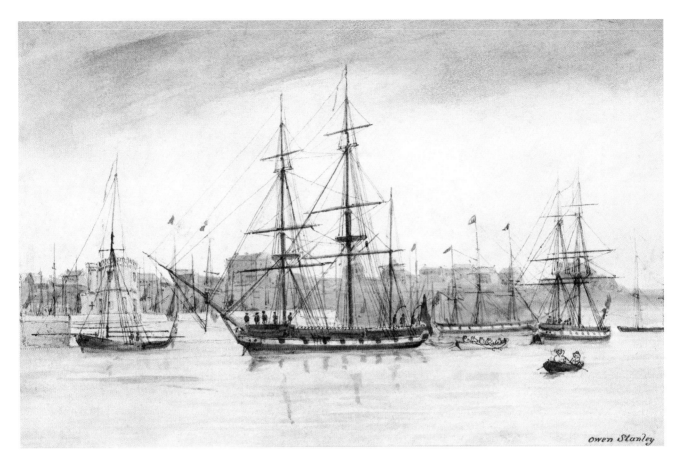

HMS Beagle *off Fort Macquarie, Sydney*, Owen Stanley.
PAD8969 / A1741

west coast of North America; and by French navigators like La Pérouse, whose voyage was planned to be the equal of Cook's. In the nineteenth century, exploration became more professional.

The Admiralty's Hydrographic Office was founded in 1795 to provide detailed and accurate charts for Britain's merchant and Royal navies; a specialist survey branch of the Royal Navy was created a few years later and ships began to be expressly designed for survey work. The *Beagle*'s famous second voyage between 1831 and 1836 was an outstanding success from the point of view of science, for it was then that Charles Darwin began to think through his theory of evolution – which would have a profound effect on late-nineteenth-century thinking. But the voyage was also notable for the accuracy of the surveys of the South American coastline, carried out by Captain Robert Fitzroy. Fitzroy was one of a growing breed of scientifically minded officers in the Royal Navy who would find an outlet for their interests in the survey

service. As the nineteenth century progressed and most of the world's coastlines had been surveyed by the Royal Navy, attention began to shift to the oceans themselves. The voyage of HMS *Challenger* in the 1870s effectively began the modern science of oceanography, which would lead to the development of the bathysphere and deep-diving techniques in the 1930s.

Although we have now been exploring under water for well over a hundred years, much is still unknown. We know more today about the Moon than we do about the sea floor, with more than 95 per cent of the deep oceans yet to be explored. Modern technology, with the introduction of deep-diving manned and unmanned submersibles in the 1960s, is now opening up these mysterious and inaccessible places, and revealing new and unexpected life forms for our wondering eyes, much as the extraordinary diversity of our world was revealed to those earlier voyagers.

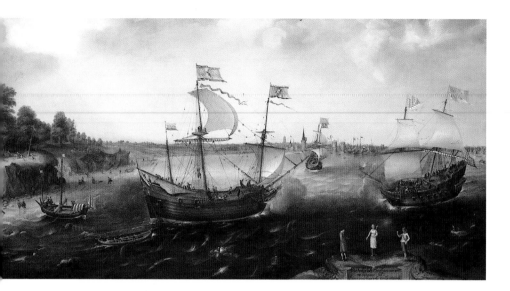

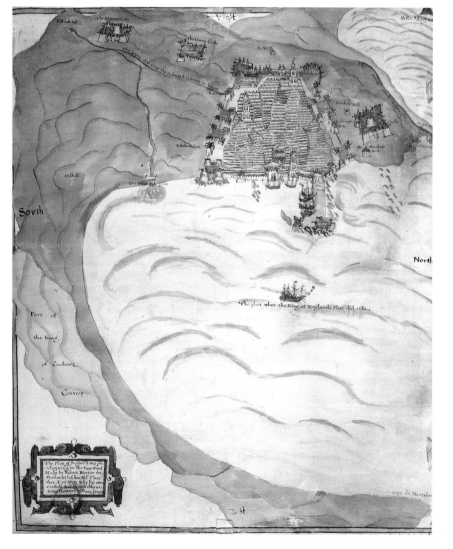

PIRATES AND PRIVATEERING

(Top left)

A DUTCH MERCHANTMAN ATTACKED BY AN ENGLISH PRIVATEER OFF LA ROCHELLE

Cornelis Claesz van Wieringen

1616

This painting is an *ex voto*, a Christian thank-offering for deliverance from danger. A Dutch merchant ship (left), approaching the harbour of La Rochelle, is being attacked by an English privateer on the right. In the foreground, the Dutch captain gives a thank-offering in the form of a model boat to a female figure in the middle representing Christian faith, who grants him safety

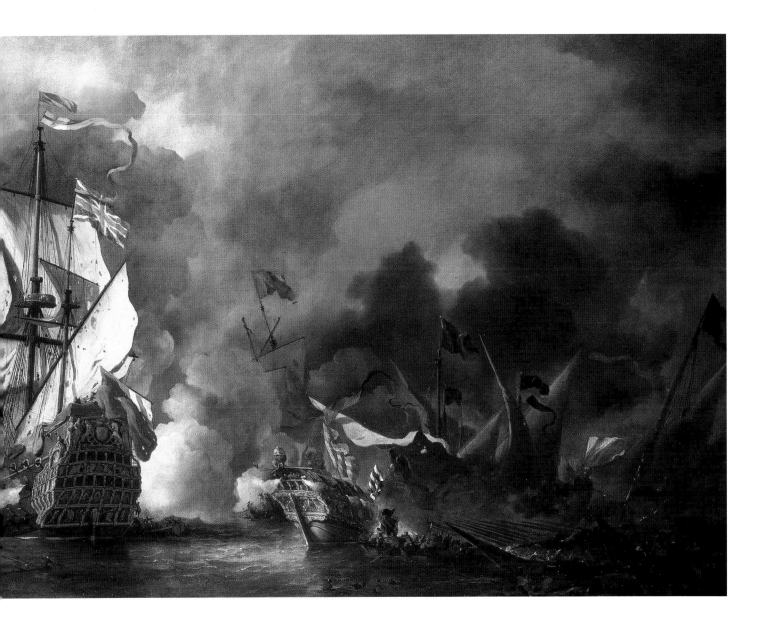

from the English raider on the right. The picture and its inscription recall the perils of seafaring in the early seventeenth century. Privateers were private warships licensed to raid enemy shipping for profit. In this case, as the inscription below the figures on the right records, the Dutchman got away: 'Fully laden the master pays no heed to the sea rover, standing in the fear of God his boat sails, not taken by surprise, into La Rochelle'.
BHC0723

ALGIERS BAY
Robert Norton
1620
In the early seventeenth century, Barbary corsairs preyed on the trade route through the Straits of Gibraltar. In 1620 an English fleet under Sir Robert Mansell sailed to Algiers, first trying to secure the release of prisoners and then sending fire ships into the pirate fleet moored in the bay. The expedition was ineffective, as during the following year about thirty-five British ships were taken by the corsairs. This chart was drawn at first-hand: 'Made by Robert Norton the Master Mr of his Mats Fleet & by his own carfull and diligent observations then not without danger'.
G.231:12/10 / D4229

AN ENGLISH SHIP IN ACTION WITH BARBARY CORSAIRS
Willem van de Velde, the Younger
c. 1678
Painted about five years after he moved to London from Amsterdam, this is a mature work in the artist's baroque manner. It depicts one of the many actions fought against Barbary corsairs at this time, but it is not clear which it is intended to be. The 'Barbary pirates' operated around the ports of the North African coast and were a constant threat to merchant shipping. They engaged in plunder as well as Christian slavery.
BHC0893

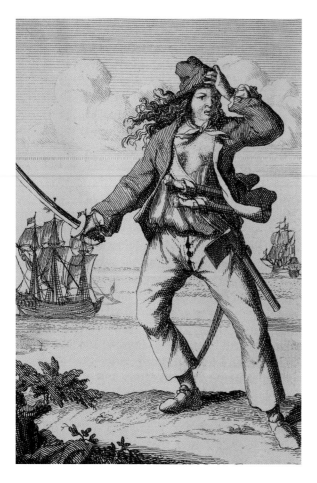

(Above)
MARY READ
Unknown artist
1724
This print comes from Charles Johnson's *A General History of the Most Notorious Pirates* which was extremely popular on publication in 1724, running into four editions in two years. Born in Plymouth in 1690, Mary Read was dressed in male clothing from birth and served in the army in Flanders. She fell in love with a soldier, revealed her secret and married him. On her husband's death she 'again assume[d] her man's apparel' and rejoined the army. Her ship was attacked by English pirates, and she joined the crew of 'Calico Jack' (Captain John Rackham). Captured and tried in 1720, she escaped hanging only due to her pregnancy and died of fever in prison a year later.
7751

(Below, centre)
NIMCHA OWNED BY VICE-ADMIRAL SIR THOMAS HOPSONN
1676
An Arabian sword with a curved blade, this example has a hilt of dark brown wood covered with chased silver plating that originally had two rubies mounted near the pommel. Sir Thomas Hopsonn is said to have captured it in 1676 when he boarded an Algerine corsair and 'wrenched the sabre from his opponent's hand and slew him with his own weapon'.
WPN1057 / E1270

(Bottom)
SILVER-MOUNTED PRESENTATION PISTOL
R. Wilson
c. 1759
This pistol was presented to Captain Peter Reed by the Council and Assembly of St Christopher's, one of the Leeward Islands. Captain Reed, commanding the privateer *Oliver Cromwell*, destroyed several French privateers in the West Indies in 1759. The pistol is extensively decorated with silver-wire inlay. The butt cap is in the form of an antique helmet and the side plate is in the form of a military trophy. A dragon or sea monster in silver wire appears under the fore-end and the cap is engraved with a representation of Neptune.
AAA2417 / D5924

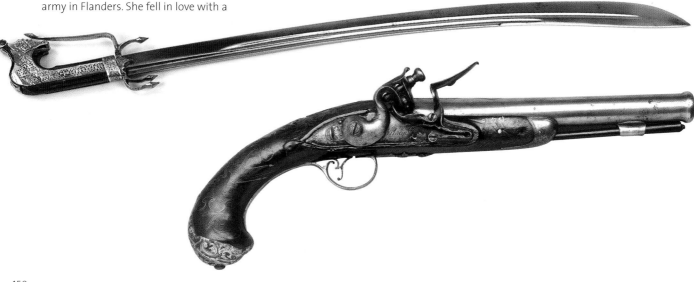

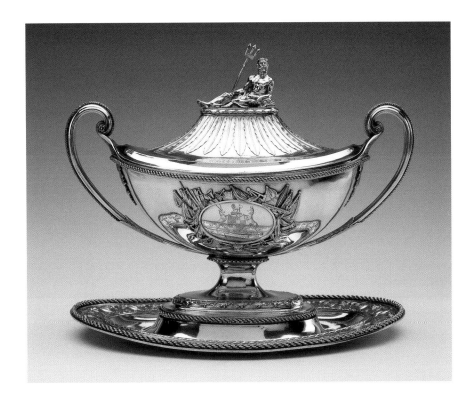

(Left)
SOUP TUREEN
Robert Makepeace, London
1796
This silver soup tureen and stand was presented to Lord Amelius Beauclerk, captain of HMS *Dryad*, 44 guns, in 1796 by the Committee for Encouraging the Capture of French Privateers. On one side are Beauclerk's arms within a cartouche of naval trophies. On the other, a presentation inscription refers to his gallant behaviour in the capture of the French frigate *La Proserpine* and his recent successes in the protection of British commerce. Indeed, he had taken the French ship with the loss of only two of his own men and shortly afterwards captured three French privateers. The cover of the tureen is surmounted by a reclining figure of Neptune with his trident and a dolphin. By the end of his life Beauclerk had risen to be Admiral of the Red, and had been appointed Principal Naval *Aide-de-Camp* to both William IV and Queen Victoria.
PLT0021 / D4619-C

(Right)
CHINESE PIRATE FLAG
1849
Reputedly the flag of the Chinese pirate Shap-ng-tsai, whose fleet of junks was destroyed by a British force in October 1849. The Chinese characters say *T'ien Hou Sheng Mu* (Empress of Heaven, Holy Mother). T'ien Hou was regarded as a calmer of storms and protectress of marine commerce, fishermen and sailors. The cotton flag is painted with a depiction of Zhang Daoling (*c.* AD 150), founder of Daoism as a religion in China. He is seated on a rock holding an eight trigram device (a symbol of Daoism), with a tiger behind him. A border of bats runs down the fly edge, a visual pun on the Chinese word for happiness.
AAA0554 / D5453

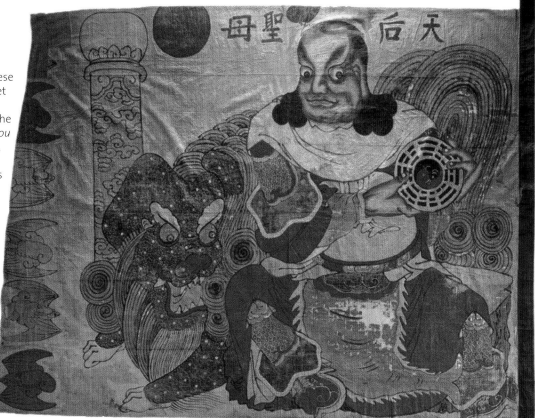

151

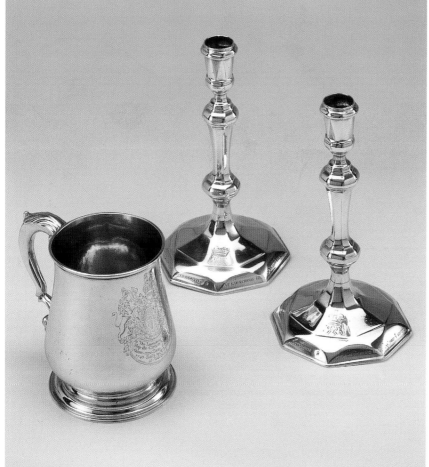

PLATE

(Above, left)
PIET HEIN DUTCH SILVER DISH
Unknown maker, Amsterdam
1629
This seventeenth-century Dutch octagonal dish commemorates the capture of the Spanish treasure fleet off Cuba on 8 September 1628 by the Dutch admiral, Piet Hein (1577–1629). This, one of the earliest commemorative silver items in the Museum's collection, is the largest in a series of eight dishes. The centre of the dish is engraved with a scene of the battle below a portrait medallion of Piet Hein. The border is engraved with other shipping scenes between figures representing the four seasons. A Dutch inscription on the back refers to 'the brave deed of Piet Hein's victory you see produced here to his everlasting memory, who risked his life for his fatherland'.
PLT0170 / C8342

(Left)
LAUNCHING SILVER; CANDLESTICKS AND TANKARD
John Bache and Thomas Farren, London
1712 and 1742
This pair of silver candlesticks, presented to Mr John Phillips, Master Shipwright at

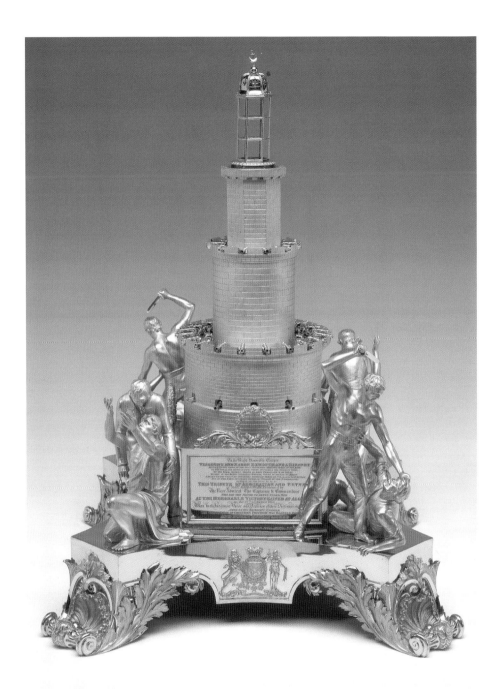

Plymouth, commemorates the launch of the *Feversham*, 40 guns, in July 1712. The tankard was a gift to Mr John Holland for the launch of the *Captain*, 70 guns, at Woolwich in April 1743. The tradition of presenting a piece of plate to the master shipwright at the launching ceremony of a naval vessel goes back at least to the seventeenth century. Originally the silver was usually a punch-bowl or drinking vessel to drink the health of the King and Lord Admiral at the launching, and the value depended on the rate of the ship. By the eighteenth century other silver items were being presented, and they were usually engraved with the name of the ship and the royal coat of arms.

PLT0211, PLT0741 & PLT0208 / D4623

(Opposite, top right)
CITY OF LONDON FREEDOM BOX
Jasper Cunst, London
1740
A gold box presented to Admiral Edward Vernon in March 1740 with the Freedom of the City of London, 'as a testimony of the greatest sense this city hath of his eminent services to the Nation by taking Portobello and demolishing the fortifications thereof.' Vernon's 1739 victory at Porto Bello, a fortified Spanish base on the Isthmus of Darien, made him a public hero, and he was rewarded handsomely. This freedom box, by one of the finest London gold-box makers, has the arms of the City of London engraved on the lid.

PLT0187 / A5896

EXMOUTH CENTREPIECE
Paul Storr
1817
This silver-gilt centrepiece was presented to Admiral Edward Pellew, Lord Exmouth, by the rear-admiral, captains and commanders who served under him at the bombardment of Algiers in August 1816. It is modelled as the lighthouse fort at Algiers, complete with guns and surmounted by a lantern. At each corner are pairs of figures, two representing seamen freeing a Christian slave and the others showing a seaman overcoming an Algerine corsair. The base of the centrepiece is chased with a view of the bombardment as well as Lord Exmouth's new coat of arms, with its freed Christian slave as one of the supporters.

PLT0047 / B9054-4

BRITISH POLAR EXPLORATION

Barbara Tomlinson

Britain first began to explore the polar regions during the reigns of Elizabeth I and James I, when a succession of English explorers from Martin Frobisher in 1576 to William Baffin in 1616 searched for a North-West Passage to Asia in the eastern part of the Arctic. The hoped-for profit from these voyages never materialized although the penetration of the inland sea named after its discoverer, Henry Hudson, opened up the interior to commercial exploitation by the fur traders of the Hudson's Bay Company later in the century.

An employee of the company, Samuel Hearne, first reached the shores of the Arctic Ocean overland in 1771. By this date, Imperial Russian expeditions had mapped the northern coast of Asia and a Danish officer in their employ, Vitus Bering, had sailed through the strait that bears his name. Spain, anxious to re-establish its territorial claims in the Pacific had,

by 1774, explored the North American coast as far as modern British Columbia. The British response was to send James Cook to search for a North-West Passage from the Pacific. He passed through the Bering Strait and sailed between the shore and the ice of the Polar Sea as far as Icy Cape. Cook turned back in order to avoid being trapped in the Arctic winter but his death in Hawaii in 1779 forestalled his planned return the following year. By the final quarter of the eighteenth century, exploration expeditions were concentrating on making detailed hydrographical and scientific surveys. Claiming land for the Crown and noting commercial opportunities, however, were still on their agenda.

After the end of the Napoleonic War in 1815, a new era of exploration was begun by John Barrow, Second Secretary of the Admiralty. Sir John Ross was sent to Baffin Bay in 1818 in a renewed search for a passage

Left: Nelson and the Bear, Richard Westall. The fifteen-year-old Nelson served as a volunteer on Constantine Phipps's Arctic expedition in 1773.
BHC2907

Opposite: Beaufort Island and Mount Erebus Discovered 28 January 1841. Watercolour, J. E. Davis. Captain James Clark Ross reaches the shores of Antarctica in *Erebus* and *Terror.*
PW0588

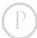

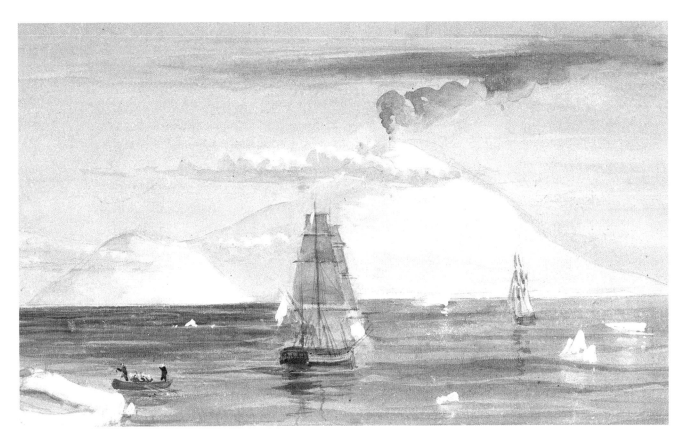

west. He confirmed Baffin's discoveries, at that time no longer credited, but turned back in Lancaster Sound, believing it to be blocked by mountains. Barrow was unconvinced and sent a second expedition the following year, commanded by William Edward Parry, which sailed straight through Ross's non-existent mountains and was halfway to the Pacific before being stopped by the ice of the Beaufort Sea. By 1845 much of the northern coast of America had been charted by overland expeditions. Sir John Franklin, in command of his third expedition, was sent to traverse the gap between the discoveries of Parry to the north and Simpson and Dease to the south. The disappearance of his two ships, *Erebus* and *Terror*, was the worst disaster in the annals of British polar exploration. More than forty expeditions were sent out in search of them but all initially looked in the wrong area. At the height of the Franklin search, the crew of *Investigator*, under Captain Robert McClure, became the first Europeans to travel all the way through the passage, albeit partly by sledge. It was a Hudson's Bay Company employee, John Rae,

who learned from the Inuit that Franklin's men had perished in the region of King William Island. The expeditions of Francis Leopold McClintock and the American Frederick Schwatka, confirmed his findings, recovering many small items and one significant document.

Captain Constantine John Phipps led the earliest Royal Naval North Pole expedition in 1773. It was unclear at this date whether the Pole stood on land, sea or ice, but the hope of finding open water north of Spitsbergen came to nothing. In 1827 Parry grappled with the problem of crossing a mixture of sea ice and open water to the Pole by taking boats fitted with sledge runners. They were originally intended to be dragged by reindeer but the reindeer proved ineffective draught animals and the Navy fell back on man-hauling. Although it made slow progress, the expedition established a farthest-north record that stood for fifty years. The last naval North Pole expedition set out in 1875. George Nares's ships, *Alert* and *Discovery*, used the route north through Smith Sound, pioneered by American explorers Kane

and Hall. *Alert* wintered at record latitude on the north coast of Ellesmere Island. Although sledge parties briefly broke the farthest-north record, scurvy forced the expedition to return early.

During the latter part of the nineteenth and early twentieth centuries, the lead in polar exploration was taken by other European nations, mainly the Scandinavians. Nils Nordenskjöld was first through the North-East Passage in 1879, Roald Amundsen through the North-West Passage in 1906. An American, Robert Peary, claimed to have reached the North Pole in 1909. There was a trend towards smaller, privately sponsored expeditions and record-breaking attempts.

On 17 January 1773, James Cook had been the first to cross the Antarctic Circle on a voyage that disproved the existence of a habitable southern continent. During the early nineteenth century, whalers and sealers were active in Antarctic waters, some, like James Weddell, making important geographical discoveries. Russian and French government expeditions caught glimpses of the coast of the Antarctic continent. A British expedition of 1839–43, led by James Clark Ross, penetrated the pack ice to reach its shores, pioneering the route taken

by Scott and Shackleton. After a lull, Antarctic exploration was relaunched by the Sixth International Geographical Congress in 1895, opening the so-called 'heroic age' of Antarctic discovery.

During the early twentieth century, five European countries and Japan sent expeditions to Antarctica. The first to overwinter on the mainland was privately funded and led by Carsten Egeberg Borchgrevink. A British expedition in *Discovery*, initiated by Sir Clements Markham and the Royal Geographical Society, and led by Robert Falcon Scott, set out in 1901. It performed valuable scientific work but was inexperienced in sledging and skiing. Ernest Shackleton, veteran of Scott's first attempt on the Pole, returned on a privately funded expedition in *Nimrod* and came within 110 miles (180 km) of the Pole. Using dog sleds, Amundsen was the first to reach it, on 14 December 1911, his achievement confirmed by Scott a month later. Scott and his companions died on the return journey, a loss that eclipsed even the fate of Sir John Franklin, in the public imagination.

Above: The sledge flag of Robert Falcon Scott (1868–1912). Scott's flag is embroidered with a stag's head, his family crest and the motto READY AYE READY. The flag is the shape of a medieval standard or banner, with the Cross of St George at the hoist to indicate the owner was an Englishman. This flag was recovered from the tent in which Scott, Wilson and Bowers died on the return journey from the South Pole. ZBA1609 / E0580

Below: Eight-man sledge, used on Sir George Nares's North Pole expedition 1875–76. D5226

POLAR EXPLORATION

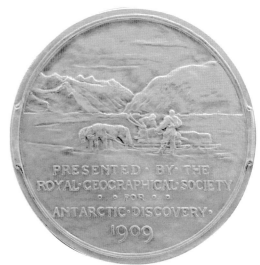

(Left)
SHOT POUCH MADE FOR ADMIRAL SIR GEORGE BACK (1796–1878)
Chippewyan
1819–34
This hide pouch with porcupine quillwork embroidery has the initials 'G.B.' at the top. The design shows a mixture of Native American geometric patterns and the floral motifs adopted as a result of European influence. It is part of a collection of craft items and trade goods assembled by George Back during three overland expeditions travelling down the rivers which flow across present-day northern Canada to the shores of the Arctic Ocean. A talented artist and entertaining writer, Back initially served under John Franklin. He led the last overland expedition in 1833–34 himself, surveying the length of the Great Fish River, which was renamed the Back River in his honour.
AAA2626 / D4890

(Above, right)
SILVER MEDAL AWARDED BY THE ROYAL GEOGRAPHICAL SOCIETY TO PARTICIPANTS IN SHACKLETON'S ANTARCTIC EXPEDITION OF 1907
Gilbert Bayes
1909
This was a privately funded expedition in the sealer *Nimrod*. Wintering on Ross Island, expedition members successfully climbed Mount Erebus and reached the area of the South Magnetic Pole. Shackleton made an attempt on the South Pole, gaining access to the Polar plateau via the Beardmore Glacier and using ponies for the early stages. After the last pony had been killed and eaten, the men continued on foot. Shackleton got to within 110 miles (180 km) of the

Pole before having to turn back due to shortage of supplies. The obverse of the medal has a striking portrait of Shackleton and the unfortunate ponies are shown on the reverse.
MED0481 / D5068-2

(Below)
DR LEONARD HUSSEY'S BANJO
Before 1914
A zither banjo, inlaid with mother-of-pearl, belonging to Dr Leonard Hussey, meteorologist on Shackleton's *Endurance*. It was rescued from the ship before she sank, crushed by the ice of the Weddell Sea. Hussey played it during morale-raising concert parties organized by the survivors while they awaited rescue on Elephant Island. Signatures include many of the expedition members: E. H. Shackleton, Frank Wild, Ruby Page le Brawn, Frank A. Worsley, L. Rickenson, George E. Marston, L. D. A. Hussey, A. H. Macklin, Frank Hurley, A. J. Kerr, F. W. Edwards, J. M. Wordie, T. O. Lees, C. Green, A. Cheetham, R. W. James, L. Greenstreet, Robert S. Clark, Harry McNeish.
AAB0225 / D9467-1

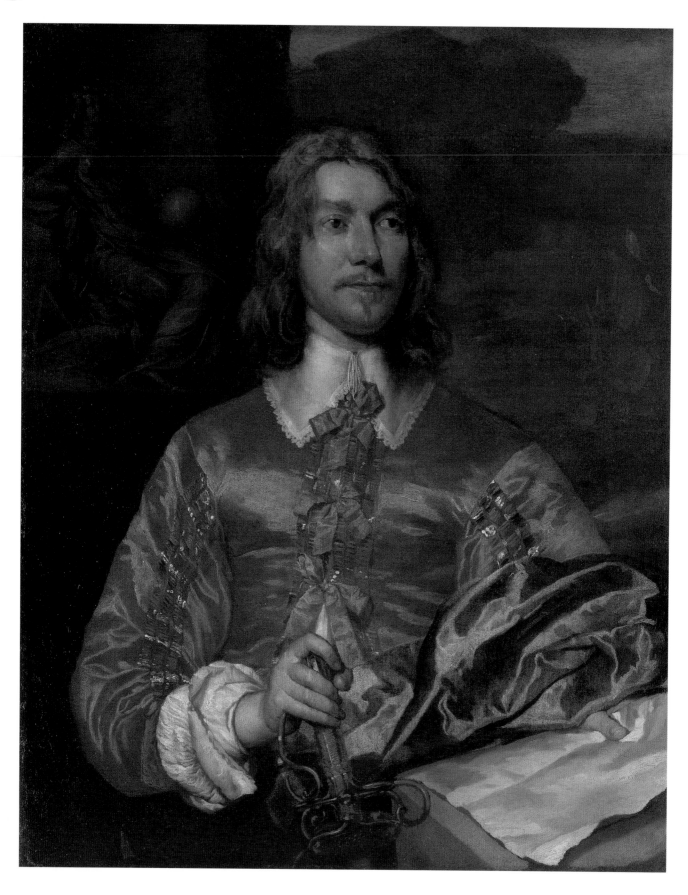

PORTRAITS

(Opposite)
A ROYALIST SEA OFFICER
William Dobson
c. 1645
Described by Aubrey as 'the most excellent painter that England hath yet bred', Dobson painted the English court during the Civil War, following the death of van Dyck in 1641. Using rich colours derived from Titian, Tintoretto and van Dyck, he painted some of the most stylish and poignant portraits of the period. From his manner and dress it can be assumed that the unidentified sitter was a close associate of Charles I.

Behind the sitter, to the left, a contrived sculptural relief of an allegorical female figure holds a globe and dividers. Globes symbolized learning and scholarship, and with compasses or dividers and other instruments formed the attributes of Geometry, one of the Seven Liberal Arts. To the sitter's right a ship, faintly painted, indicates that he is a naval commander.
BHC3133

(Above)
LORD GEORGE GRAHAM (1715–47)
IN HIS CABIN WITH HIS FRIENDS
William Hogarth
c. 1745
A conversation piece set in the enclosed space of the captain's cabin on board the *Nottingham*, 60 guns. Captain Lord George Graham, the youngest son of the first Duke of Montrose, sits on the right, smoking a pipe. The portrait was probably commissioned to celebrate his successful action off Ostend in June 1745. In command of the frigate *Bridgewater*, 24 guns, he attacked a squadron of French privateers and captured valuable prizes. This subversive portrait of Graham, surrounded by his servants, fellow dinner guest and a singer, is imbued with Hogarth's own commentary on the scene. An associate of Graham, he has inserted himself into the picture through his dog, Trump, on the right.
BHC2720

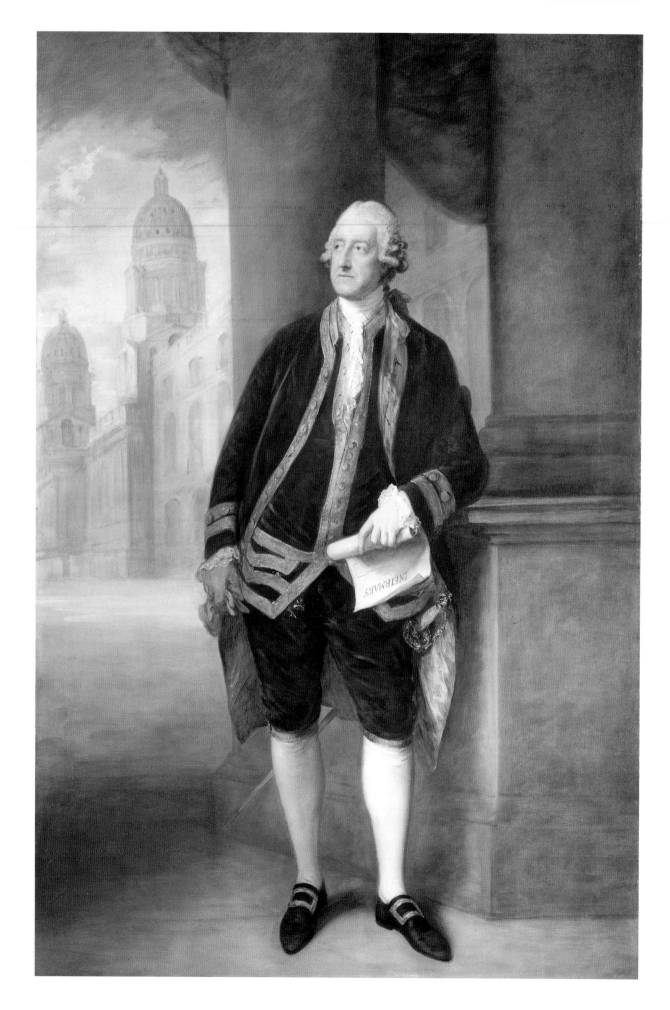

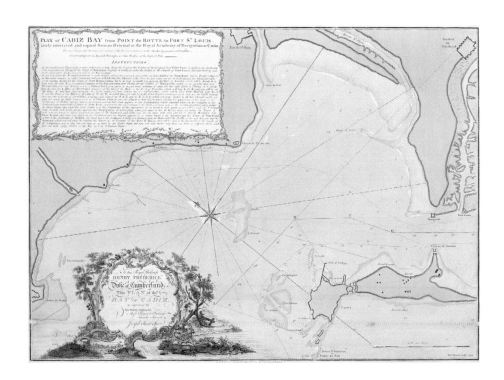

(Opposite)
JOHN MONTAGU, FOURTH EARL OF SANDWICH, 1718–92
Thomas Gainsborough
1783
Of Lord Sandwich's three terms as First Lord of the Admiralty, the last, from 1771 to 1782, was the most notable, coinciding with the War of American Independence. The portrait was commissioned for Greenwich Hospital by Sir Hugh Palliser, a protégé of Sandwich, and presented in 1783. Sandwich holds the plans of James (Athenian) Stuart's Infirmary, built during the 1760s.
BHC3009

PORTS

(Top, right)
CADIZ
Joseph Smith Speer
1773
During the eighteenth century, Cadiz handled more than 75 per cent of Spain's trade with the Americas. At the time this chart was published, Spain was still clinging on to its monopoly of trade with its overseas possessions, operating a *flota* system sailing out via the Cape Verde Islands and home via the Azores. In 1778 Spain declared free trade among its colonies. Captain Speer served in the West Indies for more than twenty years and it was presumably there that he obtained the source material for the charts of Spanish America and Spain which he published in London.
G225:4/6 / D7663

(Bottom, right)
ST IVES HARBOUR, CORNWALL
Alfred Wallis
Originally a deep-sea fisherman and then a marine scrap dealer in St Ives, Wallis took up painting in the 1920s. Poor and untrained, he often worked on odd scraps of cardboard, using flat, nearly abstract shapes to express his experience of the sea and ships. His pictures were admired by artists working in St Ives in the 1950s, among them Ben Nicholson and Terry Frost, both of whom became abstract painters.
BHC4156

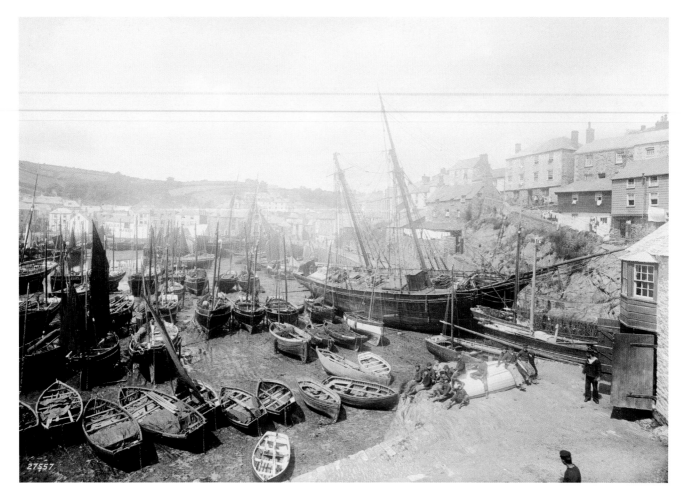

(Above)
MEVAGISSEY, CORNWALL
Frith & Co.
c. 1890
Francis Frith made his fortune at an
early age with a successful grocery
business in Liverpool. Having sold this,
Frith became interested in the new
science of photography and soon
became a competent photographer.
He published prints from his tours of
Egypt and Palestine, which proved so
popular that he was able to use the
profits from his photographs to found
Frith & Co. in 1859. Frith was quick to see
that photographic souvenirs of popular
coastal holiday spots would be good
business. The company prospered,
producing millions of picture postcards.
G02580

(Opposite, top)
WINTER AFTERNOON:
CONTAINER SHIPS OFF FELIXSTOWE
John Wonnacott
1994
Working in the container port of
Felixstowe enabled the artist to
combine his interest in industrial
landscape with his love of the coastal
scenery of East Anglia. The picture
demonstrates Wonnacott's fascination
with perspective and the way in which
pictorial space conveys the sensation
of actual space to the viewer.
BHC4249

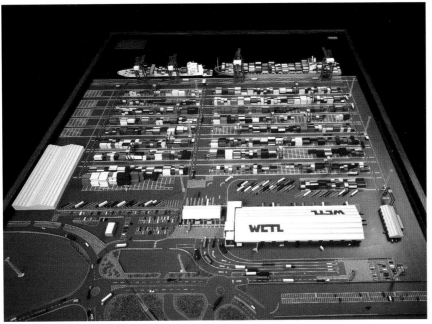

(Left)
WALTON CONTAINER TERMINAL
Minima Industrial Modelmaking
1990
This model shows the stages of
operation in a modern container port.
Lorries arrive in the foreground and are
checked in. Behind them is the container
park, where rubber-tyred gantries
unload the containers. Trailers take them
to the dockside, where they are loaded
onto ships by giant cranes. Walton
Terminal, on the River Orwell
in Suffolk, was merged into the rapidly
growing port of Felixstowe in 1991.
SLR2317 / D7829

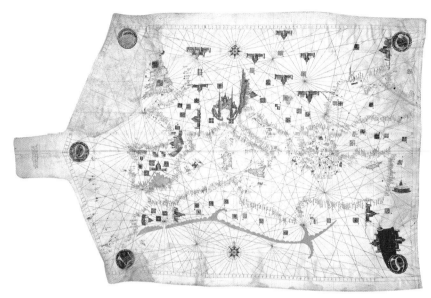

PORTULANS

(Above)
MEDITERRANEAN SEA
Jacopo Bertran and
Berenguer Ripol
1456
Portulan charts originated in the Mediterranean in the thirteenth century based on written sailing directions called *portolani*. They were drawn and painted on vellum, using a network of intersecting rhumb (direction) lines radiating out from compass roses. This chart was signed and dated by its Catalan makers at Barcelona in 1456. The Catalans superseded the original Venetian and Genoese portulan makers

before this style of charting reached its peak in Spain and Portugal in the sixteenth century. This chart, on a whole skin of vellum, shows many characteristic features: the coastal outline with place names tightly packed on the land, together with flags and banners and drawings of cities.
G230:1/7 / 3089

(Below)
NORTH ATLANTIC
Pedro Reinel
c. 1535
This manuscript chart on vellum was made by a Portuguese chart-maker during the period of Portuguese and Spanish imperial expansion. National

flags show acknowledged spheres of influence. Trading cities in Russia and North Africa are depicted. A drawing of the Hill of Golgotha represents the Holy Land. Great prominence is given to the Portuguese fort built at Elmina (the mine) on the Guinea coast in 1482. It helped to maintain Portuguese control of the export of gold, ivory and slaves from this part of Africa for a further century after this chart was drawn.
G213:2/4 / D2150

PRESENTATION SWORDS

(Opposite, top)
LLOYD'S £100 PATRIOTIC FUND SWORD PRESENTED TO CAPTAIN C. J. MOORE MANSFIELD FOR MERITORIOUS SERVICE AT TRAFALGAR
1805
One of the purposes of the Lloyd's Patriotic Fund was to award swords to officers who had distinguished themselves in the Napoleonic Wars. The swords, presented between 1803 and 1810, came in four varieties – £30 swords, £50 swords, £100 swords and Trafalgar swords – rising in magnificence according to their value. Trafalgar swords were a variation of the £100 design, the difference being the more elaborate blade and scabbard decoration. Captain Mansfield commanded the *Minotaur* at Trafalgar, forcing the Spanish ship *Neptune* to surrender. He later took part in the expedition to Copenhagen in 1807.
WPN1491 / D4861-14A

(Opposite, second from top)
SWORD PRESENTED TO CAPTAIN WILLIAM ROGERS
Osborn and Gunby
1807
Captain Rogers achieved national fame when, in command of the packet ship *Windsor Castle*, he captured the French privateer schooner, *Jeune Richard*, on 1 October 1807. The English crew numbered 28, that of the *Jeune Richard* 92. The action caused great public interest and it is possible that the cutlers, Osborn and Gunby, presented the sword as an advertisement for their company.
ZBA0098 / D8268-2

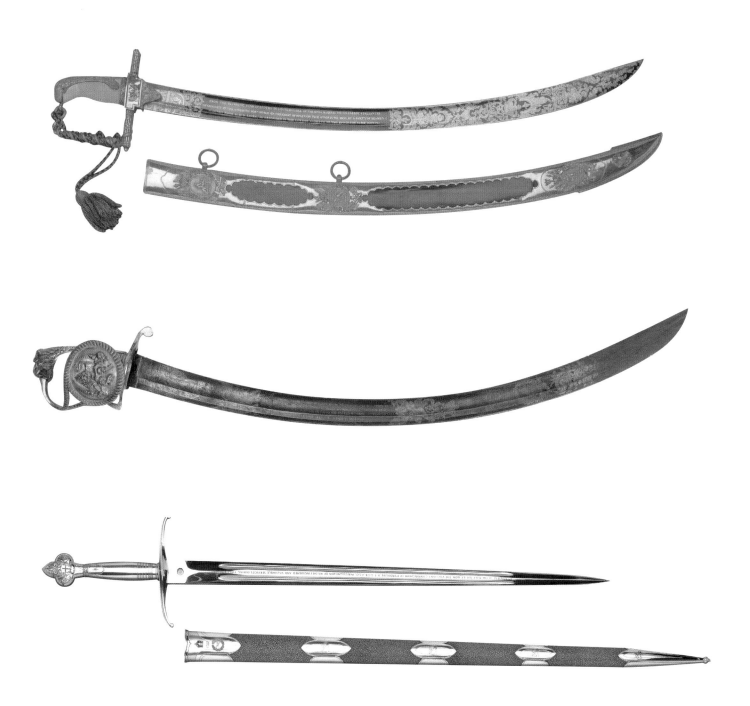

(Above)
**CITY OF LONDON PRESENTATION
SWORD GIVEN TO ADMIRAL OF THE
FLEET VISCOUNT CUNNINGHAM**
Mappin and Webb
1946
This modern sword is purely a
presentation piece as no means of suspension are fitted and it cannot be worn. The sword is in the style of the knightly weapons of the Middle Ages, with a fluted silver cross-piece and a polished silver grip, on which are the stripes of an admiral of the fleet in gilt. Cunningham's career spanned more than forty years: he served as a midshipman in the Boer War, rose to First Sea Lord in 1943 and has been described as 'the greatest admiral since Nelson'.
WPN1292 / D4861-10A

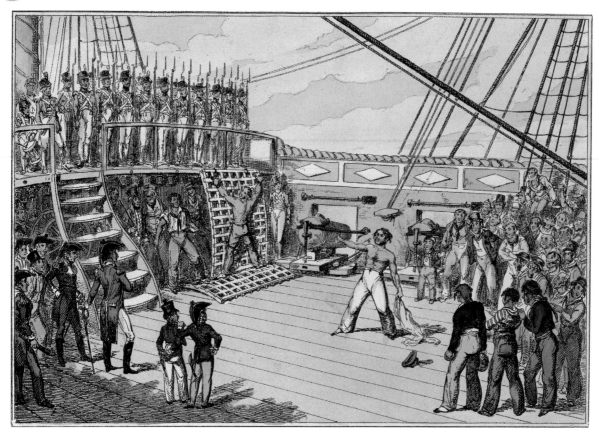

PUNISHMENT

(Above)
THE POINT OF HONOUR
George Cruikshank
1825
Cruikshank's print shows a fictitious incident, in which a seaman owns up to an offence for which another is about to be flogged and tears off his shirt to be flogged himself. It also gives a clear picture of the standard method of punishment in the days of the sailing Navy – the offender lashed to a hatch grating, the boatswain's mate ready with the cat-o'-nine-tails, the marines drawn up on the quarterdeck to keep order, the captain and officers (including two very young midshipmen) to the left, with the rest of the crew arranged informally to the right.
PAD0177 / 2032

(Right)
SEALED PATTERN NAVAL
CAT-O'-NINE-TAILS
1866–1879
A late example of a naval cat-o'-nine-tails. A label with the Admiralty seal is

attached: 'Sealed pattern of cat to serve as a pattern of the instrument wherewith corporal punishment awarded by court martial by commanding officers of HM ships for offences against the Naval Discipline Act shall be carried out. Not for use on board but to be carefully preserved and returned into store on the ship being out of commission'. The Naval Discipline Act was passed in 1866.

Shortly afterwards, following a press campaign, the Admiralty restricted corporal punishment to serious summary offences and in 1879 it was abolished altogether. For minor offences, flogging was replaced by extra work, restriction of leisure time and stoppage of grog. For more serious offences, imprisonment was imposed.
TOA0066 / D3920

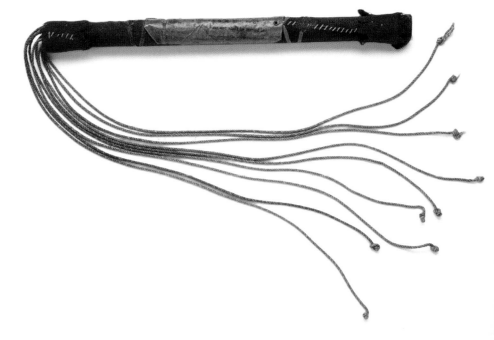

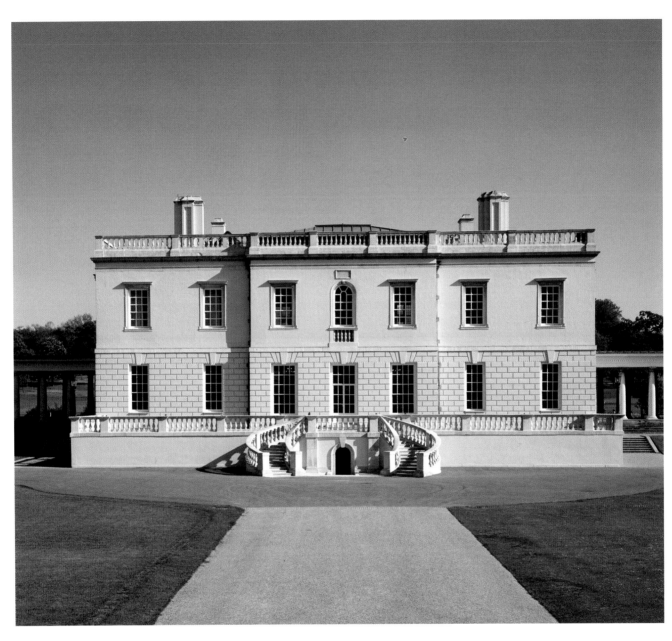

THE QUEEN'S HOUSE

THE QUEEN'S HOUSE
c. 1617–35
Designed by the first English architect of genius, Inigo Jones (1573–1652), this is the sole surviving building of the sixteenth- and seventeenth-century Palace of Greenwich. Construction began in 1617–19 for Anne of Denmark, queen of James I, but then stopped until 1629–35, when it was finished for Henrietta Maria, wife of Charles I. The House is the first purely classical building in Britain, based on the Renaissance villas that Jones had studied in Italy. Originally a private royal 'garden house', its modern prominence comes from its unforeseen later role as focal point of Charles II's 1660s redesign of Greenwich Park and of Sir Christopher Wren's 1690s masterplan for Greenwich Hospital, now the Old Royal Naval College. After its use as a school, from 1806 to 1933, the House was restored as the 'jewel in the crown' of the Museum, opened in 1937. It is now the principal venue for displaying the Museum's superb art collection.
D5021-2

RACING

(Right)
SHAMROCK III
William Denny & Bros
1903
Shamrock III, designed by William Fife Jr.
and built by William Denny & Bros. Ltd of
Dumbarton in 1903, represented Sir
Thomas Lipton's third challenge for the
America's Cup. Lipton made his fortune
as a tea merchant in Glasgow, which
earned him the nickname 'The Tea King'.
His previous efforts with *Shamrock I* and
Shamrock II in 1899 and 1901 had been
unsuccessful. *Shamrock III* was the first
of Lipton's yachts to have a wheel
instead of a tiller for steering. She was
defeated by the American yacht *Reliance*
in 1903. Lipton went on to commission

Shamrock IV and Shamrock V for the
America's Cup of 1920 and 1930; he was
defeated on both occasions. Despite this,

his sportsmanship and love of yachting
were renowned and made him popular
throughout the racing community.
E5531

(Below)
MISS BRITAIN III
Hubert Scott Paine
1933
Miss Britain III was designed, built and
driven by Hubert Scott Paine, a noted
pioneer of flying boats and fast naval
attack craft. The stepped hydroplane hull
was constructed using alcad aluminium
sheet over an aluminium and wooden
frame. It was powered by a Napier 'Lion'
series VII B engine; the aero version was
the world air-speed record holder. In
1933, *Miss Britain III* was narrowly beaten
in the Harmsworth Trophy. However, in
that same year she was the first boat
to pass the 100 mph (161 km/h) mark
on salt water in the Solent.
AE0064 / E0196

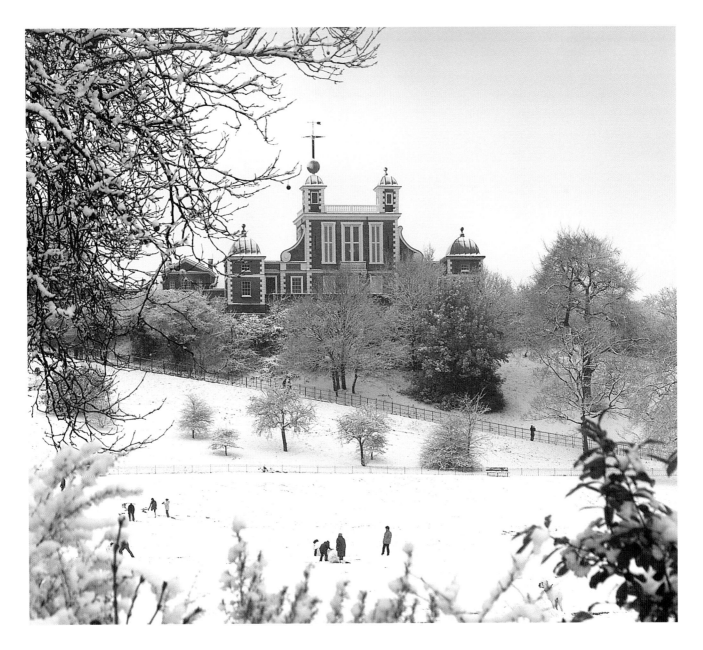

ROYAL OBSERVATORY GREENWICH

FLAMSTEED HOUSE
Sir Christopher Wren
1675–76

King Charles II founded the Royal Observatory, Greenwich, in 1675 in order to find the 'so-much desired longitude of places for perfecting the art of navigation'. It was designed by Sir Christopher Wren, himself an astronomer.

The Observatory was built on the foundations of Greenwich Castle, an old hunting lodge which had previously occupied the site. In July 1676, the first Astronomer Royal, John Flamsteed, moved in to the new building, which has been called Flamsteed House ever since. It was the seventh Astronomer Royal, Sir George Biddell Airy, who in 1851 established a new Greenwich meridian, one that would be adopted as the Prime Meridian (Longitude 0°) for the world in 1884. By the 1930s London had

expanded to engulf Greenwich, and street lighting and pollution had rendered the night sky almost impossible to observe. It was decided to move the activities of the astronomers to Herstmonceux Castle in Sussex. Over a period in the 1950s, the buildings at Greenwich became part of the National Maritime Museum. Today, the Royal Observatory houses one of the finest collections of scientific instruments in the world.

E9540-45

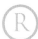

OCTAGON ROOM
Sir Christopher Wren
1675

The Octagon Room is in the original Royal Observatory building at Greenwich. It was designed in 1675 by Sir Christopher Wren and is one of the few Wren interiors with original plasterwork. The portraits show King Charles II, founder of the Observatory, on the left, and his brother, the Duke of York, who was Lord High Admiral and the future James II. Originally, the room had clocks made by Thomas Tompion, with pendulums concealed behind the panelling, but they were sold by the family of the first Astronomer Royal, the Revd John Flamsteed, after his death. The present clocks in the panelling are replicas, but one of the originals was recovered in 1994. It had been converted into a longcase clock, and the movement and case are now displayed separately.
D7054

(Opposite, left)
TIME-BALL
Maudslay & Field
1833

Erected in 1833 by order of Astronomer Royal, John Pond, the time-ball on the north-eastern turret of the Observatory was the world's first permanent visual time signal. Its purpose was to distribute Greenwich Mean Time to ships in the Thames and the docks so that they could set their chronometers accurately. Weather permitting, the ball still drops at precisely 1 p.m. The original leather-covered ball was replaced in 1919 by one clad in aluminium, operating on a teak mast.
ZBA2245 / D5600

(Opposite, centre)
CLOCK
Thomas Tompion
1676

One of two clocks supplied by the eminent maker Thomas Tompion for use in the new Royal Observatory at Greenwich. They were originally fitted into the panelling of Flamsteed's *Camera Stellarum*, now known as the Octagon Room. Technically advanced for this period, the clocks had pendulums approximately 13 ft (4 m) long, impulsed by a new type of 'dead-beat' escapement, which according to Flamsteed 'put not the second finger back by girds'. With the help of these clocks Flamsteed was able to confirm, as many had predicted but never proved, that the Earth spins on its axis at an almost constant rate, a vital factor in making accurate star catalogues.
ZAA0885 / D8930

'GALVANIC' MASTER CLOCK
Charles Shepherd
1852

The public clocks at the Great Exhibition of 1851 operated on one of the very first 'master and slave' systems. Installed by Charles Shepherd of Leadenhall Street, this patented 'galvanic' system consisted of a central 'master' clock sending regular electric impulses to any number of ancillary 'slave' dials. Seventh Astronomer Royal, Sir George Biddell Airy, saw the potential advantages of such a system, ordering one to be made for Greenwich Observatory. Installed in August 1852, this clock operated dials around the Observatory site, including the now famous 'Shepherd Gate Clock' and the time-ball. Via the telegraph system, it was ultimately linked to clocks and time-balls in London and throughout Britain and, with the advent of cross-Channel and transatlantic cables, it was able to send Greenwich Mean Time throughout the world.

ZAA0531 / D9280

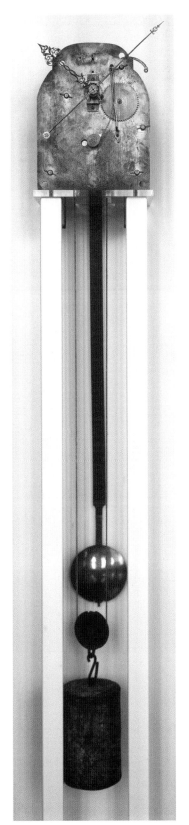

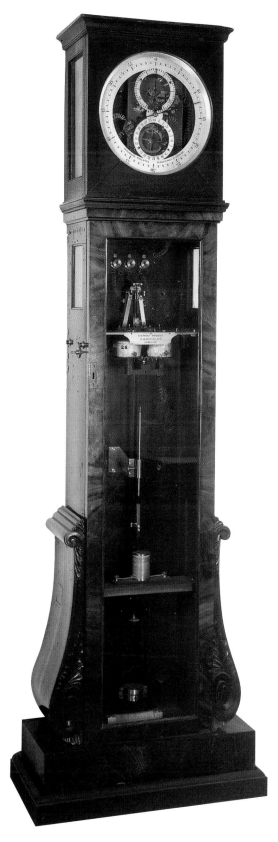

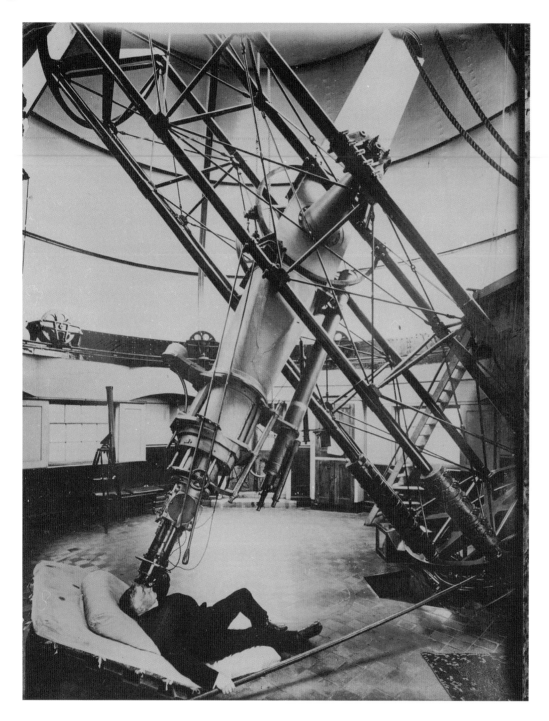

28-INCH REFRACTING TELESCOPE
Howard Grubb; Ransome and Sims
1893
This telescope is the largest refractor in Britain and seventh largest in the world. It was installed in 1893 in the mountings originally made by Ransome and Sims for the much smaller refracting telescope that it replaced. It was used mainly for double-star observations: that is, for observing stars which appear to be very close to each other. In its early days it was used for spectroscopic observations. A characteristic onion-shaped dome, originally built in 1893 of papier mâché, covers it. At the start of World War II, the telescope was dismantled and sent to a place of safety. A V1 flying bomb in Greenwich Park in 1944 caused the dome irreparable damage. In the 1950s, when the astronomers moved out of Greenwich to Herstmonceux Castle in Sussex, where light pollution was less of a problem, the 28-in (71-cm) refractor went with them. It returned to its original position at Greenwich in 1971 as a museum piece, to a new onion dome, this time made fibreglass.
AST0932 / B3775

ROYALTY

ROYAL ASTROLABE
Thomas Gemini
c. 1550

This astrolabe is signed with the mark of Thomas Gemini (active 1532–62), who came to England from Flanders in the mid-sixteenth century. It was made following a design by John Dee (1527–1608). The Tudor Royal Arms with the initials E.R. are surrounded by concentric circles showing the twelve houses of astrology, with months and zodiac signs. It is traditionally said to have been made for Queen Elizabeth I, but recent studies suggest it was more probably made for her half-brother Edward VI (1537–53). There is a comparable instrument in the collections of the Museum of the History of Science in Oxford. Additions were made to the astrolabe in 1655, when Henry Sutton (active 1649–65) engraved the scales for a spiral calculator, an early form of slide rule.

AST0567 / D9216-1

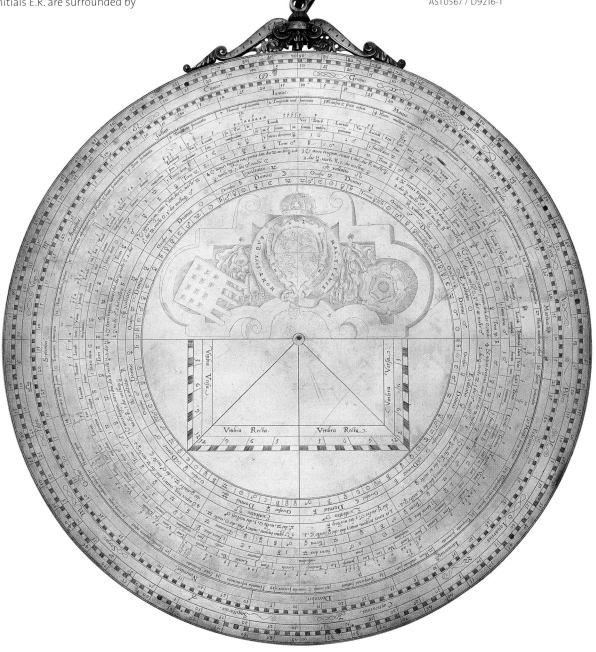

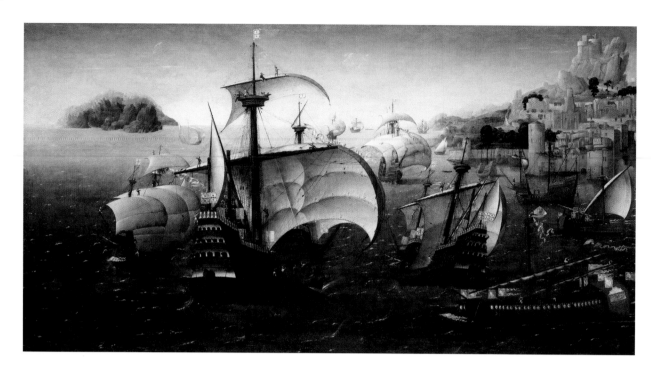

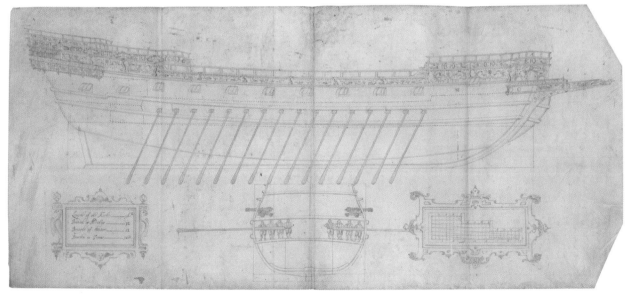

(Top)
**PORTUGUESE CARRACKS OFF
A ROCKY COAST**
Flemish school
c. 1530
This picture is remarkable because it
is one of the earliest to show detailed
depictions of ships. It may
commemorate the voyage from Lisbon
to Savoy of the Infanta Beatriz of
Portugal for her marriage to Charles III,
Duke of Savoy, in 1521. If so, the large
central ship is the Portuguese *Santa*

Caterina de Monte Sinai, which had
been built of teak in Cochin in India.
The Flemish artist Pieter Brueghel
included ships like these in his pictures
and they would have been a fairly
common sight off southern England in
the early part of the sixteenth century.
BHC0705

(Above)
PLAN OF A GALLEY ON VELLUM
c. 1625–42
One of the earliest ship plans in the

collections, this draught on vellum is a
preliminary design for a fast light galley,
several of which were proposed during
the first half of the seventeenth century.
Although it looks like a sketch, the plan
was drawn to scale, making it an early
example of a working plan for a naval
vessel. The initials of Charles I as part
of the design date the drawing between
1625 and 1649. Richly decorated details,
such as sea creatures highlighted in
gold, occupy the bulwarks.
DAR0021 / E8874

**PRINCESS ELIZABETH
(ELIZABETH OF BOHEMIA) 1596–1662
Robert Peake
1603**

The Museum has collected portraits of kings and queens of England to help to explain the context of its site and collections. This exquisite portrait of Princess Elizabeth, the daughter of James I and Anne of Denmark, and sister of Charles I, is a masterpiece of early seventeenth-century portraiture. Painted in 1603, shortly after James succeeded to the throne following the death of Elizabeth I, the seven-year-old princess is shown standing in an English landscape. In the background on the right, beyond a river and bridge, is a hunting group with her brother, Henry, Prince of Wales. On the left is a mount with two female figures, one of which may represent her mother, Queen Anne. This painting was acquired with the assistance of the National Art Collections Fund and the National Heritage Memorial Fund.
BHC4237

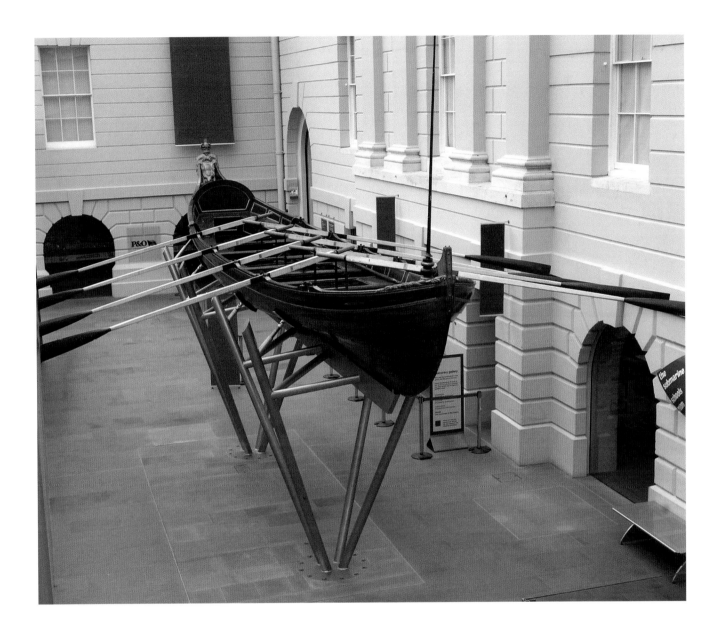

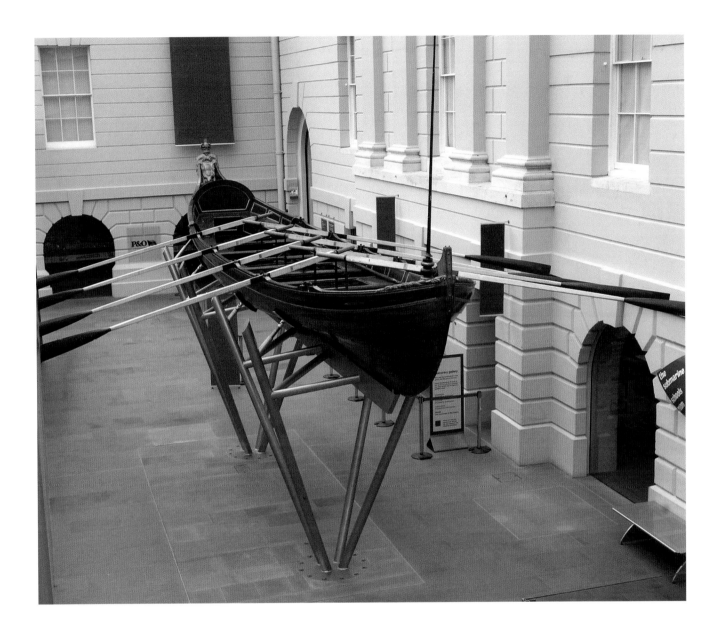

(Opposite)
JAMES, DUKE OF YORK (JAMES II)
1633–1701
Henri Gascard
1672–73
Unusually flamboyant for English taste, this portrait was painted by a visiting French artist who worked for the Catholic clique within Charles II's court. At this time, James, who is shown in Roman martial dress, was Lord High Admiral, a position from which the Test Act was shortly to exclude him as a

Roman Catholic. The background, possibly based on a painting by van de Velde, shows the Duke and the King visiting the fleet in the Thames early in the Third Dutch War (1672–74).
BHC2797

(Above)
QUEEN MARY'S SHALLOP
Unknown maker
1689
A shallop was a sea boat rather than a ceremonial river barge. Measuring 41 ft

(12.6 m) in length and with a beam of 6 ft 6 in. (2 m), it was used to carry the monarch to and from a flagship or the various royal yachts. After 1849, when Prince Frederick's barge was taken out of service, this shallop, originally commissioned by William III for Queen Mary in 1689, was the only remaining state barge of the English Crown. It was last used by King George V and Queen Mary in the Peace Pageant on the River Thames in August 1919, after World War I.
BAE0039 / F0969-3

SAILOR SUIT MADE FOR THE FUTURE EDWARD VII WHEN A CHILD
1846

Although there was no official uniform for naval ratings until 1857, naval captains tried to keep their ships' companies looking similar and smart. A miniature version of the summer rig of the crew of the Royal Yacht *Victoria and Albert* was made for the five-year-old Prince Albert Edward. The painting of the Prince in his sailor suit by F. Winterhalter helped to popularize this form of dress for children. The frock has watch stripes on both arms. They should be on one or the other; however, it is presumed that the maker did not want to offend either the port or the starboard watch!

UNI0294 & UNI0293 / D4692

(Below)
SEXTANT MADE FOR THE PRINCE OF WALES (LATER EDWARD VII)
Mrs Janet Taylor
c. 1855

Most sextants were made of brass with a plain latticework frame but this presentation instrument for Queen

Victoria's son, Edward, Prince of Wales, is silver and incorporates his elaborate crest, with its distinctive three feathers. Mrs Janet Taylor was an expert mathematician who ran her own navigation school and nautical warehouse in the Minories, near the Tower of London, selling charts and navigational instruments. She corresponded on theoretical matters with the Hydrographer of the Navy and devised new navigational tables and instruments.

NAV1135 (S.81) / C1552

(Opposite, top)
KING GEORGE VI COMING ABOARD HMS *ESKIMO* AT TRIPOLI
Lieutenant-Commander J. E. Manners
19 June 1943

King George VI made only his second overseas visit during World War II to Allied forces in North Africa and to the besieged island fortress of Malta. The King's visit coincided with preparations for the Sicily landings, which would see Allied forces fighting on European soil for the first time since 1940. The King arrived at Algiers on 12 June 1943 and made his way to Tripoli, where he embarked on the Tribal-class destroyer *Eskimo* before joining the Arethusa-class cruiser *Aurora* for the journey to Malta, which had been awarded the George Cross a year earlier.

PM1145/2
(Left)

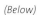

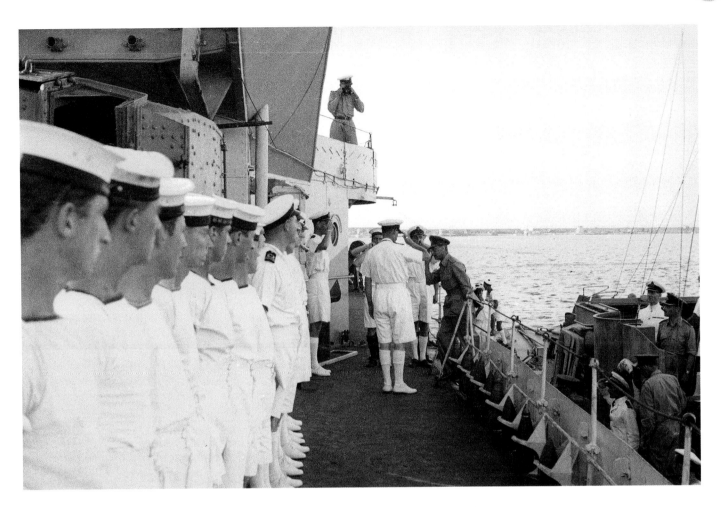

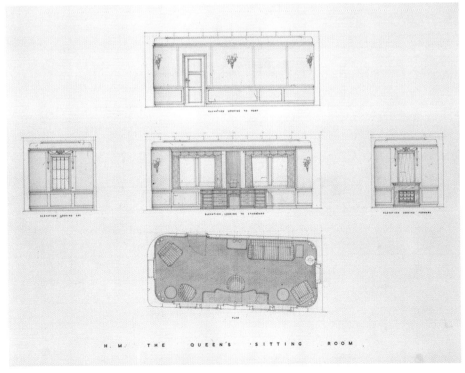

H. M. THE QUEEN'S SITTING ROOM

PLAN OF RY *BRITANNIA*
John Brown & Co. Ltd
1953
These interior design drawings are from
a series of seventeen coloured sketches
from the Clydebank yard of John Brown
& Co. Ltd. They represent the proposed
permanent decoration and variable
furnishings of the royal apartments
in the Royal Yacht *Britannia*. The Queen
and Prince Philip oversaw the interior
design of the vessel, approving plans
and choosing many of the fittings.
The Queen used her sitting room
as an office to complete state business.
Prince Philip's sitting room is opposite,
on the port side.
E8876-1

SAIL TO STEAM

Pieter van der Merwe

Mankind has probably used boats for 40,000 years but it is only from within the last 10,000 that we have evidence to suggest the forms these may have taken: rafts, including craft made of reed bundles; boats 'dug out' from tree-trunks; and others of skins or bark stretched over light frames. The oldest intact 'ship' is the plank-built funerary barge of the Pharaoh Cheops, from 2600 BC, found dismantled in a special burial pit beside his Great Pyramid. This is of a type which wall paintings and models from Egyptian tombs show was either rowed or propelled by a square sail on a mast amidships, and the largest were certainly sea-going vessels. The next oldest sea craft known, probably used as coastal cargo vessels, are three fragmentary Bronze Age boats, found together in the mud of the River Humber at North Ferriby, Yorkshire. Up to about 60 ft (18 m) long and made of heavy planks 'sewn' together with lashings, these date from around 2000–1700 BC. They were probably paddled but may also have used simple sails.

The square-sailed and rowed galleys and sailing cargo vessels of ancient Greece and Rome are now familiar from images on painted pottery, stone carvings, and from some excavated cargo wrecks and one or two modern reconstructions (including a Greek trireme) built from such evidence. So too are other vessels of ancient origin which still exist in

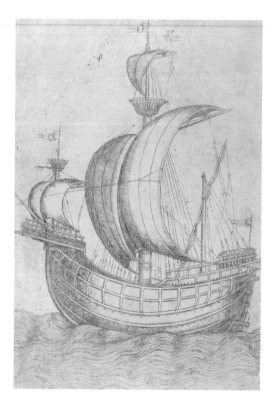

This Italian engraving of about 1470–80 is one of the earliest images of a three-masted, ocean-going cargo ship with a topsail. This rig became more sophisticated but did not change in principle until sail gave way to steam over 400 years later.
PAD7170 / B8571

modern forms – Chinese junks and the lateen-sailed craft of the Arab regions, for example.

The period from the fall of the Western Roman Empire (AD 455–76) to the final eviction of Norman Crusaders from Syria in 1291 saw a wide variety of vessels in use in Europe. One of the most significant was the 'cog', a high-sided, single-masted North-European cargo vessel with a single square sail. This also had a central rudder fixed to its sternpost, rather than a steering oar on one or both sides, as used by Viking craft in the first case and large Mediterranean ships in the second. A Florentine chronicler reported that Basque pirates brought cogs into the Mediterranean in 1304 and, by about a hundred years later, their characteristics were combined with those of contemporary two- or three-masted lateen-rigged Mediterranean craft to produce what we now call the classic, full-rigged sailing-ship. Its essential features were a centreline rudder and a three-masted rig, with square sails on the fore- and mainmasts and a lateen sail on the mizzen or after-mast. This new ship type, the first capable of meeting all the conditions and purposes of long ocean voyages, unlocked the age of European maritime exploration, trade and colonization of the world. However, although they were further developed in this process, such full-rigged ships and their later variants did not

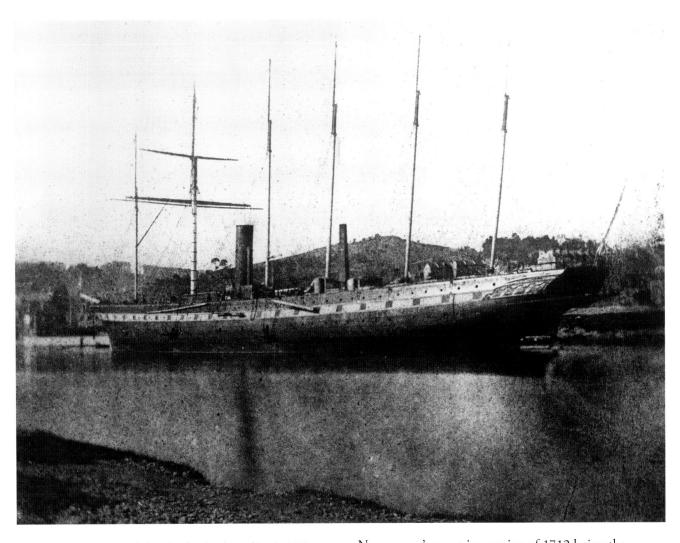

SS *Great Britain* at Bristol, shortly after her launching in 1843.
This is a very early photograph in the Museum's collection
by W. H. Fox Talbot. 3758

change in essential principles between the voyages of
Columbus, Magellan and Drake and the end of
commercial sail after World War I. The clipper *Cutty
Sark*, now preserved at Greenwich, represents almost
the final perfection of the classic sailing-ship and also
a critical moment in its long, steam-driven downfall.
The year she was built, 1869, saw the opening of the
Suez Canal as a short cut to the East. Built for
steamers and unusable by sailing-vessels, this was an
omen of the new age, in which ships of wood and
canvas, dependent on the world's wind patterns, gave
way to those of iron and steel, screw propulsion and
rapid movement almost at will.

Steam power itself goes back to around 1700,
Newcomen's pumping engine of 1712 being the
earliest successful example. The idea of 'steam
navigation' was first suggested in 1736 and
experimental paddle steamers had been tested in
England and France by 1790. Between 1812, when the
Comet initiated a regular service on the River Clyde,
and 1816, when the *Elise* (ex-*Margery*) made the first
English Channel crossing, several British river and
coastal services developed. The *Rob Roy*, originally a
Clyde steamer, launched the age of the modern cross-
Channel ferry when she began a regular service in
1821. The steam-assisted *Savannah* crossed the
Atlantic in 1819 and the *Sirius* made the first
transatlantic passage entirely under steam in April
1838. She reached New York only hours ahead of
Brunel's paddle-steamer *Great Western,* on the maiden
voyage of the first scheduled liner service. By then

steam tugs were in wide use, supporting sail, and the Navy had begun to use small wooden paddle war vessels, such as the 4-gun *Rhadamanthus*, which took part in the blockade of the River Schelde in 1832. However, it was 1846 before the Navy acquired its first large iron paddle frigate, the *Birkenhead*, wrecked with great loss of life off South Africa in 1852.

Although paddle power was to continue into the twentieth century, the screw propeller was successfully demonstrated in Wimshurst's *Archimedes* of 1838 and the Navy was eventually convinced of its superiority by the 'screw versus paddle' trials between HMS *Rattler* (screw) and *Alecto* in 1845. Commerce was further ahead, with the launch of Brunel's SS *Great Britain*, the first screw passenger liner, in 1843. The wooden 80-gun *Agamemnon* of 1852 was the Navy's first large warship designed with integral screw propulsion (although a number of others were converted) and in 1860 the revolutionary iron clad screw frigate *Warrior* heralded the end of sailing warships such as Nelson knew. *Warrior*, now preserved near Nelson's *Victory* at Portsmouth, was the most powerful ship in the world and bigger than any other except Brunel's vast paddle and screw steamer, *Great Eastern* (1858). All these ships, however, and the majority of large steam vessels also used sail. They continued to do so to some degree until around 1900, although the first entirely 'mastless' battleship, HMS *Devastation*, was launched in 1871.

Development was rapid as boiler pressures and engine efficiency increased. The years between 1865 and the early 1880s saw the introduction of the compound engine, comprising a high- and low-pressure cylinder and a condenser system, and its refinement into the triple-expansion engine through the addition of a third, medium-pressure piston. The Navy experimented with oil-firing from 1893, although this was initially combined with coal, as in the Dreadnought-class battleships launched from 1906, and most of the fleet was oil-fired or still a combination by World War I. Merchant vessels, beginning with Shell oil tankers, saw the start of oil-firing from 1898–99.

The experimental *Turbinia*, built by C. A. Parsons and powered by his revolutionary steam turbine, was completed and tested in 1894. By the time it made a spectacular public appearance at Queen Victoria's Diamond Jubilee Review of the fleet in 1897, the Navy was already adopting Parsons's invention for small, fast-attack craft, and the first turbine Atlantic liner, *Victorian*, was launched in 1904. At the same time, in 1896, the French-born Rudolf Diesel completed the successful prototype of the multi-purpose engine that bears his name and by 1898 he was a millionaire, largely through licensing its international production. While steam turbines were the motive power of the fast liners of the twentieth century, and still drive warships, it is reliable, efficient and economic marine diesels which power most modern commercial shipping today, from super tankers down to fishing boats.

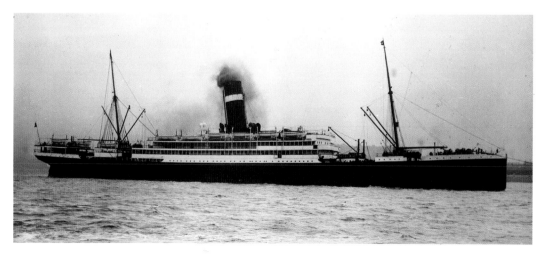

Victorian, shortly after her launching in 1904.
P14837

SCULPTURE

(Below)
BUST OF SIR WALTER RALEGH
John Michael Rysbrack
1757

This terracotta bust was modelled by the eminent sculptor Rysbrack, from an engraving after an earlier painting of Ralegh with his son. It is one of a series of seven busts of notable Englishmen made for Sir Edward Littleton's library at Teddesley Hall, Staffordshire. The terracotta busts of Sir Francis Bacon and Oliver Cromwell are also in the Museum's collection. Ralegh is sculpted in a feathered hat, ruff and embroidered doublet. Rysbrack wrote to his patron in July 1756: 'When I can possibly have an opportunity to begin the head of Sir Walter Raleigh I will take it in hand, but it is one of the most difficult in your whole list to make it do well'.
SCU0043 / D4677

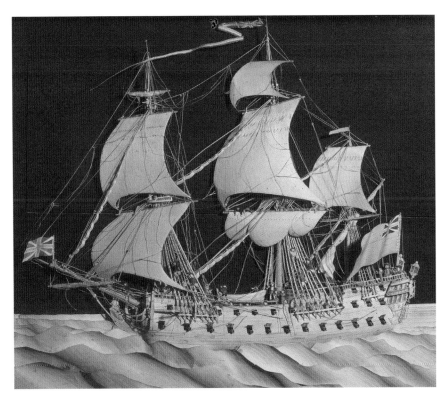

PAPER SHIP
Augustine Walker
1761

Among the more unusual treasures of the Museum are two warship models made entirely of paper, including the hull, sails, rigging and sea. These intricate paper sculptures are also accurate representations of eighteenth-century ships. We have little information about the maker, Augustine Walker of Rye, but he clearly specialized in this art, as other examples are known.
OBJ0531 / 3264

(Right)
BUST OF ADMIRAL JOHN FISHER
Sir Jacob Epstein
1916

This is a bronzed plaster version of Epstein's bust of Admiral of the Fleet Lord Fisher of Kilverstone. Epstein described it as the 'most powerful I have ever done'. Fisher, he wrote, was 'one of the greatest men of this age, one of the greatest figures of this war, and the head and features are a wonderful expression of this tremendous personality... Fisher had an extraordinary appearance. His light eyes, with strange colours, were set in a face like parchment ivory, and his iron grey hair was cut short and bristled on his head ... He was the typical man of war'.
SCU0018 / D4663

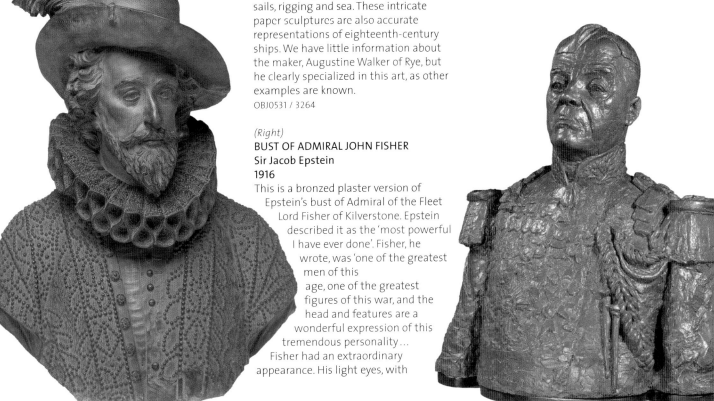

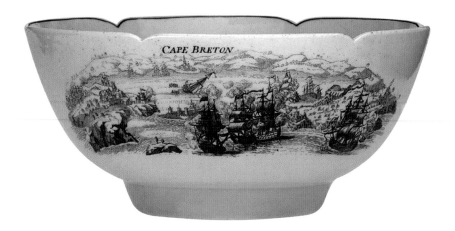

Seven Years War, 1756–63

(Above)
SEVEN YEARS WAR BOWL
Worcester
c. 1760

The Seven Years War, in which Britain supported Prussia against attack from Austria, France, Sweden and Saxony, was fought in distant locations. This small Worcester bowl is finely printed with views of some of the naval victories. The interior has a scene of warships outside the harbour at Senegal and the exterior shows ships engaged in action at Cape Breton and Guadeloupe. Fort Louis, on the Senegal River, surrendered to Captain Henry Marsh and Major Mason on 1 May 1758, and Cape Breton capitulated to the British, under Admiral Boscawen and General Amherst, after the surrender of Louisbourg on 26 July 1758. The island of Guadeloupe finally succumbed on 1 May 1759 after bombardment by Commodore Sir John Moore.
AAA4356 / D5522

(Below)
MARINE SOCIETY BOWL
Robert Hancock, Worcester
c. 1760

At the beginning of the Seven Years War in 1756, the Marine Society was founded by the philanthropist Jonas Hanway and others to provide funds to kit out poor boy volunteers for sea, thereby both recruiting for the Navy and removing them from the streets. The Marine Society is the world's oldest public marine charity and still operates today. This small transfer-printed porcelain bowl dates from about 1760. The print of Britannia and Charity overseeing the Marine Society's reclothing of ragged boys includes a boy pulling on a pair of the loose canvas protective trousers worn by seamen. The same engraving had appeared in Jonas Hanway's letters on the subject of the Marine Society, which had been published the previous year.
AAA4483 / D5840

(Below, right)
ADMIRAL BOSCAWEN MUG
Robert Hancock, Worcester
c. 1758

This Worcester porcelain mug commemorates Admiral Edward Boscawen's part in the Siege of Louisbourg (1758) during the Seven Years War. Having served under Admiral Vernon at Porto Bello in 1739, he was made Admiral of the Blue in 1758 and appointed Commander-in-Chief of the fleet fitting out for Louisbourg, Canada. This mug is among the earliest printed commemorative porcelain pieces and the portrait of the admiral is a composite one, combining two engravings after paintings by Allan Ramsay and Joshua Reynolds. He holds a chart of Louisbourg and on the other side of the mug are two warships and the Boscawen coat of arms.
AAA4385 / D5860

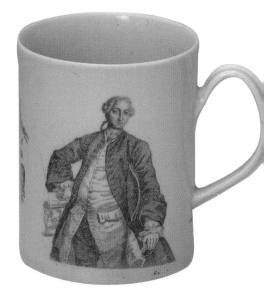

CAPTURE OF HAVANA WINE GLASS
c. 1762
This wine glass, inscribed 'The Twelth [*sic*] of August is a Very Good Toast', commemorates the capture of Havana, Cuba, on that day in 1762. The glass is set on a facet-cut stem and the gilded decoration on each side depicts a palm tree and distant fortress, a standing figure and military trophies. A shield of arms bearing three scallop shells, the arms of the Keppel family, marks the part played in the capture by General George Keppel, 3rd Earl of Albemarle, Commander-in-Chief of the expedition, and his two brothers, who were all awarded considerable sums in prize-money.
GGG0297 / D5539

SHIP DESIGN

(Above)
PLAN OF THE *SOVEREIGN OF THE SEAS*
Unknown maker
1637
Designed and built in Woolwich in 1637 by Phineas Pett and his son Peter as the largest warship of her time, *Sovereign of the Seas* was intended as the flagship of Charles I's navy. The decoration of the vessel was conceived by the dramatist and actor Thomas Heywood. King Edgar (AD 44–75) is represented on horseback, forward of the forecastle, trampling on the British kings from whom he received submission. While *Sovereign of the Seas* was at Chatham in January 1696, a candle was left alight in the cook's cabin and she suffered a devastating fire.
ZAZ0047 / E8875

(Below)
***BOYNE*, 80 GUNS**
1690, scale 1:48
A particularly fine example of late-seventeenth-century modelmaking, this illustrates the design and ornate decoration of the ships of this period very well. The model is thought to be unique in that it bears its name in a scroll carved at the break of the poop deck, which reads `YE BOYNE Bt [built] BY MR HARDING DEP [Deptford] SA ...' The richly carved stern decoration is complete with the original and almost

circular stern lanterns, while the intertwined monograms of William and Mary appear on the quarter galleries. The *Boyne* was one of the first of a large class of 80-gun two-deckers built between 1692 and 1695. She took part in the battle of Velez Malaga leading to the capture of Gibraltar in 1704, before being rebuilt in 1708 as a three-decker.
SLR0006 / D1898-C

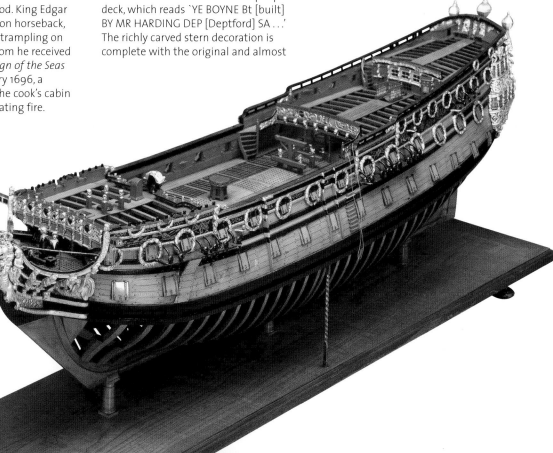

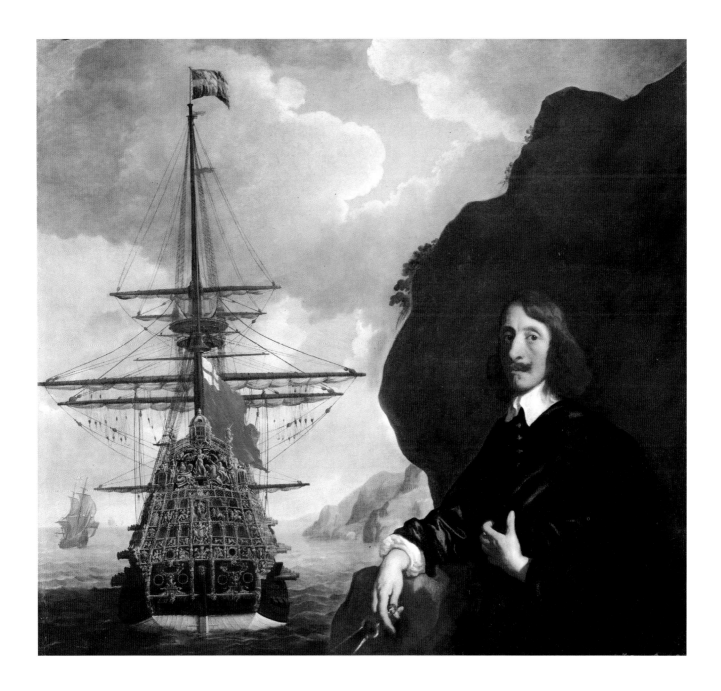

PETER PETT, 1610–70, AND THE
SOVEREIGN OF THE SEAS
Sir Peter Lely
c. 1645

Painted early in Lely's career, following his arrival in England from Holland in 1643, the portrait shows in great detail the *Sovereign of the Seas*. Her elaborate decorations, devised by the dramatist Thomas Heywood, tell the story of Jason and the Golden Fleece and were executed by the same craftsmen who carved the woodwork in the Great Hall in the Queen's House at Greenwich. In fact only the portrait of Pett is by Lely. Who painted the ship remains a matter of debate.
BHC2949

(Below)
SHIP OF 48–50 GUNS
1691, scale 1:48
A large number of small two-deckers of this class were built from 1691 onwards. A particularly interesting feature of this model is the almost vertical planking either side of the rudder below the stern galleries. 'Square tuck' sterns disappeared in all but small craft after about 1630. The superb quality of the decoration, which is both deep and sharp, is more apparent as it has not been obscured by gesso and gold paint. Just below the lower row of windows are the clearly defined monograms 'W. R' and 'M. R', which date the model between King William's accession in 1689 and Queen Mary's death in 1694.
SLR0349 / D4066-5

(Bottom, right)
BELLONA, 74 GUNS
1760, scale 1:48
This is one of the few eighteenth-century models in existence that shows the actual method of constructing a ship. The framing and timbering of the hull is complete and sections of the planking have been fastened to the port side below the main wale. Just below, running bow to stern, are narrow battens known as 'ribbands' which hold the frames in position and are removed just before the planking is applied. This model clearly illustrates the massive construction of these ships and *Bellona* would have required at least 3000 oak trees for the hull alone.
SLR0503 / D5945

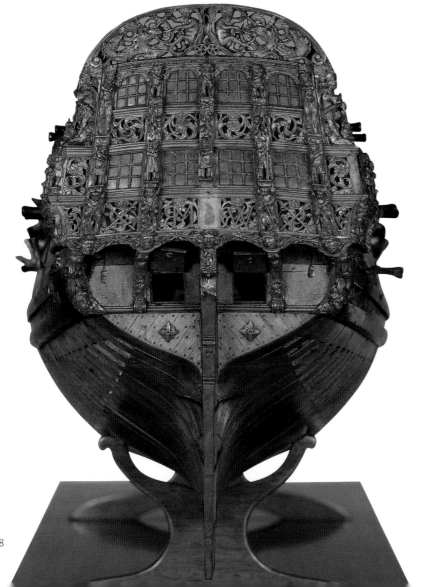

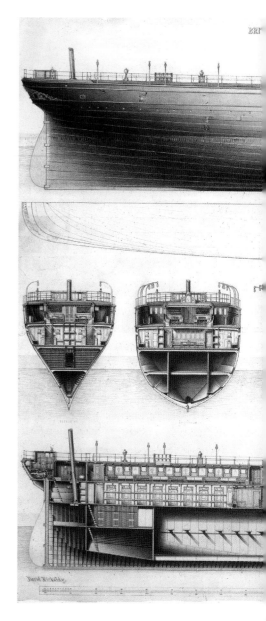

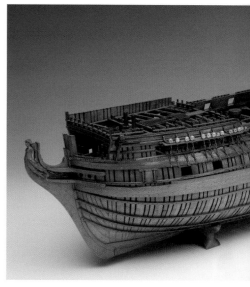

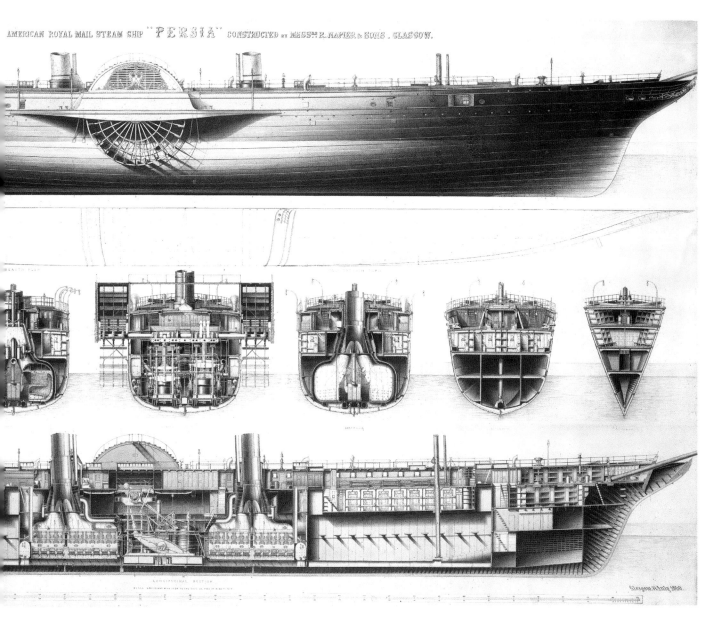

AMERICAN ROYAL MAIL STEAM SHIP "PERSIA" CONSTRUCTED BY MESS.RS R. NAPIER & SONS. GLASGOW.

(Above)
PERSIA
David Kirkaldy
1856
David Kirkaldy was chief draughtsman at the shipbuilding and engineering firm of Robert Napier & Sons Ltd, Glasgow. His plan of the *Persia*, the first iron-hulled vessel built for Cunard in 1856, was the only engineering drawing to be exhibited at the Royal Academy. The drawing highlights the *Persia*'s steam machinery and interiors. The *Persia* was renowned for having the finest accommodation afloat at this time. She took the Blue Riband for the fastest sea crossing of the Atlantic in July 1856, a record she held until 1862.
D4033

SHIPBUILDING

(Above)

A SIXTH-RATE ON THE STOCKS
John Cleveley, the Elder
1758

The exact location of this shipyard is unclear but it may be on the south bank of the Thames at Rotherhithe. The ship in the foreground ready for launching is a 24-gun sloop of war. In the right foreground, tree-trunks are piled ready to be used in shipbuilding and behind them two figures sit on a stack of wooden planks. Cleveley has therefore chosen to include three stages of the use of wood in shipbuilding, an activity with which he would have been very familiar from his background as a shipwright in Deptford Dockyard.
BHC1045

(Opposite)

BELLONA, 74 GUNS
Probably by George Stockwell
c. 1775, scale 1:38.4

A persistent problem facing mariners from earliest times was the protection of the underwater hull from the attack of marine boring worms, molluscs and weed growth, all of which required dry-docking the ship for expensive and time-consuming repairs. By the early 1760s a successful remedy was found, which was to sheathe the hull with copper plates. Because of the projected expense of coppering the entire fleet, this model was probably commissioned to enlist the support of King George III. *Bellona* is mounted on a slipway and not only demonstrates the practice of coppering but also the actual colour scheme and decoration for a warship of this period.
SLR0338 / C1099

SAILMAKING MUG
c. 1800

This creamware mug, which was probably made in north-east England, is inscribed 'Success to the Sailmakers'. It is transfer printed with a scene of a sailmaker seated at his bench sewing a sail, while two other figures work on a second sail and another stands holding a length of twine. Sailmaking tools and equipment can be seen on the floor and mounted on the back wall of the sail loft. The illustration is based on an engraving in David Steel's *Elements of Mastmaking, Sailmaking and Rigging*, first published in 1794.
AAA6332 / D6624

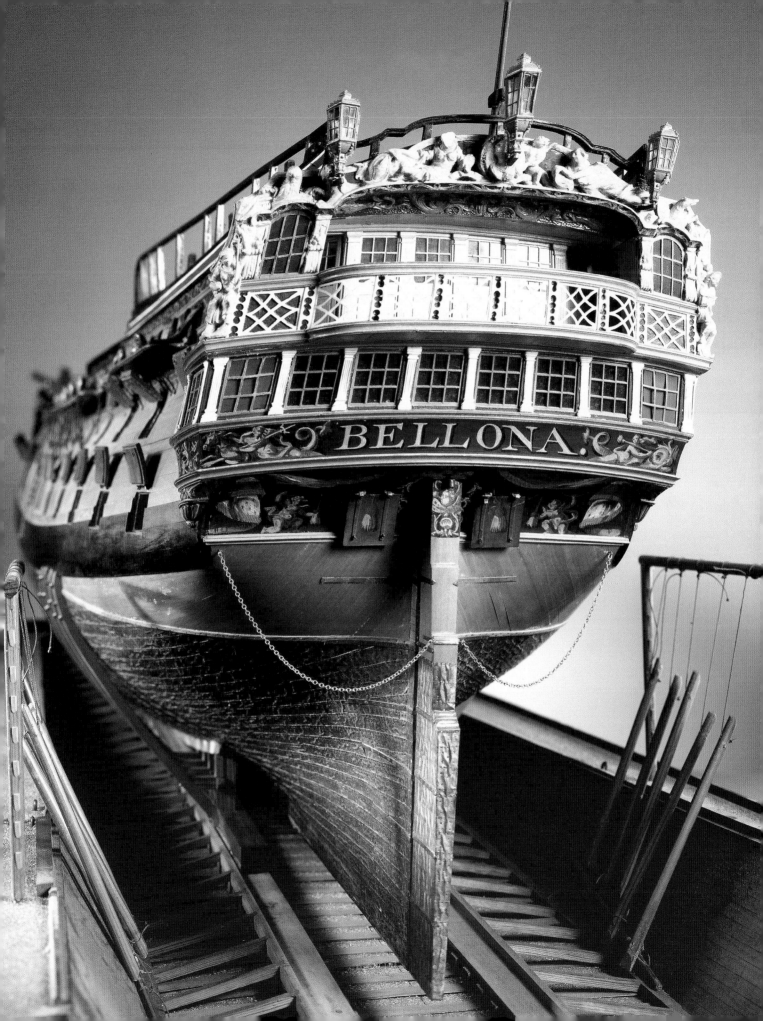

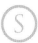

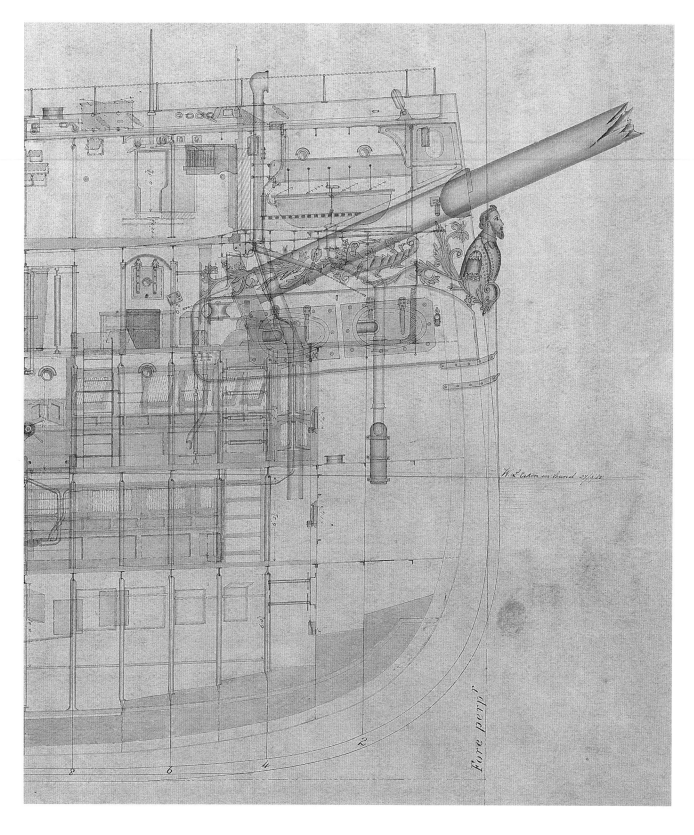

Fore perp.

8 6 4 2

192

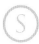

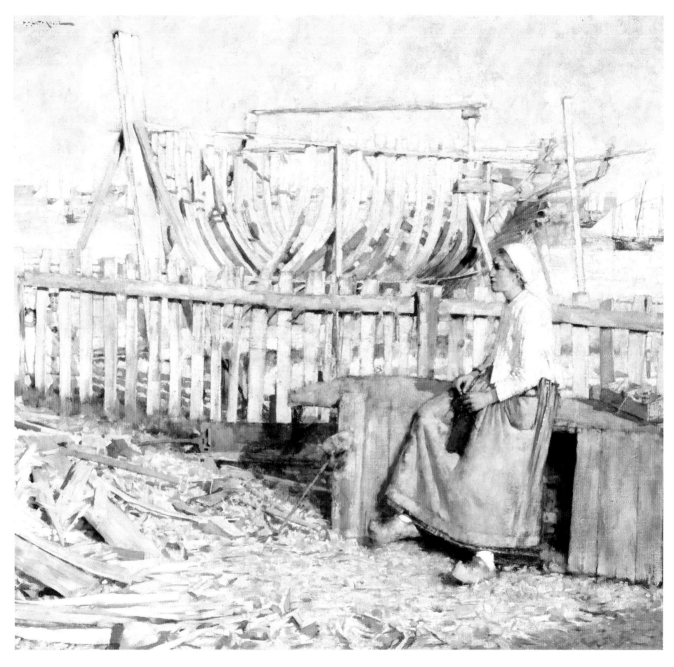

(Opposite)
PLAN OF HMS *RALEIGH*
The Admiralty
1885 and 1898
HMS *Raleigh* and her two near sister ships – *Inconstant* and *Shah* – were launched between 1868 and 1873 as iron frigates. *Raleigh* was refitted twice at Devonport, the renovations being completed in 1885 and 1898. This inboard profile plan details both these refits, the later one detailed in red ink. The prow detail of the plan displays the watercolour wash applied to the design to differentiate between materials and areas of the ship. A figurehead of Sir Walter Ralegh is fitted under the bowsprit. The spelling of names often varied, and Ralegh himself spelt his name in different ways throughout his life.
NPB9670 / E0766

THE BOAT-BUILDER'S YARD, CANCALE, BRITTANY
Henry Herbert La Thangue
1881
La Thangue was one of the English artists who followed the French realists in painting the Brittany coast in the 1880s. They painted subjects of ordinary working life, done on the spot.
This work was regarded as revolutionary because it challenged the artistic conventions of English art institutions. In its observation of the working methods and conditions of Breton boat-building, an industry culturally linked with the fishing villages of Cornwall, the painting anticipates the Newlyn school. It was acquired with the assistance of the National Art Collections Fund.
BHC4184

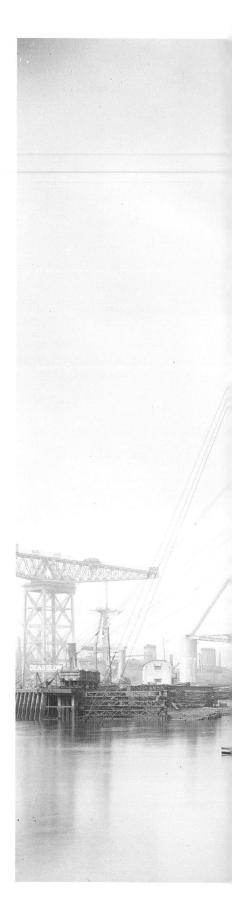

(Above)
JOHN BROWN'S SHIPYARD AT CLYDEBANK
H. Bedford Lemère
1901
This is one of a series of photographs taken in 1901 by the professional photographer, H. Bedford Lemère only two years after John Brown, the Sheffield-based steel company, took over the Clydebank Shipbuilding & Engineering Co. The year 1901 saw the beginning of the golden age of British shipbuilding with John Brown at the forefront, constructing many famous ships, such as the passenger liners *Lusitania*, *Aquitania* and *Saxonia* and the warships *Repulse* and *Hood*. The photographs show the vast scale of the shipyard in extraordinary clarity and detail, this one depicting the massive engine-erecting shop.
G10560

(Right)
***AQUITANIA* ON THE STOCKS AT CLYDEBANK**
H. Bedford Lemère
1913
This striking image of the Cunard liner *Aquitania* is another in the series taken by H. Bedford Lemère at John Brown's shipyard on Clydebank. The figure to the left gives an indication of the size of the 45,000-ton vessel. *Aquitania* was built to join the ships *Mauretania* and *Lusitania* on Cunard's transatlantic route and she became the company's longest-serving liner. She was launched amid great celebrations on Monday, 21 April 1914. *Aquitania* served as a hospital ship and troopship in both World Wars and was eventually scrapped on the Clyde in 1950.
G10695

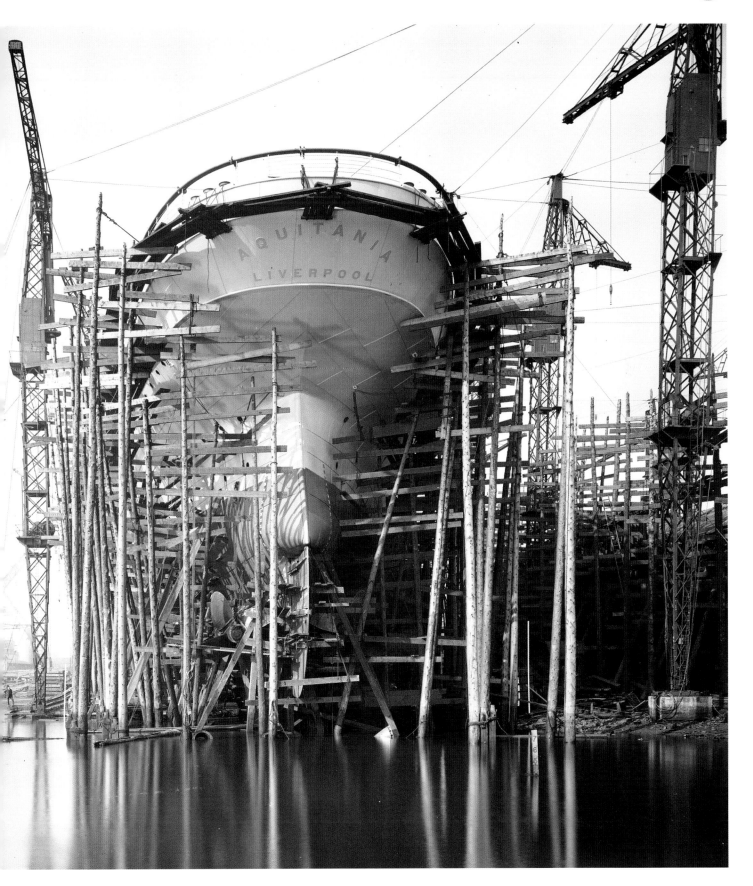

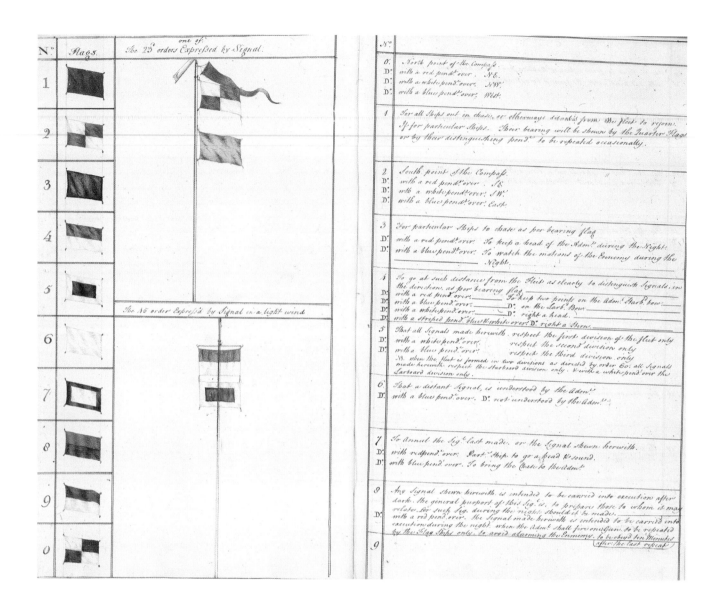

Signalling

**MANUSCRIPT SIGNAL BOOK
ILLUSTRATING ADMIRAL LORD HOWE'S
CODE OF 1776**
In the seventeenth century messages
were sent by flying flags in different
parts of the rigging, and hoisting and
lowering particular sails. From these,
signal flags evolved: each flag was
numbered and combinations of these
numbers corresponded to various
messages in the signal book.
SIG/A/8 / D4701

Slaves, Spices and Settlements:
the British Maritime World, c. 1600–1850

Robert Blyth

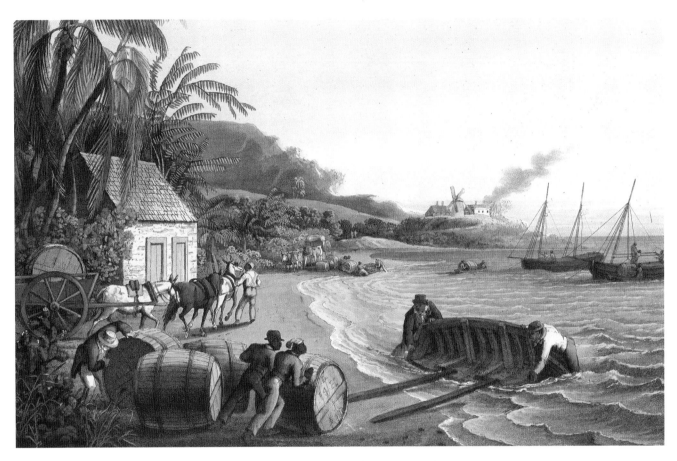

Shipping sugar from Antigua. PAH3019 / PY3019

By virtue of being an island on the very edge of Europe, Britain was perhaps destined to become an important maritime power. For centuries, traders from the British Isles had been involved in the commerce of the North Sea, the Baltic and the Mediterranean. At the end of the fifteenth century, English navigators began to venture farther afield. In 1497, only five years after Columbus's famous transatlantic voyage, John Cabot sailed from Bristol to North America. In the century that followed this epic feat, English seamen travelled to West Africa and the Caribbean, searched for the North-West Passage, circumnavigated the globe and attempted to establish colonies in North America. This interest in the wider world was driven primarily by the pursuit of profit rather than the quest for knowledge. By 1600, England (later Great Britain) began to emerge as a more significant maritime power. In the Atlantic Ocean and increasingly in eastern seas, British sea power helped to establish an expanding empire and secure profitable trading routes.

By the early seventeenth century, English settlements were established along the eastern seaboard of North America. The colonies attracted emigrants from Britain who wanted to escape oppression and poverty at home or who simply wished to make a new start. The settlers traded timber, furs and tobacco in return

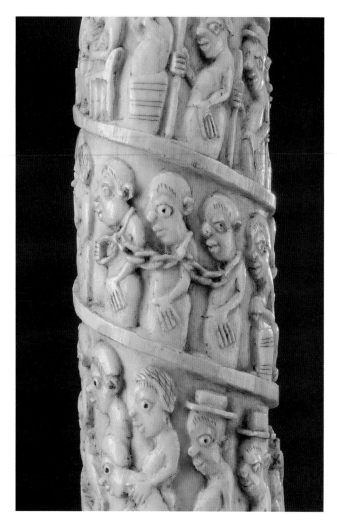

Detail from a carved tusk depicting the African slave trade.
Congo, nineteenth century. ZBA2430 / E9110

for cloth, metal goods, weapons and other man-made goods. From this perilous beginning, British North America became a prosperous and important possession.

Further south, Caribbean islands were seized and developed for sugar production. This style of plantation economy was labour-intensive and required a huge work-force. The climate of the Caribbean proved unhealthy for Europeans and the islands did not attract the type of immigrants that settled in New England. Labour had to be imported and Britain became involved in the transatlantic slave trade to meet the demands of the planters. This appalling trade quickly developed a complex and unique pattern of operation. Ships left British ports carrying manufactured goods, guns, alcohol and cloth, and

sailed to the West African coast. Within Africa the slave trade was sustained by the seizure of millions of men, women and children by fellow Africans. The African traders then drove their captives to the coast where they were exchanged for European goods. The captured Africans were chained together and packed into cramped and unsanitary conditions on board ship. They now faced the horrors of the 'Middle Passage' from West Africa to the Americas. The voyage could take many months, with the captives given little exercise and only the most basic of provisions. Many died from disease and cruelty. Once in the Americas, the survivors were sold to planters at auction, to work as slaves in the fields. The ships then took on cargoes of sugar, tobacco or rum and returned to Britain to sell these lucrative commodities, before embarking on another voyage, continuing the trading cycle. The trade was full of risks but was enormously profitable. By the middle of the eighteenth century, Britain was the most successful slave-trading nation.

The switch in British trade from Europe to the Atlantic led to the development of west coast ports such as Bristol, Liverpool and Glasgow, which had a geographical advantage over London. Bristol and, later, Liverpool became important ports for the slave trade and Glasgow became the centre of the tobacco trade. Transatlantic trade was often disrupted by war, in particular the American Revolutionary War, 1775–83. Despite these serious setbacks, the Atlantic trade was profitable. But people began to question the morality of the slave trade and from the 1780s a large and vocal campaign fought to outlaw Britain's involvement. In 1807 an Act of Parliament made it illegal for any British subject to trade in slaves. In 1833–34 the institution of slavery was outlawed in the British Empire and slaves received their freedom in 1838. By this time, the sugar islands of the Caribbean had declined in relative economic importance as India had begun to develop as a major British market.

On New Year's Eve 1600, the English East India

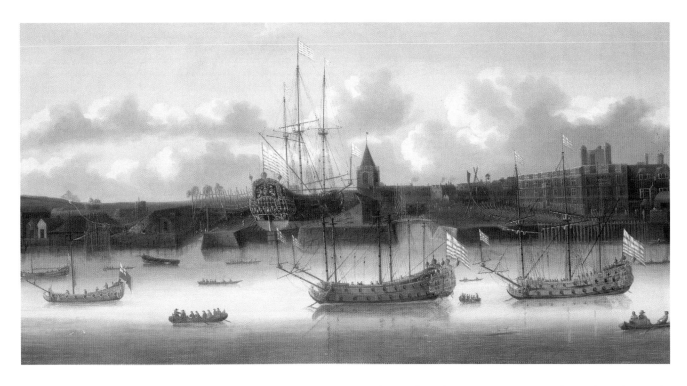

The East India Company's Yard at Deptford, c. 1660, seventeenth-century English school. BHC1873

Company received its royal charter from Elizabeth I. The Company was granted a monopoly of English trade with the East. It sent ships to India and South-East Asia to bring home a share of the riches of the exotic 'Spice Islands'. This important commercial enterprise grew steadily and the Company and many of its servants made vast fortunes. It built its own dockyard at Deptford on the Thames and soon operated a fleet of large merchant vessels. These East Indiamen were armed to protect their valuable cargoes from attack by South-East Asian pirates and the ships of rival European powers. The Company's huge trading network spread from Britain to St Helena in the Atlantic, from the Cape of Good Hope and the Persian Gulf to China, and across the Pacific to the west coast of North America.

From the mid-1600s, the Company began to acquire pieces of territory in India. From these footholds at Bombay, Madras and in Bengal, the Company expanded outwards to create a large territorial empire by the middle of the eighteenth century. This was achieved by raising native armies and by exploiting the complex Indian political situation to oust rival Dutch and French interests. While commerce remained profitable, the Company became more involved in the military, political and financial affairs of the Indian states. In 1813 the Company's monopoly over the India trade was ended, and in 1833 the lucrative China tea trade was thrown open to competition. The East India Company became, in effect, the government of British India with London regulating its affairs. Finally, following the rebellions associated with the Indian Mutiny of 1857–58, the Company was abolished and the Indian Empire came under more direct British rule.

Although English navigators had sailed across the Pacific in the sixteenth century, it was not until Captain James Cook's voyages in the eighteenth century that Britain began to take a greater interest in the region. Cook's charting of New Zealand and eastern Australia was the first stage in the gradual colonization of these 'new' southern lands.

In 1788 the First Fleet took convicts from Britain to Botany Bay to establish the colony of New South Wales and Captain Arthur Phillip, its first Governor, founded a settlement at Port Jackson (Sydney). The British began to establish towns and to settle in other parts of Australia. In 1829 the entire

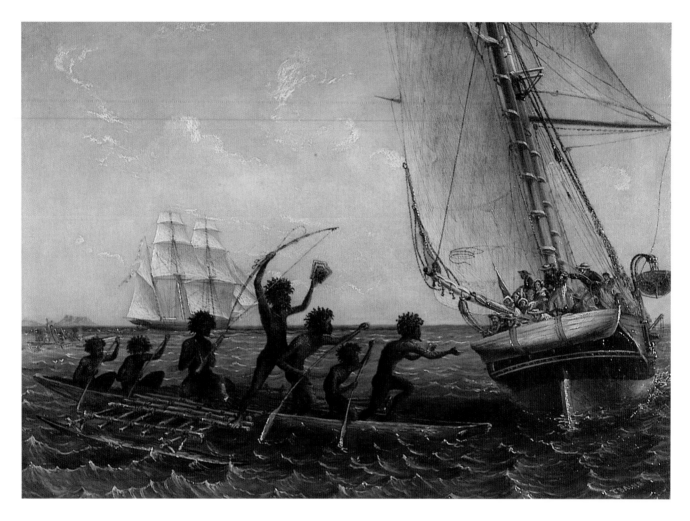

Aboriginal canoes communicating with Monarch *and* Tom Tough, *28 August 1855*, John Thomas Baines. BHC1191

Opposite: Deck plan of the slave ship, *Vigilante*, 1822. Images like this, showing a captured French slaver, graphically illustrated the appalling conditions on slave ships and became widely used by the Abolition movement. D4695

continent was declared British and in 1850 most convict transportation to Australia was ended.

In New Zealand, British traders and settlers had to contend with the native Maori inhabitants, who proved much more warlike than the Australian Aborigines. By the 1790s, naval vessels were making regular visits to the northern ports of the islands to trade in flax and timber. The arrival of Christian missionaries and early European settlers in the 1820s and 1830s led to greater tension with the majority Maori population. This led the Maori chiefs to declare their independence from Britain in 1835. But, faced with more systematic settlement, the chiefs signed the Treaty of Waitangi in 1840, which went some way towards guaranteeing Maori rights and allowed Britain to claim sovereignty over the islands of New

Zealand. During the nineteenth and twentieth centuries, Australia and New Zealand became important destinations for British emigrants.

By the 1850s, the British Empire had spread to every continent and its continued growth was spurred on by the expansion of Victorian industry, commerce and capital. Sea power and communications were the Empire's connective tissue, holding together the sprawling British dominions, which soon came to encompass nearly one-quarter of the globe.

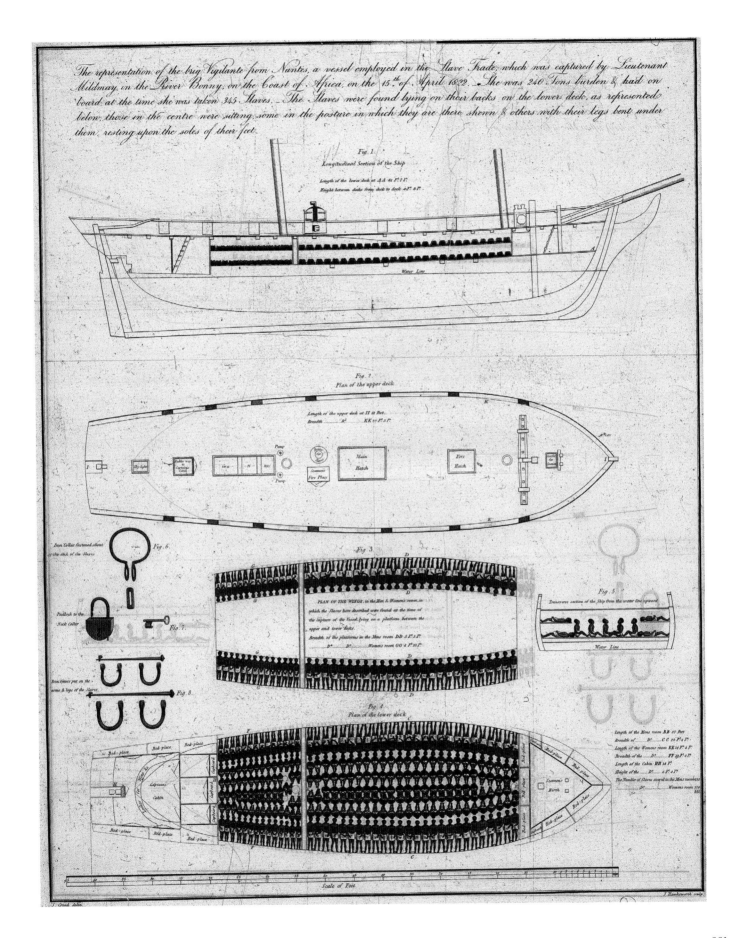

The representation of the brig Vigilante from Nantes, a vessel employed in the Slave Trade, which was captured by Lieutenant Mildmay, in the River Bonny, on the Coast of Africa, on the 15th of April 1822. She was 240 Tons burden & had on board at the time she was taken 345 Slaves. The Slaves were found lying on their backs on the lower deck, as represented below, those in the centre were sitting, some in the posture in which they are there shewn & others with their legs bent under them, resting upon the soles of their feet.

Fig. 1.
Longitudinal Section of the Ship

Fig. 2.
Plan of the upper deck

Fig. 6.
Iron Collar fastened about the stick of the Slaves

Padlock to the Neck Collar

Fig. 7.

Iron fetters put on the arms & legs of the Slaves

Fig. 8.

Fig. 3.

PLAN OF THE WINGS, in the Men & Women's room, in which the Slaves here described were found at the time of the capture of the Vessel, lying on a platform between the upper and lower decks.

Fig. 5.
Transverse section of the Ship from the water line upward

Fig. 4.
Plan of the lower deck

Scale of Feet.

201

SOLAR SYSTEM

(Opposite)
ARMILLARY SPHERE
Gualterus Arsenius
1568
An armillary sphere is a three-dimensional model of the solar system, often, as in this case, with the Earth at the centre. As with an astrolabe, there are pointers to indicate the position of prominent stars. The rings represent the apparent paths of the Sun, Moon and planets. This sphere is unusual in that it has a mechanism for demonstrating 'trepidation', a medieval concept intended to explain the apparent movement or 'precession' of the equinoxes. Armillary spheres by Gualterus Arsenius of Louvain are among the few rare instruments to demonstrate mechanically the apparent complexities of the motions of the starry sky.
AST0618 / D8014

(Left)
GRAND ORRERY
James Simmonds (clock);
Malby & Co. (orrery)
1780
This orrery was mainly a teaching instrument. It shows the relative movements of six planets and some of their moons: Mercury, Venus, Earth (with the Moon), Mars, Jupiter (with four moons) and Saturn (with seven moons). Around the edge are the twelve signs of the zodiac representing the different constellations on the ecliptic – the apparent annual path of the Sun through the background stars.
When correctly set up and going, the moons and planets move to show where they are in relation to each other and to the zodiac, for the date and at the time shown on the clock.
AST1067 (P26) / 7255

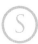

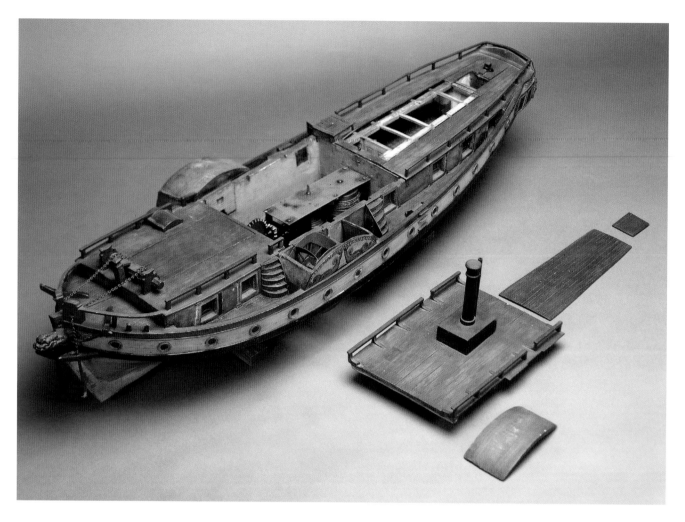

STEAMSHIPS

(Top)
STEAM YACHT *DOLPHIN*
Allen Hunt
1822, scale 1:32
This is possibly the world's first powered ship model, as paddle- and steamships were only just coming into use when it was made. Miniature steam engines had not yet been developed, so this model is powered by clockwork. It was probably made for the Duke of Northumberland, a patron of naval innovation. Allen Hunt

had a long career as a professional modelmaker. He was born in 1742 and issued a business card towards the end of the century, from his workshop in Southwark, London.
SLR0149 / D6020

(Opposite, bottom left)
SS *LIVERPOOL* BOX
Nathaniel Mills, Birmingham
1838

This gold box was presented to Robert Fayrer, captain of the paddle-steamer SS *Liverpool*, by the passengers on her first voyage from New York to Liverpool in 1838. The lid is engraved with a portrait of the ship based on a contemporary lithograph by John Isaac. The *Liverpool* was the first two-funnelled paddle-steamer to make the transatlantic crossing. The 240-ft (73-m) *Liverpool* was built in 1837 and purchased by the newly formed Transatlantic Steamship Company for their Liverpool and New York service. Captain Fayrer, who had previously served in the Royal Navy, received his unusually generous gift from the passengers on return to Liverpool 'as a token of their esteem and regard, and acknowledgement for his kind attention to their comforts during the passage'.
ZBA0095 / D8276-1

(Opposite, bottom right)
***TURBINIA* UNDER WAY**
Cribb
1897

The yacht *Turbinia* was the first vessel in the world to be powered by steam-turbine engines. It was designed by Charles Parsons (1854–1931), who was the first person to see the turbine engine's potential for maritime propulsion. The 103-ft (31.4-m) yacht was built for him by Brown and Hood of Wallsend in 1894 and reached hitherto unattainable speeds of over 34 knots. However, it was not until *Turbinia*'s surprise appearance at Queen Victoria's Diamond Jubilee review of the fleet at Spithead in 1897 that Parsons's design received the praise and publicity it deserved. The first Royal Navy battleship to incorporate steam turbines in its design was HMS *Dreadnought*, launched in 1906.
N47745

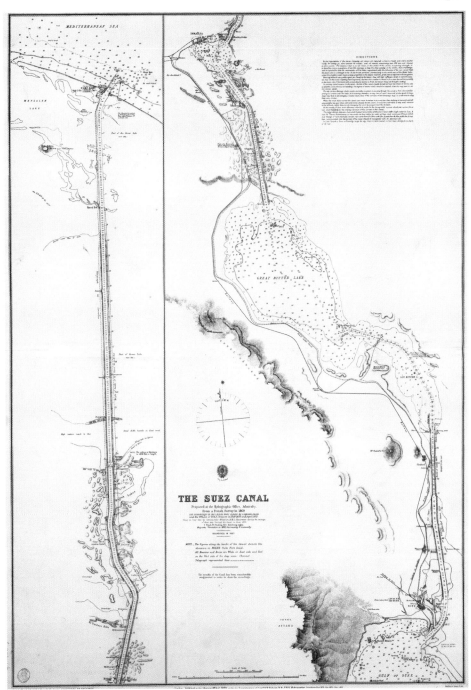

SUEZ CANAL

(Above)
SUEZ CANAL
George Nares
1869

The opening of the Suez Canal in 1869 was a glittering gala occasion but the British surveying ship, *Newport*, was attending with a serious purpose. Captain Nares made several passes through the canal, taking detailed soundings and resurveying Port Said. Eminent surveyors had predicted that silting would make the canal unusable and some who had opposed the French project on political grounds still hoped that this might be true. Subsequent surveys showed these fears and hopes to be unfounded and Britain soon took shared control and full advantage of this new route to the East.
G235:16/6 / F0136

SS *NONSUCH*
1906, scale 1:48
This is a fine example of a builder's model with gold- and silver-plated fittings, a technique designed to catch the eye when displayed in various boardrooms and international trade fairs. The *Nonsuch* was a turret-decked steamer, a type introduced by the shipbuilders Doxford & Sons in 1891. The Suez Canal charges were related to the width of the upper deck and so the narrower upper deck qualified the vessel for lower dues. The *Nonsuch* was built for Messrs Bowles Brothers in 1906 and, after a relatively uneventful career, was reported sunk by German air attack in Hamburg harbour in 1944.
SLR0083 / C9298

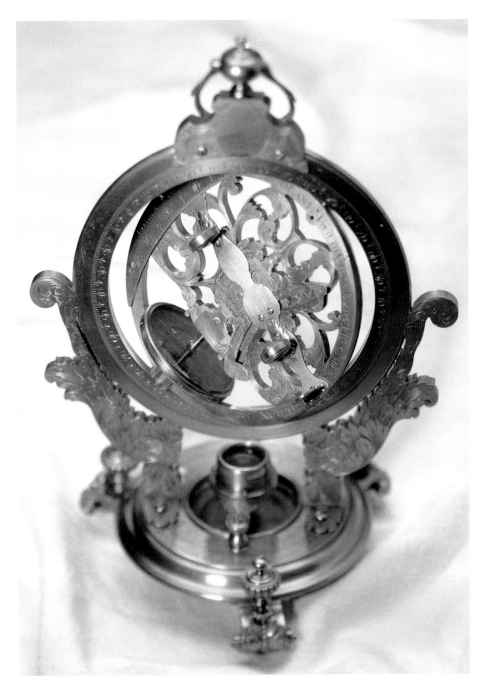

SUNDIALS

NAVICULA
c. 1450

The *navicula de Venetiis*, or 'Little Ship of Venice', is a medieval portable sundial. There are now only four other navicula known to exist: at Oxford, Cambridge, Florence and Milan. They were made in a number of European countries in the Middle Ages for wealthy travellers and pilgrims. The instrument is used to measure the altitude of the Sun, by viewing it through a pair of sighting holes and noting its altitude from a plumb line. From this observation the traveller could find out local solar time for virtually any location in the northern hemisphere.

AST1146 / D8339-A

MECHANICAL EQUINOCTIAL SUNDIAL
William Deane
c. 1720

In this portable equinoctial, or equal-hour, sundial the image of the Sun is projected through two lenses, which are geared to a clock dial. The angle at which the inner circle has to be set to align the Sun's rays with the lenses gives the time, which is then shown on the clock dial. There is a compass at the base of the instrument, to ensure the dial is lined up correctly, and a table with the equation of time to allow the dial time to be translated from solar to mean time for regulating clocks and watches.

AST0391 / D7733

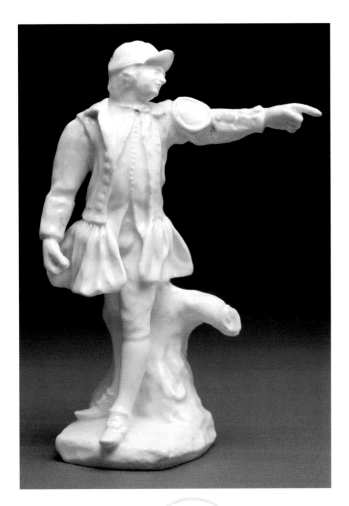

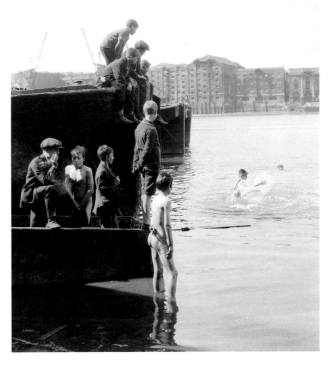

THAMES

(Opposite)
PRINCE FREDERICK'S BARGE
John Hall
1731–32
This state barge was built for Frederick, Prince of Wales, eldest son of George II and Queen Caroline. It was designed by the celebrated architect William Kent and built by John Hall on the south bank of the Thames just opposite Whitehall. The hull is of the traditional wherry type and the long raking stem and sharply flared bow enabled passengers to step on to dry land once beached bows-on. The lavish carved decoration was executed by James Richards, who succeeded Grinling Gibbons as Master Carver to the Crown in 1721. The overall length of the barge is 63 ft (19.2 m) with

a beam of 6 ft 6 in. (2 m). And it was pulled by up to 22 watermen.
BAE0035 / E0248

(Above, left)
THAMES WATERMAN
London
c. 1750
This porcelain figure, made in the Bow factory in the mid-eighteenth century, shows a Thames waterman wearing his distinctive full-skirted coat with a large brassard on the left sleeve, a peaked cap, buttoned waistcoat, breeches and stockings. At that time the Thames was the major highway of London, and licensed watermen ferried passengers up and down the river in their wherries. Such costume has survived to this day in the ceremonial red coat with silver buttons and arm badge worn by

winners of the annual Doggett's Race on the River Thames.
AAA6052 / D0834-1

(Above, right)
ROTHERHITHE BOYS
Waldo Mcgillycuddy Eagar
1923
Eagar was Assistant Director of the Borstal Association. He founded the National Association of Boys Clubs to encourage young boys off the streets and into organized sporting activities. 'Mudlarks' were children, like these pictured at Rotherhithe, who scavenged for things washed up from passing ships, and were a common sight along the Thames until the advent of compulsory education.
P27576

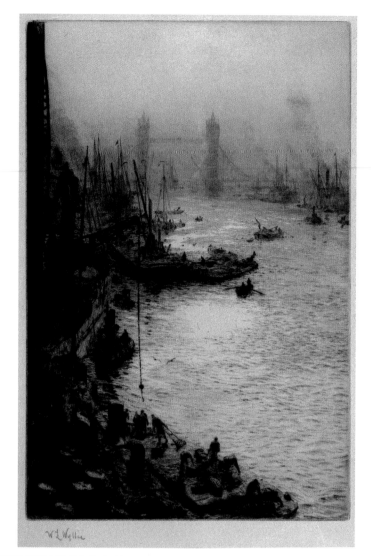

TOWER BRIDGE
William Lionel Wyllie
c. 1925

Wyllie made etchings and drypoints of the Thames from the 1880s right until the end of his life. This is one of his finest late drypoints. In it he used a variety of techniques in order to achieve the intensely atmospheric effect he wanted. The upright format is reminiscent of some of Whistler's compositions, which Wyllie would certainly have known. Some years earlier, in 1894, Wyllie had witnessed and painted the pageantry during the opening of the newly completed bridge.
PAF0707 / PW0707

THE ROYAL NAVAL COLLEGE, GREENWICH
William Lionel Wyllie
c. 1900

This rapid watercolour sketch illustrates Wyllie's skilful and fluid use of his favourite medium. It is likely that he painted it from life from the river, perhaps from his own Thames barge. Using dampened paper, he applied watercolour washes for the water and the sky, and then suggested the buildings, clouds and shadows on the water with remarkably few brushstrokes, painting on the still-damp paper. Wyllie had his first one-man watercolour exhibition, 'The Tidal Thames', at the Fine Art Society in London in 1884.
PAE4923 / PV4923

BOAT RACE BOWL
Designed by Eric Ravilious
for Wedgwood
1938
This Wedgwood Queen's Ware punch-bowl was designed by Eric Ravilious to celebrate the Oxford and Cambridge University Boat Race of 1938. Views of the race and the spectator boats are printed in black and colour around the outside of the bowl, and the inside has a London scene with buses in Piccadilly Circus. Wedgwood also used this design on vases and dishes. Much admired as an artist, designer and book illustrator, Ravilious was commissioned by Wedgwood to produce a number of designs including the 'Travel' pattern and Coronation mugs.
AAA6327 / D6895-1 & D6895-2

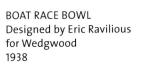

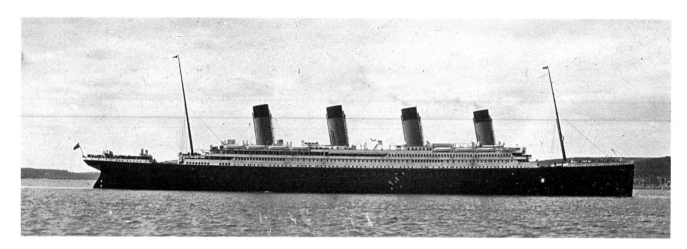

TITANIC

TITANIC
Unknown photographer
1912

The White Star Liner *Titanic* is probably the most famous ship in the world, with more films, books and documentaries about her than any other vessel ever built. The history of how the 'unsinkable ship' hit an iceberg on her maiden voyage to New York, and of the inadequate supply of lifeboats which condemned 1503 people to a freezing death in the Atlantic Ocean, shocked Britain and the United States at the time, and is still fascinating people today. This photograph was taken as the *Titanic* left Queenstown, Ireland, at 1.30 p.m. on Thursday, 11 April 1912. It was to be her last-ever port of call.
3794

POCKET WATCH OF *TITANIC* VICTIM, ROBERT DOUGLAS NORMAN
Unknown maker
c. 1880

Robert Douglas Norman perished in the *Titanic* disaster on the morning of 15 April 1912. He was one of more than 300 second-class passengers aboard the vessel heading for New York. Norman worked for an engineering company in Glasgow but had resigned his appointment with the intention of visiting his brother in Vancouver before completing a world tour. This gold-cased watch was found among his clothing when his body was recovered. The rusted watch hands still show the time the

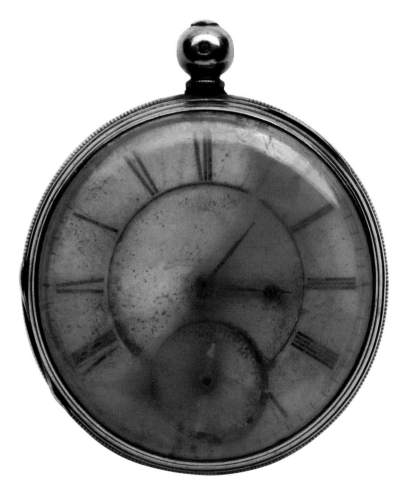

watch was reading when he entered the water: 3.07 a.m. Clocks and watches on board the *Titanic* would have been set back daily to account for the ship's new local time but at the time the ship sank,

approximately 2.20 a.m., it seems Norman had not had the opportunity to reset his watch from the previous day's local time.
ZBA0004 / D8137

TRADE

(Right)
SOUTH SEA COMPANY COAT OF ARMS
c. 1711

The South Sea Company was founded in 1711 with the aim of monopolizing trade with Spanish South America, including the lucrative transportation of enslaved Africans. The company quickly became involved in high-risk speculation and corruption on a grand scale. These activities produced the so-called South Sea Bubble, with large numbers of people investing substantial sums in the Company. In 1720 the bubble burst, creating an enormous financial scandal and leading to the Company's collapse. Many investors lost their entire fortunes. This fine coat of arms was mounted in the lobby of the Company's headquarters at the corner of Bishopsgate and Threadneedle Street in London.

HRA0043 / D4847-1

(Left)
ENGRAVED GLASS GOBLET
Dutch-engraved
c. 1730

This fine eighteenth-century glass wine goblet was probably made in Newcastle-upon-Tyne but engraved in the Netherlands. The bell-shaped bowl is wheel-engraved with a Dutch quayside scene with warehouses, a gabled house dated 1645 and a ship loading cargo. Around the rim is engraved *VIVAT NEGOSIAE* (Long live traders).

GGG0201 / D2025-A

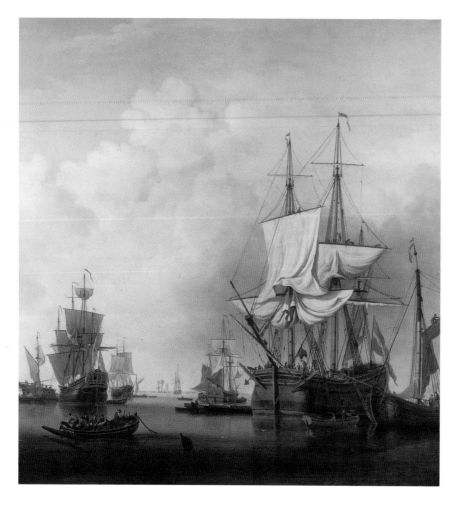

(Opposite, top)

SHIPS OF THE EAST INDIA COMPANY
Nicholas Pocock
1803

East Indiamen were the largest merchant ships of the age, carrying passengers as well as cargo, with guns to defend themselves in unfriendly waters. The round trip to India took about a year and officers and crew could often make large sums of money by private trade. Pocock shows several ships, including the *Hindustan* with Captain George Millet as Commodore. They are wearing in succession, that is, turning with their sterns to the wind.
BHC1097

(Opposite, bottom)

THE INDIAMAN *EUPHRATES* OFF CAPE TOWN
Samuel Walters
1835

Walters is an excellent example of the many ship-portrait painters who made their living in the great days of the British shipping industry by commemorating elegant and profitable vessels for their proud owners and masters. Born at sea and the son of a marine painter, Walters spent most of his life in Liverpool, apart from a brief period in London. The painting may commemorate the building of the 617-ton vessel in Liverpool in 1834 and the background may look forward to her first voyage to Calcutta in 1836–37.
BHC3330

(Above)

A DANISH TIMBER BARQUE
Samuel Scott
1736

Scott was one of the first native English marine painters working in the first half of the eighteenth century in London, where the Dutch van de Veldes had been established in the latter part of the seventeenth century. He painted views of London as well as naval actions for naval families. This large square picture, a peaceful scene of trading vessels, was probably intended to hang with its pair, a contrasting naval subject, over doorways in a grand room. The picture, set in the Thames, shows men in a boat weighing and fetching home the anchor of the timber barque.
BHC1040

(Right)

EAST INDIAMAN TUMBLER
Dutch-engraved
c. 1783

This unusual and delightful tumbler is engraved with a British ship and inscribed around the top 'Success to the Berrington'. The tumbler is of English manufacture, decorated with Dutch wheel-engraving, and the ship referred to in the toast was an East Indiaman of 816 tons, launched in 1783. The glass may have been engraved to celebrate a successful first voyage. Opposite the ship are two sailors, in their distinctive dress, standing beside a table with punch-bowl and wine glasses. One is smoking a pipe, holding a glass aloft and dancing; the other holds a stick and a clay pipe and points to the ship.
GGG0455 / D4317-1

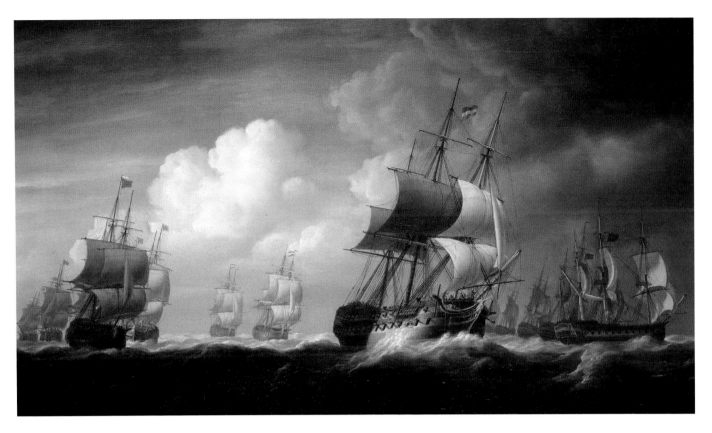

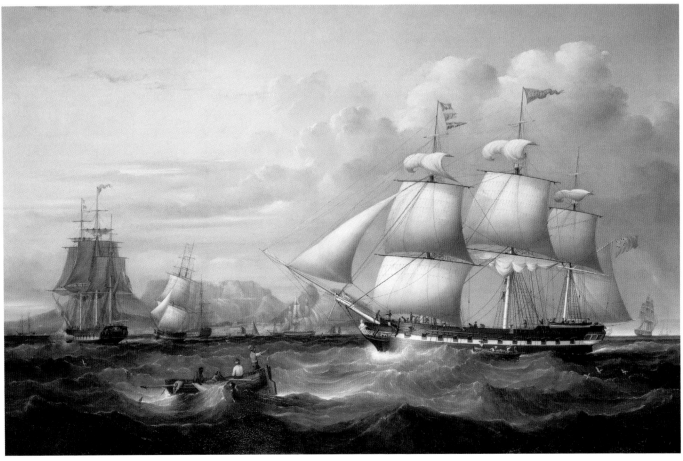

(Below)

COAT OF A COMMANDER, HONOURABLE EAST INDIA COMPANY, 1830 PATTERN

The Company's commanders were given a uniform in 1781, but the blue coat and white breeches attracted complaints from the Royal Navy that these merchant officers were too easily mistaken for those of His Majesty's service. The white waistcoat and breeches were exchanged for crimson ones, these in turn changed to deep buff after complaints from the commanders. The blue woollen coat has black velvet lapels, cuffs and collar with what the Court of Directors described as 'A light gold embroidery as little expensive as may be'. The buttons bear the Company's crest – a rampant lion holding a globe, above a foul anchor.
UNI0164

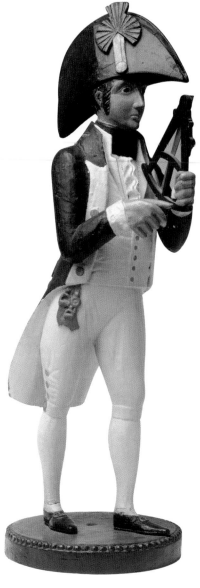

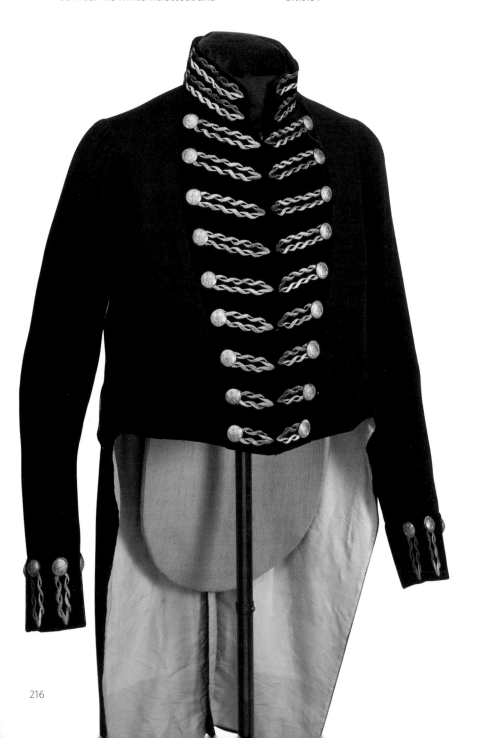

(Above)

TRADE SIGN
Nineteenth century

This carved and painted wooden figure holding a wooden octant was the trade sign of an optical instrument maker. Although such figures are frequently referred to as 'The Little Midshipman' or 'The Little Admiral', this particular example is actually wearing a lieutenant's full-dress uniform of the 1787 to 1812 pattern. Charles Dickens, in his novel *Dombey and Son*, describes 'outfitting warehouses ready to pack off anybody anywhere, fully equipped in half an hour, and little timber midshipmen in obsolete naval uniforms eternally employed outside the doors of nautical instrument makers in taking observations of the hackney coaches'.
AAB0173 / A5596

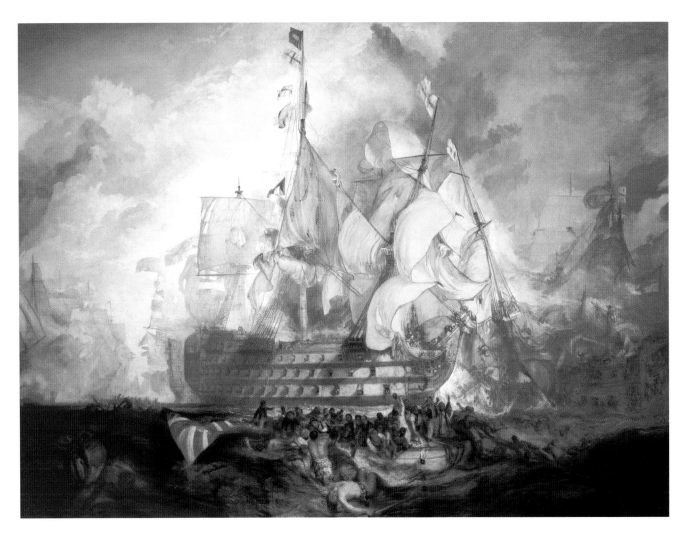

Trafalgar

(Above)

BATTLE OF TRAFALGAR, 21 OCTOBER 1805
Joseph Mallord William Turner
1823–24

George IV commissioned Turner to paint
The *Battle of Trafalgar* in 1822, to hang in
St James's Palace as a companion
to de Loutherbourg's *Battle of
the First of June, 1794* as part of
a series of British victories. The
commission was one of Turner's
most important. Despite the pains he
took with the nautical detail it was
criticized by those who demanded
documentary accuracy, rather than
Turner's complex Romantic vision of the
Victory, which casts the ship as a symbol
of national strength as the battle rages
round her.

BHC0565

(Below)

LT JOHN PASCO'S TELESCOPE
c. 1800

The silver-mounted inscription on the
telescope reads: 'This telescope, then in
the possession of John Pasco, Flag-
Lieutenant to Lord Nelson, was on the
Victory's Poop at the Battle of Trafalgar,
21st October, 1805'. The telescope was

presented by Commander Pasco to H.R.H.
Prince Alfred, Duke of Edinburgh, when he
visited the Colony of Victoria, Australia, as
a Royal Navy captain in command of HMS
Galatea. It was then donated to the Royal
United Service Institute by Vice Admiral
H.R.H. the Prince of Wales, the future King
George V. The RUSI collection was later
transferred to the National Maritime
Museum. The design of the telescope, in
mahogany and brass, is typical of the late
eighteenth century.

NAV1649 / D7563

(Left)

HAND-DRAWN PLAN OF THE BATTLE OF TRAFALGAR
Viscount Horatio Nelson
c. 1805

At a first glance, this doodle *(top)* on the back of a note written by Viscount Horatio Nelson to his elder brother, William, looks unremarkable enough. However, on closer inspection, the sketch, rough though it is, appears strongly to suggest that it is a diagram of the tactics Nelson planned to employ in his imminent battle with the combined forces of France and Spain.

Sketches by Nelson of his earlier battles survive, but each was drawn after the event. This example, penned sometime in 1805, possibly as an *aide-mémoire*, is the only plan of Nelson's greatest victory drawn by the great commander himself. It is as though we are looking over Nelson's shoulder as he explains to his assembled captains his tactics – 'When I came to explain to them the Nelson touch it was like an electric shock. Some shed tears, all approved – It was new – it was singular – it was simple!'.

BRP/6 / E7102

(Opposite, top)

LOG OF THE *BRITANNIA* DURING THE BATTLE OF TRAFALGAR
Captain Charles Bullen
1805

The *Britannia* flew the flag of Rear-Admiral the Earl of Northesk at the battle. She was part of Nelson's weather line as the fleet sailed in double column with Collingwood's division to leeward to engage the combined Franco-Spanish fleet. In the light winds prevalent at the start of the action *Britannia* was one of the last to engage. However, with two others she captured a French ship, and shortly afterwards chased a detached squadron of the enemy. She crippled several of these and captured another.

ADM/L/B/183 / D4444

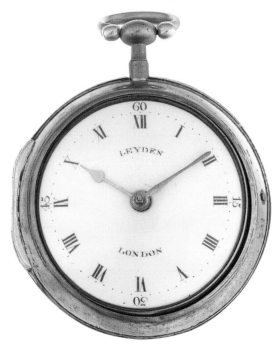

WATCH, NO. 1305
Thomas Leyden
1793–4

This watch is said to have been worn by Lord Nelson's flag captain, Thomas Hardy, at the Battle of Trafalgar. Of standard design for the period, the watch has a silver pair case and fusee-driven, gilt-brass movement with verge escapement, the accuracy of which would only have been to within a minute or two per day. Unlike newly developed marine and pocket chronometers, this watch would have been of little use as a navigational aid. Engraved on the outer case back 'Watch worn by Capt. Thomas Masterman Hardy RN at Trafalgar 1805', and on the inner case back 'T. M. H.' Hardy eventually rose to be First Sea Lord and Governor of Greenwich Hospital.

JEW0231 / E2039

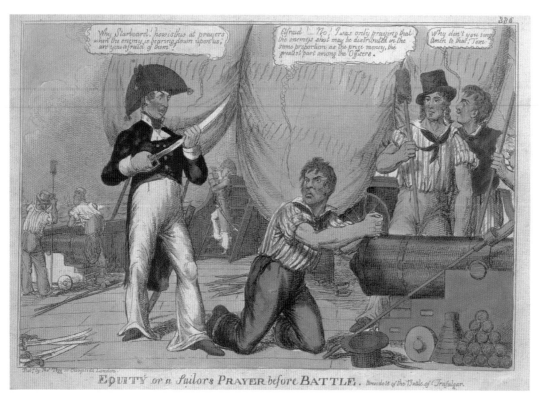

EQUITY or a Sailors PRAYER before BATTLE. *three days of the Battle of Trafalgar.*

(Above)

EQUITY, OR A SAILOR'S PRAYER BEFORE BATTLE
William Heath
c. 1805

Prize-money was the greatest material incentive in a naval career. When an enemy ship was captured, its value was divided among the officers and crew, but on a very unequal basis – the captain had a quarter share to himself, the crew (who might number several hundred men) had a quarter share among them. Captains and admirals could become very rich through prize-money: ordinary sailors might have enough for a good few days ashore (if they were allowed leave).
This print satirizes the inequality, and points out that officers and men took equal risks in battle.

PAF3761 / A3320

(Right)

TRAFALGAR VASE
Benjamin Smith, London
1807

The Patriotic Fund, founded at a meeting at Lloyd's Coffee House at the Royal Exchange in 1803, gave awards of money to wounded seamen, as well as gifts of silver and swords for distinguished services. The sixty-six Patriotic Fund vases that went to naval and military officers were designed by John Flaxman and bear the marks of several different silversmiths. The design of most of the vases is similar, although the original values varied from £100 to £500. Fifteen vases were presented to captains after the Battle of Trafalgar in October 1805. The vase illustrated here is special, however, being one of only three large silver-gilt £500 vases mounted on additional plinths. It was presented to Lord Nelson's brother William, and is engraved with the Nelson arms rather than the more usual figures of Britannia and Hercules.

PLT0094 / D7636

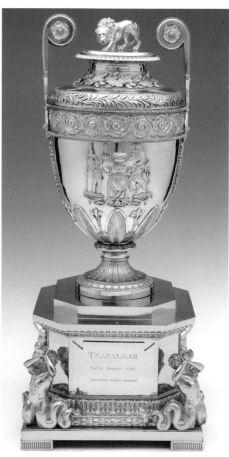

TRAVELLING TO AMERICA

John Graves

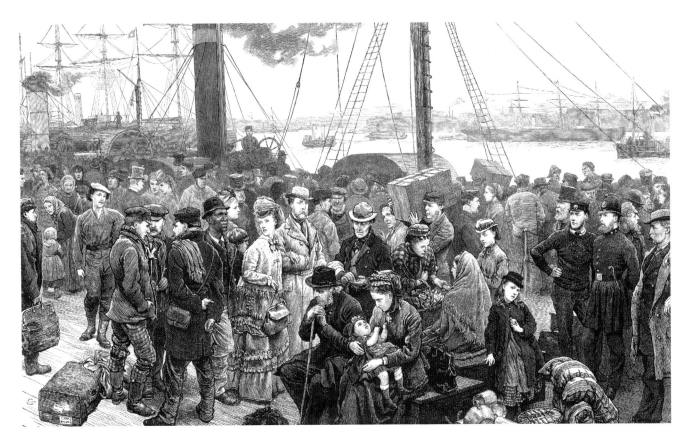

For many years in Britain, official attitudes towards emigration swung between two opposing views. Was emigration taking away the best and most energetic of the population? Or was it peopling the colonies with Britain's dross? The debate came into sharper focus at the end of the Napoleonic War in 1815, when an increasingly industrialized society and large numbers of demobilized ex-servicemen gave rise to concerns about a population explosion in Britain, and the potential for political unrest. With the loss of the thirteen American colonies at the end of the eighteenth century, however, the British government was not anxious to help to populate a country that had so recently been an enemy and so directed its efforts towards supporting colonization in the growing British Empire. More than 150,000 convicts were transported to Australia between 1788 and 1853; British colonists began to arrive in large numbers in South Africa, in the wake of the treaty of 1815 that transferred ownership of the colony from the Dutch to Britain; the New Zealand Company was formed in the early 1840s to encourage emigration – and it was particularly effective in attracting Scottish migrants. Emigration to Canada was also actively encouraged. The British Empire also created many opportunities for 'secondary' migration: large numbers of workers from India settled in the Caribbean as indentured

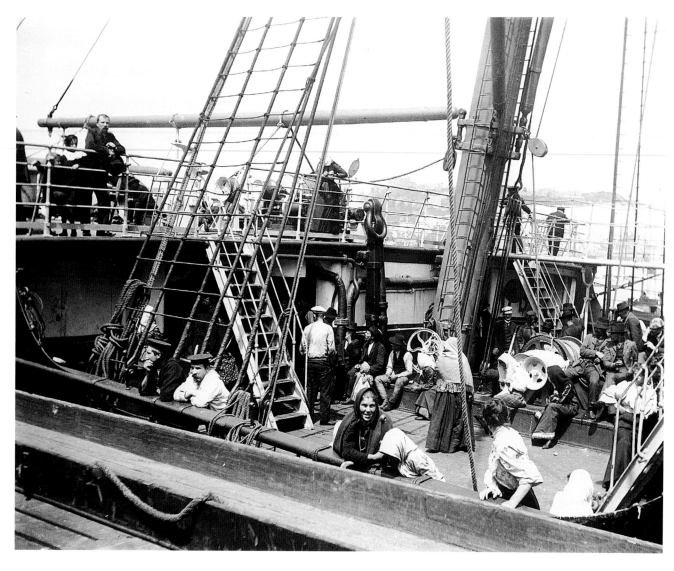

Steerage passengers on the *Deutschland*, bound for the United States, in 1906. N19706

labourers to work in the sugar-cane plantations, for example, and other Indian workers would later go to East Africa to build the Uganda railway. America continued to be the most popular destination for emigrants in the nineteenth century. It was, of course, much closer to Europe than Australia or New Zealand, and it was also a country with an already established structure of roads, railways, ports and cities. Between 1815 and 1914, almost 35 million people entered the United States of America in the largest human migration in history. Although Britain did not officially encourage migration to America, its shipping lines played a key role in transporting migrants across the Atlantic, many of whom had already made long journeys to Britain from their homes in other countries. The great majority were young, usually between 15 and 35 years of age. They were also poor. Poverty as well as religious and political oppression continued to be important driving factors in the great exodus from Europe.

Until sailing ships gave way to steam, Atlantic crossings could take more than three months. Migrants would live together in cramped, dimly lit and poorly ventilated compartments. The passage was one of sheer squalor and misery. Seasickness, lack of proper food, contaminated water and unhygienic conditions were endured by all, crews included.

On 25 July 1807 the *Kitty's Amelia* left Liverpool.

She was the last slave ship to sail from a British harbour, Parliament having that year abolished slave-trading. Needing another source of income, Liverpool soon became the largest and most profitable emigrant port in Europe. Migrants from as far as Scandinavia and Russia flocked to make use of the port.

Warehouses that had once supplied handcuffs and leg-irons now sold food, cooking utensils and bedding. Not all Liverpool's income was gained legally, as the hapless emigrant was exposed to an army of petty criminals. Tickets were sold for non-existent ships, moneychangers cheated their customers and overcharging for provisions was commonplace.

Once aboard ship, migrants on the US run were berthed together, regardless of age and sex. There was no privacy. It was frequently suggested that, in the interests of decency and morality, steerage should be divided into three compartments, with men forward, women aft and married couples amidships, as was the case on vessels carrying emigrants to Australia. But passengers themselves were opposed to this – they preferred to be berthed with the people they knew. Parents, in particular, did not want to risk 'the contamination of their daughters … by improper characters'. In 1852 a law was passed which segregated single men but even this tended to be ignored.

Wooden-built ships were particularly vulnerable to fire and to being wrecked. One hundred and seventy-six lives were lost on the *Ocean Monarch* in 1848 when a passenger who was cold lit a fire in a ventilator. In one year alone – 1834 – seventeen wooden vessels were lost, in which 731 emigrants were drowned.

Ventilation, too, was a persistent problem. Everyone suffered – those in the lower steerage berths found it dark and airless, while those berthed on the upper decks had to put up with the stench from the passengers below.

Most complaints, though, were about the food and the behaviour of the crews. Vere Foster, a steerage passenger on the Liverpool to New York run in 1850, was severely critical of the ship's officers and their failure to supply the passengers with the provisions

to which they were entitled. During the first few days of the voyage nothing but water was issued. Thereafter food was regularly distributed but correct amounts were never given and whenever provisions were issued by the crew passengers were 'cursed and abused … cuffed and kicked by them'.

After 1815, emigrant ships were required by law to carry provisions but migrants from Great Britain and Ireland were allowed to bring their own. Irish migrants usually took with them a bag of potatoes, oatmeal and some dried herrings. The poor quality of the drinking water stemmed from the practice of storing it in wooden casks that had formerly contained oil, vinegar, turpentine, wine or, indeed, anything. Virtually no attempt was made to keep the casks clean.

Emigrant ships were also prone to epidemics, in particular the so-called 'ship fever' or typhus. It was highly contagious and often fatal. Associated with poverty, filth and overcrowding, it became rampant whenever conditions favoured the spread of the lice that conveyed it. When it broke out in ships, it ran through the passengers like wildfire. In 1847, 7000 migrants, mostly Irish, died from typhus during the crossing and 10,000 more perished after reaching the US. Obviously something had to be done about the high mortality rate. By the mid-nineteenth century every maritime country in Europe and North America had codes of regulations in place regarding the transport of migrants. Slowly, things began to improve.

Later, in the 1850s, William Inman realized that there was a class of emigrant prepared to pay more for a faster passage. His company made the daring decision to use iron sail-assisted screw-steamers. The Inman line had mixed fortunes but it quickly set a trend that other companies followed. By the 1870s the westbound crossing was taking less than two weeks, while the fastest 'Blue Riband' ships took just over a week.

As the century drew to a close, competition for the passenger trade, and for steerage passengers in particular, became intense. British and German lines dominated emigrant traffic. New, bigger, faster ships were coming on to the North American route, which

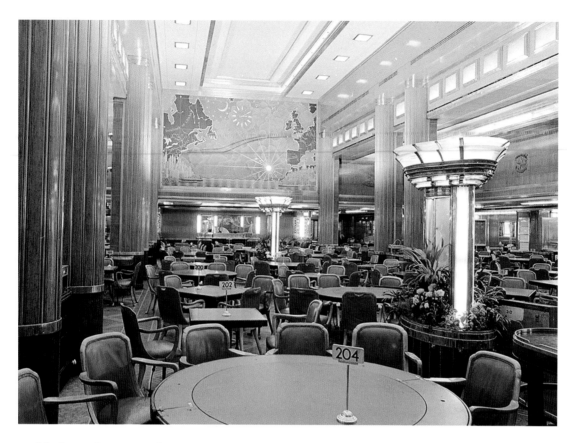

The sumptuous Art Deco dining room on Cunard White Star Line's transatlantic liner *Queen Mary*, which entered service in 1936.
B1448-37

enabled even larger numbers to emigrate. In 1907, emigration to the US reached a record level that has never been exceeded since: total arrivals in American ports came to 1,285,000. Almost 60 per cent of these sailed from one of just four ports – Naples, Bremen, Liverpool and Hamburg. Also in this year, what can probably be described as the first pair of truly modern liners entered service, Cunard's *Mauretania* and *Lusitania*. They were technological marvels and could carry first-, second- and steerage-class passengers across the Atlantic, in unrivalled comfort, in just six days. The White Star Line responded to the competition with the *Olympic* and *Titanic*. The twentieth century had arrived.

All these ships cocooned their first- and second-class passengers from the merest suggestion that they were even on a ship. The architectural styles of the past were ransacked for the public rooms. This trend continued throughout the so-called 'golden age' of passenger travel in the 1920s and 1930s. Travelling to America on ships like the *Queen Mary*, be it for business, for pleasure or for a new life, was an experience to be enjoyed, rather than endured, by all. Moreover, these great liners were symbols of national pride and their names reflected this – *Normandie*, *Bremen*, *Empress of Britain*. The Italian liner, *Rex*, was dubbed 'the Riviera afloat' and even emigrants could enjoy facilities such as large outdoor lido areas, tiled pools and sandy 'beaches'.

After the end of World War II, air travel to North America began to encroach on the territory of the liner. However, Cunard's new ship, *Queen Mary 2*, which was launched in January 2004, will take over from the *QE2* on the regular Southampton to New York run, which the latter has been plying since 1969. The introduction of the *QM2* proves that a core of élite passengers still prefers a leisurely, pampered, six-day crossing, rather than a hectic six-hour flight. The meteoric rise in the popularity of cruising has driven the need for a new breed of cruise ship. Typically over 100,000 tons, with luxurious cabins, private balconies and 24-hour dining, these ships may only cross the Atlantic twice in a year – spending winters in the Caribbean and summers in the 'Med'.

Uniform

(Below)

FULL-DRESS COAT AND WAISTCOAT
OF A ROYAL NAVAL LIEUTENANT
1748–67 PATTERN

A naval officers' club first put forward
the proposal that naval officers should
have a uniform in 1745. The idea was
approved by George II in 1748 and the
Admiralty supplied pattern suits which
could be copied by officers' tailors. The
surviving pattern garments are
preserved in the Museum's collections.
They are the dress waistcoat of a senior
and junior captain, a lieutenant's dress
coat, waistcoat and frock, a
midshipman's coat and two hats.
UNI0003 & UNI0005 / A5399-3

(Right)

WRNS RATING'S DRESS AND HAT
1918–19

The Women's Royal Naval Service was
founded in 1917 to take over some
auxiliary services such as clerical work
and net-mending. This rating's dress is
made of navy blue serge, with a small
sailor collar and patch pockets. The
buttons are made of black horn with
the crown-and-anchor pattern used by
all naval ratings. The pudding-basin hat
is made of gaberdine and has a brim
stiffened with circles of stitching and
a cotton cap cover worn in summer.
All ranks wore black stockings and
shoes with their uniforms.
UNI1008 & UNI0995 / D8407

(Below)

SEAMAN'S SENNIT HAT
Horace Slade
c. 1910

This type of straw hat worn by naval
seamen during the nineteenth century
finally disappeared in 1921. Extremely
detailed uniform regulations were
printed at the back of the *Navy List*
at this time describing each item
of a rating's kit and the
occasions on which it should be
worn. Sennit hats were worn
with blue uniform in summer,
weather permitting but not at
sea, unless required as
protection from the sun. The
edge of the hat is bound with
black braid, it has a chin stay
to keep it on and a ribbon is
attached with the name of
the owner's ship.
UNI0930 / D5866

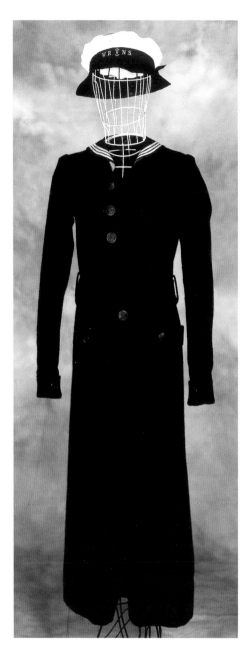

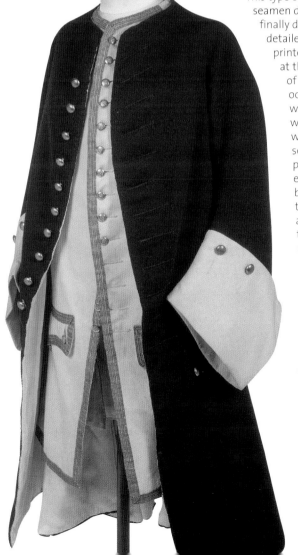

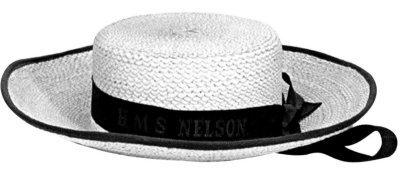

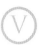

VILLIERS, ALAN

ON BOARD THE *PARMA*
Alan Villiers
1932–33
Alan Villiers was born in Melbourne in
1903 and began sailing as a young man
aboard merchant barques. Square-
riggers became a passion rather than
just a job for him and Villiers is rightly
regarded as the outstanding writer
and photographer of the final days of
sail. These photographs are from his
voyages aboard the four-masted barque
Parma, carrying grain from the Spencer
Gulf, Australia, to Cardiff and from Port
Victoria to Hull. In 1948 Villiers was
appointed a trustee of the National
Maritime Museum and left his extensive
collection of maritime photographs to
the Museum on his death in March 1982.
N61533 (LEFT), N61613 (BELOW) & N61670 (RIGHT)

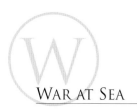

(Below)

THE SIEGE OF MALTA: THE TURKISH BOMBARDMENT OF BIRGU, 6 JULY 1565
Matteo Perez d'Aleccio

In the spring of 1565 Suleiman I, Sultan of Turkey, decided to attack and destroy the Knights of St John at Malta, the sole survivors of the medieval crusading orders, before invading Italy and western Europe. The four-month siege is one of the great military epics of history. The outnumbered knights resisted the enemy, and the Turks eventually retreated after thousands of their troops were killed. These paintings, which bear the cipher of Charles I, and were once in his collection, are small versions of the frescoes in the hall of the Grand Master of the Knights of St John in Valletta.
BHC0256

(Opposite, top)

THE BATTLE OF LEPANTO, 7 OCTOBER 1571
H. Letter, possibly South German school

In 1571 Pope Pius V proclaimed a Holy League with Venice, Spain and other Christian allies to check the expansion of the Ottoman Empire. More than two hundred galleys and other vessels under Don John of Austria attacked the Turkish fleet off the western coast of Greece. This magnificent contemporary painting highlights the encounter between the Christian right wing under Admiral Gianandrea Doria, with the Turkish left under Uluj-Ali, King of Algiers. It was possibly painted for the Genoese Negroni family.
BHC0261

(Opposite, bottom)

THE DUTCH ATTACK ON THE MEDWAY: THE *ROYAL CHARLES* CARRIED INTO DUTCH WATERS, 12 JUNE 1667
Ludolf Backhuysen

During the Second Anglo-Dutch War, the Dutch under de Ruyter carried out a daring raid up the River Medway and captured the *Royal Charles* at Chatham. This was a humiliation for the English. Backhuysen, an almost exact contemporary of van de Velde the Younger, depicts the English vessel, named after the king, brought back to Hellevoetsluis in triumph. The picture is likely to have been painted for a Dutchman involved in the raid. Backhuysen's use of light and shade emphasizes the sense of drama as the ship, silhouetted against the sky, approaches the coast of Holland.
BHC0292

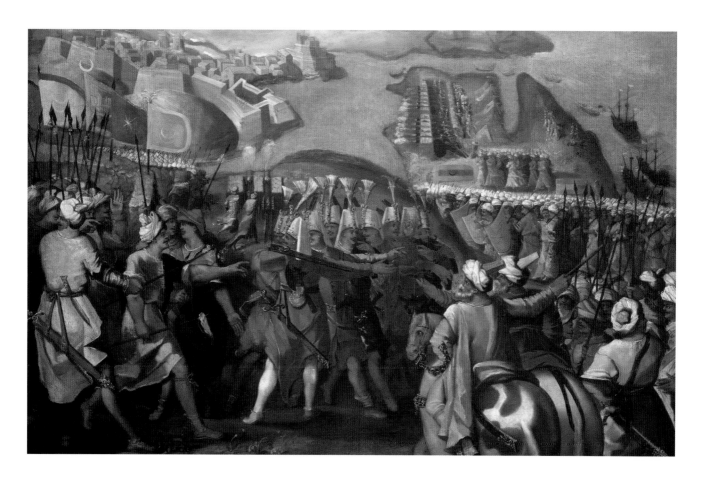

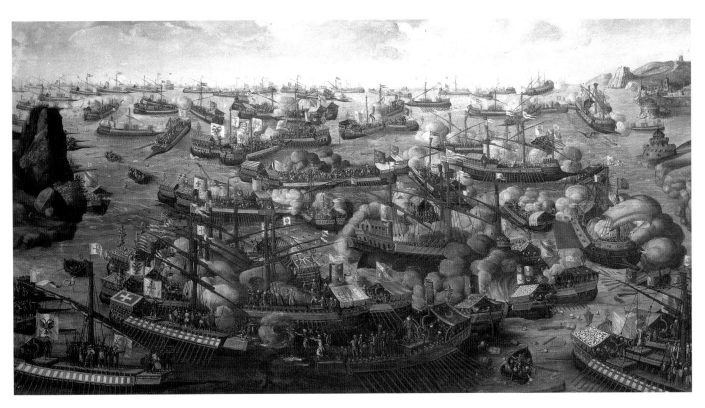

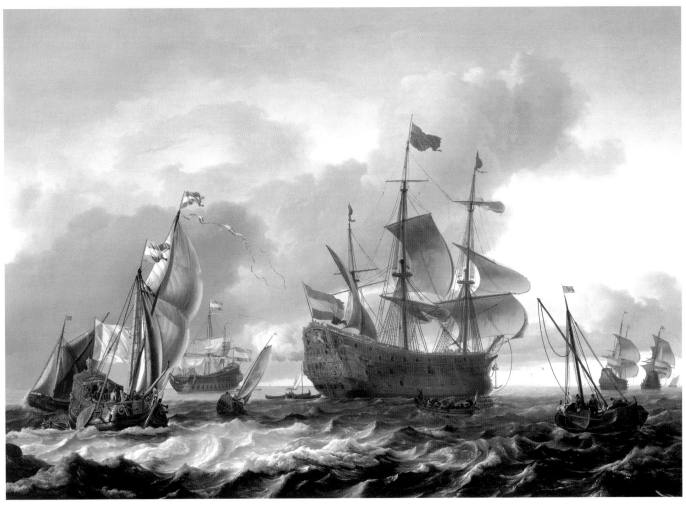

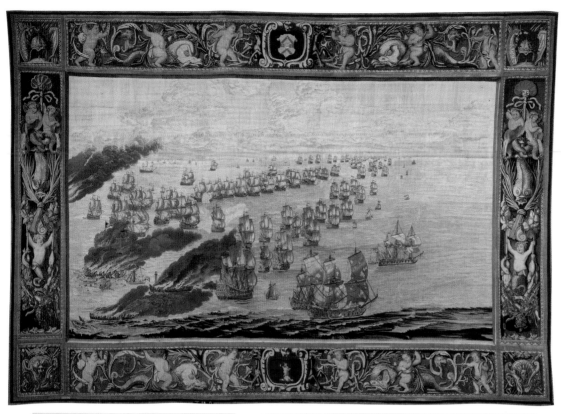

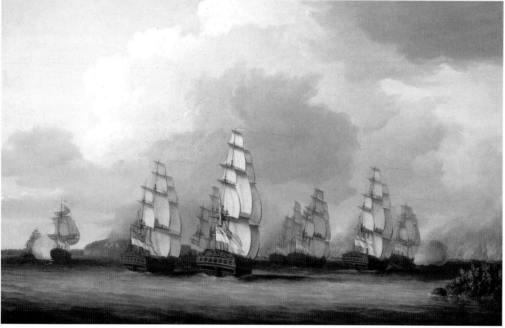

(Top)
SOLEBAY TAPESTRY
Thomas Poyntz
c. 1672
This signed tapestry commemorates an incident in the Battle of Solebay, the first battle of the Third Anglo-Dutch War, on 28 May 1672. It depicts the burning by Dutch fire-ships of the *Royal James*, flagship of the Earl of Sandwich. She can be seen on the extreme left, with the Dutch fire-ships. The deep borders are woven with putti, sea monsters and tritons, with the arms of the Walpole family added in 1720. This is one of a set of six Solebay tapestries that were woven at the famous Mortlake factory after drawings by Willem van de Velde the Elder, who was present at the battle. The other tapestries in the set are part of the Royal Collection at Hampton Court Palace.
TXT0106 / D1987

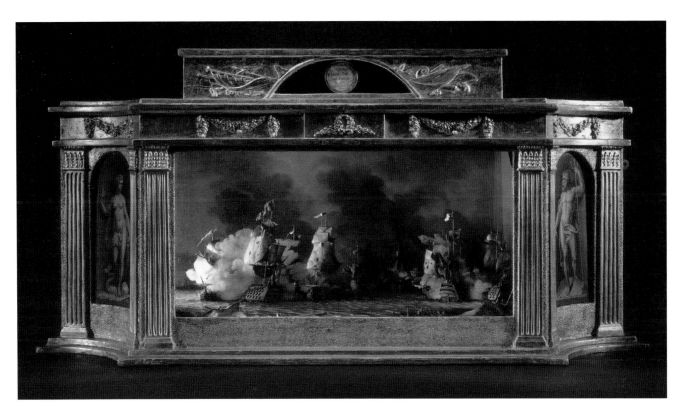

(Opposite, below)

DESTRUCTION OF THE AMERICAN FLEET AT PENOBSCOT BAY, 14 AUGUST 1779
Dominic Serres
c. 1780

It is perhaps a little ironic that it was Dominic Serres, a Frenchman, who finally brought acclaim to the genre of marine painting in England in the second half of the eighteenth century. Serres ran away to sea and was brought to England when captured by the British. His probable association with the artist Charles Brooking (d. 1759) is reflected in the accuracy of his shipping as well as in an awareness of the landscape potential of marine paintings. He painted naval actions of the Seven Years War and, as here, of the American Revolutionary War. As well as being a founder member of the Royal Academy, he also became Marine Painter to George III.
BHC0425

(Above)

DIORAMIC MODEL OF THE BATTLE OF THE SAINTS
c. 1782

This contemporary model of Admiral Rodney's victory at the Battle of the Saints, 1782, is believed to have belonged to

Rodney himself. The unknown maker probably used an engraving after a painting of the battle by Richard Paton, but it owes much to artistic invention. Model ships are mounted in a gilded wooden case, and dramatic effects of sea and sky are achieved by the use of painted glass sheets, false perspective and (today) a hidden light source reflected into the case from a mirror. On the left, Rodney's flagship *Formidable* engages a group of French ships, and to the right the French flagship *Ville de Paris* surrenders to Rear-Admiral Hood in the *Barfleur*.
MDL0011 / C7269

(Right)

FLAG OFFICER'S NAVAL GOLD MEDAL AWARDED TO VICE-ADMIRAL CUTHBERT COLLINGWOOD (1750–1810)
T. Pingo
Before 1810

Naval gold medals were first struck for presentation to flag officers and captains after the Battle of the Glorious First of June, 1794. Twenty-two of the larger size were awarded to admirals for various actions before 1815. The reverse of this example is inscribed within a wreath of oak and laurel:
CUTHBERT COLLINGWOOD ESQUIRE, VICE-

ADMIRAL AND SECOND IN COMMAND. ON THE 21 OCTOBER MDCCCV. THE COMBINED FLEETS OF FRANCE AND SPAIN DEFEATED. Collingwood received this medal after Trafalgar, a battle in which he assumed command after Nelson's death.
MED0159 / D5056-2

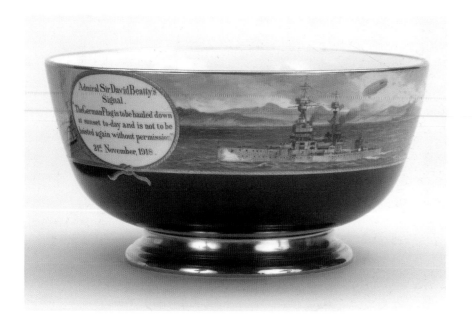

BEATTY PUNCH-BOWL
Painted by J. E. Dean for Minton
1918

This unique china bowl commemorates the surrender of the German High Seas Fleet to Vice-Admiral David Beatty, Commander-in-Chief, Grand Fleet, in the Firth of Forth in November 1918. The hand-painted border by J. E. Dean has a view of the fleet with an airship and the words of Beatty's signal, 'The German Flag is to be hauled down at sunset today and is not to be hoisted again without permission'. Under the terms of the Armistice, the defeated German High Seas Fleet was interned at Scapa Flow, but on 21 June 1919 Admiral Ludwig von Reuter ordered the fleet to be scuttled rather than be allowed to fall into enemy hands.

AAA5185 / D0852-14

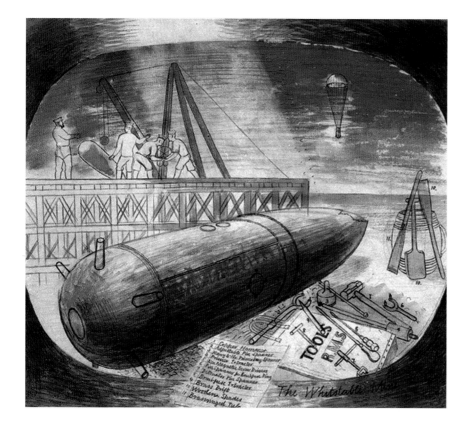

THE WHITSTABLE MINE
Eric Ravilious
1941

Ravilious, painter, graphic artist and designer, was appointed official war artist to the Admiralty in 1940. While posted to the naval bases at Portsmouth and Gosport he made studies for a series of submarine prints, for which this drawing was to be the frontispiece. The War Artists' Advisory Committee considered reproducing the studies as a children's colouring book but the cost was so high that Ravilious published the prints himself. This allowed him to experiment with colour lithography, and the resulting prints display his characteristic concern with pattern, colour and claustrophobic space. Ravilious was lost in an air-sea rescue mission off Iceland in 1942.

PAJ0744 / D3665-10

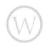

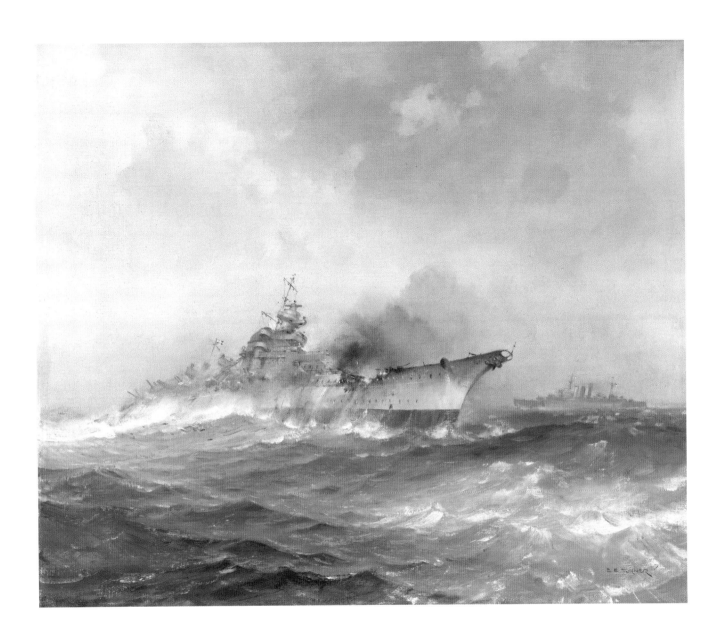

**THE SINKING OF THE *BISMARCK*,
27 MAY 1941**
Charles Turner
c. 1941
The German battleship was completed
at Kiel early in 1941 and sailed on
18 May to attack British convoys in
the North Atlantic. From the time she
was first sighted in the North Sea the
Bismarck was stalked and attacked by
aircraft, destroyers and capital ships. She
sank the *Hood* and damaged the *Prince
of Wales*, but when making for
a French port she was brought to action
by the *Rodney* and *King George V*, and
finally sunk by the *Dorsetshire*'s
torpedoes. Charles Turner was an
illustrator whose paintings of naval
actions during World War II were
accurate and well observed.
BHC0679

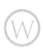

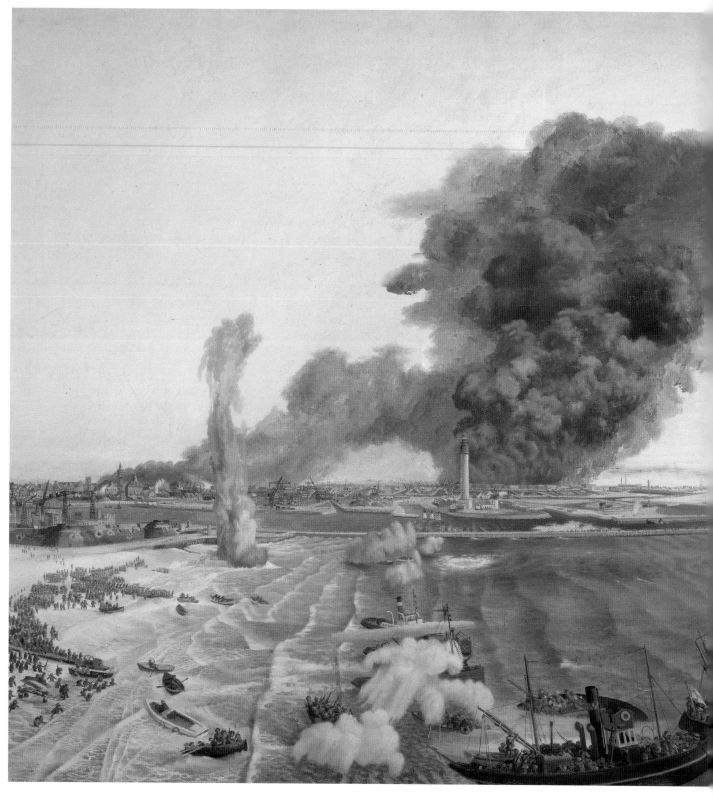

**WITHDRAWAL FROM DUNKIRK,
JUNE 1940**
Richard Ernst Eurich
1940

Completed in three weeks, Eurich based
this painting of the dramatic evacuation
on a combination of notes, eyewitness
accounts, sketches made the previous

summer and photographs. In all, 366,162
men escaped in destroyers and small
boats from the north coast of France.
Eurich's style was much influenced by

the naïve paintings of Christopher
Wood, who painted the fishing people
on the coast of Brittany.
BHC0672

HMS *ANTRIM*
Central Office of Information
1975

HMS *Antrim*, a County-class guided-
missile destroyer, was laid down in 1966
but not completed until 1970. By the
time this photograph was taken,
however, she had already had one major
refit with her B turret replaced by four
Exocet missile canisters. HMS *Antrim*
served and received bomb damage in
the Falklands conflict in 1982; she was
eventually sold to the Chilean navy in
1984 and renamed *Almirante Cochrane*.
N18253

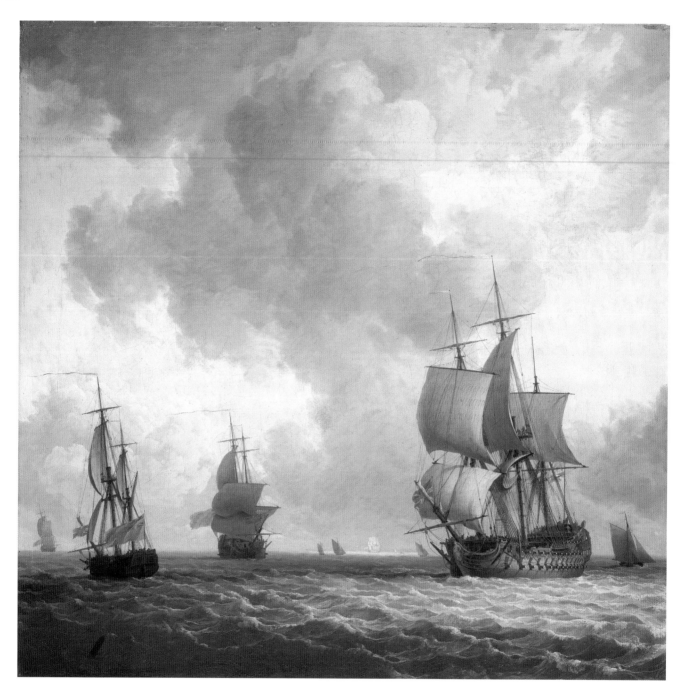

WEATHER

(Above)
SHIPS IN A LIGHT BREEZE
Charles Brooking
c. 1750–59
The main vessel in this carefully observed and atmospheric work is a naval two-decker of 70 guns, with a cutter astern of her. Figures can be seen aloft. Although this ship has not been identified, it is probably one of the *Dublin* class, which came into operation at the end of the artist's life. On the left is a ketch-rigged sloop, or bomb vessel, and in the middle distance another two-decker. Brooking was perhaps the most original of English marine painters of the middle of the eighteenth century. He developed a style quite independent of the van de Veldes, but remained faithful to their spirit in his accurate depiction of weather, sea, sky and shipping.
BHC1022

(Left)
**HEAVY WEATHER IN THE CHANNEL:
STOWING THE MAINSAIL**
Sir Frank Brangwyn
1894
Four men are stowing the mainsail of a sailing-ship. The composition is sharply angled, and looks down on the foredeck, helping to create the sensation of a ship rolling in a heavy sea. Brangwyn trained as a wood engraver and worked under William Morris. He made a large body of woodcuts and an astonishing quantity of etchings, as well as a few lithographs. His early work revolved around the sea and this example emanates from his 'grey' period when he worked with a limited palette. Brangwyn was interested in photography and the cut-off appearance of the picture is a photographic device. The limited tones of this work are also reminiscent of black-and-white photography. In 1892 he began working as the designer for the magazine, *The Graphic*, and this painting, produced two years later, shows an appreciation of the monochrome techniques necessary in his work as an illustrator.
BHC1532

(Right)
GARTHSNAID
Alexander Turner
1920
This dramatic photograph was taken between April and July 1920 by Alexander Turner, the nineteen-year-old second mate of the three-masted barque *Garthsnaid*. Four members of the crew can be seen here making fast the foresail in a gale off Cape Horn. The *Garthsnaid* had an adventurous career. She was chased into Queenstown Harbour, Co. Cork, in 1917 by German submarines, was dismasted in the mid-Atlantic and was the last working sailing ship to go up the River Avon to Bristol.
P7148

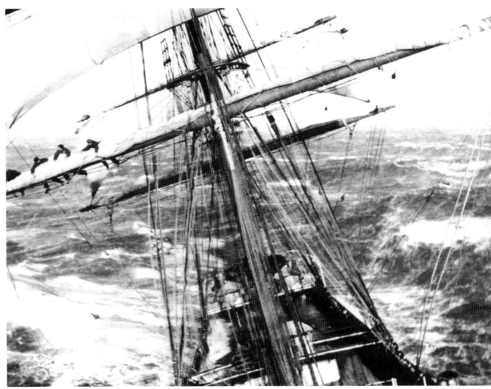

237

World Navies

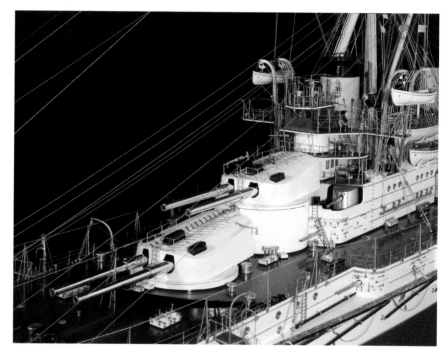

(Top)
NUESTRA SENORA DE PILAR DE SARAGOSA
Unknown maker
c. 1668
This plan drawn on parchment depicts the Spanish naval vessel *Nuestra Senora de Pilar de Saragosa*, built in 1668. Although drawn to scale, the image is more a sketch than a plan, detailing the positions of the gunports and the shape of the hull. The letters on the plan allude to various parts of the ship such as the sternpost and hawsepipe as detailed in the key above the drawing. The plan is part of the Dr R. C. Anderson collection held at the Museum, which includes merchant and naval plans for the seventeenth to nineteenth centuries.
ANN0056 / E8877

(Above, right)
BATTLESHIP *MINAS GERAIS*
W. G. Armstrong Whitworth & Co.
1908, scale 1:48
During the later nineteenth century, British shipyards evolved an economical but effective style of modelmaking, mainly to market their products to shipping lines and the world's navies. Models made in this way decorated company boardrooms and offices, and were transported to the great international exhibitions of the age. The

model of the Brazilian battleship *Minas Gerais*, built by Armstrong at Elswick, Newcastle, is a particularly good example, with very fine detail. The ship was one of the most powerful in the world when she was built. She survived until 1953.
SLR1387 / D4748

(Opposite, below)
RUSSIAN *KOVSH*
Carl Fabergé
1916
A *kovsh* is a traditional boat-shaped Russian bowl, originally a drinking vessel, which later became a decorative symbol of honour awarded for outstanding service to the state. The Imperial Russian Navy presented this silver-gilt *kovsh* by Fabergé to Rear-Admiral R. F. Phillimore in 1916 to mark

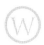

eighteen months' service as British naval representative on the Tsar's staff. He left Russia a few months before the Revolution, and the *kovsh* is thought to be one of the last pieces to come out of Imperial Russia. The centre of the bowl is chased with the double-headed Russian eagle and the flat handle is engraved with the dates of Rear-Admiral Phillimore's service.

PLT0168 / D5082-1

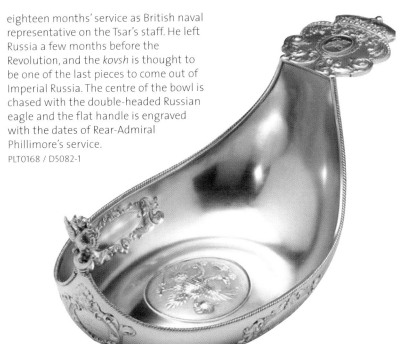

THE COMMANDER
Claus Bergen
1918
This large painting was the result of official war work by the German artist when he was aboard U-53 crossing the Atlantic to Newport and back in a stormy voyage of many weeks. The resulting images were then used to illustrate a book called 'U-Boat Stories', which refers to the responsibilities and duties of such a commander. The painting employs an unusual composition to evoke the boat itself in the vastness of the ocean, and to capture the emotions associated with the role; above all that of its isolation and the need for vigilance and silence in order to survive and be effective in submarine warfare.

BHC1284

XEBEC

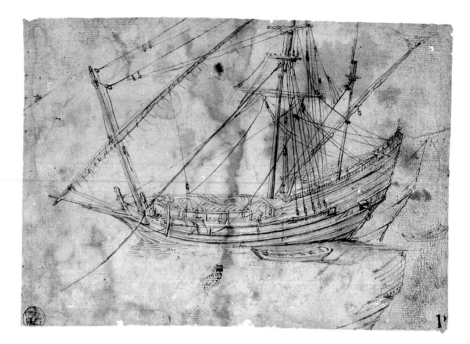

STUDY OF A XEBEC
Attributed to Abraham Casembrodt
Messina, Sicily
Seventeenth century

A fast, rakish Mediterranean sailing-craft, most familiar as an armed merchant vessel of the sixteenth to nineteenth centuries. It was a favourite of the Muslim corsairs of North Africa, who persistently preyed on European shipping over that period until finally suppressed in the 1820s. Xebecs could be rowed or sailed and usually had a three-masted lateen rig, or one combining lateen and square sails. The foremast raked forward over a sharp projecting stem and there was an overhanging counter stern. One version (also spelt *chébec*) was used by the French on the Canadian Great Lakes in the eighteenth century and the last xebecs were twentieth-century Tunisian fishing boats. The artist, Abraham Casembrodt, is thought to have been from the Netherlands.
PAD8357 / PU8357-1

X-CRAFT

LIEUTENANT BASIL GODFREY PLACE
c. 1921
John Worsley

X-craft were British midget submarines of World War II developed in 1941–42 for attacking enemy warships in harbour. They were 40 ft (12 m) long, with a crew of four and a pair of 2-ton, time-fused side-charges for dropping under their target. Towed by conventional submarines from Scotland, six tried to sink the *Tirpitz* in Kaa Fjord, Norway, on 20 September 1943. One was lost when the tow parted, one was scuttled for technical reasons and another (the sole survivor) had to turn back during the attack run. *Tirpitz* spotted and sank X5: X6 and X7 were abandoned after laying their charges, which badly damaged *Tirpitz*. The six captured survivors included the commanders, Lieutenants Place and Cameron, who won VCs. X-craft were also successfully used in the Pacific for cutting sea-bed cables.
BHC2954

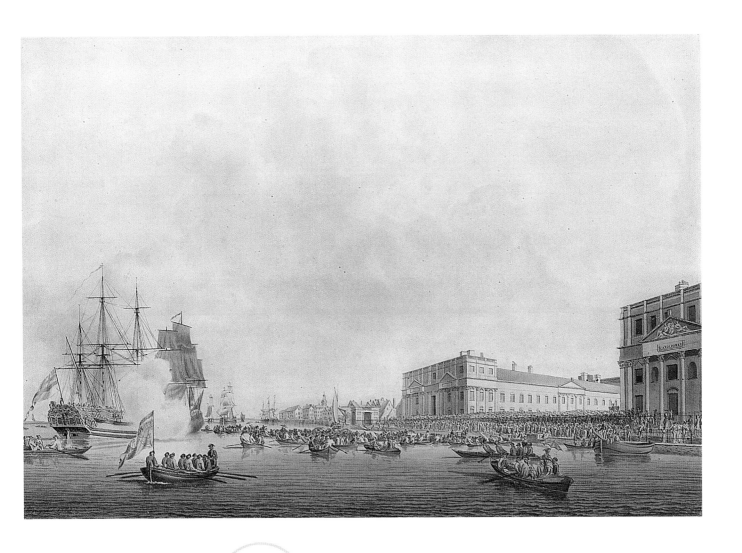

Y

YACHTS

**THE DEPARTURE OF PRINCE
WILLIAM HENRY FROM GREENWICH
FOR HANOVER**
1783
Robert Cleveley
This watercolour, signed and dated by
the artist, shows the departure of Prince
William Henry (later William IV) for
Hanover from Greenwich on 31 July 1783
in the *Princess Augusta* yacht,

commanded by Cleveley's friend and
patron, Captain George Vandeput.
Cleveley, who was a naval purser as well
as an artist, sailed with him in the royal
suite. After the Prince became Duke of
Clarence, Cleveley was appointed Marine
Draughtsman to him, and later to the
Prince of Wales.
PAH3990 / PY3990

241

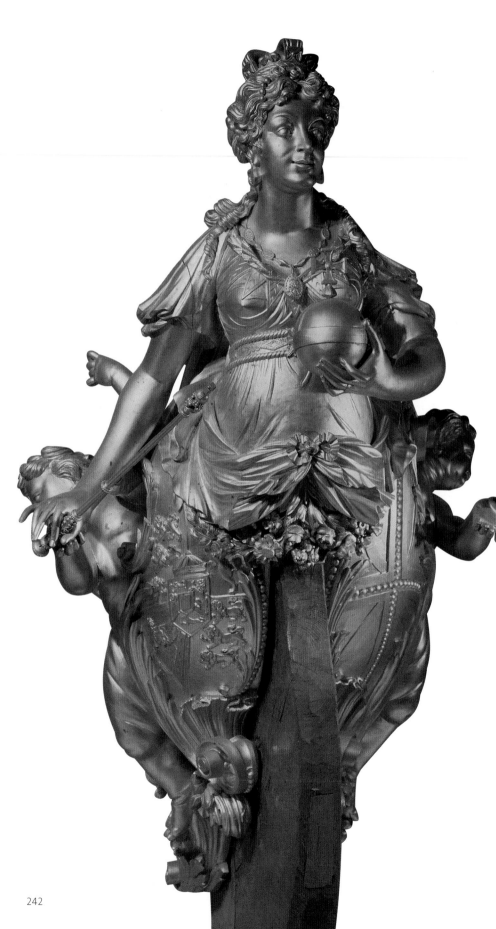

(Left)
FIGUREHEAD FROM THE
ROYAL CHARLOTTE
1824

The Royal Yacht *Royal Charlotte* was launched at Woolwich in 1824 and broken up only eight years later. The gilded figurehead, the finest in the Museum's collection, depicts a young Queen Charlotte, bride of George III, with orb and sceptre, and cherubs in attendance. A Victorian label described the figurehead as 'a very good likeness of Her late Majesty'. *Royal Charlotte* was rarely used, which helps to explain the excellent condition of the figurehead.
FHD0097 / D4736-1

(Opposite, bottom left)
KING'S CUP FOR YACHTING
John Bridge, London
1830

This silver-gilt yachting trophy, known as the King's Cup, was awarded in 1830 by the Royal Yacht Club, forerunner of the Royal Yacht Squadron. The third annual King's Cup Race was won on 21 August 1830, at the Royal Yacht Club regatta at Cowes, by Joseph Weld of Lulworth in his large racing cutter *Alarm*, built by Inman of Lymington. This was the *Alarm*'s first major race but she went on to become one of the most outstanding racing yachts of her age, and Joseph Weld one of the most famous yachtsmen. In 1851 *Alarm* competed with the *America* and other yachts in an event that was the forerunner of the America's Cup races.
PLT0256 / D1185

(Opposite, bottom right)
QUEEN'S TROPHY FOR YACHTING
Benjamin Preston, London
1838

This silver-gilt circular shield was the first Queen's Trophy awarded at the Royal Yacht Squadron's regatta of 1838. The central boss depicts Britannia and around the border are racing yachts under sail, taken from a painting by W. J. Huggins, owned by the Royal Yacht Squadron. It shows Lord Yarborough's 351-ton full-rigged ship *Falcon* and the Squadron yachts *Alarm*, *Pearl* and *Waterwitch*. The race, which was open to

yachts of all classes, took place on 17 August 1838. Joseph Weld won the race in his yacht *Alarm* and was awarded the Queen's Trophy. Later converted from cutter to schooner rig, *Alarm* continued racing until 1867 and was not broken up until 1889.

PLT0257 / D5952-1

(Right)

FIGUREHEAD FROM THE *SUNBEAM*
1874

The steam yacht *Sunbeam* was built for Lord Brassey, the Liberal MP for Hastings, 1868–86. Lady Brassey wrote several popular accounts of the family's voyages in the yacht, including a circumnavigation of the globe in 1876–77. The Brasseys had many adventures aboard: they rescued shipwrecked sailors, fought with Chinese pirates and witnessed many strange sights. *Sunbeam* made a number of cruises in the 1920s before being broken up in 1929. The figurehead, depicting a cherub, is said to be a good likeness of the Brasseys' daughter, Helen.

FHD0106 / D6046-2

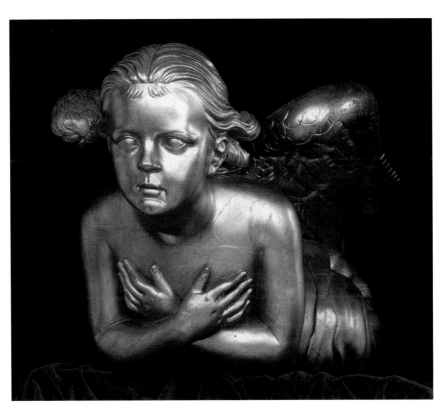

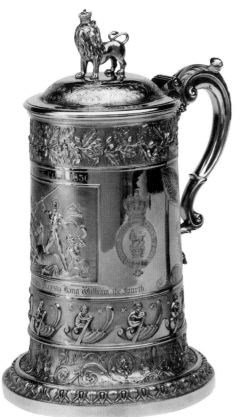

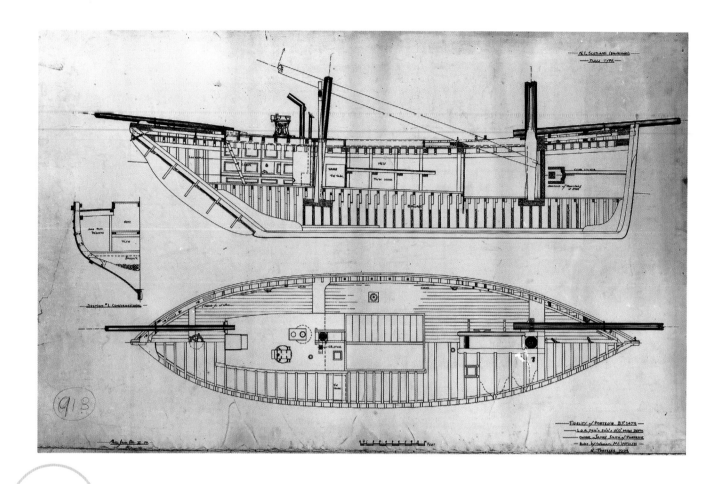

ZULU

FIDELITY, A ZULU-CLASS HERRING DRIFTER
Philip Oke
c. 1930

The Zulu class was introduced in north-east Scotland during the time of the Zulu War (1879) and the vessels were used in the North Sea herring fishing industry until they were superseded by steam drifters. In the 1930s Philip Oke was commissioned by the Society for Nautical Research to record the

indigenous craft of the British Isles and the Museum retains this collection of drawings. The sloping sternpost, as seen in the plan for *Fidelity*, was ideal for protecting the rudder in overcrowded harbours and the plan illustrates the scale and solidity of the Zulus, which could measure up to 79 ft (24 m) in length in their final days. *Fidelity* was registered in Banff and built by William McIntosh of Portessie in 1904.
CC91B

CHRONOLOGY

1433 Humphrey, Duke of Gloucester, half-brother of Henry V, encloses Greenwich Park and builds a watchtower on the hill.

1491 Future King Henry VIII born at Palace of Placentia, Greenwich.

1500–06 Henry VII rebuilds the Palace of Greenwich, replacing the medieval buildings of Placentia, on the site of the present Old Royal Naval College.

1515 Henry VIII builds tournament yard and towers on present east lawn area of the National Maritime Museum.

1516 Queen Mary I born at Palace of Greenwich.

1533 Queen Elizabeth I born at Palace of Greenwich.

1616–17 Inigo Jones designs the Queen's House for Anne of Denmark, queen of James I. Construction starts 1617–19.

1629–38 Queen's House finished for Henrietta Maria, queen of Charles I.

1662–69 Charles II adds 'bridge rooms' to the Queen's House and begins construction of a new palace (now part of the King Charles Court of the Old Royal Naval College).

1675–76 Charles II founds and builds the Royal Observatory, Greenwich.

1696 Sir Christopher Wren begins construction of the Royal Hospital for Seamen, following its foundation by warrant of William III and Mary II in 1694.

1705 First naval pensioners enter the Hospital.

1715 Start of Greenwich Hospital School.

1751 Completion of the four main courts of Greenwich Hospital.

1806 George III allocates the Queen's House as new home for the Royal Naval Asylum, an orphanage school.

1807–11 Colonnades and flanking wings added to the Queen's House.

1821 Greenwich Hospital School and Naval Asylum combine as 'Upper and Lower Schools of Greenwich Hospital'.

1824 'National Gallery of Naval Art' opened in the Painted Hall of the Hospital.

1833 First time ball installed at the Observatory.

1851 Establishment of modern Greenwich Meridian by Sir George Biddell Airy, seventh Astronomer Royal.

1861–62 Extension of west wings of school complex.

1869 Greenwich Hospital closes.

1873 Royal Naval College moves into the Hospital buildings.

1880 Greenwich Mean Time (GMT) becomes legal time for Britain.

1884 GMT becomes standard time for the world and Airy's Greenwich Meridian Universal Prime Meridian of Longitude.

1892 Greenwich Hospital Schools become the Royal Hospital School.

1894–99 South Building and Altazimuth Pavilion of Observatory built. The 28-inch telescope installed at Observatory in 1894.

1919 New time ball installed.

1927 'National Maritime Museum Trust' formed.

1933 Royal Hospital School moves to Holbrook, Suffolk.

1934 National Maritime Museum founded by Act of Parliament.

1937 The Museum and restored Queen's House opened.

1953–58 Royal Observatory transferred to the Museum.

1954 *Cutty Sark* dry-docked at Greenwich, restored and opened in 1957.

1967 Royal Observatory fully open to the public.

1968–79 Remodelling of the Museum buildings.

1983–97 Queen's House further restored.

Major restoration of the Royal Observatory.

1996 Start of National Maritime Museum's Neptune Court redevelopment.

1997 'Maritime Greenwich' becomes a UNESCO World Heritage Site.

1998 Royal Naval College passes into care of the Greenwich Foundation when service training is relocated to Wiltshire. Royal Greenwich Observatory at Cambridge closed and some functions return to Greenwich.

1999 NMM Neptune Court development completed and opened.

GLOSSARY

ALLEGORICAL
When the literal content of a work stands for abstract ideas, suggesting a parallel, deeper, symbolic sense.

AQUATINT
A method of printmaking by acid etching that gives the effect of an ink or wash drawing.

ARMILLARY SUNDIAL
A sundial in the form of a 'skeleton' globe made up of rings, from the Latin *armilla* (meaning bracelet).

BALEEN
A horny substance made of keratin, that comes from the mouths of certain whales, popularly called 'whalebone' and used for a variety of fashion and domestic purposes.

BARBARY
The former name for the Muslim city states and territories of North Africa.

BRASSARD
Metal arm badge worn on livery, often heraldically engraved.

BRIG
Two-masted vessel, square-rigged on both fore and main masts.

BUNTING
Plain woven cloth used for flags, originally of wool.

CARRACK
A large type of trading vessel of northern and southern Europe, used between the fourteenth and seventeenth centuries.

CHASING
The art of engraving on the outside of raised metalwork.

CHRONOMETER
A high-precision, portable timekeeping instrument used mainly on board ship for assisting in the determination of longitude. A chronometer has certain technical features that distinguish it from a standard clock or watch.

CHRONOMETER ESCAPEMENT
See detent escapement.

CHRONOMETER TRIALS
Tests carried out at Greenwich and other Observatories where chronometers were put on trial, often for a whole year, to ascertain their timekeeping qualities under various monitored conditions. Trials at Greenwich ceased in 1915.

CREAMWARE
Cream-coloured earthenware first produced in the eighteenth century.

CUTTER
A fast vessel with a single mast, fore-and-aft mainsail and two foresails, introduced about 1740.

DEAD-BEAT ESCAPEMENT
Unlike the standard 'anchor' escapement, the action of the dead-beat does not cause the wheels of the clock to reverse slightly with every swing of the pendulum. This allows the pendulum to maintain an arc much closer to the theoretical ideal.

DELFTWARE
British tin-glazed earthenware with opaque white glaze and blue pattern, influenced by the Dutch design.

DETENT ESCAPEMENT
An escapement where the driving wheels of a clock or watch are blocked by a lever (detent) which is temporarily unlocked by the pendulum or balance, allowing the impulse to be given before relocking occurs. This way the pendulum, or balance, swings for most of its arc, almost free from external influence. The majority of chronometers use this type of escapement with the locking detent mounted on a spring.

EAST INDIAMAN
Ship of the East India Company.

ENSIGN
A version of the national flag, flown by ships at or near the stern.

ESCAPEMENT
Part of the mechanism of every mechanical clock and watch. The escapement converts power transferred from a driving weight or spring into small, even impulses needed to keep the pendulum, balance or oscillator swinging.

FIRST-RATE
The largest size of ship in the six divisions of the sailing navy, carrying 100 guns or more.

FLENSING
Stripping a whale carcass of blubber and other usable parts.

FLOTA
A Spanish merchant fleet or convoy, often carrying high value cargoes.

FULL DRESS
Ceremonial uniform, first introduced for naval officers in 1748. Everyday uniform is termed 'undress'.

FUSEE
A type of variable gearing in the form of a conical spiral fitted to a clock or watch, to even out the delivery of power from a mainspring as it unwinds.

GABERDINE
A shower-proof woven cloth.

GALVANIC
Originally 'electric' but now generally understood as chemically generated electrical action.

GORES
Sections of maps of the world or the sky shaped so that when pasted onto a globe they join up to form a complete map of the Earth or the celestial sphere.

GRASSHOPPER ESCAPEMENT
Invented by John Harrison in the 1720s, this escapement utilizes a pushing, rather than a sliding action to impart its impulse, almost eliminating friction in this part of the clock. Called the 'grasshopper' because, in operation, its flicking action resembles that of the back legs of that insect.

GRIDIRON
A device sometimes incorporated into the pendulum of precision clocks. It utilizes the different expansion of dissimilar metals to compensate for changes in temperature that would otherwise have an adverse effect on timekeeping.

GRISAILLE
Painted in shades of grey monotone.

GROG
Rum diluted with water.

HYDROGRAPHY
The scientific description of the waters of the Earth.

ISOCHRONOUS
A pendulum or balance wheel in a clock or watch is said to be isochronous if its vibrations are of equal length, despite variations in its arc of swing.

JACK
Small flag flown at the bows of a vessel.

KOVSH
Russian ceremonial drinking vessel or presentation bowl.

MAINTAINING POWER
A system used to keep a clock or watch running while it is being wound. Particularly important with precision timekeepers.

MAN-HAULING
Pulling sledges by using manpower rather than draught animals or machinery.

MINIATURE
A portrait painted on a small scale with a minute finish.

NAP
A raised pile on the surface of cloth.

NORTH-WEST PASSAGE / NORTH-EAST PASSAGE
The sea routes between the Atlantic and Pacific Oceans round the northern coast of present-day Canada and northern Russia.

PENNANT
A narrow tapering flag, flown at the masthead.

PORCELAIN
Fine, translucent ceramic.

PORTULAN CHART
Early manuscript sea chart, characteristically drawn on vellum, with a pattern of intersecting compass direction lines (rhumb lines) and with place names written end-on to the coastline.

PRIVATEER
A privately owned, armed vessel with 'letters of marque' licensing it to take the ships of enemy nations as prizes.

QUEEN'S WARE
Creamware developed by Josiah Wedgwood, popularized by royal patronage.

REGULATOR
A clock primarily designed to keep accurate time at the expense of ornamentation or superfluous features such as a striking mechanism. These clocks, often used in observatories, are usually of high quality with simple, highly legible dials.

SALTIRE
The heraldic term for a diagonal cross. The Burgundian saltire has a ragged appearance, like two tree limbs with the branches lopped off.

SARD
A semiprecious stone, a variety of chalcedony.

SCHOONER
Vessel rigged with fore-and-aft sails on two or more masts, the mainmast taller than the foremast.

SCRIMSHAW
Carved or inscribed craftwork by whalemen, on whalebone and whales' teeth.

SCURVY
A potentially fatal illness caused by a deficiency of vitamin C in the diet.

SERGE
A twilled, worsted fabric.

SIDEREAL TIME
A sidereal day is defined as the time between successive transits of a known star over a meridian and is approximately 3 minutes and 56 seconds shorter than a mean solar day. Sidereal time is used in astronomy.

SPRING DETENT
See detent escapement.

SQUADRONAL COLOURS
Until 1864, British warships would have worn (in descending order of seniority) red, white or blue ensigns according to the rank of the flag officer in command.

STAY BUSK
Strip of whalebone or baleen used to stiffen the front of a corset.

TIMEKEEPER
The name given to a precision clock or watch, mostly from the seventeenth and eighteenth centuries, that usually has no other function such as striking, chiming or calendar work.

TIN-GLAZED
Earthenware with opaque white glaze, commonly termed 'delftware' in Britain.

TOPOGRAPHICAL
Depicting particular places and landscape.

TRITON
A merman, the male equivalent to a mermaid.

VELLUM
A fine parchment made from calf, lamb or kid skin used for writing or painting on, and often for book binding.

WATCH STRIPES
A strip of material worn round the top of the right sleeve by the starboard watch, and the left sleeve by the port watch. They were abolished as a part of naval uniform in 1895.

ACKNOWLEDGEMENTS

Many NMM staff members contributed to this book. Particular thanks are due to Nigel Rigby and Gloria Clifton for their editorial leadership. Authorship and other expert input on many fronts was supplied by Jonathan Betts, Robert Blyth, Imogen Gibbon, John Graves, Gillian Hutchinson, Daphne Knott, Brian Lavery, Jonathan Potts, Roger Quarm, Rina Prentice, Matthew Read, Bob Todd, Barbara Tomlinson, Simon Stephens, Pieter van der Merwe, Liza Verity, Robert Warren, Meredith Wells, Emily Winterburn and Gwen Yarker.

NMM Photographic Studio: Josh Akin, Ruth Ashdown, Tina Chambers, Ken Hickey, Darren Leigh, Lisa Macleod

NMM Publishing: Eleanor Dryden, Rachel Giles and Fiona Renkin

NMM Picture Library: Eleanor Driscoll, Colin Starkey, David Taylor and Lucy Waitt

COLLECTIONS CREDITS

The following bodies made substantial grants towards the acquisition of items illustrated in this book, as listed below.

The Heritage Lottery Fund
p.156: ZBA1609; 198: ZBA2430

The National Art Collections Fund
p.44: ZBA1219; 104: BHC1796; 175: BHC4237; 230: TXT0106
p.65: BHC0774 (part of the Palmer Collection)

The New Opportunities Fund
p.33: H2576

The following items come from special named collections in the National Maritime Museum:

Caird Collection
p.23: GLB0170; 25: SLR1083; 42: SLR0442; 43: ZAA0011;
54: BHC0636; 64: BHC3582; 65: BHC0860; 66: BHC2680;
SNG/4/XE90777; GLB0135; 78: GLB0096, GLB0097;
79: GLB0171; 81: GLB0140; 82: BHC1823; 85: BHC2736;
BHC1827; 94: BHC2823; 95: BHC2823; 113: SLR0002;
116: BHC0801; 123: BHC0513; 125: BHC0314; 149: BHC0723;
158: BHC3133; 159: BHC2720; 174: BHC0705; 187: BHC2949;
188: SLR0349; 190: BHC1045; 199: BHC1873; 204: SLR0149;
210: PAE4923; 228: BHC0256; 229: BHC0261; 230: BHC0425

The collections marked * are part of the Caird Collection:

Debreuil Collection*
p.41: AST0334

George Gabb Collection*
p.173: AST0567; 207: AST0391

Nicolas Landau Collection*
p.17: AST0570

Macpherson Collection*
p.64 BHC0711; 200: BHC1191

Greenwich Hospital Collection
p.13: BHC2853; 20: AST0172; 29: BHC3287; 55: MED1252;
59: BHC2389; 60: BHC1782; 85: REL0116; 87: AAA3310;

114: SLR0336; 127: BHC2889; 131: AAA2565; 136: UNI0024,
UNI0065, UNI0067, UNI0021; 140: AAA2079; 144: BHC2603;
145: BHC2628; 154: BHC2907; 157: AAA2626; 160: BHC3009;
176: BHC2797; 186: SLR0006; 217: BHC0565

Ingram Collection
p.233: BHC0679; 236: BHC0721

Ministry of Defence Art Collection
p.53: BHC1906; 106: ZAA0034; 107: ZAA0035, ZAA0036;
108: ZAA0037

Nelson-Ward Collection
p.129: JEW0168

Royal Collections Trust
p.208: BAE0035

Royal Greenwich Observatory Collection
p.18: ZBA2211; 22: ZBA1293

Royal United Service Museum Collection
p.217: NAV1649

Sutcliffe-Smith Collection
p.137: JEW0356

Trafalgar House Collection
p.132: JEW0078

Alan Villiers Collection
p.226: N61533; N61613; N61670

**Ordering Pictures and Prints from the
National Maritime Museum**

Pictures and prints of NMM copyright images may be ordered from the Picture Library, National Maritime Museum, Greenwich, London, SE10 9NF (tel. 020 8312 6600). Please quote the object's Item Number or Repro Identity Number as listed under each individual picture caption in this book (e.g. GLB0170 / D3340-1). For further information, please visit the Picture Library's website at:
http://www.nmm.ac.uk/picturelibrary.

INDEX